THEORY OF THE GIMMICK

THEORY OF THE GIMMICK

Aesthetic Judgment and Capitalist Form

Sianne Ngai

THE BELKNAP PRESS OF
HARVARD UNIVERSITY PRESS

Cambridge, Massachusetts
London, England
2020

First printing

Library of Congress Cataloging-in-Publication Data
Names: Ngai, Sianne, author.
Title: Theory of the gimmick : aesthetic judgment and
capitalist form / Sianne Ngai.
Description: Cambridge, Massachusetts : The Belknap Press of
Harvard University Press, 2020. | Includes bibliographical references and index.
Identifiers: LCCN 2019038757 | ISBN 9780674984547 (cloth)
Subjects: LCSH: Aesthetics, Modern—20th century. |
Aesthetics, Modern—21st century. | Aesthetics, Modern—Philosophy. |
Hoaxes. | Influence (Literary, artistic, etc.) | Capitalism.
Classification: LCC BH201 .N49 2020 | DDC 111/.85—dc23
LC record available at https://lccn.loc.gov/2019038757

For Hans Thomalla

Contents

THEORY OF THE GIMMICK

Introduction

This book is about the irritating yet strangely attractive gimmick as an aesthetic judgment and capitalist form. Focusing on an *ambivalent* judgment tied to a *compromised* form, it underscores the fact that aesthetic categories have two sides—the judgment we utter, a way of speaking; the form we perceive, a way of seeing—sutured by affect into a spontaneous experience.[1] In the case of the extravagantly impoverished, simultaneously overperforming and underperforming gimmick, we are dealing with an aesthetic specific to a mode of production that binds value to labor and time, giving rise to a unique set of collectively generated abstractions and peculiarly asocial kinds of sociality.

Always dubious if never entirely unappealing, the gimmick wears multiple faces. It can be a catchy hook, a timeworn joke, a labor-saving contraption. In the studies that follow, we will encounter it in even more specific guises: as a smiley face, a financial strategy, a readymade artwork that interprets itself. Gimmicks are fundamentally one thing across these instances: overrated devices that strike us as working too little (labor-saving tricks) but also as working too hard (strained efforts to get our attention). In each case we refer to the aesthetically suspicious object as a "contrivance," an ambiguous term equally applicable to ideas, techniques, and things.

In our everyday encounter with the gimmick, we are thus registering an uncertainty about labor—its deficiency or excess—that is also an uncertainty about value and time. These metrics become inseparable in a system necessitating unceasing innovation as competing capitals move

1

around the world in search of profit, expelling labor from abandoned lines. Each variable determines and is necessary for expressing the others. The gimmick thus acquires its reputation of bad timing—being too old or too new—based on its deviation from a tacit standard of productivity. Under- or overperforming with respect to this historical norm, it strikes us as technologically backward or just as problematically advanced: futuristic to the point of hubris, as in the case of Google Glass, or comically outdated, like the choreographed jerks used to simulate turbulence in television episodes of *Star Trek*.

Finally, as what we call devices that strike us as cheap even when we know they were expensive to develop, the gimmick is a judgment that asks us, in a well-nigh blasphemous way, to conflate aesthetic value with economic value—money—and more specifically, unproductively utilized money. For one of the gimmick's paradigmatic instances is the overrated product one would be a sucker to buy, and thus an unsold commodity whose value cannot be realized. Yet from the stainless steel banana slicer to the cryptocurrency derivative, our very concept of the gimmick implies awareness that, in capitalism, misprized things are bought and sold continuously. Its flagrantly unworthy form can be found virtually anywhere: manufacturing, law, banking, education, politics, healthcare, real estate, sports, art.

The gimmick is thus capitalism's most successful aesthetic category but also its biggest embarrassment and structural problem. With its dubious yet attractive promises about the saving of time, the reduction of labor, and the expansion of value, it gives us tantalizing glimpses of a world in which social life will no longer be organized by labor, while indexing one that continuously regenerates the conditions keeping labor's social necessity in place.[2]

Notice how the appraisals of labor, time, and value that our judgment of the gimmick conjoins are left unparticularized, as if implicitly grasped as historically relative and moving. This is strikingly akin to Kant's judgment of beauty, which not only claims universality in the absence of concepts, but as Rodolphe Gasché suggests, "denudes" or strips the concept of content, retaining it as "bare" form, or in Kant's words, "merely formal" (bloß).[3] Similarly, our implicit assessment of the deficient or excessive amounts of labor, value, and time objectified in the gimmick all presuppose social norms that the act of judgment leaves unspecified.[4] None of the appraisals encoded in our judgment of the gimmick thus interfere with its affective spontaneity. Rather, our experience of the gimmick under-

scores the surprisingly dynamic formalism—the formalizing activity—of aesthetic judgment overall. Grounded in feelings activated by appearance, as opposed to in concepts, rules, or laws, aesthetic judgment is by definition neither cognitive nor practical. Yet such judgments are crucially elicited in its immediate aftermath. In the gimmick, specifically, our spontaneously affective, explicitly aesthetic appraisal of an object's form as unsatisfyingly compromised triggers and comes to overlap with economic and ethical evaluations of it as cheap and fraudulent.

Labor, time, and value are of course interconnected nonaesthetically through the billions of interactions between capital and labor that enable the calculation of wages, profit, and interest. This interconnection presupposes a mode of production involving competition between capitals, the equalization of intrasectoral profit rates, and the structurally compelled transformation of labor processes toward increasing productivity. If the gimmick seems too expensive or too cheap, it is because the technology behind it is too new or too old. And the fact of technology being too new or old often directly accounts for why a gimmick seems to be over- or underperforming. These relations hold true in reverse. If the gimmick seems to be working too hard or too little, it is because the social timing of its appearance is off. And when it is said that a productive technology has arrived too early, what is meant is that its cost is proving too high.

These ratios get filtered into the conscious and unconscious decisions of all producers and consumers. Yet each carries a seed of worry that the gimmick objectifies. If the overworking device generates the image of too many goods produced per hour for the market to absorb, its underworking twin generates the image of not enough goods produced per hour for a producer to stay competitive. These images in turn invoke bigger specters, such as overproduction or underconsumption (leading to surplus or idle capitals), structural unemployment (leading to surplus populations), and economic stagnation. All lurk at the edges of our sensory encounter with the gimmick's ostentatiously impoverished form.

The gimmick thus names an experience of dissatisfaction—mixed, for all this, with fascination—linked to our perception of an object making untrustworthy claims about the saving of time, the reduction of labor, and the expansion of value. No other aesthetic experience so directly invokes, as if explicitly to solicit our misgiving about these promises. At the same time, the hoaxes of Edgar Allan Poe and P. T. Barnum, avid deployers of the gimmick avant la lettre, remind us that the suspicion that the gimmick activates can be counterintuitively enjoyed.[5] In this legacy of deliberately

introducing doubt into aesthetic experience, continued in Marcel Duchamp's incorporation of the gimmick's brazenly contemptible form into his ready-mades (staged collisions of artistic and value-producing labor designed to highlight their equivocal relation, John Roberts argues), and in Alfred Hitchcock's fondness for what D. A. Miller calls "compelling, but meaningless" displays of technical virtuosity (which might be read similarly), it becomes clear that suspicion does not come only in one unhappy flavor.[6] Poe, Duchamp, and other deployers of gimmicks remind us that it is often rather an occasion for comedy and a catalyst for debate, as we will see across this book.

The judgments of labor, time, and value encoded in the gimmick suggest that this aesthetic category reflects nothing less than the basic laws of capitalist production and its abstractions as these saturate everyday life. If this is the simplest thesis of this book, its more complex claim is that in reflecting these laws—the extraction of surplus value from living labor; the systematic pursuit of greater productivity per worker, as rates of profits between industries equalize and eventually fall—the gimmick also encodes the limits to accumulation and expanded reproduction that expose capitalism to crisis. Both arguments are reflected in the timeline of "gimmick." The *Oxford English Dictionary* dates its first appearance to 1926, while Google shows its steadily rising usage coming to a spike in 1973, a common marker for the end of the "Golden Age of Capitalism" and the start of the "Long Downturn."[7]

The circulation of "gimmick" thus begins in earnest with the onset of global recession in the 1930s and surges at the beginning of the turbulent 1970s, in tandem with stagnating wages, rising household debt, and increasing market volatility. It is accordingly telling that representations of the gimmick in this book tend to thematize what Beverly Silver and David Harvey call capitalism's "fixes": the "spatial fix" (David Mitchell's horror film *It Follows*), the "product-based fix" (Helen DeWitt's novel of ideas *Lightning Rods*), the "technological fix" (ditto), and the "financial fix" (Robert Louis Stevenson's "The Bottle Imp").[8] The texts in which these ingenious solutions become foci are also aesthetic risk-taking experimentations with the use of the gimmick's compromised form. They intriguingly suggest that capital's historical repertoire of remedies—geographical relocation, movement into new product lines with less intense competition, experimentation with cultural and technological ways of organizing production, and eventual movement out of production altogether—tend to "reschedule" crises of profitability rather than "permanently resolv[ing]

them."[9] Hence they highlight underlying features of capitalism associated with crisis, as much if not more than the fixes applied to them: the expulsion of labor from the production process (*Lightning Rods*), the growth of low-productivity service occupations (the late fictions of Henry James), the rise of "surplus populations" ("The Bottle Imp").

The encoding of internal barriers to expanded reproduction sets the over- and / or underperforming gimmick apart from other aesthetic categories that also tell us something about how ordinary people process capitalism. The cute, mixing tenderness and aggression, speaks to our equivocal relation to the commodity as consumers. The zany, which is supposedly fun but primarily stressful, highlights the shifting and sometimes ambiguous borders separating work from nonwork. But the flagrantly unworthy gimmick, our culture's only aesthetic category evoking an abstract idea of price, is also the only one in which our feelings of misgiving stem from a sense of overvaluation bound to appraisals of deficient or excessive labor encoded in form. It names an encounter with aesthetic appearance that not only reflects the capitalist mode of production's innermost laws but the daily ways in which we interact with the economic abstractions these laws precipitate, from wages to rents.

Like all aesthetic categories, the gimmick names a relationship between a relatively codified way of seeing and a way of speaking that the former compels.[10] As a judgment, however, the gimmick contains an extra layer of intersubjectivity: it is what we say when we want to demonstrate that we, unlike others implicitly invoked or imagined in the same moment, are not buying into what a capitalist device is promising. Robert Pfaller refers to this structure of displacement as a "suspended illusion": beliefs like the superstitious rituals of the sports fan that "always belong to others, that are never anyone's own [beliefs]."[11] It is a phenomenon in which one's cultural skepticism, coupled explicitly here to enjoyment, comes to hang on the abstraction of a believer elsewhere. Conversely, the way in which our judgment of the gimmick conjures the image of a dissenting judge—a generic person for whom one's gimmick is a nongimmick—suggests that one needs this abstraction to have an experience of the gimmick at all.

When a device does not strike us as suspiciously over- or underperforming, we will not perceive it as a gimmick but as a neutral device. This judgment will contain no "axiological charge"; it will be cognitive and not aesthetic.[12] But since the gimmick lies latent in every made thing in capitalism, devices can flip into gimmicks at any moment and vice-versa as well. As I write it still feels easy to make fun of Google Glass, which

"went dark" only three years after its overhyped debut as a consumer good in 2012.[13] But a renamed version of Glass is now used in factories and warehouses in which workers need real-time information and both hands free, including in what Marx called "Department I" factories producing machines for other factories. In the same way that credit cards, cell phones, and prepared meals were once but no longer considered extravagances, "smart glasses" look destined to become everyday industrial tools.

Such reversals are endemic to the world that gives rise to the gimmick's compromised aesthetic. Like capitalism itself, in which paradoxes like planned obsolescence and routinized innovation abound, the gimmick is a temporally sensitive and fundamentally unstable form. As we can intuit from names like Active Edge and Turbo Boost, the toggle between gimmick and device is internal to the gimmick and indeed to the device. Each names a potential station in the other's developmental trajectory.[14]

This dynamic comes to the fore in early twentieth-century popular science.[15] As Grant Wythoff notes in his study of the "gadget stories" of Hugo Gernsback, inventor of labor-saving devices like the Isolator and Dynamophone and publisher of the science fiction magazine *Amazing Stories* (1926), "the positive sciences and the fantastic arts [have long been] linked in a dialectic of doubt and certainty." Gernsback's bestselling Telimco telegraph was for instance "little more than a gimmick, a parlor trick—press a button and a bell in another room would ring without the need for any intervening wires." Yet "it was also a rough prototype, an aggregate of handmade components that encouraged a conversation on what the wireless medium might look like in the future."[16]

The gimmick is a trick, a wonder, and sometimes just a thing. But it is also something accounting for the systematic slippage between these positions, in a way that focusing exclusively on its technological dimension will cause us to miss. Overperforming and underperforming, encoding either too much or not enough time, and fundamentally gratuitous yet strangely essential, the gimmick is arguably a miniature model of capital itself, as described by Marx in this oft-quoted passage from the *Grundrisse* nicknamed the "Fragment on Machines":

> Capital itself is the moving contradiction, [in] that it presses to reduce labour time to a minimum, while it posits labour time, on the other side, as sole measure and source of wealth. Hence it diminishes labour time in the necessary form so as to increase it in the

superfluous form; *hence posits the superfluous in growing measure as a condition—question of life or death—for the necessary.*[17]

Some post-Marxists interpret this passage optimistically. The idea is that two twentieth-century trends summarized by "general intellect" and "real subsumption"—the growing role of science and technology in production; capitalist control over not only production but "all of the allied processes of social reproduction (education, sexuality, communication, etc.)"—will eventually decouple value from labor in a way that will prove disastrous for capital, "explod[ing] the older value form" and putting the "Law of Value into crisis."[18]

Others read the "Fragment" as we might imagine the extravagantly impoverished gimmick doing.[19] Here we see the "moving contradiction" as less a utopian prophecy of an automated future in which wealth will no longer be tied to labor than as a description of what Joshua Clover pithily calls the "annihilation of the source of absolute surplus value . . . by the pursuit of relative surplus value."[20] In this dynamic, as described by Marx, the accumulation of capital relies on the extraction of surplus value: value created in the hours of labor performed after a laborer has completed those enabling the capitalist to recoup the price of her labor power.[21] Absolute surplus value results from a lengthening of the working day, while relative surplus value results from a reduction in necessary labor time through increases in efficiency generated by technological innovation. Intercapitalist competition for greater productivity ("the pursuit of relative surplus value") replaces living labor with machines. This makes an increasing fraction of living labor ("the source of absolute surplus value") redundant but without changing accumulation's dependency on surplus labor. Regardless of rising levels of productivity per worker, "value-creating labor remains at the heart of the system."[22] Yet value-creating labor is what is being perpetually thrown off. Closely related to what Moishe Postone calls capitalism's "treadmill effect," this pattern as analyzed by Marx in *Capital* leads directly to his discussion of "relative surplus populations": a "population . . . superfluous to capital's average requirements for its own valorization," which can take the "striking form of the extrusion of workers already employed, or the less evident, but no less real, form of a greater difficulty in absorbing the additional working population through . . . customary outlets."[23]

We will see a recurring narrative of this process in the studies of the capitalist gimmick that follow: in the rise of the temp agency narrated in

Lightning Rods (Chapter 1), in the unpaid yet curiously still working servants who populate Henry James's mature and later fictions (Chapter 8), in the kinless and/or nonproductive persons used to bring closure to the circulation of a bad financial device in "The Bottle Imp" and the horror film *It Follows* (Chapter 4), and in the allegories of technological obsolescence and fairytale-like stories of exchange in Stan Douglas's video installation *Suspiria* (Chapter 7). These texts suggest that when the gimmick takes the form of a labor-saving device, in particular, it is closely attended by its shadow: the becoming "superfluous" of value-productive labor and rise of more uncertainly productive kinds. As autoworker James Boggs puts it in "The American Revolution: Pages from the Negro Worker's Notebook" (1963): "It is in this serious light that we have to look at the question of the growing army of the unemployed. We have to stop looking for solutions in pump-priming, featherbedding, public works, war contracts, and all the other gimmicks that are always being proposed by labor leaders and well-meaning liberals."[24] Boggs hints that the "gimmick" is as much (if not more) about *non*labor as labor. And indeed, that the relation between nonlabor and labor is already encrypted in labor, the structural antithesis as well as counterpart of capital.[25]

The "annihilation of the source of absolute surplus value . . . by the pursuit of relative surplus value." Reflecting this "moving contradiction" in its abstract or implicitly social estimations of deficient or excessive labor, time, and value, the gimmick is not only an aesthetic "about" capitalism's labor-expelling drive toward increasing productivity. It indexes unease about the future of accumulation attending it.

To say that an idea of crisis lies coiled in the transparently banal gimmick sounds strange. Yet as Miller is quick to notice at the beginning of "Anal Rope," which opens with an acerbic discussion of the way critics "fuss" or hype up Hitchcock's technical stunt in *Rope* (the trick of supposedly shooting without a cut) while casually acting as if its homosexual story is no big thing, the gimmick has a clever way of disarming us from taking it seriously: "The gimmick arrests attention, *but only in the process to relax the demands put on it by an ostentatiously unworthy object.*"[26]

Miller suggests two moments in this aesthetic encounter. The first is a snapping to alertness, triggered by an initially energizing perception of form. The second is a slackening, as one becomes aware of the form's disappointing poverty. The moment in which the gimmick arouses *critical* response is therefore simultaneously a *dissipation* of criticality. Why

continue paying attention to that which you've just judged as undeserving of attention? The "ostentatiously unworthy," "sumptuously extraneous," "compelling, but meaningless" gimmick thus discourages us from not only looking more closely at it but at the very suspicion it activates. That suspicion indexes nothing less than how the relation between labor and capital structures the way we perceive the world, seeping into how people share their pleasures and displeasures.[27] It is our society's distinctively aesthetic way of processing the fundamentals of capitalist accumulation: the production of wealth as value, the binding of value to labor's abstraction, the determination of abstract labor by socially necessary labor time. Yet protected by its own slickness, as a thing whose sheer stupidity cleverly neutralizes the critical feeling it incites, the gimmick defends itself from intellectual curiosity in a way that puts any person seeking to analyze it at a comical disadvantage.

Handle, Wig, Prop

In a world in which the necessary hangs on the superfluous, the gimmick is often a survival strategy. Let us briefly consider three representations of this dynamic, widely varying in affect and tone.

In "Letter from a Region in My Mind" (1962), James Baldwin describes the summer he reached puberty as the moment when "crime" first struck him as an alternative to waged employment. "One would never defeat one's circumstances by working and saving one's pennies; one would never, by working, acquire that many pennies, and, besides, the social treatment accorded even the most successful Negroes proved that one needed, in order to be free, something more than a bank account."[28] The onset of adulthood thus coincides with disenchantment with social promises tied to the wage, a form linked not just to the "bank account" but indirectly to "school," which Baldwin says had begun "to reveal itself as a child's game that no one could win."

> One needed a handle, a lever, a means of inspiring fear. It was absolutely clear that the police would whip you and take you in as long as they could get away with it, and that everyone else— housewives, taxi-drivers, elevator boys, dishwashers, bartenders, lawyers, judges, doctors, and grocers—would never, by the operation of any generous human feeling, cease to use you as an outlet for his frustrations and hostilities.

A few paragraphs later, "handle" morphs into "gimmick." The shift arises when the narrator finds his antagonism returned at full power by the forces giving rise to it. "I did not intend to allow the white people of this country to . . . polish me off that way. And yet, of course, at the same time, I *was* being spat on and defined and described and limited, and could have been polished off with no effort whatever." Pessimism about direct conflict leads Baldwin to the gimmick, which he describes in an impersonal manner before returning to the first-person:

> Every Negro boy . . . who reaches this point realizes, at once, profoundly, because he wants to live, that he stands in great peril and must find, with speed, a "thing," a gimmick, to lift him out, to start him on his way. *And it does not matter what the gimmick is.* It was this last realization that terrified me and—since it revealed that the door opened on so many dangers—helped to hurl me into the church. And, by an unforeseeable paradox, it was my career in the church that turned out, precisely, to be my gimmick.

"Every Negro boy" needed "a 'thing,' a gimmick, to lift him out"; "One needed a handle, a lever, a means of inspiring fear." If this metrical parallel suggests "gimmick" and "handle" might be versions of the same thing, it invites us to regard the morally polarized things they stand for—"crime" and "church"—as contiguous ways of surviving "racial capitalism" via fidelity to something other than "saving one's pennies."[29] Baldwin knows that neither handle nor gimmick offer true exits from the system linking them together. What his brief gloss on their relation rather suggests is that in a world in which the essential depends on the gratuitous, gimmicks are sometimes necessary to get out of other gimmicks.

One sees this even more clearly in Charles Stevenson Wright's dark comedy *The Wig: A Mirror Image* (1966), which holds the gimmick's suspicious and unstable form at its very center.[30] "SET IN AN AMERICA OF TOMORROW" which nonetheless resembles Harlem in the mid-1960s, the novel opens as follows:

> I was a desperate man. Quarterly, I got that crawly feeling in my wafer-thin stomach. During those fasting days, I had the temper of a Greek mountain dog. It was hard to maintain a smile; everyone seemed to jet toward the goal of The Great Society, while I remained in the outhouse, penniless, without "connections." Pretty girls, credit cards, charge account, Hart Schaffner & Marx suits, fine shoes,

10

> Dobbs hats, XK-E Jaguars, and more pretty girls cluttered my butterscotch-colored dreams. Lord—I'd work like a slave, but how to acquire an acquisitional gimmick? (7)

Confronting us at the very start with the necessity of something trivial, hunger sets the existential mood for Wright's stylized introduction to the "acquisitional gimmick." That gimmick will be first and foremost a way of acquiring a *wage*, but also, as we quickly discover, a *wig*, or new way of doing his hair. "The Wig is gonna see me through these troubled times," he says to his neighbor Nonnie. *The Wig*'s gimmick is the eponymous wage-conjoined "wig," tempting us to imagine *The Gimmick*—or better, *The Wage*—as its "mirror image" or alternative title.[31]

The confusion produced by a gimmick that is *necessary* but which must by definition be *trivial*—although can hair or anything related to physical appearance ever be successfully trivial in racist culture?—gets echoed in the swerve in *The Wig*'s opening paragraph from the discomfort of hunger ("I got that crawly feeling in my wafer-thin stomach") to its list of what seem to be escalatingly sumptuous luxury items: "credit cards, charge account, Hart Schaffner & Marx suits, fine shoes, Dobbs hats, XK-E Jaguars." If the swerve reinforces our uncertainty about whether *The Wig*'s gimmick is fundamental or frivolous, it also evokes the surreal contrast between the promises of Johnsonian democracy and racialized economic inequality. It additionally highlights the historical contingency of the capitalist "wage basket," whose use values are as subject to flux as the value of reproducing labor power. Credit cards, for example, while included in Wright's list of seemingly nonessential commodities above, are a necessity for many in the United States today, enabling households to make monthly ends meet by compensating for stagnant wages and declining benefits.

One sees this development precipitating in the 1970 documentary *Finally Got the News*, which features the voice of one member of the League of Revolutionary Black Workers, Ken Cockrel, denouncing the "whole credit gimmick society":

> They give you little bullshit amounts of money for working, wages and so forth and then they steal all that shit back from you in terms of where they got this whole other thing set up, this whole credit gimmick society, man. Consumer credit: buy shit, buy shit, on credit. He gives you a little bit of shit to cool your ass out and then steals all that shit back. With shit called *interest*. The price of money.

> Motherfuckers are non-producing, non-existing, you know, industry, you know, motherfuckers who deal with paper.[32]

Is finance gratuitous or necessary for capitalism to run smoothly? This question will be taken up in Chapter 4. Is the gimmick itself a gratuitous or necessary object? *The Wig* forefronts this question in a way Baldwin's text does not. For while the goal of Lester's wig is bare subsistence, it can be strangely hard to see this because of the hyperbole surrounding it:

> Remember, I said to myself, you are living in the greatest age mankind has ever known. Whereupon, I went to the washbasin, picked up the Giant Economy jar of long-lasting Silky Smooth Hair Relaxer, with the Built-in Sweat-proof Base (*trademark registered*). [. . .] The red, white, and gold label guarantees that the user can go deep-sea diving, emerge from the water, and shake his head triumphantly like any white boy. (10)

The application of Silky Smooth, which has cost him two days of food, does not make Lester look white, but more racially ambiguous in a way that raises his hopes for employment.

> I had tried so hard. Masqueraded as a silent Arab waiter in an authentic North African coffeehouse in Greenwich Village. . . .
>
> What happened after [losing that job]? More of the crawly worms in the stomach. Misery. I tap-danced in front of the Empire State Building for a week and collected only one dollar and twenty-seven cents. . . . I could have got on welfare, but who has the guts . . . ? There are some things a man can't do.
>
> No, a man tries another gimmick. But what? . . . Filipino? American Indian? . . . Was I capable of bringing off a Jewish exterior? I wondered. Becoming a nice little white Protestant was clearly impossible. (8–9)

Gimmick, wage, and "wig" qua device for bringing off a performance of nonblackness—any kind—are rendered synonymous by the end of this passage.

The Wig thus presents the gimmick as both impoverished and extravagant. It is not even yet a labor-saving device (one of its more prominent guises, as we shall see) but an even more basic commodity: what Lester must acquire in order to complete a sale of his labor power, which will

in turn enable him to buy what he needs to reproduce it. But even when Lester's "Giant Economy" investment becomes a cause of triumphant exultation due to its technical success ("My hair will not go 'back home,' back to the hearth of kinks and burrs. Silky Smooth is magnificent!"), his "acquisitional gimmick" does not finally make much difference to the story; it remains an "ostentatiously unworthy," "sumptuously extraneous," "compelling, but meaningless" object.[33] Indeed, *The Wig* is a picaresque comedy whose main throughline is its repeated staging of the wig's ineffectuality.

Consider, as our last example of the gimmick's interweaving of the superfluous and essential, "You Gotta Get a Gimmick" from the Broadway musical *Gypsy* (1959).[34] It is a scene in which young Louise, who will eventually become Gypsy Rose Lee, receives vocational advice from three seasoned strippers: Mazeppa, whose trick is a trumpet; Electra, whose trick is electrical lights; and Tessie, whose trick is idealized femininity: she has figured out a way to perform burlesque's simulation of sex acts while flitting about in ballerina drag (Fig. 0.1). Each device constitutes a jaunty salute to a key dimension of theater—music, lights, costume—via

FIGURE 0.1

13

a component noticeably less prestigious than these other categories: the ambiguous stage prop.[35] Stephen Sondheim's lyrics are worth quoting in their entirety:

MAZEPPA

You can pull all the stops out
Till they call the cops out
Grind your behind till you're banned
But you gotta get a gimmick
If you wanna get ahead

You can sacrifice your sacro
Workin' in the back row
Bump in a dump till you're dead
Kid, you gotta get a gimmick
If you wanna get ahead

You can (*bump!*), you can (*bump!*)
You can (*bump!*) (*bump!*) (*bump!*)—
That's how burlesque was born
So I (*bump!*) and I (*bump!*)
And I (*bump!*) (*bump!*) (*bump!*)—
But I do it with a horn!

(*Performs her act with trumpet.*)

Once I was a schlepper
Now I'm Miss Mazeppa
With my Revolution in Dance
You gotta have a gimmick
If you wanna have a chance

ELECTRA

She can (*bump!*), she can (*bump!*)
She can (*bump!*) (*bump!*) (*bump!*)—
They'll never make her rich
Me, I (*bump!*) and I (*bump!*)
And I (*bump!*) (*bump!*) (*bump!*)—
But I do it with a switch!

(*Performs her act with lights.*)

I'm electrifying
And I'm not even trying
I never have to sweat to get paid
'Cause if you got a gimmick
Gypsy girl, you've got it made!

TESSIE

All them (*bump!*) and them (*bump!*)
And them (*bump!*) (*bump!*) (*bump!*)
Ain't gonna spell success
Me, I (*bump!*) and I (*bump!*)
And I (*bump!*) (*bump!*) (*bump!*)
But I do it with finesse!

(*Performs her act interspersing bump and grind with fluttery
 ballet moves.*)

Dressy Tessie Tura
Is so much more demurer
Than all them other ladies, because
You gotta get a gimmick
If you wanna get applause!

ALL

Do somethin' special
Anything that's fresh'll
Earn you a big fat cigar
You're more than just a mimic
When you got a gimmick—
Take a look how different we are!

(*They all do exactly the same moves*)

ELECTRA

If you wanna make it
Twinkle while you shake it

TESSIE

If you wanna grind it
Wait till you refined it

MAZEPPA

If you wanna pump it
Pump it with a trumpet!

ALL

Get yourself a gimmick
And you, too,
Can be a star!

This testimony to the gimmick's paradoxical necessity brings out features which will be more closely explored in Chapter 6. First, the gimmick is a fetish, hence inevitably sexualized. It is what sticks out: a part-object making presumptuous claims for aesthetic autonomy. This obtrusiveness makes the gimmick comical: being "sumptuously extraneous" has its charm. Yet the gimmick remains a law imposed; it is, after all, what one must acquire to work. At the same time, with the goal of continuing to work indefinitely, the strippers use it to mitigate work's harmful effects: its wearing down of the body ("sacrifice your sacro"); possible criminalization ("grind your behind till you're banned"). The world in which attaining this superfluous device becomes necessary is of course marked by stark economic polarities (dying in a "dump"; getting a "big fat cigar").

This song about workers and their ambivalent relation to the gimmick also doubles as a gimmicky homage to the prop (and indeed, to the metaleptic thrill of "baring the device").[36] What distinguishes a prop from other onstage objects, such as those we would classify as part of a costume or set? Andrew Sofer argues that it is "manipulation by an actor in the course of performance," which makes the prop into something temporal. "Irrespective of its signifying function(s)," the prop is "something an object becomes, rather than something an object is."[37] A stage object "must be 'triggered' by an actor in order to become a prop," which is why a "hat or sword remains an article of costume until an actor removes or adjusts it." Props, like gimmicks, encode "actor-object interaction." More than other theatrical objects, they evoke dead labor activated by living labor in the immediate production process.[38] We might therefore repurpose Sofer's definition: what sets the prop apart from other objects in theater, perhaps accounting for its lesser prestige therein, is its uncanny isomorphism with the gimmick as capitalist form.

Verbal Performance

The protagonists of our examples seem noteworthy: queer black men with thwarted or ambivalent relations to the Fordist wage; women performing at the boundary of cultural and sex work; activist autoworkers pointedly highlighting the creation of "all kinds of gimmicks" to compensate for a "growing army of the unemployed."[39] Are those whose labor power is structurally devalued, or whose ability to sell it is more precarious, more likely to call out the gimmick than others? Is this because they are more exposed to its dangers? We can add another layer to this question. Given the consistency with which gender and race get written off as peripheral to capitalism, does the relation of those marked by these categories to the superfluous/necessary gimmick become especially charged? Or is it because ideologically fetishized categories of difference are just as consistently relied on as capitalist "fixes," lowering the value of labor power and intensifying rifts among the exploited?

In any case, our lineup of examples shows how the tone of the gimmick's judgment can be strikingly varied in ways corresponding to differing inflections of the form. In "Gotta Get a Gimmick," the gimmick is a tool deftly manipulated by the worker; it is dead labor subject to living labor's skill or control and, in part for this reason, cute. It retains its comedy in *The Wig*, although here in a way that is more edgily zany. Precisely because of his different relation to the wage, Lester's relation to his gimmick is different too: it is not a skill but a finagling or trick, conning racism just enough to transact the sale of his labor power. Functioning as protection from direct violence, the gimmick is even less funny in Baldwin. And Cockrel uses the word with vehemence, tinged with none of the contemptuous affection we hear in *The Wig* or *Gypsy*.

Such variation in tone underscores the specificity of "gimmick" as a verbal performance. And indeed, as affective speech capable of being put to critical or even political uses in a way other negative aesthetic judgments are not. For as we have noted, the "gimmick" is not just a negative judgment but the more complex negation of another person's judgment of the value of the same object we find unworthy. As Dalglish Chew might say, it is a way of "problematizing" other people's aesthetic pleasures, and in a way that discloses the surprising importance

of the "attunement" of their aesthetic pleasure with ours in the first place.[40]

The gimmick thus has a redoubled way of highlighting how other judges, abstract figures standing in for our relations to others in general, are already "inside" our most spontaneous, affectively immediate experiences of form. As Kant argues in one of his thought experiments in *Critique of Judgment*, a world consisting only of a single human would be a world devoid of taste (§41, 177). In a sense, aesthetic judgment or experience—for Kant, one and the same—involves thinking the social in abstract. It is, as Anna Kornbluh puts it, a "registering of qualities beyond subjective sensation" (if also, importantly, through subjective sensation) that "conjures an extensive social field of others who share the same registering." Every aesthetic experience is thus a "palpability of sociality, a mental experience of the objectivity of our interdependent interconnectedness."[41] But certain ones bring this out more than others.

The heightened confrontality of the gimmick, for instance, with its internalized image of a dissenting judge, highlights one of the most fundamental, yet as Kant notes, "strange and anomalous" things about aesthetic judgments, which is the compulsion to demand that other people agree with them.[42] Kant's third *Critique* takes off from this puzzle of compulsion unique to aesthetic judgment and, in asking what it tells us about how our minds relate to the world, discovers that this relation presupposes other minds. And therefore communication, as some readers have stressed. For Hannah Arendt, judgment is a public activity that is not only "communicable" but "expects others to join in," and proceeds by taking the judgments of others in account.[43] The sensus communis, which Kant holds to be a transcendental a priori condition for the judgment of taste, is for this reason not a mental abstraction for Arendt: it is an empirical, matter-of-fact condition.[44]

Staying closer to Kant's transcendental analysis, Michel Chaouli elegantly notes that "in its very bearing," aesthetic experience "faces others."[45] And this is precisely through its claim to universal assent: "'This is beautiful' is not an ordinary proposition about an object, though it takes that form, but rather an act—an act of speaking. Kant's word for 'claim' holds this speech act within itself: before *Anspruch* can come to carry the weight of a demand or a request, the word informs us that it is an act of address: it derives from *an-sprechen*, 'to speak to,' 'to address.'" As Chaouli continues:

> Aesthetic experience, then, consists [of]—or at least has as part of its essential structure—the act of speaking to another, not necessarily an actual speech act directed at a specific other, *but the very idea of a speech act addressed to a generic other.* Thus while this experience must unfold in the particular life that is mine, it is never mine alone, a secret only I can know, *for in its very bearing it faces others.* (52; my emphasis)

The act of addressing another, "not necessarily an actual speech act directed at a specific other, but the very idea of a speech act addressed to a generic other" is part of the essential structure of aesthetic experience. Chaouli no doubt has in mind §7 of *The Critique of Judgment*, which makes it clear that beauty is about how we *speak*, how we *demand*, and how we *rebuke*: "er *sagt*"; "er *fordert*"; er *tadelt*."[46]

> It would be ridiculous if . . . someone who prided himself on his taste thought to justify himself thus: "This object (the building we are looking at, the clothing someone is wearing, the poem that is presented for judging) is beautiful *for me*." For he must not call it (*nennen*) beautiful if it pleases merely him. Many things may have charm and agreeableness for him, no one will be bothered about that; but if he pronounces (*ausgibt*) that something is beautiful, then he expects the very same satisfaction of others: he judges not merely for himself, but for everyone, and speaks (*spricht*) of beauty as if it were a property of things. Hence he says (*sagt*) that the *thing* is beautiful, and does not count on the agreement of others with his judgment of satisfaction because he has frequently found them to be agreeable with his own, but rather *demands* (*fordert*) it from them. He rebukes them (*tadelt*) if they judge otherwise, and denies they have taste (*spricht ihnen den Geschmack ab*), though he nevertheless requires (*verlangt*) that they ought to have it; and to this extent one cannot say (*nicht sagen*), "Everyone has his special taste." This would be as much as to say (*heißen*) that there is no taste at all, i.e., no aesthetic judgment that could make a rightful claim (*einen Anspruch machen*) to the assent (*Beistimmung*) of everyone. (§7, 98)

This passage is a veritable catalog of speech acts: pronouncing, naming, denying, demanding, admonishing, assenting. It also shines a spotlight on

idiomatic sayings: "This object is beautiful for me"; "Everyone has his special taste."

Kant is interested not only in what *cannot* be said but in what specifically *is* said, and *how* people say it. His anthropological turn to ordinary conversation, to the codified expressions used in our compulsive sharing of judgment, recurs whenever Kant tries to do justice to the "oddity" (*Merkwürdigkeit*) of the judgment of taste (§8, Chaouli's translation). It *is* the oddity and thus the starting point of critique:

> If one judges objects merely in accordance with concepts, then all representation of beauty is lost. Thus there can also be no rule in accordance with which someone could be compelled to acknowledge something as beautiful. Whether a garment, a house, a flower is beautiful: no one allows himself to be talked into his judgment about that by means of any grounds or fundamental principles. One wants to submit the object to his own eyes, just as if his satisfaction depended on sensation; and yet, if one then calls (*nennt*) the object beautiful, one believes oneself to have a universal voice (*allgemeine Stimme*), and lays claim (*macht Anspruch*) to the consent of everyone, whereas any private sensation would be decisive only for him alone and his satisfaction. (§8, 101)

The entire design of the *Critique* affirms that how we talk is immanent to aesthetic experience, diffused into the feelings that underpin it and the key to its significance. Even Kant's discussion of the sublime begins with an attention to ordinary language by asking, "what does the expression (*Ausdruck*) that something is great or small or medium-sized say (*sagen*)?" (§25, 132).

It will therefore come as no surprise to find that in "Representation of the antinomy of taste" (§56), Kant prefaces his dramatic pairing of Thesis and Antithesis—"The judgment of taste is not based on concepts, for otherwise it would be possible to dispute about it (decide by means of proofs)"; "The judgment of taste is based on concepts, for otherwise . . . it would not even be possible to argue about it (to lay claim to the necessary assent of others in this judgment)"—by asking us to reflect on two "proverb[s] in general circulation": "Everyone has his own taste"; "There is no disputing about taste." And when he turns to beautiful art, Kant will propose that we approach it in analogy "with the kind of expression that people use in speaking in order to communicate to each other,"

paying especial attention to "the *word*, the *gesture*, and the *tone* (articulation, gesticulation, and modulation)" [§51, 198; Kant's italics]. Art, Kant is suggesting, should be analyzed in the same way we approach ordinary verbal communication, which if reversed suggests that ordinary ways of communicating aesthetic feeling can be analyzed as art-like artifacts.[47]

If "being social and being communicative are not optional features of Kant's conception of aesthetic experience" but rather its core dimensions, Baldwin's handle, Lester's wig, and the strippers' props bring out this discursivity by stealing the limelight.[48] Across our examples, the gimmick is not only an aggressively charismatic object but an equally charismatic utterance, deployed in genres ranging from comedy to invective. Communicability may be integral to every aesthetic experience, but some judgments are more rhetorically confrontational in their performance than others. Conversely, if all aesthetic judgments are stylized, verbally complex performances that can become objects of aesthetic enjoyment and judgment in turn, something about the insistently expressive, other-facing gimmick helps us see this in particular.

Passionate Utterance

Given the neglect of this component of aesthetic experience in the philosophy of aesthetics, the point is worth repeating: aesthetic judgments are stylized verbal performances that can become objects of aesthetic judgment in turn. Among the few who follow Kant in taking what people say and how they say it as crucial to what makes a specific aesthetic encounter significant (regardless of whether it takes place in literal silence or not), it is really only Stanley Cavell who has treated the dialogical features of judgment as seriously as one might take the same features in the analysis of a poem, play, or film.

Art theory's indifference to the verbal "side" of aesthetic experience is in fact mirrored in literary studies, where scholars have focused predominantly on forms of appearance. Although judgments also have form, style, and a kind of apparitionality (through a "strange and anomalous" grammar converting evaluations into properties of objects), it is as if the mere fact of being verbal blocks us from recognizing that they are no less "aesthetic" than the perception of form, a moment stereotypically imagined as silent. *Theory of the Gimmick* thus continues to press a point made in *Our Aesthetic Categories*, which is that ways of speaking tethered to

specific ways of perceiving are as meaningful as the latter—and constitute forms of appearance in their own right, too.[49]

Although aesthetic experience spontaneously elicits feeling-based judgment and is crucially inseparable from it, one reason the verbal dimension often gets dropped from theorization is because its moment seems secondary. The overlooking of judgment's performative dimension may also have something to do with the consolidation of single-word labels like "cute," which can convey the impression that the speech acts in which they appear will be boringly uniform, in contrast to the rich diversity of objects inciting them. Words like "cute" also contribute to the deceptive resemblance of aesthetic evaluations to ordinary assertions. One does not say, "I judge this beautiful," even if this is a true description of what is taking place. One must rather, in an slippery way akin to what Kant refers to elsewhere as "subreption," put one's judgment in the form of an objective statement: "X is beautiful." But as Chaouli underscores, "X is beautiful" is "not an ordinary proposition about an object, *though it takes that form*" (my emphasis). Rather, in judging something beautiful, "I have issued a demand."[50]

Another possible reason, soon to click into sharper focus below, is that aesthetic judgments tend to seem erroneously monolithic even when read though J. L. Austin's theory of performative language. For as Cavell argues, Austin's theory itself suffers from being dominated by his model of the illocutionary speech act, and thus by a juridical, unidirectional, rule or convention-bound image of verbal performativity which aesthetic evaluations in their very essence violate, qua judgments exerting normative force in the absence of determinate norms.[51] Taking Cavell's intervention to heart, the following studies pay special attention to richly variegated scenes of judgment unfolding around the repulsive yet fascinating gimmick and thus to the discursive-evaluative, but no less stylistically and historically meaningful, "side" of this aesthetic category. For focusing exclusively on the (supposedly silent) perception of form causes one to miss what is most crucial and strange about aesthetic experience, which is precisely how it binds the way in which we face or address others to appearances we can only perceive for ourselves.

Theory of the Gimmick is also the anatomy of an aesthetic judgment specific to mature capitalism whose equivocality points to something unique about its culture. For subjects weaned on an incessant flow of advertisements, who can intuit what the mediation of relations by "spectacle" means without reading theory, and who are familiar in some way with the gen-

dered, racialized, or class-interpellating experience of aesthetic shame, most aesthetic judgments, while affectively spontaneous, are not ones of "conviction."[52] However ignored by those in the academy who harp on "the aesthetic" as a morally purified, specialized domain of art, this fact is obvious from the noticeably impious judgments most actively put to use in everyday social interactions. To call something cute can be either to admire or express contempt for it—and usually both. "Interesting" can sometimes mean "not interesting." In a world in which everything is made to be sold for profit and engineered to appeal to what a consumer is pre-shaped to desire, how can there not be a philosophically as well as historically meaningful uncertainty at the heart of the aesthetic evaluations through which we process the pleasures we take in it? This uncertainty does not mean that our aesthetic experiences *feel* weak. As we learn from Freud's theory of ambivalence and the thinkers who treat it seriously, the copresence of negative and positive affects strengthens the overall intensity of our attachment to an object.[53] The clashing feelings at the heart of the judgments / experiences most central to capitalist culture thus testify to anything but their lack of affective power.

The gimmick stands out for its instability in a deeper sense, in that it is paradoxically internal to its aesthetic form to slide out of the realm of aesthetic phenomena altogether. Sometimes gimmick just means thing, as we see in this midcentury engineering handbook: "The gimmick in this circuit serves the purpose of capacitively coupling the outside antenna to the L-C tank circuit for the r-f input signals."[54] But even when the gimmick is an aesthetic experience, it is one that perpetually tarries with the nonaesthetic. For here our dissatisfaction with the form of the object, based on spontaneous appraisals of the labor, time, or value it embodies, quickly morphs into ethical, historical, and economic evaluations of it as fraudulent, untimely, and cheap. Registering a multilayered "felt disorder of norms," which in turn grounds its "intimate claim to the intersubjective validity of the feelings it expresses," the gimmick has an amplified, one might even say quadrupled, relation to normativity.[55] Judgments like cute or interesting also exert normative force but do not have this specific cluster of violated norms at their center: all based on interlinking estimations of value, labor, and time.

Bristling with its bouquet of normative claims, the gimmick is thus an aesthetic judgment ironically marshaling all of the speech act's brazenness to question its own object's aesthetic legitimacy. Other judgments involve

conflicting feelings too. But the gimmick puts *aesthetic misgiving as such* at the heart of our encounter with compromised form.

Let us now return to Cavell and his approach to aesthetic judgment as a "passionate utterance," in his larger effort to thicken Austin's concept of the perlocutionary.[56] Cavell argues that even after Austin dissolves the initial distinction between performative and constative utterances in *How to Do Things With Words*, replacing it with the triad of locutionary, perlocutionary, and illocutionary forces, the illocutionary utterance, which stays noticeably close to Austin's original conception of the performative (speech in the first-person present-tense indicative, in which the act performed is ruled by conventions and explicitly named) remains the paradigm that governs his theory of performativity, inadvertently marginalizing the affective dimension of speech.

When approached as a passionate or perlocutionary utterance, aesthetic judgment emerges as a mode of speech that does not need to name what it is doing and in fact stands a higher chance of succeeding when it doesn't. For perlocutionary acts such as complimenting, insulting, persuading, alarming, interesting, boring, seducing, and amusing "not only do not name what they do (as to say the illocutionary 'I promise, beseech, order, banish . . . you' *is* to promise, beseech, order banish . . . you), they cannot, as noted, unprotectedly be said at all" (171). As Cavell points out, to declare "I seduce you" is hardly likely to bring a seduction off (170). To say "I insinuate X" is quite precisely to not. And thinking that one can persuade by merely saying, "I persuade you!" implies thinking "I [have] some hypnotic or other ray-like power over you," leaving you with "[no] freedom in responding to my speech" (172).

Because the force of a passionate utterance is not "built into the verb that names it," and because there is no "accepted conventional procedure or effect" when it comes to perlocutionary acts—for in this case "I am not invoking a procedure but inviting an exchange"—these speech acts offer "invitation to improvisation in the disorders of desire."[57] For this reason, they "make room for, and reward, imagination and virtuosity, unequally distributed capacities among the species." As Cavell continues, "Illocutionary acts do not in general make such room—I do not, except in special circumstances, wonder how I might . . . render a verdict. But to persuade you may well take considerable thought, to insinuate as much as to console may require tact, to seduce or to confuse may require talent" (173).

Judging something a gimmick, Cavell's theory of passionate utterances implies, can involve all sorts of inventive indirection. It can unfold over

several chapters of a novel. It can involve props. It may involve language that does not especially look performative and that does not name its own concept: "total hype"; "cheap trick"; "rip-off"; "charlatan"; "bullshit"; and as Cockrel shows, "motherfuckers" are ways of calling something a gimmick, too. Anything goes—with the exception of the illocutionary "I judge this a gimmick." Indeed, in contrast to illocutionary acts, in which the response of the addressee has little bearing on the utterance's felicity—it is not "you" but "I" who, explicitly naming what I am doing, primarily determines whether I have successfully issued a verdict, made a vow, or placed a bet—perlocutionary utterances foreground the response of the addressee: it is "you" who ultimately determines whether I have insulted, consoled, seduced, or persuaded you.[58] On top of this: passionate utterances "demand" a freely given response from the other, "in kind," and immediately: "now." (We will hear an echo of Kant's *verlangt* in this last axiom). For Cavell, then, aesthetic judgments can never be unidirectional. They not only presuppose but must produce an opportunity for "exchange" in which the other may contest what is said and the assumptions that underpin it.[59]

Uncertain Powers: Two Examples

So, in contrast to Austin's performative as an "offer of participation in the order of law," Cavell's concept of the passionate utterance as an "invitation to improvisation in the disorders of desire" reveals aesthetic judgment as a verbal performance that does not need to name its own concept.[60] Yet the overall thrust of Cavell's careful attention to language suggests that the specificity of the charismatic word "gimmick" matters. Consider its comically unshakable presence in this moment from Clarence Major's experimental novel *Emergency Exit* (1979).[61]

A scholar once asked me are you trying to write like Barth you know Barth in his stories always sounds like he's teaching a creative writing class I don't like that kind of stuff I think it's misdirected it's just a gimmick. Hello gimmick. Naturally I couldn't answer the scholar's question but it's nice to meet gimmick again.

I introduced gimmick to Deborah.

Hello Deborah. Deborah manages to arrive at the summer place due to the presence of a gimmick. It's called language. But it likes its nickname best: gimmick. [. . .] Oscar arrives with Deborah he's

a chubby pinkish boy with light hair and eyes. . . . Deborah, dear gimmick, is in a tight white cotton dress. . . . Only with a gimmick can you have a decent literary fashion show. The two, Oscar and Deborah, are coming down the path toward the house. There is no point of view, except your own, to observe them. You have to be the judge. Thanks to the gimmick of language you can take on this responsibility.

Here we go. The birds were out that morning singing in the trees and the sun was already high up and bright. It was clearly going to be a warm pleasant day. Good old gimmick.

Scene in the little house: Julie asleep. . . . Al heard Deborah and Oscar arriving but did not look. . . . Due to a gimmick before he realized it someone was knocking at the screened door. Hello in there you lovebirds can you stand company. It was beautiful Deborah. . . . Deborah smelled of expensive perfume thanks to the gimmick of money. (145–46)

In a pattern we have learned to parse through Mark McGurl's study of Program Era fiction, the scholar's low opinion of postmodern literary experimentation comes down to its supposedly inherently insulting association with the techniques one learns in a "creative writing class."[62] The word "misdirected" intensifies the depreciation by adding the connotation of a cheap conjuring trick. Yet "gimmick" is voraciously embraced at the level of the signifier—it is repeated no less than fifteen times after the scholar first mentions it—and wielded like a special password giving the narrator renewed license to break realist codes with gleeful abandon, moving across diegetic and extradiegetic registers ("I introduced gimmick to Deborah") and addressing the reader directly ("There is no point of view, except your own, to observe them. . . . Thanks to the gimmick of language you can take on this responsibility"). As if precisely because the scholar has indirectly called metafictional reflexivity a gimmick, Major decides to double down on it:

Al, she said, you were supposed to lift me across the threshold does he lift you Julie. No I don't believe in that communist stuff Mother. Do you ever follow the rules Al. Deborah it's just a gimmick he said. . . . Deborah placed her arms around them and pulled them to her hugging them as tightly as she could. Listen to me you two lovebirds don't ever let anybody come between you you hear me there's nothing on earth more important than love or loving. Due

to the warmth of this gimmick Al felt very moved by the gimmick. Julie who was already familiar with her mother's sentimental nature was not moved at all in fact she was thinking that the bacon might be burning and that it should probably be turned over and due to the gimmick of the word fork she was able to turn each of the six strips of bacon over before any of them burned badly. . . .

If I could place the scholar there with them he would see Al get up now and go out on the deck leaving his breakfast untouched. Looking at the back of his head Julie says, Aren't you going to eat. He looks so beautiful and strong and black standing there in his white shorts. He does not answer and Julie and Deborah look with raised eyes at each other. Al may not know it but his gimmick is working and he's never been anywhere near a creative writing class. (146–47)

While in every aesthetic category, form and judgment imply each other, *Emergency Exit* experiments with their uncoupling. The sheer repetition of the word in the discourse removes its critical sting, while reinforcing the form's thingly presence in the story: "Due to the warmth of this gimmick Al felt very moved by the gimmick."

The repetition also conveys a pleasure *in the simple uttering of the utterance*, underscoring how hard it is to hate the gimmick without loving it too. In a similar vein, *Emergency Exit* raises the question of whether the gimmick is a weak or strong aesthetic. For while referred to contemptuously as a dumb object ("good old gimmick"), "gimmick" nonetheless emerges as the primary agent behind events in the story: "Deborah manages to arrive at the summer place due to the presence of a gimmick"; "Due to a gimmick . . . someone was knocking at the screen door." Uncertainty about its own aesthetic power lies at the heart of the gimmick, which is perhaps why the two allegories of socially diffused debt we encounter in Chapter 4—each a telling synthesis of comedy and horror—use it to highlight an uncertainty about whether finance is marginal or immanent to capitalism.

This indecision about agency also arises in what seems to be the only published work of criticism which has taken the gimmick seriously enough to use it as a literary concept, on equal footing with any other. In "'Gimmick' and Metaphor in the Novels of William Golding" (1963), James Gindin notes a pattern repeated across the author's corpus: the use of "unusual and striking literary devices."[63] Each novel is "governed by a massive metaphorical structure—a man clinging for survival to a rock in the

Atlantic Ocean or an excursion into the mind of man's evolutionary antecedent—designed to assert something permanent and significant about human nature." As Gindin notes, "The metaphors are intensive, far-reaching; they permeate all the details and events of the novels"; however:

> at the end of each novel the metaphors, unique and striking as they are, turn into "gimmicks," into clever tricks that shift the focus or the emphasis of the novel as a whole. And, in each instance, the "gimmick" seems to work against the novel, to contradict or to limit the range of reference and meaning that Golding has already established metaphorically. The turn from metaphor to "gimmick" (and "gimmick" is the word that Golding himself has applied to his own endings) raise questions concerning the unity and, perhaps more important, the meaning of the novels. (196)

"Gimmicks" are endpoints of poetic decline: results of an entropic devolution of literary figures into "tricks." Yet the tricks are still "clever": apparently endowed with enough critical power to actively "work against" the agenda of the original metaphor, "to *contradict* or to *limit* the range of reference of reference and meaning" it establishes (my emphasis).

In *The Lord of the Flies* (1954), for instance, the "unique and striking literary device" is the island society constructed by the plane-wrecked boys, which Golding uses to offer a critique of society's claims to overcoming humankind's brutality with reason alone. Its power is however undermined by Golding's gimmick: the last minute rescue of the boys by a British naval officer. The twist implies that "adult sanity" exists in truth; that the godless world, for all its self-congratulatory rationalism, is not so bad. Thus "the rescue is ultimately a 'gimmick,' a trick, a means of *cutting down* . . . the implications built up within the structure of the boys' society on the island" (my emphasis, 198). The deus ex machina recurs in *The Inheritors* (1955) and *Pincher Martin* (1956):

> In each novel the final "gimmick" provides a twist that, in one way or another, palliates the force and the unity of the original metaphor. In each instance Golding seems to be backing down from the implications of the metaphor itself . . . adding a twist that makes the metaphor less sure, less permanently applicable. *The metaphors are steered away from what would seem to be their relentless and inevitable conclusions, prevented, at the very last moment, from hardening into the complete form of allegory.* (204, my italics)

At this moment Gindin does more than suggest that Golding's gimmicks undercut his original devices, all designed to convey humanity's sublimely depraved essence and the terrible powerlessness of rationality to combat it. He comes within a hair's breadth of suggesting that the devices were gimmicks all along.

> In one sense, each "gimmick" seems to widen the area of the artist's perception as it undoubtedly lessens the force of the imaginative concept. The "gimmicks" supply a wider perspective that makes the following questions relevant: If the adult world rescues the boys in *Lord of the Flies*, are the depravity and the brutality of human nature so complete? How adequate is *Pincher Martin*'s microcosmic synthesis, if it all flashes by in a microsecond? . . . All these relevant questions are implicit in the "gimmicks" Golding uses, *"gimmicks" that qualify the universality of the metaphors, question the pretense that the metaphors contain complete truth*. (204–205, my italics)

The gimmick here emerges as remarkably muscular. Instances of nothing if not literary badness, Golding's gimmicks rescue his metaphors from *their* literary badness, steering their "relentless and inevitable conclusions" from "hardening into the complete form of allegory." Positions reverse: the "unique and striking" metaphor was a gimmick in waiting; meanwhile the gimmick functions like a corrective tool. Gindin never says it directly, but he unmistakably implies that in enabling Golding to retract or "qualify the universality" of his original statements, his gimmicks may have been doing his novels a favor.

But in the end, the retraction doesn't happen. Why not? Because the gimmicks are too weak to complete the job they begin. Yes, Golding's "'gimmicks' . . . qualify the universality of the metaphors, question the pretense that the metaphors contain complete truth." But:

> [This] qualification is achieved at the expense of artistic form, for the "gimmicks" also palliate and trick, force the reader to regard the issues somewhat more superficially even though they widen the range of suggestion. *The "gimmicks" are ultimately unsatisfactory modifiers, for, in the kind of qualification they provide, they reduce the issues of the novels to a simpler and trickier plane of experience.* (my italics, 205)

Golding's "orthodox Christian versions of man's depravity and limitations" are thus left standing; his metaphors cannot be reversed by the

"slender 'gimmicks'" because they are ultimately gimmicks. In this manner, an argument energetically heading towards a counterintuitive conclusion about the power of gimmicks ends up "backing down" from its original implications in a way that eerily parallels the very effect in the novels it describes, leaving us with a final uncertainty about the gimmick's aesthetic strength.

Gimmick + Sublime

Anticipating our return to it in Chapters 4 and 7, let us think about the same problem from a different angle. In poet Kevin Davies's *The Golden Age of Paraphernalia* (2008), the image of a Google-ized planet, networked via "meticulously cross-referenced" measurements whose astonishing precision might leave us speechless, culminates in the image of a hilariously stupid, garrulous object:[64]

> Any surface at all, inside or out, you touch it
> and a scrolled menu appears, listing recent history,
> chemical makeup, distance to the sun in millimeters,
> distance to the Vatican in inches, famous people
> who have previously touched this spot, fat content,
> will to power, adjacencies, and further articulations.
> And each category has dozens of subcategories
> and each subcategory scores of its own, all
> meticulously cross-referenced, *linked*, so that each square
> centimetre of surface everywhere, pole to pole,
> from the top of the mightiest Portuguese bell tower to
> the intestinal lining of a sea turtle off Ecuador, has
> billions of words and images attached, and a special area,
> *a little rectangle*, for you to add your own comments. (58)

Consider, alongside Davies's image of capital covering the earth "pole to pole," this iconic moment from *The Crying of Lot 49* (1966). Staring down at the sprawling Southern Californian city of San Narciso, where her dead financier boyfriend Pierce Inverarity had "begun his land speculating . . . ten years ago, and so put down the plinth course of capital on which everything afterward had been built . . . toward the sky," and noticing its resemblance to the inside of a transistor radio whose hieratic complexity once put her in a trance, Oedipa Maas finds herself overcome by a paralyzing experience of totality that includes the comically obtrusive detail

of her "rented Impala": "[She] and the Chevy seemed parked at the centre of an odd, religious instant."[65]

Why do we so often find the flagrantly disappointing gimmick in the vicinity of the capitalist sublime, as seems to happen with almost systematic regularity in Davies's poetry and Pynchon's novels? And indeed, in a way similar to Golding's way of inadvertently (if never completely) sabotaging his own "massive metaphorical structure[s]" or "absolutes" with flimsy "tricks"?

In a sense this proximity of banality to extremity is not surprising, given capitalism's volatility and generation of yawning inequalities. Crisis was already something people could think of as ordinary by the late nineteenth century, even as the magnitude of wealth destroyed in each disaster was increasingly great.[66] As *The Golden Age of Paraphernalia* makes clear, wonder and trick, capitalist awe and disappointment, are intertwined products of the same "young-adult global civilization . . . blinking vulnerably in the light of its own / *radiant connectedness*." Both point to capitalism's chronic instability, if in crucially different ways. For the gimmick does so not via a paralysis of cognition in the face of what Kant calls the "absolutely great," but through an everyday perception of form encoding too much or little labor.[67] Rooted in this appraisal invoking production, it thus implies a far less dramatic (if no less serious) theory of crisis than the sublimity of finance, with its explosive markets, unruly derivatives, and mind-bogglingly rapid transactions.

Oedipa's rented Impala, a synecdoche for *The Crying of Lot 49*'s used car lot—itself a metonymy for working-class desperation at the height of the golden age—is thus inextricably tied to the glittering silicon spectacle generated from Pierce's "plinth course of capital" by a single logic encompassing both. Their pairing makes sense at another level too. For the sublime and the gimmick are both about where the aesthetic and nonaesthetic meet. Each involves an integration of displeasure with pleasure that is bound up in a crucial way with "estimating the magnitude of the things of the sensible world."[68]

The sublime and gimmick, in other words, are judgments about judging. And about a very specific kind—the qualitative estimation of sizes or quantities—that sits in a strange place between aesthetic experience and cognition.[69] Both are moreover built around acts of "estimating . . . magnitude" (*die Größenschätzung*) that in a sense fall short; either in relation to a "rational idea" for which there is no sensible intuition (the Kantian sublime qua "absolute totality") or to a historical norm which is left

indeterminate (the gimmick, encoding too much or little labor, value, or time).[70] In both cases, the falling short or into indeterminacy is, as people say, a falling upward. For in the Kantian sublime, the "very same violence that is inflicted on the subject by the imagination" when confronted with its insufficiency for estimating the magnitude of things "in comparison with which everything else is small" is "judged as purposive for the whole vocation of the mind"; hence the object is taken up "with a pleasure that is possible only by means of a displeasure" (142–43). Concomitantly, our judgment of the dissatisfying gimmick and everything it involves feels satisfying to perform, especially in the company of others. The gimmick's suspicion, as we have seen, is "purposive" for our reflexive pleasure in judging and its sociabilities. Put simply, it makes us want to talk.

"The notion that capital—as an infinitely ramified system of exploitation, an abstract, intangible but overpowering logic, a process without a subject or a subject without a face—poses formidable obstacles to its representation has often been taken in a sublime or tragic key," Alberto Toscano and Jeff Kinkle write.[71] Yet the place where the aesthetic approaches its own breakdown "need not be approached solely in this iconoclastic, quasitheological guise":

> A surfeit of representations—of personae, substitutes, indices and images—may turn the unrepresentability of capital into something more akin to a comedy of errors. . . . Those abstractions that in one register are as immaterial, mute and unrepresentable as the most arcane deities, reappear in another as *loquacious, promiscuous, embodied*. (40, my italics)

What Toscano and Kinkle have in mind is the often grotesquely cute device of prosopopoeia, famously used by Marx in the first volume of *Capital* to illustrate the logic of the commodity (and through it, value, money, and abstract labor).[72] The contrast they are drawing between an aesthetic of capital as unrepresentable absolute that, as the very idea of the sublime suggests, shuts speech down, and a conversational aesthetic through which people figuratively "face others" on something they really do register about rudimentary laws of accumulation, helps get at how the gimmick subtends the similarly "loquacious, promiscuous, or embodied" categories in *Our Aesthetic Categories*. The gimmick is not its missing fourth category but an undercurrent running through all three—and indeed, all of capitalist culture.

FIGURE 0.2

The speech-suppressing effect of the capitalist sublime, in which the totality of class relations on a global scale confronts us as an cognitively disempowering absolute, mirrors one of the key things that distinguishes it from the all-too voluble gimmick, which is its absence from everyday speech. The fact that "sublime" is rarely said aloud—the fact that it is a theory word used primarily in the writing of academics and not a phrase one might overhear on a train or at a bar—is not just an incidental socio-linguistic fact. It is a key to what the sublime is. We have heard arguments for why discursivity is immanent to aesthetic judgment and thus aesthetic experience. If the specificity of what is said, or how one faces or addresses others matters, so does the generality of who says it, and here the "gimmick" comes to the fore for its pervasiveness in everyday conversation across social divides (Fig. 0.2).

The silence of the sublime and the garrulousness of the gimmick—two divergent aesthetic responses to mature, crisis-prone capitalism—are thus mirrored by their asymmetrical presence in culture as speech acts. One wonders if their tendency to appear in close quarters in so many representations of capital has something to do with the way in which one needs both for a full picture. For while a complete picture will need to include the ways in which capital thwarts our ability to represent it, it will also need to include all the ways in which representation takes place. "A social theory of capitalism as a totality, and the imaginations and aesthetics that strive toward it, could only be marked by an excess of coherence—as its opponents see it—to the extent that it papered over the incoherence (or contradictoriness, difference, unevenness) in its object," write Toscano

and Kinkle.[73] Marx's chattering commodities, Oedipa's obtrusive Impala, Davies's comment box and almost hysterically insistent, italicized Web 3.0 slogans (*"radiant connectedness"*), Mazeppa's horny wind instrument, and Lester Jefferson's wig—"loquacious, promiscuous, embodied" devices all—are working as vivid reminders of this incoherence. Which is to say: working properly as gimmicks.

Gimmick vs. Theory

In *Wages Against Artwork*, Leigh Claire La Berge notes that while "the problem of labor has slowly worked itself into art discourses, labor as a site for investigation of the economy has receded from critical theory."[74] She identifies two primary reasons for this conceptual waning. The first is the widespread influence of "Foucault-based biopolitical discourse," in which "biopower" and "human capital" are privileged as critical categories.[75] The second is post-Marxism organized under the rubric of "real subsumption."[76] In *Capital*, Marx describes "real subsumption" as the transformation of existing labor processes toward increasing relative surplus-value production and as a process coextensive with the rise of large-scale industry.[77] The strand of Marxism associated with the concept today, however, proceeds from Hardt and Negri's influential claim for a significant break between the "old competitive capitalism" and the "social capitalism of the present age," in which, thanks to the rise of "general intellect," "immaterial labor," and once again, "biopower," value will no longer be bound to labor (as "surplus value" implies).[78] In tandem with the subsequent transformation of virtually every activity into value-generating "labor," from breastfeeding to uploading cat videos, value comes to escape not only labor but measurability. For Hardt and Negri this is an auspicious turn, George Caffentzis argues, since they "identify measurability with all that is intellectually hateful to the rebel soul: 'the great Western metaphysical tradition,' 'a transcendent order,' 'God,' 'cosmos' . . . etc."[79]

As La Berge notes, it is not hard to see this strand of Marxism's rejection of Marx's value theory, in its claims for a radical break between pre- and post-1968 capitalism, as a response to the real decline of labor's power against capital in this period.[80] Nor is it hard to see its appeal for post-structuralist thought, as Caffentzis observes: "Why be saddled with an elaborate and, in the bargain, mythical 'value-foundation' for an anticapitalist ideology, especially in an era when 'foundationalism' is out of favor as a philosophical/political attitude (Derrida)?"[81]

In this position taking, post-Marxism falls in alignment with, and draws directly on, Foucauldian biopolitical discourse, with its opposition of forms of measurement to "life."[82] The two labor-jettisoning tendencies tracked by La Berge thus shelter under the expanding umbrella of what Anna Kornbluh calls "anarcho-vitalism," a family of theories linked by their shared allergy to formalization and conceptual generalization, ranging from Giorgio Agamben's radical enlargement of the concept of biopower to the new empiricisms, assemblage theories, and vitalist ontologies inspired by Bruno Latour.[83] Gutting Marx's concepts while often continuing to draw on the cachet of the shells—Brian Massumi's use of a term he calls the "surplus value of life" in his *99 Theses on the Revaluation of Value: A Postcapitalist Manifesto* is a good example—the new postcritical continuation of a once critical poststructuralism also sometimes flies under the flag of affect theory and aesthetics, fields to which this book also belongs.

Yet if so much theory no longer sees labor (but rather "biopower" often shading into "human capital"), or no longer thinks that labor can be measured (because with "real subsumption," nothing is not labor), the extravagantly impoverished, overperforming/underperforming gimmick testifies to the fact that ordinary aesthetic subjects do. Which account is more trustworthy: the theory of theory, or that of the gimmick? Reviewing a little, let me try to justify why I think we should side with what the latter tells us it knows—or rather, tells us we ourselves already know—about the world that gives rise to it.

As an aesthetic judgment, the gimmick possesses all of the features of this peculiar genre while writing some of them large: affective spontaneity, immanent discursivity, claims to normativity in the absence of norms. It more uniquely registers our encounter with a form making wrong claims to value that our judgment refutes, in a way evoking the image of other judges who evaluate differently. The gimmick is thus a judgment on and about judgment. It is also, uniquely, comprised of a multiplicity of interlacing judgments: "works too hard"/"works too little"; "technologically outdated"/"too advanced"; "cheap"/"overpriced." These measurements of excess and deficiency seem economic as opposed to aesthetic. They would even seem to be quantitative. But are we so sure?

The kinds of appraisal that the gimmick encodes—"working too hard"; "too old"; "overvalued"—are in fact strikingly hard to categorize. Evaluations of labor, time, and value would seem to lead to determinate cognitions; they would in other words seem to be instances of what Kant calls cognitive judgment. This seems especially the case for judgments of

excess or deficiency, which presuppose averages making the registration of deviation possible. Yet as we have seen in our discussion of the gimmick's kinship with the sublime when it comes to appraising the "magnitude of the things of the sensible world" (*Größenschätzung der Dinge der Sinnenwelt*), the norms involved here are merely formal. What is *economic* about the gimmick as judgment—its way of encoding the metrics of capitalism—thus oddly reinforces what is distinctively *aesthetical* about it: aesthetic judgment's "denuded" universality, in which a concept is retained as "mere" form, with its determinative content scrubbed out.[84] It may sound strange to say that the gimmick, in a way inflected by Marx, helps us grasp something theoretically essential to Kant. Yet it does so in a way that also extends in the opposite direction, showing how Kant might help us better grasp aspects of Marx.[85] Indeed, as we will see throughout this book, what most distinguishes the gimmick from other aesthetic phenomena is its intimate relation to the social forms capitalism generates "behind the backs" of capitalists and workers on the basis of the same three measurements it uniquely links together.

The gimmick is thus an aesthetic judgment uniquely reflecting on the genre's capacity for absorbing and transcoding nonaesthetic judgments. In contrast to claims for the contemporary immeasurability of value, it shows how a kind of quantitative measurement can persist, abstracted, inside qualitative judgments. It invites us to think of capitalism's aesthetic forms as not reducible to but rather contiguous with economic forms, existing in the same continuum.

For in their ordinary experience of the gimmick, people "see" an indeterminate or implicitly moving measurement of labor. They moreover "say" their "seeing" in a way that binds this abstraction of labor to value, "red-circling" an overrated object's claim to worth and re-evaluating it as false. This negation counters the implicit claims for value's expansion (into new frontiers of accumulation) that both anti- and post-Marxist theories use their categories detaching value from labor to make. Whereas in "Foucault's scheme, the investor of human capital might turn anything (a crime, an illness, a marriage) into a site of risk-based profit," as La Berge notes, "in real subsumption, capital might turn anything (an email, a fantasy, a nap) into a site of surplus-value generation."[86] We might therefore say: the gimmick sees not so much labor as abstract labor—and in exactly those places where others see only capital. And where others see continuingly increased or expanding value, it sees their very *not-seeing* of that expansion's *absence*.

The judgment of the flagrantly unworthy gimmick, and the ordinary aesthetic experience it names, is in short exactly everything that theory in its dominant tendencies is not. It has, or *is*, a "value theory of labor."[87] Binding the estimation of one to the other in a way that implies that the averages from which it registers deviation are historically moving, it encodes something strikingly akin to "socially necessary labor time." Its everydayness signals that it is a response to a world in which labor's social abstraction objectively happens. As so many strains of theory move for varying reasons toward a state of generalized postcritique, the judgment of the over- and/or underperforming gimmick remains suspicious, unapologetically negating the judgment of others who think that the object's exaggerated claims to value are true. At the same time, the damaged gimmick's intimate relation to comedy, tracked across this entire book, reminds us of how the exercising of suspicion can be creative, playful, and sometimes queer.

Forms of Appearance

"[All] science would be superfluous if the form of appearance of things directly coincided with their essence," writes Marx.[88] We've seen how the gimmick illuminates Kant's take on the structure of aesthetic judgment. Does it also pedagogically underscore something about Marx's approach to capitalist forms?

What happens in the encounter with impoverished form we use *gimmick* to name? We are confronted with a brazenly overstated claim of value on the part of an aesthetic object that implicitly obfuscates a true one. Our spontaneous appraisal of the gimmick binds these judgments together in a way that suggests that one law encompasses both. Indeed, the logical primacy of the false valuation suggests that its falseness may be indispensable to the truth of the true one—that the true *includes* the false.[89]

The relation between mystified and objective valuation in the gimmick thus mirrors the nonidentity yet inseparability of the central categories in *Capital*: abstract labor and exchange-value, value and price; surplus value and profit. Value is not price (money), as David Ricardo already maintained, regarding money as mere appearance.[90] For Marx, by contrast, money is value's *necessary* form of appearance and thus part of its "essence" (*Capital*, vol. 1, 188). "Without money there can be no value," Patrick Murray glosses.[91] Or as Diane Elson puts it, "values cannot be calculated or observed independently of prices."[92] They are bound together as inseparably as

the experience of the gimmick binds the point of view of the person who sees an impoverished, overrated object to the point of view of a person who does not.

In societies marked by an unreconciled dualism between private and social aspects of labor, Marx thought, economic essences must appear as something other than themselves. In Murray's words, "abstract labor (value) *must* appear as exchange value (money, price) and surplus value *must* appear as profit."[93] In each case, the appearance concealing the essence is part of that essence, entailed by and indispensable to it. Surplus value, the essence of profit, thus includes both the appearance of profit and what the category of profit's use in everyday transactions obscures.[94] The gimmick points to a similar relation between false and true assessments of aesthetic worth, *and links this logic* to the ratios of labor, time, and value that lie at the core of Marx's "value theory of labor" (Elson's memorable phrase) and all of capitalism's social forms.

In this sense, the judgment of the gimmick performs a "transvaluation of value" akin to what Caffentzis argues Marx undertook in tandem with his contemporaries in morality, mathematics, and logic. It similarly questions "value"—for "why indeed should the value of a commodity be 'the material expression of human labour expended to produce them?'"—without confusing "skepticism towards the 'false' objectivity of value" with "skepticism towards the value of objectivity itself."[95] The gimmick may leave its estimations of labor, time, and value unparticularized, but it never challenges the objective existence of the norms that make the measurability of deviation possible.

The gimmick is not our only aesthetic category about labor or exploitation. The zany, which has a much older history stretching back to the sixteenth century, is concerned with the same themes. The gimmick however uniquely reflects on the interlinking variables that make capitalist exploitation *measurable*, even if, as an aesthetic rather than cognitive judgment, it leaves its own estimations blank. As Kant reminds us, a norm against which deviation can be measured still exerts force, even when it is a "merely formal" one from which "nothing can be cognized."[96] This capacity to produce "an apparently precise and measurable definition of exploitation" is crucial in capitalism, Caffentzis notes, because exploitation is formally and legally obfuscated by all of capitalism's forms, including, as we have seen, the wage.[97]

If how things seem, in distinction from but also lamination to how things are, lies at the core of the gimmick, it lies at the core of Marx's

genealogy of capitalist value phenomena as well. His attention to the "forms of appearance" arising from the unity of production and circulation reaches a head in the third volume of *Capital*, when he attends to the "forms of revenue"—profit, interest, rent—into which a society's total mass of surplus-value becomes divided among competing factions of the ruling class, giving rise to the illusion of merchant capital, interest-bearing capital, and land ownership as "factors of production."[98] Marx is not discussing explicitly aesthetic phenomena here (or elsewhere). But he is thinking about the plasticity of objectively existing, collectively generated semblances and of their impact on everyday activity. How might "concrete forms [growing] out of the process of capital's movement considered as a whole" shape other ways of seeing and appraising value? Conversely, what role could aesthetic judgment—an affective, compulsively shared registration of semblance—play in shaping how people perceive the economic abstractions that most deeply structure their relations to other people?[99]

Our experience of the gimmick is always of something meretricious. But however untrustworthy, this damaged form knows certain truths. Binding a false to implicitly true measurement of value, asking us to see both measurements at once, it knows that capitalist value phenomena hold essence and appearance together. It knows these phenomena are not eternal, yet underestimated at risk; and that "value," the specific form taken by wealth in this system, is not a substance but a relation between variables. The gimmick finally knows that in capitalism, essence's impossibility without appearance hints at something "wrong" about the essence: a system that grounds accumulation on surplus labor.[100] This hinting at the wrongness *of* tethering value to labor is crucially different from saying that it is wrong to see value *as* tethered to labor, which would simply mean that it is wrong to say that capitalism persists.

Archive

As in the case of most aesthetic categories, no obviously delimited archive for the gimmick exists. It is therefore time to discuss why, given the glut of available material, this book's selection looks the way it does. Doing so will involve saying something about the gimmick's precursors and how it should be disambiguated from other categories.

Consider the prop once again, and this comic deploration of its overuse in Shakespeare's *Othello*, by Thomas Rymer in 1693:[101]

So much ado, so much stress, so much passion and repetition about an Handkerchief! Why was not this call'd the *Tragedy of the Handkerchief*? What could be more absurd . . . ? We have heard of Fortunatus his Purse, and of the Invisible Cloak, long-ago worn threadbare, and stow'd up in the Wardrobe of obsolete Romances: one might think, that were a fitter place for this Handkerchief, than that it, at this time of day, be worn on the Stage, to raise every where all this clutter and turmoil. Had it been Desdemona's Garter, the Sagacious Moor might have smelt a Rat: but the Handkerchief is so remote a trifle, no Booby, on this side of Mauritania, cou'd make any consequence from it. (140)

The wrongness of the hanky is attributed to its problematic relation to time ("obsolete"), to labor ("so much *ado*, so much *stress*"), and to value ("so remote a trifle"). Is this not a judgment of the gimmick avant la lettre, in which the evaluation is evoked—as Cavell shows us, it can be—without being named? At the same time, both Kant and Cavell imply that the specificity of what is said about an aesthetic experience matters for grasping its structure and content at deeper levels. Is it significant then that the word for the form limned in Rymer's critique only crystallizes at a later moment of fully-fledged capitalism? I would argue that it is. But this results in a seeming antinomy: (a) the gimmick is an aesthetic category specific to mature, crisis-prone capitalism; (b) the gimmick is not specific to mature, crisis-prone capitalism, since it is described in writing before 1700.

Is it possible to show that this contradiction is finally not really one? For help we might turn to Michel de Montaigne's "On Vain Cunning Devices" (1580), written almost a century before Rymer's marvel at the power of a "trifle" to ruin a tragedy. The proto-gimmick here is an entire class of "frivolous" techniques encoding a wasteful overexpenditure of artistic energy, epitomized in "those poets who compose entire works from lines all beginning with the same letter."[102] Montaigne's cunning devices represent too much time spent on unworthy things; while conceding that what we now call concrete poetry involves "skill," he compares it to that of a showman "throwing grains of millet so cleverly that they infallibly went through the eye of a needle." His essay ends by correcting the misguided praise of other judges: "It is a wonderful testimony of the weakness of Man's judgment that things which are neither good nor useful it values on account of their rarity, novelty, and even more, their difficulty."[103]

No freestanding concept yet exists for the aesthetic badness Montaigne describes. And yet, most of the features we have been ascribing to the gimmick—including its status as metajudgment—are already present here.

Is there a difference, then, between the problematic objects in Montaigne and Rymer and those in *Gypsy* and *The Wig*? Yes. Linked to problems of value, time, and labor as the former are, neither evokes exploitation. Their badness is nonsystemic, a sign of unfortunate artistic decision-making. Nor do the self-aggrandizing trifle or cunning device "through which a reputation is sought" seem particularly connected to the idea of cheapness. Indeed, the techniques Montaigne describes as overprized for "rarity" evoke the preciousness of difficult-to-attain luxury goods.

The early modern protogimmick testifies to harmlessly subpar craft. It is only with the maturation of capitalism and its abstract forms of domination (like the wage which the wig and props are devices for getting) that the gimmick comes into being, explicitly identified or not, as an overvalued and yet dangerously *underestimated* form. And moreover, as a form that an artist might incorporate into the making of an artifact *deliberately*, knowing full well that the gimmick is the compromised and unstable object it is.

Why indeed have the artists featured in this book—Poe, Duchamp, Barnum, Twain, Huysmans, Villiers de l'Isle-Adam, James, Mann, Stevenson, Goldberg, Doctorow, DeWitt, Halpern, Argento, Douglas, Rødland, Barker—wanted to utilize, engage, or just tarry with a dubious thing like the gimmick in the first place? (This was a criterion for my selection of examples—that these representations not only reflect on the gimmick but riskily instrumentalize it in the service of doing so.) The answers in each case are strikingly different; in a sense, they organize the design of this book. Going straight to the heart of representational difficulties surrounding capital, Douglas's *Suspiria* does so to think about how one might visualize the ghostly objectivity of "value" (his solution: through the simulation of aging "special effects," including what looks like off-brand Technicolor). Rødland's photographs do so to meditate on the damaged form of the gimmick itself, its relation to the sexual fetish, and the dubious status of the "concept" in contemporary photography. Barker's stunt-like novel of ideas, comprised almost entirely of conversations surrounding a transparently gimmicky artwork, does so to highlight the strange intensity of our responses to other people's aesthetic judgments, which can often overtake the intensity we feel about the objects behind them.

In a culture inundated with "ballyhoo," as Cavell shows in *Philosophy the Day after Tomorrow* (but also, I would add, with "art religion"), it can be difficult to praise aesthetic objects felicitously.[104] This is sometimes because they arrive oversaturated with generations of praise (Shakespeare), or because there is something coercive about the circumstance of praising (Cordelia's crisis in *King Lear*). Sometimes it is due to historical factors: the way, for example, in which centuries of racial inequality can't help but make a white man's act of dancing an "homage" to African American dance seem condescending or dubious (a routine by Fred Astaire in *Bandwagon*).[105] Using praise as a synonym for the judgment of beauty, Cavell underscores that its performative difficulty is intersubjective, affective, and rhetorical—not a difficulty related to knowledge or meaning.

Wrongful praise is of course what we are always indirectly judging when we confront the overvalued gimmick, as comes to the fore in our encounters with the overwrought speech called gushing (highlighted in Chapter 3). "I think highly of X, but I can't stand it when he starts gushing about it," one hears. Gushing is aesthetic evaluation that is itself aesthetically compromised or unconvincingly performed. To its hearers, it evokes or simply is the sound of someone falling for a gimmick, which is why it repels even when one cherishes the thing gushed over. It thus epitomizes what Cavell primarily means by "problematic" praise: the ease of spewing hyperbole versus difficulty of appraising rightly. And it brings out something easy to miss about the gimmick: that, more than being a negation of another person's positive aesthetic judgment, the gimmick is a judgment of the *performative felicity* of a passionate / perlocutionary utterance, asking us to ask about situations in which praise fails regardless of propositional content.

Why are we repelled by the style of people's expressions of aesthetic appreciation, when not by the fact or intensity of their pleasure per se? And is this not another site over which we find the unmentioned gimmick immanently hovering? Take this moment from James's "The Birthplace" (1903), in which Morris Gedge, caretaker for a tourist attraction advertising itself as the birthplace of England's "supreme poet," starts to feel like his fellow tour guide is overdoing her spiel: "He had given her hints and digs enough, but she was so inflamed with appreciation that she either didn't feel them or pretended not to understand."[106] This is a description of someone *participating in* overvaluation and of somebody else simultaneously *detecting it*—which, if we think about it, is simply the evaluative

structure of the gimmick. The passage also enacts a shift in the judgment's grammar, as Gedge's original object of suspicion, the Birthplace, recedes in face of the much more pressing problem of *how the object is valorized*. All of this underscores that the gimmick is sometimes less a compromised thing than a compromised *evaluation*. It may be why writers like Barker, and in an indirect way, Cavell, draw on this category as a way to think about the discursivity of aesthetic judgment in general.

If we are judging bad evaluation when we encounter the gimmick, that badness can stem from evaluation's style. "'Oh, how delicious!' cried one of the women." As "The Turn of the Screw"'s first-person narrator reports, Douglas's response to this enthusiastic response to the preview of the ghost story he is about to tell is to flatly rebuff it: "He took no notice of her; he looked at me. . . ."[107] The affective micropolitics of scenes like this fascinated James, who repeatedly returns to a depiction of people watching and finding other people's public performances of appreciation slightly repellent. The scene he liked describing comically inverts a moment in the *Critique of Judgment*, in which Kant observes a solitary man engaged in the act of judging something in nature beautiful, and then judges his act of judging as aesthetically sublime.[108] Like Kant, James subjects other people's acts of judging to the reader's judgment in turn and indeed with a particular eye to "the *word*, the *gesture*, and the *tone*" in which the speech act is performed (§51, 198). There are even times when he moves from second- to third-order judgment, inviting us to evaluate the style in which others evaluate the style of the aesthetic evaluations of others. Such is the case in the opening sentences of "The Beast in the Jungle" (1903) when we are introduced to John Marcher, whose snobbery quickly becomes clear through his disgust at others "gloating" about aesthetic objects:

> There had been after luncheon much dispersal, all in the interest of the original motive, a view of Weatherend itself and the fine things, intrinsic features, pictures, heirlooms, treasures of all the arts, that made the place almost famous; and the great rooms were so numerous that guests could wander at their will, hang back from the principal group and in cases where they took such matters with the last seriousness give themselves up to mysterious appreciations and measurements. There were persons to be observed, singly or in couples, bending toward objects in out-of-the-way corners with

their hands on their knees and their heads nodding quite as with the emphasis of an excited sense of smell. When they were two they either mingled their sounds of ecstasy or melted into silences of even deeper import, so that there were aspects of the occasion that gave it for Marcher much the air of the "look round," previous to a sale highly advertised, that excites or quenches, as may be, the dream of acquisition. The dream of acquisition at Weatherend would have had to be wild indeed, and John Marcher found himself, among such suggestions, disconcerted almost equally by the presence of those who knew too much and by that of those who knew nothing. The great rooms caused so much poetry and history to press upon him that he needed to wander to feel in a proper relation with them, though his doing so was not, as happened, like the gloating of some of his companions, to be compared to the movements of a dog sniffing a cupboard.[109]

In an almost uncanny prefiguring of arguments in Bourdieu's *Distinction*, Marcher's distaste at the way in which his fellow guests "give themselves up" to their "appreciations and measurements" figures their style of judging in terms of appetite, theatre, and commerce. "Mingl[ing] their sounds of ecstasy" with those of others, the visitors appraise by "sniffing" like dogs in pursuit of food; their overdramatic way of being "in relation" to the aesthetic objects around them transforms the entire scene into one of a "sale highly advertised." It transforms it, we might say, into the scene of the fraudulent Birthplace or gimmick avant la lettre. Notice, once again, that Marcher does not find the objects judged by the visitors to be compromised; the problem is *the manner* in which they are being judged. What is finally most striking about this scene of gushing is how it shows the gimmick's evaluative structure presiding over a situation in which the specific judgment is not only left unstated, but in which the form it points to never appears. There is no doubt about whether the artworks at Weatherend are worthy of appreciation. Where the gimmick nonetheless asserts its presence is in the repulsion produced by erroneous praise. Erroneous not because the content of the perlocutionary speech act is wrong but because, in a way signaled by affect, its mode of social relationality is. The fact that all of this comes through the unsympathetic character of Marcher reminds us of something that should go without saying: that specific judgments of the gimmick, however interesting as verbal performances, are not always ones to which will we feel attuned.

The gimmick is thus not just an object we regard as wrongly over-praised or even that overvaluation's critical addressing or naming. It indexes a bigger wrongness in the way a society goes about valorization as such.

Higher Form of Prank

"Philip Morris promotional gimmick kills two in Poland," we learn from a 1998 article in *British Medical Journal*. Trick matches designed to push American cigarettes to Eastern European teenagers had begun exploding in their cartons, setting fire to the cars of the workers hired to distribute them.[110] As Dale Orlandersmith make clear in her play *The Gimmick* (1998), underestimating the form is hazardous: "The Gimmick is blood/a blood circus/how much blood can pour onto the streets of Harlem/on our block in Harlem/there's the Gimmick/there's the Gimmick/gonna live by it/die by it/the Gimmick."[111] Yet the fundamentally overrated gimmick also seems cruelly designed to penalize those who do take the form's hazards seriously. This may be why those most conscious of it as a capitalist phenomenon try to circumvent this by speaking of it in tones of derisive contempt: "this whole credit gimmick society, man" (Cockrel); "pump-priming, featherbedding . . . all the other gimmicks . . . being proposed by . . . well-meaning liberals" (Boggs).[112]

The gimmick in art has a more specific way of laying a trap for those attempting to analyze it, which is to suggest reactionary conservatism as the true cause for every act of its detection. There are of course times when the label fits. As Miller notes in the account of the gimmick preceding his attack on critics who fall for Hitchcock's stunts (*Rope*'s supposedly single shot, in which cuts are hidden in dissolves into James Stewart's backside) *and* for the director's repudiation of their meaning: "The evidence of a compelling, but meaningless, device (a paradox writ large in the debate over the role of technique in Hitchcock's work as a whole) is as familiar as the accompanying denunciations of mass culture's tendency to degrade formal experimentation to the status of a gimmick." He continues: "But it is never simply enough, here or elsewhere, to observe the gimmick structure, or to identify it as that which elicits technicist accounts and at the same time betrays them into an all but self-acknowledged pointlessness. *Far from ever truly installing a site of nonmeaning . . . the gimmick only exploits the idea of such a site in relation to specific meanings whose production is felt to need obscuring.*"[113]

Even the etymology of *gimmick* seems to encourage its dismissal. With obscure origins in United States slang, it is born jargony, as this entry from the 1926 edition of *American Speech* suggests: "Every snipe endeavors to impress the poor swabbos with his talk of gillguys, gadgetts, and gimmicks." From *The Wise-crack Dictionary* (1929) we learn that it is a "device used for making a fair game crooked," while a reference from 1936 states that "gimac . . . is an anagram of the word magic, and is used by magicians the same way as others use the word 'thing-a-ma-bob.'"[114] Was entertainment magic with its repertoire of equipment, skills, and practices—and distinctively nonsupernatural, businesslike approach to enchantment—a crucible for the capitalist gimmick?[115] Explored further in Chapter 2, this possibility highlights the gimmick's embodiment of the same marriage of "calculation and enchantment" Daniel Tiffany associates with kitsch in *My Silver Planet*—bringing us to the question of how the gimmick relates to this more frequently discussed category.[116]

The two types of aesthetic badness quickly diverge if we hold our gaze steady. The paradigmatic kitsch object that is the collectible is a finished object designed for aesthetic contemplation and not an element integrated into a process of production. Kitsch is never a "handle," never a skill or technique associated with work. Even the toy gimmicks in the comic book *Yps* (1975–2000) have a briskly "productive" vibe, as one sees in the recurring *Geld Maschine* (Fig. 0.3). The leisurely tchotchke, by contrast, makes no promise to expand value or enhance the efficiency of labor. Indeed, the iconic snow globe does just the opposite, signifying dilatory pleasures, a utopia of luxurious purposelessness, and affordable waste.[117] Kitsch tends to be nostalgic, in contrast to the gimmick's antic insistence on its up-to-dateness. And finally, if kitsch resembles "poshlost," as Tiffany suggests, another divergence comes to light.[118] As Vladimir Nabokov writes:

English words expressing several, although by no means all aspects of *poshlust* are for instance: "cheap, sham, common, smutty, pink-and-blue, high falutin', in bad taste." [*Roget's Thesaurus*] . . . supplies me moreover with "inferior, sorry, trashy, scurvy, tawdry, gimcrack" and others under "cheapness." *All these however suggest merely certain false values for the detection of which no particular shrewdness is required.* In fact they tend, these words, to supply an obvious classification of values at a given period of human history; but what Russians call *poshlust* is beautifully timeless and so cleverly painted all over with protective tints that its presence . . . often escapes detection.[119]

FIGURE 0.3

While poshlost is timeless, subtle, and easy to consume, the time-conscious, hard-to-swallow, flagrantly unworthy gimmick is not fooling anyone: exactly like the "false values" falling under "cheapness" Nabokov rules out from his definition.

Some gimmicks are of course more flagrant than others. Given that they can be found anywhere (politics, business culture, social media . . .), what is to be gained by studying the form's contradictions in art? Why not go for a jumbo-sized gimmick like the one documented in *FYRE: The Greatest Party That Never Happened* (2018), a Fitzcarraldo financed with capital from the sale of metal "credit" cards to Instagramming millennials with FOMO? Or a mass-produced commodity designed to save labor and time in the reproductive sphere, like Hamburger Helper? Or, the gimmicks of William Castle, famous for stunts like attaching buzzers to the undersides of theater seats for the finale of *The Tingler* (1969)?[120] Why focus on seemingly esoteric problems related to idea-driven novels, metafictional reflexivity, the convergence of contemporary art with aesthetic judgment, or the later James's obsession with plots involving people working in secret without wages?

"One wants some device which is not a trick," wrote Virginia Woolf in her diary while working on *The Waves*.[121] If the problem of the

"ostentatiously unworthy," "sumptuously extraneous," and "compelling, but [pointless]" gimmick haunts art in a more intense way than other areas of culture, the theory we've been outlining suggests one primary reason for why: art's equivocal status as a capitalist commodity and the uncertain relation of artistic to value-producing labor. For as richly analyzed by Dave Beech in *Art and Value*, John Roberts in *The Intangibilities of Form*, Jasper Bernes in *The Work of Art in the Age of Deindustrialization*, and La Berge in *Wages Against Artwork*, art under conditions of capitalist production raises all the same questions about labor, time, and value that the overperforming/underperforming gimmick does. Why so much exertion for a nonproductive activity? As Adorno suggests, this is why the acrobatic stunt remains a viable image for art in capitalism, even as art continues to resemble a luxury good.

> Thus the once disdained concept of the "artiste" recovers its dignity. That trick is no primitive form of art and no aberration or degeneration but art's secret, a secret that it keeps only to give it away at the end. Thomas Mann alludes to this with his provocative comment that art is a higher form of prank. Technological as well as aesthetic analyses become fruitful when they comprehend the tour de force in works. At the highest level of form the detested circus act is reenacted: the defeat of gravity, the manifest absurdity of the circus—Why all the effort?—is *in nuce* the aesthetic enigma.[122]

Given that it comes from the author of *The Magic Mountain*, the idea of art as "prank" opens up a second question: Why does the gimmick hover over modernism, and modernist techniques in particular? From op-art effects and Wagnerian leitmotifs to the constraints driving works of "total organization" straddling the fence between "too easy" and "too difficult" (as in Queneau's *A Thousand Million Sonnets*), these devices have seemed dubious at times even to the artists who use them. The very question, in its inevitability—"is it a gimmick or modernism?"—tells us that we are already inside the former's domain.

The idea that there is progress in art's technical procedures, in a way paralleling innovation in capitalist technology, is acknowledged by Adorno as controversial but ultimately accepted: "Undoubtedly, the historical materials and their domination—technique—advance."[123] Noting the "differentiation of harmonic consciousness between the age of thoroughbass composition and the threshold of new music" as a key example of this "logical development of established methodology," he adds that "such un-

mistakable progress" is "not necessarily that of quality."[124] In a similar spirit, Cavell argues that post-atonal music's increasing convergence with technical problem-solving results in an ambiguous feedback loop. Music's rising technicism gives rise to a thickening critical apparatus, which music internalizes as a newly necessary condition for its continuing production.[125] This changed relationship between criticism and art results in what Cavell calls the "modernist problematic": the awakening of a suspicion of the artwork as always possibly fraudulent.[126] In a development just as "irreversible" as advances in the procedures of art-making (or for that matter, commodity production), the new uncertainty about trickery becomes extended to the idea of art in general, retroactively affecting our relation to works of the past.

The impersonal concept of technique, and not the moral one of artistic intention, ultimately leads Cavell to this remarkable thesis: *all art becomes intrinsically gimmick-prone after modernism.*[127] Questions of technique and about the gimmick thus lead to the same relatively rarely visited place in aesthetic theory: aesthetics from the point of view of production. And more specifically: capitalist production, binding value to abstract labor and time.

Conclusion

We call things gimmicks when it becomes radically uncertain if they are working too hard or too little, if they are historically backward or just as problematically advanced, if they are wonders or tricks. After Chapter 1 introduces this set of contradictions via their centrality to comedy, each chapter examines one in greater detail. Capitalist enchantment is taken up most explicitly in Chapter 2 and again in Chapter 3, which turns to the ersatz "magic" produced by the overstraining of technique in the novel of ideas. Labor is the central focus of Chapter 8, which links James's abstract late style, his fondness for "cheap tricks," and the theme of abandoned servants and/or women working secretly or without pay. Time is the focus of Chapter 4 on finance, understood as an "orientation and a contestation over futurity."[128] Reading *It Follows* alongside Stevenson's "The Bottle-Imp," Chapter 4 raises another question about capitalist timing. "It follows" can mean either succession or causality. Were breakdowns in the finance, insurance, and real estate sector the root cause of recessions in 1890 and 2007, or simply a more immediate trigger? Both texts mobilize the temporally unstable gimmick to reflect on this problem.

The overperforming and underperforming, grossly overvalued but also dangerously underestimated gimmick's contradictions are inextricably connected. Value is accordingly at stake in every chapter but comes most to the fore in three chapters that focus on capitalist abstractions. Through readings of the smiley face, Marx on money as the necessary form of value, and poet Rob Halpern's *Music for Porn*, Chapter 5 introduces the idea of "real abstraction" subsequent chapters take up: Chapter 6, on the gimmick as botched concept in the corpus of photographer Torbjørn Rødland, and Chapter 7, on the gimmick as jerry-rigged effect in the installations of Stan Douglas. Every chapter highlights the gimmick's intimate relation to comedic failure, whether in the guise of out-of-synch dubbing, an idiotic doodad, or a ludicrously slow-moving, debt-collecting zombie.

Across these representations, a higher-order pattern emerges. Uncertainties surrounding value tied to labor end up pointing to capitalist labor's inextricable linkage to nonlabor. As we examine how artists funnel sex, credit, magic, and other topics through the gimmick's extravagantly impoverished form, we begin to see how its "law of value" describes more than just the economic laws of capitalist production, including those already binding production to nonproduction: a "scarcity of jobs in the midst of an abundance of goods."[129] It hints at an even more submerged tie between the official economy and the noneconomic relations that make it possible—and at the crises that threaten this gendered and racialized sphere of reproduction, too.

As the studies in *Theory of the Gimmick* show, nonlabor in its tie to labor can take various forms: unpaid, willingly donated, thrown-off. The cheapening and eventual expulsion of employed labor comes to the fore in Chapters 1 and 8, via DeWitt's anatomy of an all-female temp agency and James's obsession with cast-off servants. Unpaid caring labor bubbles to the surface in Chapters 3 and 4, even as these focus on subjects seemingly remote from reproduction. Barker's *Clear*, the work in this book most closely identified with the gimmick, becomes, as if precisely through this intimacy, a novel in which acts of tending to unwell strangers culminate in the protagonist's loss of employment. Meanwhile, horror stories of cheap credit in Chapter 4 suggest how financialized capitalism dreams of patching up holes in the capacity of the system to expand by leaning harder on "family values" than ever. Tracking the gimmick here reveals a crisis of social reproduction in the feminist sense (the "care gap," sutured with low-paid, racialized labor), while the same endeavor in Chapter 1 discloses a crisis of reproduction in the Marxist sense (a breakdown in

the reproduction of the capitalist system's capacity to accumulate as a whole). Chapter 4 shows how each implies the other, while in Chapter 8, Henry James's linking of the expelled labor of domestic workers to the unpaid labor of housewives suggests that one logic encompasses both.

The gimmick can be an idea, a technique, or a thinglike device. It is sometimes instrumental and other times pointless. It is a form with an objectivity akin to that of the capitalist appearances analyzed by Marx, which hide exploitation in the very act of expressing it. It is a contrivance that writers, composers, and visual artists not only represent but use, deploying it to think through other aesthetic, conceptual, or historical problems.

But the gimmick most fully unfurls as a complex instance of evaluation. Like all aesthetic judgments, it is an outward-facing act of address, a perlocutionary speech act, and an improvisatory performance. It is also an invitation to playful sociality around an object of suspicion; a displacement of belief in an illusion that in this very displacement acknowledges its social effectivity and reality; and a transvaluative judgment of other judgments. What we ultimately judge in our spontaneous encounters with its flagrantly unworthy form is the erroneous appraisal of value in general—and through this, an entire system of relations based on the mismeasurement of wealth.[130]

Theory of the Gimmick

Labor-Saving Device

What are those of us living in capitalist societies saying when we call something a gimmick, regardless of the varying objects to which the evaluation is applied and varying identities of those applying it? What is being accurately registered about our world, and also our sociality or way of sharing this world, in this ambivalent, if mostly negative aesthetic judgment? And without the speakers necessarily or explicitly knowing it?

We can work our way in with a more indirect question: Why are gimmicks often *comically* irritating? The very sound of the word seems to grate on popular philologist Ivor Brown, who nonetheless gives it a full entry in *Words in Our Time* (1958). "Comedians have their gimmicks, either as catch-phrase, theme-song, or bit of 'business,' which they exploit in . . . their appearances."[1] Gimmicks seem to provoke contempt simply because they are job-related: mere tools that have a strange way of stealing attention. Here the idealized condition of aesthetic autonomy turns into a problem for once, when asserted not by the work as a whole but illicitly by an instrumental part-object: one that performers "exploit" but in exploiting make their witnesses feel exploited, too. Most significantly, in addition to being what Brown calls a "poor kind of artifice," the gimmick irritates because it "abbreviates" work and time. As Brown writes, "I remember an old music-hall comedian called Phil Ray who began his turn by announcing, 'I always abbriev. It's my hab.' Never to finish a word was his (not wildly diverting) gimmick" (48).

Repulsive if also strangely attractive, with a layer of charm we find ourselves forced to grudgingly acknowledge, labor and time-saving gimmicks are of course not exclusive to comedy. We find them in shoes and cars, appliances and food, politics and advertising, journalism and pedagogy, and virtually every object made and sold in the capitalist system. But comedy, and especially what David Flusfeder calls the "comedy of procedure," has a unique way of bringing out the gimmick's aesthetic features in explicit linkage to its status as a practical device.[2] Like the "operational aesthetic" Neil Harris describes in *Humbug: The Art of P. T. Barnum*, the comedy of procedure turns modern rationality itself into an aesthetic experience, encouraging the reader's "fascination with the ways things come together"[3] and the "visualization of cause and effect."[4] This incitement of pleasure in "information and technique," which Harris locates in a range of nineteenth-century objects "expos[ing] their processes of action," from newspaper hoaxes to sea novels, was also central to early film comedy.[5] As we learn from Tom Gunning, the invitation to visualize causality becomes especially noticeable in films featuring a "device gag" or "apparatus": the sausage machine in which animals herded into one end come out as links from the other; or the webs of string with which children join wigs, chairs, fishbowls, blankets, and other commodities to unsuspecting adults who thus become parts of an elaborate "connection device"—one which the living beings absorbed into it cannot fully see.[6]

With this image of an apparatus binding agents who otherwise seem to be acting independently—connecting them "behind their backs," as Karl Marx likes to say—we may begin to suspect that the gimmick, like the comedy of procedure that puts it so ostentatiously on display, is a phenomenon distinctive to a specific mode of production and not just "modernity."[7] A compromised form bound to an ambivalent judgment that its perception spontaneously elicits, the gimmick is an entirely capitalist aesthetic. As noted in the Introduction, it is telling here that the word that consolidates the concept of this not-so-marvelous marvel does not appear in print until the late 1920s, a moment of both euphoria as well as radical disenchantment with capitalist techniques, industrial and commercial as well as financial.[8]

To be sure, there are marvelous devices centuries before these economic developments that we might be tempted to call gimmicks today. Describing the "mechanical apparatuses, restored and painted by Melchior Broederlam, that sprayed the guests of Philip the Good with water and dust," Giorgio Agamben writes that prior to the seventeenth century European

sensibility did not recognize a significant difference between "works of sacred art" and elaborate contraptions such as those in the castle of Hesdin, where "in a hall decorated with a series of paintings representing the story of Jason, a series of machines was installed which, in addition to imitating Medea's spells, produced lightning, thunder, snow, and rain, to obtain a more realistic effect."[9] Gimmicky as we might think them now, these devices made no particular claim to abbreviating work on which they could henceforth renege. More significantly, they were objects of admiration unmixed with suspicion or contempt. It is only today that the deus ex machina, the machine or crane used to transport gods to the stage in ancient Greek tragedy, has become the name for a "cheap" or aesthetically unconvincing contrivance for achieving narrative closure.[10]

Devices like these were wonders, not in any way equivocal or "funny" to their ancient and feudal contemporaries. The capitalist gimmick, however, is both a wonder *and* a trick.[11] It is a form we marvel at *and* distrust, admire *and* disdain. Indeed, the gimmick is the perpetual slippage between these positive and negative judgments in a way that sparks comedy, opening a porthole to this genre of ambivalence in a way that the precapitalist device does not.

With its image of humans unknowingly tied to commodities (dead labor) and other living beings in the formation of a larger structure, the "connection device" singled out by Gunning as a classic gimmick (and example of early film comedy's operational aesthetic) offers a diagram of an entire mode of production. Could our experience of the gimmick's compromised aesthetic form, as illuminated for us by the comedy of procedure, be related in an even deeper way to the methods and devices of capitalism? And in a way indexed by the gimmick's claims about time (its saving), about labor (its reduction), and about value (its appreciation)?

As already glimpsed in Brown's comments about comedians and their occupational shortcuts, there is clearly a link between our negative evaluation of the gimmick's aesthetic integrity and our relation to the labor it appears to encode. Take "Notes on Comedy" by L. C. Knights (1933). Knights opens with a complaint about literary criticism, invoking the domestic appliance—vacuum cleaner, dishwasher, coffeemaker—to underscore the contempt that the gimmick's promise of reducing labor elicits therein: "Labor-saving devices are common in criticism. Like the goods advertised in women's journals they do the work, or appear to do it, leaving the mind free for the more narcotic forms of enjoyment. Generalizations and formulae are devices of this kind."[12]

Note how the very idea of a "labor-saving device" is suspicious to Knights, and in a way underscored by its association with machines tied to women, regardless of whether such devices merely appear to or *really do* save labor. A social insight thus lies behind what might seem just like huffiness on the part of someone resistant to the lure of gimmicks in his own line of work. In what circumstances might the reduction of labor by way of a device—the simplest promise of all technology—become regarded, even when *not* illusory, as a dubious, untrustworthy, and generally negative thing? When, due to the structurally compelled pursuit of maximal profits by capitalists solely capable of reuniting what capitalism fundamentally separates—means of production and labor power—efficiency-increasing innovations proliferate in tandem with rising proportions of machines to workers. After initially surging markets for lower-priced commodities become saturated, periods of falling profitability produced by this rising "organic composition of capital" lead capital to move into other sectors, expelling labor from the lines it abandons while extending its innovations to the new industries it takes up. Meanwhile capitalists in surviving lines continue devising increasingly nuanced ways to squeeze increasingly small increments of surplus labor from workers in the immediate production process on which the expanded reproduction of the entire system continues to depend.[13] Hence while we can certainly also hear it in Knights's comment, indignation on behalf of a violated Protestant work ethic is only part of the story. It cannot by itself account for this more fundamental distrust of the labor-saving device, which relates not only to the "spirit" of capitalism but its basic operations. Here the very concept of "labor-saving" becomes profoundly ambiguous. Whether in the form of an idea ("generalizations and formulae") or thing ("goods advertised in women's journals"), the capitalist device that "saves" labor contributes to both its intensification and elimination over longer periods of time.[14]

The gimmick is the objective correlative of this ambiguity, translating a source of increased productivity and material wealth, the reduction of socially necessary labor through progressively advanced machines and techniques of production, into a sign of impoverishment in the aesthetic realm. For gimmicks register as deficient in aesthetic value even when their appeal is obliquely acknowledged. Calling something a gimmick is a distancing judgment, a way to apotropaically ward off the trick's attractions by proclaiming ourselves unconvinced by them. At the same time the gimmick enables us to indirectly acknowledge this power to enchant, as one

to which others, if not ourselves, are susceptible. In this elliptical fashion, the gimmick can be found amusing or even cute; indeed, it often takes the form of a miniaturized machine. Yet it is our feeling of suspicion, followed closely by contempt, that defines the aesthetic judgment/experience of the gimmick as such. A device cannot be a gimmick—it would just be a device—without this moment of distrust or aversion, which seems to respond directly to or even correct our initial euphoria in the image of something promising to lessen collective toil. This is again what separates the gimmick proper from ancient or feudal machines that make work more efficient, because the compound crank or water mill's promise of decreasing labor does not elicit feelings of fraudulence. Always enchanting and repulsive at once, and never simply one or the other, the gimmick is one of capitalism's "sad marvels."[15]

This ambiguity comes forth most strongly in the aspect of the gimmick that irritates and charms us the most: the way in which it seems to work both too hard and too little. The self-described "inventions" of former vaudevillian and mining engineer Rube Goldberg, explorations in his own words of "man's capacity for exerting maximum effort to accomplish minimal results," highlight this contradiction in a memorably comedic fashion (Fig. 1.1).[16] In these tongue-in-cheek designs for fictional machines, first appearing as newspaper cartoons in the early twentieth century and living on today in examples ranging from engineering contests to Peter Fischli and David Weiss's art film *The Way Things Go* (1987), a stunning variety of inanimate devices are combined with animal or human agents in painstakingly elaborate ways, if also in ultimately simple chains of linear cause and effect, to perform anticlimactically ordinary tasks: emptying ashtrays, buttoning a collar, sharpening a pencil (Fig. 1.2).[17] Reminiscent of the gag film's "connection device," the Rube Goldberg perfectly captures what the gimmick does to achieve its intended effect, which seems at once excessively laborious but also strangely too easy. This is why we can refer to it both admiringly as a labor-saving "trick" and also disparagingly as a labor-avoiding "dodge."[18]

Mirrored in this appearance of doing too much and yet also not enough work, the equivocal saving of labor that the gimmick encodes is the main reason for why it attracts and repels us. Because the capitalist seeks state-of-the-art machinery at costs lower than those at which new technologies are introduced, his mode of production requires a constant negotiation with the social aging of productive devices. If we speak of outdated equipment as underperforming, below a standard of productivity continually

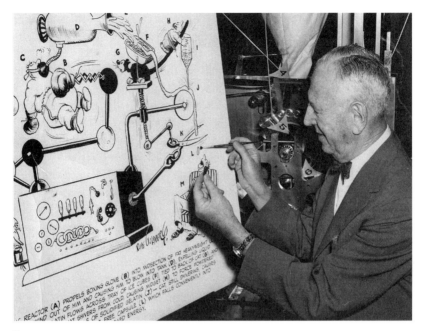

FIGURE 1.1

Pencil Sharpener

The Professor gets his think-tank working and evolves the simplified pencil sharpener.

Open window (A) and fly kite (B). String (C) lifts small door (D), allowing moths (E) to escape and eat red flannel shirt (F). As weight of shirt becomes less, shoe (G) steps on switch (H) which heats electric iron (I) and burns hole in pants (J).

Smoke (K) enters hole in tree (L), smoking out opossum (M) which jumps into basket (N), pulling rope (O) and lifting cage (P), allowing woodpecker (Q) to chew wood from pencil (R), exposing lead. Emergency knife (S) is always handy in case opossum or the woodpecker gets sick and can't work.

FIGURE 1.2

reset at higher levels, expensive new technology adopted too early might be described as overperforming, well above standard but crucially unprofitably. The ambiguous reduction of labor by productive devices whose timeliness matters is thus reflected in another closely related contradiction on the part of the gimmick: that of seeming either too old or too new.[19] Being out of synch with "the times," whether by hubristically advancing too far ahead (the comically oversized cell phone Gordon Gekko takes to the beach in *Wall Street*) or lagging behind (the comically oversized cell phone Gordon Gekko takes to the beach in *Wall Street*) is another reason why the gimmick irritates us, and all the more so given how aggressively it insists on contemporaneity with its audience.[20] With this insistence significantly shared by advertising, one of the gimmick's aims becomes transparent: that of giving its addressee what it says we want (now). We recoil from this interpellation: not because the gimmick's claim to knowing our desire is wrong, but because it usually isn't.

Comedy shares the gimmick's insistence on contemporaneity, according to some critics, because of its special relation to appraisals of worth (and to the meta-appraisal of those appraisals). Due to a commitment to "exhibiting current evaluations in light of their shortcomings," James Feibleman argues, comedy's "specific points bear always upon the contemporary world." The "contemporaneity of comedy" is thus "one of its essential features" and directly linked to its reevaluative correction of falsely inflated or untimely values.[21] Alenka Zupančič makes a similar argument, albeit from a point of view pitted against the humanism underpinning Feibleman's claim about comedy's critique of idealization. Rejecting the thesis that comedy brings us back to earth from our identification with ideals by exposing the universal's contamination by particularity, returning us to our embodiment and knowledge that we are only human, comedy is rather understood as a finitude compromised by universals—as a finitude that "leaks."[22] In making this argument about the inherently comical contamination of particularity by universality (and its corollary image, the walking abstraction or idea in the flesh), Zupančič expands on Agnes Heller's claims about the genre's "preeminent involvement with the present" (177). Heller points out that in contrast to the centrality of mourning in tragedy, no past-oriented emotion seems equally central to comic experience. We see comedy's attachment to the present reflected also in the fact that live improvisation on the stage is the exclusive métier of comic actors: "there is no tragedia dell'arte, only comedia dell'arte," Heller writes.[23] To these insights Zupančič adds the following: comedy is "extremely adept at

showing how something functions—that is to say, it is adept at showing the mechanisms, *in the present*, that allow its functioning and perpetuation."[24] Here comedy's special tie to the present lies in the way in which it shares the gimmick's operational aesthetic, its interest in showcasing how things function or the way things go. Zupančič hints that this focus on procedure might not just define one species of comedy among others but comedy as such.

Toggling between overvaluation and correction, the gimmick thus draws into sharper relief something about the workings of comedy, just as comedy brings out the features of the gimmick as aesthetic form. Yet gimmicks also belong to a world of practical and industrial inventions.[25] In twentieth-century engineering manuals and popular science magazines, we see the term used as technical slang to refer to the working part, often a unit enclosing or comprised of many smaller parts, of a larger machine.[26] Here "gimmick" seems descriptive instead of evaluative—a generic term, like "gadget," "thingamabob," or "doohickey," for any functional device.[27] Yet it is this explicitly industrial as opposed to aesthetic version of the labor-saving gimmick that best reflects the way some early twentieth-century aesthetic theorists regard comedy. For Theodor Lipps, for example, the "feeling of the comical" is what results when the mind's preparation for grasping something it thinks will be challenging is revealed as being in excess of the actual amount of effort required.[28] What was anticipated as being strenuous suddenly turns out to be "easily comprehended and mastered" in a kind of paradoxically uplifting deflation (395). At the same time, for Lipps the "feeling of the comical" produced through this reduction of mental exertion is interestingly one that does not "gratify" even as it "arouses joy" (394). Rather, it remains a complex, ambivalent pleasure that never forgets the initial moment of strain, retaining an unease akin to that which the gimmick's promise of saving labor elicits. Freud makes this connection between comedy and the reduction of work even more explicit, though in his case mental exertion is not the problem but the cure: "By raising our intellectual expenditure we can achieve the same result with a diminished expenditure on our movements. Evidence of this cultural success is provided by our machines."[29]

There is an emphasis on the "intellectual" in these theories of comedy as a "diminished expenditure" of work that comes to a peak as a fetishization of the "idea" in the comedy of procedure. "If you're an ideas man you don't just stop having ideas because cash flow is not a problem," thinks the personification of capital who is the protagonist of Helen DeWitt's

Lightning Rods (more on this novel soon). "You go right on having new ideas, and when you have an idea you want to see that idea in action."[30] In a way that might explain why the conceptual artwork remains such a prominent stereotype of a gimmicky artifact, in capitalist culture "idea" and "gimmick" often become synonymous. We see this slippage in the *Oxford English Dictionary*'s definition:

> gimmick, n. A gadget; spec. a contrivance for dishonestly regulating a gambling game, or an article used in a conjuring trick; now usu. a tricky or ingenious device, gadget, *idea*, etc., esp. one adopted for the purpose of attracting attention or publicity.[31]

If, as Zupančič suggests, the materialism of comedy resides not in the rejection but rather enticization of abstractions, something similar seems encoded in the form of the gimmick. The gimmick is both an idea and also its materialization in a "gadget," "article," or "contrivance"; it is more precisely the metamorphosis of idea *into* thing in a way that charms but also disturbs us. It is worth lingering on the negative side of this mixed response. Is not the movement from supposedly abstract ideas to supposedly concrete things regarded as generally desirable by critics and fans of capitalism alike? And is not the gimmick a merely symptomatic phenomenon, miles removed from a critical stance on the mode of production for which it is a synecdoche? Yet in this aesthetic experience the well-nigh universally celebrated transformation of ideas into things becomes an object of rare misgiving—as if to underscore just how little distance separates realization from reification in a system that binds value to labor and time.

Here the production of commodities also includes the production of the specific way in which they will be consumed. As one "business bible" designed to look like a bro-friendly cookbook advises, the marketing of a commodity should not be organized post hoc by a separate division of workers but rather "baked" into the commodity during production. The male authors of *Baked In: Creating Products and Businesses That Market Themselves* attempt to market this conflation of reception and production as a cutting-edge capitalist technique (if also, interestingly, as a domestic one). Yet it is already central to the gimmick as a historical form coinciding with the birth of mass advertising, when methods for realizing the values of unsold commodities by creating new kinds of desire were streamlined in response to one of many waves of visible overaccumulation of manufactured goods. Mirroring the unity of production and exchange

distinctive to capitalism—beginning with the worker's sale of labor power to the capitalist, these activities mediate one other at every point—in the gimmick making and selling always seem to happen at once.

We are given a detailed demonstration of how this "classic" version of the gimmick works in "The Glory Machine" by symbolist writer Villiers de l'Isle-Adam (1883).[32] The device at the heart of this late nineteenth-century story, narrated in the blustery tone of a market still closely aligned with theatre, is a "machine" for insuring French playwrights against ruin by guaranteeing that their aesthetic productions will be met with an unequivocally positive response. "In the future, [such] risks will be completely ruled out" (62).[33] The punch line of Villiers's laying bare of the gimmick form—the story's metagimmick, if you like—is that the "sublime mechanism" for generating "Glory" proves to be nothing other than the physical building of the theatre.

The output of the "The Glory Machine" is thus a paradoxically glorious deflation akin to that at work in Lipps's and Freud's theories of comedy. For we quickly discover that the Machine is not a scientifically advanced marvel difficult to understand but just an ordinary amphitheater modified with hundreds of mechanical devices and controlled by a hidden operator on a giant keyboard for generating a simulation of collective aesthetic pleasure. Even more than the theatrical production for which it is simultaneously produced as both a response and a work to be aesthetically consumed in its own right, the artificial reception is an elaborately orchestrated Gesamtkunstwerk. In addition to "laughing and lachrymatory gases" pumped out at the appropriate moments from pipes, automated cane ends to thump on floors, and the installation under every seat of a folded "pair of very shapely hands, in oak" (the narrator archly notes, "It would be superfluous here to indicate their function"), its devices include "tiny bellows . . . operated by electricity" placed in "phonographic machines" hidden in the mouths of the proscenium cupids. At appropriate moments these phonographic machines play the prerecorded sounds of aesthetic reactions—"Bellowings, Chokings, 'Encores,' Recalls, Silent Tears, Recalls-with-Bellowings-extra, Sighs of Approbation, Opinions Proffered, Wreaths, Principles, Convictions, Moral Tendencies, Epileptic Seizures, Sudden Childbirths, Blows, Suicides"—said to exceed the variety already offered by any "well-organized Claque," the paid human applauders who represent what the Machine technologically supersedes. The Glory Machine's much vaster repertoire extends even further to "Ideas" or "Noises

of Discussion (art for art's sake, Form and Idea)" and even to full-blown "Critical Articles," churned out while the play under review is still in process of being performed (65).[34]

The seemingly exotic futuristic device for securing the ideal reception for an aesthetic commodity ends up being nothing other than the ordinary present-day apparatus for the commodity's production. The final joke is that the Machine's production of an unambiguously positive aesthetic reception ends up producing an *unfeigned* pleasure for the audience in the world of the story. "Whence it comes—and here is the solution of the problem of a physical means attaining an intellectual end—that success becomes a reality—that Glory does veritably pass into the auditorium! And the illusory side of the ... Apparatus vanishes, fusing itself, positively, in the glow of the True!" (63). With this moment of metaphysical triumph, the emergence of the "real thing" from its simulation, which Robert Pfaller claims defines the essence of comedy, the tale completes its comedic act of *generic* deflation, as the speculative allegory or philosophical parable we may have thought we were reading—which begins with a series of pseudo-Hegelian reflections on the "common point" between matter and thought—collapses into a satire on the pettiness of contemporary French dramatists and the mediocrity of their drama.[35] In accordance with the disappointment specific to the overworking/underworking, too laborious/insufficiently laborious gimmick, this downgrading cleverly takes place in tandem with the story's demonstration of how its eponymous aesthetic machine works.

Yet there is disappointment because euphoria precedes it. The gimmick lets us down—self-corrects our overestimation of its abilities—only because it has also managed to pump us up. We express contempt for it as a labor-saving trick because our attention was in fact caught by its promises of saving labor; we describe it as cheap or aesthetically impoverished only because it seemed so truly shiny with value. Even if the gimmick is fundamentally an aesthetic failure, our irritation by it has everything to do with the fact that it also partially succeeds. One wonders if we find gimmicks repulsive *insofar as* we find them attractive, as if in a reevaluation of the initial evaluation (here, reversing the order of the sublime's two affective phases, our negative response overrides the positive one). In an almost homeopathic as well as auto-correcting way, the gimmick qua device of capitalist production, as well as distinctively capitalist aesthetic judgment, deflates the hype it initially excites.

This prompts us to ask: Is it production per se that irritates us in our aesthetic experience of the gimmick or something about the specific way in which the gimmick comes to index it? Why is the gimmick's procedural aesthetic not a source of simple pleasure, as it is in the practical jokes and how-to-do-it books Harris describes in *Humbug*, the "task films" and "device films" analyzed by Trahair and Gunning, or today's Discovery Science Channel television show *How It's Made?* Given that all reveal and invite audiences to take pleasure in learning about methods of production, why are we charmed in these instances but primarily irritated here? Although his archive lies at the opposite end of the cultural spectrum from these popular entertainments, a similar question could be asked about Viktor Shklovsky's concepts of "art-as-device" and "exposing the device," in which the elucidation of the procedures by which an aesthetic effect is achieved contributes to the salutary project of art as *ostranenie* or making-strange, a formalist idea politicized in Bertolt Brecht's epic theater and high modernist *Verfremdungseffekt*.[36] For Brecht and Shklovsky, whose privileged example is Laurence Sterne, the making visible of methods of production *adds* pleasure, *adds* aesthetic value, whereas in the gimmick it directly detracts from our enjoyment and esteem. What accounts for this difference in our relation to the exact same maneuver of calling attention to the process of making by way of the aesthetic device? It can only be the fact that the capitalist gimmick seems to make promises about the reduction of labor in a way Shklovsky's literary device explicitly does not—promises that, interestingly, we feel we distrust from the start.[37]

Ambiguities surrounding labor and value in capitalism are also ambiguities about time. We will take a much closer look at this aspect of the gimmick below, which will return us in a direct way to the issue of comedy.

Timing

Consider this display of comic devices in E. L. Doctorow's *Ragtime* (1974): scaled-down versions of the spectacular products made in the fireworks factory that symbolically dominates this satire of capitalist life in the early twentieth-century United States:

> There were exploding cigars, rubber roses for the lapel that squirted water, boxes of sneezing powder, telescopes that left black eyes,

exploding card decks, sound bladders for placing under chair cushions, glass paperweights with winter scenes on which snow fell when you shook them, exploding matches, punch-boards, little lead liberty bells and statues of liberty, magic rings, exploding fountain pens, books that told you the meaning of dreams, rubber Egyptian belly dancers, exploding watches, exploding eggs.[38]

This passage is curiously static, even though every gimmick featured in it—including simulations of luxury items designed to self-destruct for the fun of those who might not afford them—seems to be a kind of action.[39] Each device is presented in or as a tiny blast of text but with no sense of momentum due to the cordoning of each successive squirt, sneeze, and flash from its neighbors by commas. In this manner the possibility of the explosions affecting one another or accumulating into something larger is blocked, highlighting their disconnection even while packed into the same discursive space.

Popped off like tiny, nonreusable fireworks, the gimmick here in its specifically comedic form looks a lot like what Fredric Jameson calls a "singularity," a "pure present without a past or a future."[40] This is also how Gunning describes the film gag: as an "essentially discontinuous" comic action. Simply adding one gag to another will not a narrative make, Gunning argues, because of a tractionless surface that keeps the form's action self-contained: "Each gag ends in such a way that the gag machine must be started all over again to produce an additional one. Rather than a flow, longer gag films are structured as a series of explosions. After an explosion there is little to do."[41] The ultimate gag that is the one-time explosion epitomizes the gimmick's status as a device for producing a quick but immediately vanishing aesthetic payoff, which can neither begin a project nor sustain a tradition. It is this very unrepeatability, we might say, that the series of exploding devices in *Ragtime* repeats.

There is thus a sense in which the gimmick confronts us with a mode of bad contemporaneity akin to the "elongated present," "endless present," or "perpetual present" strikingly different theorists use to account for the peculiar feel of our contemporary moment.[42] It is Jameson, however, who makes an argument about the reduction of time to the present in a way that hints at its especial relevance for a theory of the gimmick as a capitalist and especially late-capitalist aesthetic. In "The Aesthetics of Singularity" (2015), his reassessment of postmodernism and postmodernity as "indispensable" periodizing concepts, Jameson returns to the action film

as example, noting how "nowadays they are reduced to a series of explosive presents of time, with the ostensible plot now little more than an excuse and a filler, a string on which to thread these pearls which are the exclusive center of our interest: at that point the trailer or preview is often enough, as it offers the high points of films which are essentially nothing but high points."[43] Arguing that the temporal form of this "singularity-event" dominates every semi-autonomous "level" of late capitalism (economics, technology, politics, and so on), Jameson singles out two high-cultural examples of its characteristic "reduction to the present or the reduction to the body": Tom McCarthy's *Remainder*, in which a man who has lost his past from a head injury pays people to re-create isolated memory fragments he can obsessively re-experience in the present; and the installation art of Xu Bing, whose *Book from the Sky* is based on what looks like but isn't writing. For Jameson, postmodern works "soaked in theory" like these are to be distinguished from an older modernist conceptualism, in which ideas are "universal forms" used to "put a contradiction through its paces" or "flex mental categories" in a way that actively sustains or energizes thought (114, 113). By contrast, the idea in the gimmicky neoconceptual works is no longer a universal but rather nominalist form and as such is no longer generative. Rather, it assumes the form of a one-off or mere "technical discovery," the "single bright idea" that leads to the "contraptions of the lonely crackpot inventors or obsessives" (112).

This argument about the postmodern transformation of the idea in art from universal concept to a historically isolated contrivance leads Jameson to note the following:

> Both these works are one-time unrepeatable formal events (in their own pure present as it were). They do not involve the invention of a form that can then be used over and over again, like the novel of naturalism for example. Nor is there any guarantee that their maker will ever do anything else as good or even as worthwhile (no slur on either of these illustrious artists is intended): the point being that these works are not in a personal style, nor are they the building blocks of a whole oeuvre. The dictionary tells us that the word "gimmick" means "any small device used secretly by a magician in performing a trick": so this is not the best characterization either, even though it is the one-time invention of a device that strikes one in such works. It is, however, *a one-time device which must be thrown away* once the trick—a singularity—has been performed. (113, my emphasis)

The word "gimmick" produces a hesitation in this essay, highlighting similar uncertainties inherent to the form. A likeness between the singularity and gimmick is suggested ("The dictionary tells us . . ."), then retracted ("so this is not the best characterization either"). The retraction is then *itself* retracted ("even though . . ."). The likeness is then re-asserted a final time on the grounds that gimmicks are, indeed, "one-time" devices that cannot be reused.

Yet gimmicks are "used over and over again." Indeed, the perpetual reuse of a device for producing an effect is often exactly what transforms it into an impoverished gimmick. This is one of the reasons why another paradigmatic instance of a gimmick is the overrepeated joke, such as the one compulsively retold in Mark Twain's time-travel comedy *A Connecticut Yankee in King Arthur's Court* (1889). Hank Morgan's complaint about the unfunniness of the Round Table's official clown, Sir Dinadan the Humorist ("I never heard so many old played-out jokes strung together in my life") not only inadvertently perpetuates the Humorist's unfunniness—to demonstrate the badness of his repertoire, Hank must repeat it—but ends up being as longwinded as the aptly named Dinadan.

Hank informs us that Dinadin's worst joke has managed to survive into Hank's own century, running on repeat long enough to get stale then, too. If one problem with Dinadin's joke is thus that it is at once excessively and yet insufficiently contemporary, similar criticisms have been surrounded *Connecticut Yankee* from its moment of publication. For the novel's main device, regarded by many as clichéd as Hank finds the Humorist's gimmick, is precisely its juxtaposition of two historical eras and modes of production.

Fittingly, the comically indestructible joke is about a "humorous lecturer" whose jokes fail not because they are inherently unfunny but because the provincial members of the performer's audience prove to be out of historical phase with him. The audience is unable to recognize the distinctively modern genre of comedic performance—Twain's specialty, the humorous lecture—to which the laughter they suppress is the correct and intended response, thinking instead that they have attended a sermon:

> While Sir Dinadan was waiting for his turn to enter the lists, he came in there and sat down and began to talk; for he was always making up to me, because I was a stranger and he liked to have a fresh market for his jokes, the most of them having reached that stage of wear where the teller has to do the laughing himself while

the other person looks sick. I had always responded to his efforts as well as I could, and felt a very deep and real kindness for him, too, for the reason that if by malice of fate he knew the one particular anecdote which I had most hated and most loathed all my life, he had at least spared it me. It was one which I had heard attributed to every humorous person who had ever stood on American soil, from Columbus down to Artemus Ward. It was about a humorous lecturer who flooded an ignorant audience with the killingest jokes for an hour and never got a laugh; and then when he was leaving, some grey simpletons wrung him gratefully by the hand and said it had been the funniest thing they had ever heard, and "it was all they could do to keep from laughin' right out in meetin'."

Hank's narration continues:

The anecdote never saw the day it was worth telling; and yet I had sat under the telling of it hundreds and thousands and millions and billions of times, and cried and cursed all the way through. Then who can hope to know what my feelings were, to hear this armor-plated ass *start in on it again*, in the murky twilight of tradition, before the dawn of history, while even Lactantius might be referred to as "the late Lactantius," and the Crusades wouldn't be born for five hundred years yet?[44]

Note the complexity of the gimmick's compulsory repetition in this passage, which illuminates the strange power of its aesthetically impoverished form. Hank tells us he initially felt fond of Dinadan because Dinadan, at least initially, does *not* tell the bad joke ("he had at least spared it me"). Hank then immediately goes on, as if for precisely this reason, to tell it to us himself ("It was about . . ."). And then, just a little further, to tell us how Dinadan *also* went to tell it ("Then who can hope to know what my feelings were, to hear this armor-plated ass *start in on it again* . . ."). The joke that should not be told, or gimmick that should not circulate, is thus effectively told three times (and a fourth again here, by me), as if it had a power to override every effort to contain it.

The gimmick, in short, is nothing if not a device used "hundreds and thousands and millions and billions of times." Yet Jameson is clearly not wrong in noting its presentism, which is what the Humorist's joke is also about. The bad joke about how good joke-telling goes bad when it fails to be contemporary endlessly repeats *in every present*. What turns it into

a gimmick is not just its re-use but *also* its perpetual present tense, and these now start to look less like opposites than versions of the same thing.

We now have the last of the several temporal ambiguities specific to the gimmick as form. At once dynamic (like an action) and also inert (like a thing), at once like a cause but also its effect, the gimmick is *both* a singular event *and* the proverbial old saw. As Jameson rightly argues, it is a novelty with no consequences beyond its immediately vanishing moment. The gimmick is also, as Twain suggests, the outdated device that still refuses to die.[45] As this paradoxical unity of discrepant temporalities—instantaneity and duration, disruption and continuity, singularity and repetition—the gimmick embodies one of the most significant contradictions of capitalism: the way in which its organization of production enables the "ongoing *transformation* of social life—of the nature, structure, and interrelations of social classes and other groupings, as well as the nature of production, transportation, circulation, patterns of living, the form of the family" but also "the ongoing *reconstitution* of its own fundamental condition as an *unchanging* feature of social life—namely, that social mediation ultimately is effected by labor."[46]

For Moishe Postone, this contradiction is reflected in the emergence of two distinctly capitalist kinds of time, the first involving "changes in concrete time effected by increased productivity," which Postone calls historical time, and the second the abstract time involved in the labor-based production of value (Marx's socially necessary labor time).[47] A discord that becomes "increasingly perceptible" arises between the production of wealth made possible by the accumulation of past knowledge or historical time (increasingly the case for production *over* time) and the production of value based on the expenditure of abstract time, which takes place only in a present tense. This is the case even as the very dynamism of capitalism depends on the "constant *translation* of historical time *into* the framework of the present, *thereby reinforcing that present*."[48] Postone's language is technical but his point bears directly on the gimmick's temporal contradictions and is therefore worth the time it takes to digest:

> Changes in concrete time effected by increased productivity are mediated by the social totality in a way that transforms them into new norms of abstract time (socially necessary labor time) that, in turn, redetermine the constant social labor hour. Note that inasmuch as the development of productivity redetermines the social labor hour, this development reconstitutes, rather than supersedes,

the form of necessity associated with that abstract temporal unit. Each new level of productivity is structurally transformed into the concrete presupposition of the social labor hour—and the amount of value produced per unit time remains constant. *In this sense, the movement of time is continually converted into present time.* In Marx's analysis, the basic structure of capitalism's social forms is such, then, that the accumulation of historical time does not, in and of itself, undermine the necessity represented by value, that is, *the necessity of the present*; rather, it changes the concrete presupposition of that present, thereby constituting its necessity anew. Present necessity is not "automatically" negated but paradoxically reinforced; it is impelled forward in time as a perpetual present, an apparently eternal necessity. (299; my emphasis)

A perpetual present (Jameson's singularity) and a relentlessly ongoing historical continuity (Twain's joke). Postone refers to the interaction between these two kinds of time generated by capitalist labor as capitalism's "treadmill effect," and it is what we register in the gimmick's own peculiarly "alienated interaction of past and present" (289, 300).

Twain's comedy about the Colt Arms factory foreman who attempts to impose his century's mode of production onto a mythical precapitalist England was written when Twain was falling into bankruptcy after years of financial hemorrhaging through his ill-fated investment in a newfangled technology. The infamous "Paige contraption" with which Twain's novel came to have a "strange identification" was a capitalist machine that failed the test of proper timing in its quest for social uptake, rendered obsolete by the Linotype typesetter before its technical problems could be corrected (Fig. 1.3).[49] Questions about capitalist timing were thus at the forefront of Twain's mind while writing a novel in which we see the gimmick's temporal contradictions played out at every level and in a way highlighted as much by the novel's comedic failures as by its successes. Excoriated by reviewers from the 1890s up to as recently as 2010 as a one-joke production, with a title communicating the novel's gist so efficiently that one feels released from any obligation to read it, the novel is essentially a series of fast-acting but ultimately inert gags.[50] These gags are in turn nothing but simple anachronisms: knights with tabards painted with advertisements for soap, a bowing and praying hermit harnessed to a sewing machine for the automated fabrication of linen shirts; newspapers and telephones in Camelot; and so on. Twain's own contemporaries saw these

THE PAIGE COMPOSITOR.

FIGURE 1.3

palimpsests as tired contrivances. "The conceit of taking a Yankee of this generation of telephones and the electric light back to King Arthur's Court may please some minds, if presented in a story of moderate length," the *Boston Literary World* noted, "but there can be few who will really enjoy it when long-drawn out to the extent of nearly six hundred pages."[51] "No doubt there is *one* element of wit—incongruity—in bringing a Yankee from Connecticut face to face with feudal knights," wrote the *London Daily Telegraph*, "but sharp contrast between vulgar facts and antique ideas is not the only thing necessary for humor." Twain's take on the "alienated interaction between past and present" at the heart of capitalist production thus seemed strangely out of synch with the author's own present.[52] His time-travel device was already a gimmick—a compromised form for which the funnily unfunny, all-too contemporaneously noncontemporaneous humor of the Humorist comes to serve as an inadvertent mise en abyme.

At the same time, much in the spirit of P. T. Barnum's exhibitions, which as Harris argues deliberately invited audience suspicion in order to activate the pleasures of judgment, *Connecticut Yankee* puts the capitalist

gimmick as aesthetic trickery on self-conscious display. Hank's series of "effects" ostensibly showcases his historical advantage as the novel's officially designated contemporary.[53] But so much so, James Cox points out, that as novel moves forward and the "effects" of the "compulsive showman" accumulate, the target of Twain's satire becomes increasingly unclear and, with a remarkable "waste of energy," the narrative disintegrates into a "mere sequence" of gags (or anachronisms).[54] The plot manages to obtain closure out from this bad infinity only through the gimmickiest of literary devices: the deus ex machina of Merlin's powers of magic, ineffectual for the majority of the novel but now suddenly revived and inexplicably effective at restoring Hank neatly back to the nineteenth century. At the same time, commentators repeatedly describe the novel's form as machinelike, a description that counterbalances Twain's all-too subjective assertion of authorial will (via Merlin) and in a way that testifies further to *Connecticut Yankee*'s overarching identification with the unsuccessful, promise-breaking capitalist "contraption." The novel is said to lean overheavily on "a fairly mechanical proliferation of burlesque 'contrasts'"; on "stock devices" and "clichés of travelogue nostalgia" that become "mere parts of the machinery of this mechanical novel"; and on a protagonist "more mechanical than any of the gadgets in which he specializes, [who] grinds laboriously through his 'acts,' his only means of attracting attention being to run faster and faster, to do bigger and bigger things, until the mechanism of his character flies apart."[55]

Both the obtrusive surge of authorial subjectivity, tellingly coinciding with the revival of magic in the diegesis, and the all-too mechanical literary contrivance are gimmicks that simultaneously constitute and undercut the novel's comedy. Not surprisingly, the novel seems only halfheartedly committed to the illumination of capitalist procedure in spite of it being repeatedly pointed up in the discourse. We are told that "at the great arms factory," Hank Morgan "learned to make everything; guns, revolvers, cannon, boilers, engines, all sorts of labor-saving machinery," as well as how to become "head superintendent" of a "couple of thousand men." Hank brags: "Why, I could make anything a body wanted—anything in the world, it didn't make a difference what; and if there wasn't any quick new-fangled way to make a thing, I could invent one—and do it as easy as rolling off a log."[56] Yet as Henry Nash Smith reminds us, Hank "actually performs no constructive feat except the restoration of the holy well; and it will be recalled that the technology in this episode does not go into repairing the well, but into the fraudulent display of fireworks with

71

which he awes the populace."[57] Twain's novel never delivers on the operational aesthetic to which it initially seems so enthusiastically to subscribe.

This brings us to one final contradiction. On the one hand, the gimmick seems to make certain capitalist operations transparent, in a not entirely pleasurable way. On the other hand, something about it seems to make these operations obscure. In "The Glory Machine" the device exposes its own process of action, laying bare how it achieves its intended effect. In *Connecticut Yankee*, however, the gimmick takes the form of the engineer's black box: an opaque input/output structure actors can implement without knowledge of its internal workings.

We can now add this to the list of the gimmick's other antinomies—contrary propositions that are equally true—that together go a long way toward explaining the obtrusiveness of the aesthetic form and peculiarly intense form of irritation it elicits:

The gimmick saves us labor.
The gimmick does not save labor (in fact, it intensifies or even eliminates it).

The gimmick is a device that strikes us as working too hard.
The gimmick is a device that strikes us as working too little.

The gimmick is outdated, backwards.
The gimmick is newfangled, futuristic.

The gimmick is a dynamic event.
The gimmick is a static thing.

The gimmick is an unrepeatable "one-time invention" (Jameson's singularity)
The gimmick is a device used "hundreds and thousands and millions and billions of times" (Twain's joke).

The gimmick makes something about capitalist production transparent.
The gimmick makes something about capitalist production obscure.

These antinomies are about labor, time, and value—elements capitalism makes impossible to separate. To single out one is necessarily to invoke the others, which is what sets the features of the gimmick in such tight relation.[58] As it shuttles between the poles of each pair of conflicting yet

partially true observations, the gimmick points to a "situation which encompasses the opposed terms but which neither side can grasp on its own," or to which "we can only allude . . . in the oscillation itself." Drawing on the work of Kojin Karatani, Michael Wayne refers to this as a "parallax," a "shuttling between perspectives that cannot be synthesized."[59] In this manner, the gimmick's defining features index the fundamental contradictions of capitalism: proliferation of labor-saving devices in tandem with an intensification of human labor in the immediate production process; increase of labor productivity in tandem with lesser availability of secure work; planned obsolescence and routinized innovation; overproduction of commodities in conjunction with the creation of "surplus populations" unable to buy goods. It is the parallax between the aesthetic and economic overall that obtrudes in our everyday experience of the gimmick, which more than any other capitalist aesthetic experience demands that we "hold multiple registers of value in sight at once."[60]

There is yet another way in which the gimmick demands this: in seeming "cheap" even when it looks (or is) expensive. Here the economic concept designates the spectator's sense of a specifically *aesthetical* fraudulence, in which value is judged as not being what or where we expect it to be. We thus arrive at a feature that for all its simplicity distinguishes the gimmick from other capitalist aesthetic categories like "cute" or "cool": the way in which its judgment of aesthetic worth aligns with a judgment of economic worth. The cheap commodity is one whose cost of production is low. What the gimmick brings out is how this *ostensively neutral* idea of a low production cost, like that of the reduced labor so frequently underlying it, becomes inextricable from connotations of illegitimacy and deception in capitalist culture. Brown's meditation on the labor and time-saving devices of comedy in *Words in Our Time* thus fittingly ends with him noting the derivation of "gimmick" from "gimcrack," an initially neutral description of the inlay work of a craftsman which eventually flips into a synonym for the cheap and the fake with the development of mechanized methods of production.[61]

Under conditions in which the production of value entails the appropriation of surplus value and surplus labor, the promises of saved time and work made and broken by the capitalist gimmick are also promises made and broken about value refracted across "multiple registers." The economic measurement of cheapness—already in an interestingly gray zone between the qualitative and quantitative—is thus embedded inside the aesthetic judgment of the gimmick in an odd way worth underscoring.

For as we all know, aesthetic evaluations typically sit at a vast distance from economic ones, even in the case of a commodity aesthetic like cute (which does not call up anything so explicit like a price or cost). The beautiful with its spiritual claims relies especially on seeming radically disconnected from a sphere in which value must be expressed in/as money. By contrast, one cannot think or even perceive a gimmick without a judgment of cheapness immediately attending that perception; that is, without a gestalt of a commodity's cost of production based on a rapid synthesis of sensory and cognitive cues (materials, design, location of manufacture, skills, and price of the labor most likely involved).[62] Typically polarized registers of value converge in this appraisal.[63] However obliquely, nothing seems less likely to factor into our aesthetic experience than a production cost! Yet our everyday spontaneous judgment of things as gimmicky and implicitly cheap involves precisely this qualitative relation *to* the quantitative, linking a world of judgments based on feelings to a world of values necessarily expressed as money after being created in production and realized in exchange. The gimmick, like the concept of cheap at its center, is in this sense a catachresis, involving an illogical, if also ordinary, reevaluation of value defined in one universe in terms of value defined in another.

We have already seen comedy regarded as fundamentally about evaluation: an art of judgment on judgments and of the contemporary in particular. Some theorists suggest that comedy more specifically turns on the minimization of claims to value: on a "strained expectation suddenly reduced to nothing," as Immanuel Kant argues, anticipating Lipps and Freud;[64] or, for William Hazlitt, on a pleasure we take in disappointment, which becomes possible when the object that disappoints us is suddenly revealed to be a "trifle."[65] Elder Olson makes this argument most explicitly. If tragedy involves the belated bestowal of worth on the right objects, comedy involves a timely devaluation of overvalued goods, not unlike periodic crises that reset the relation of prices to values. And if tragedy bestows value in part through *katharsis*, the characteristic technique of comedy is by contrast *katastasis*, which Olson describes as a "special kind of relaxation of concern." This "annihilation of the concern itself" happens not through the displacement of one emotion by another, "not by the substitution for desire of its opposite, aversion, [or] of fear . . . by the contrary emotion of hope," but rather through a rational process of "conver[ting] the grounds of concern into absolutely nothing."[66] Such minimization or reduction by reason, however, often involves fairly

elaborate affective-aesthetic procedures. It can sometimes take up the length of an entire novel, as we are now about to see.

Guné ex machina

Helen DeWitt's *Lightning Rods* (2011) is a comedy about Joe, a white male heterosexual American personification of capital, and his gimmick. While masturbating to his favorite sexual fantasy—a woman visually "divided in half" does office work in front of others as if nothing unusual is happening while being fucked by a man from behind—Joe comes up with the perfect idea for increasing the profits and protecting the assets of American corporations (12). The key lies in enhancing the productivity of a select group of "high-performing" heterosexual male employees while simultaneously indemnifying firms against the risk of sexual harassment lawsuits from their female coworkers. How exactly does this all transpire? Showing us in a way that highlights "information and technique" is what makes for the novel's procedural comedy. We are thus taken carefully through the steps by which Joe turns his idée fixe into a device and then service around which he in turn builds a firm and then a vast corporation. His first step, the device, consists of a metal contraption transporting the anonymous "naked bottom half" of a woman through a hidden door into a bathroom stall for the male user to fuck, discreetly retreating back through the same door after the conclusion of his purgative act.[67]

The productivity-enhancing, profit-guarding device at the heart of the novel's larger story of capitalist *poesis* is a *guné ex machina*. But the Lightning Rod is not only a machine. Founded on a classic principle of repressive desublimation—dispensing sex at work to desexualize and increase the efficiency of work—it is also a service, embedded in a temp agency also called Lightning Rods that initially serves as its front but which eventually becomes openly coextensive with its backend operations. The complex Rube Goldberg of a commodity comprised of these interlocking parts (female body, machine, sex service, temp agency) enables the firms in the story to provide straight male employees with a hygienic way to get rid of distracting sexual tensions, increasing the productivity of this core of permanent workers while conveniently reducing risks of sexual harassment litigation on the side (reducing actual sexual harassment comes only as an afterthought).[68]

The novel's productivity-enhancing gimmick, a woman embedded in a machine embedded in a sex service embedded in a temp agency, is thus

finally a product for protecting firms against employee-related liabilities—
and by implication, from what the novel depicts as the ultimate employee-
related liability that is simply *a full-time employee*. Used to justify layoffs
even at times of high profits, we see this "liability theory of labor," of the
employee as a drain on rather than a creator of value and thus an inherent
risk to her or his employer's financial well-being, reflected in DeWitt's extra
comic flourish of making all of her novel's characters either sexual ha-
rassment litigants or litigators in waiting.[69] By the end of the novel, through
nothing other than the initial advantage gained by Joe's "bifunctional per-
sonnel" gimmick and the basic laws of capitalist competition, Lightning
Rods has evolved into the largest company in the global temp industry. Its
superior position has moreover enabled it to revolutionize temping by
compelling all its competitors to adopt its innovation, which eventually
becomes the industrial status quo.

In the spirit of the novel's operational aesthetic, or explicit invitation
to us to take pleasure in analyzing cause and effect, how exactly does the
sex business that is Lightning Rods come to be embedded in and eventu-
ally isomorphic with a temp agency? As Joe makes clear in his spiel to
both his prospective male clients and prospective female employees, the
distinguishing feature of Lightning Rods is that it keeps identities (rela-
tively) anonymous:

> A notification would appear on a participant's computer screen. It
> would be entirely up to the participants whether they took action
> or not. Administrators of the program would have no information
> as to uptake on the part of individuals. Participation or non-
> participation would be entirely confidential. . . . Should the par-
> ticipant choose to avail himself of the opportunity, he could either
> accept immediately or select the LATER option on the menu, in
> which case he would be allowed to either specify a later time, or
> simply wait until a convenient moment occurred and then click on
> the I'M READY NOW icon. (67–68)

Male employees might suspect some of their female coworkers are side-
lining as Lightning Rods but will never know for sure (a uniform of PVC
tights slit at the crotch, an innovation introduced by Lucille, ensures that
the one or two token Lightning Rods of color can remain anonymous,
too).[70] Lightning Rods will know some of their male coworkers are using
the service but never the specific individuals. (Left out of the loop entirely
are the female employees who are not Lightning Rods—a slot logically

implied in the story but occupied by characters barely mentioned in the diegesis and fewer and fewer as the story and Joe's product concomitantly develop.) This ambiguity implicitly turns *all female workers* in workplaces using Joe's invention—and it is key that the novel ends with every workplace adopting a version of it—into *possible* sex workers. And it is the need to maintain this perpetual ambiguity (the essence of the product is "is she or isn't she?") that provides Joe with his rationale for convincing corporate clients to outsource all their temporary hiring exclusively to Lightning Rods:

> Now it was Joe's belief that in the long run a company that wanted to include lightning rods in its team for the twenty-first century had only one option: to outsource all personnel recruitment. Otherwise how are you going to guarantee anonymity? If you just outsource the lightning rods somebody in the company is going to know which employees are handled by personnel and which are handled by an outside firm, and if that person happens to know why the outside firm was taken on that person is going to be able to identify the members of staff who are providing an extra service for the company. The thing was, though, that there was no way in the world that he was going to persuade a company to hand over its entire personnel operations to an outsider. The actual service he was providing was radical enough without challenging received opinion on personnel. The important thing is not necessarily to persuade someone straight off the bat to do something in some totally different way; the important thing is that you need to be aware of what your ultimate aim is. What Joe did, anyway, was he left the whole question of personnel strictly out of bounds. He simply explained that, given the importance of anonymity, his company would have to handle all temporary personnel requirements. Some of the temps provided would be lightning rods; some would not. At the end of a six-month period they would review the success of the program. (58)

All Lightning Rods must be temps, which means that when Joe's innovation becomes the standard all temp agencies adopt, all temps become possible Lightning Rods. This is the moment when "bifunctional personnel" both ceases to be a gimmick (an isolated contraption of a crackpot inventor) and also truly becomes one (an endlessly repeated overfamiliar device).

The gimmick of DeWitt's comedy is the Lightning Rod, which is also capital's gimmick. This labor-saving device is a sex worker whose reverse image is that of the *permanent temp*, whose paradoxical synthesis of perpetuity and transience echoes the gimmick's temporal contradictions. It is a synthesis perfected in the bizarre-sounding but entirely nonfictitious concept of "in-house outsourcing," in which workers are staffed through a temp agency discreetly *embedded inside the company* for which such permanent nonemployees are *specifically* trained to work (as in Warwick University's Unitemps and Bank of America's B&A Temps).[71] In this shift staged from seemingly exotic contraption to ordinary contemporary labor practice, DeWitt's novel produces a comically elevating deflation akin to that of "The Glory Machine." But there is a sense in which DeWitt's anatomy of the gimmick downshifts things further, suggesting that, at bottom, capitalism's ultimate labor-saving device is just simply a woman (Fig. 1.4).

The feminization of labor and the becoming contingent of labor: Which is the presupposition, and which is the result? In a world in which all Lightning Rods *must* be female and *must* be temps and in which *all* employers use Lightning Rods (in an interesting turn of events, the US government becomes Joe's biggest client), the positions of temp and woman structurally coincide. And of course this diegetic situation is not fantastic but points to a familiar truth: still the world's largest reserve army of labor, women continue to be, as they historically have been due to the gendering and subsequent devaluation of specific activities (the two faces of reproductive labor: housework and sex work), capital's most popular and longstanding profit-protecting device—permanently transient, cheaper labor used to further cheapen labor in general. It is worthwhile to note Zupančič on comedy's reliance on the surprising absence of surprise, which echoes arguments by Feibleman and Olson on its function of corrective devaluation:

> [Comedy] likes to unveil the veils, tear down the folding screens, and open the closets. Yet it does not usually claim directly that there is nothing behind. Rather the contrary: behind the veil there is always a naked bottom, behind the folding screen a scantily clad lady. . . . We could even say that in comedy, there is always something behind. Yet the comic point is that what is behind is—Surprise, surprise!—nothing but what we would expect (from the surface of things). (O, 209)

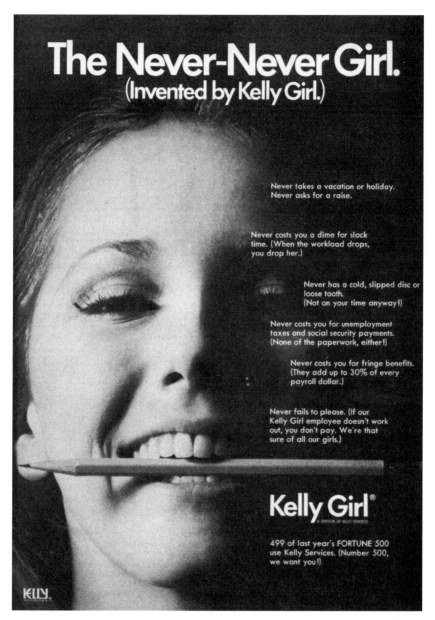

FIGURE 1.4

Comic art here is not so much defamiliarization as a kind of funnily irritating refamiliarization, constantly surprising us with things we already roughly expect. We see this principle worked out to the fullest in DeWitt's story of capital/Joe, whose gimmick of "bifunctional personnel" simply literalizes the temp industry's efforts at midcentury to recruit workers to temping and sell temping to businesses by explicitly feminizing and eroticizing temporary work. Such eroticization, as we learn from Erin Hatton's history of the industry, did not preclude comparisons of female temps to labor-saving household appliances ("Turn her loose on temporary workloads of any kind and watch the work disappear") nor to office equipment, as in the case of one 1970 Manpower ad featuring a female typist inside a packing box.[72]

In laying bare the operations of a labor-saving gimmick that converts half the working population into nonproductive and permanently contingent labor (that is, sex workers and temps), DeWitt's comedy is significantly telling a story about the *standardization*, not the innovation, of a capitalist technology. This focus makes her story of Joe stand out among other narratives about male American inventors on which it clearly also riffs.[73] Amplifying this theme of normalization is the strikingly homogenous free indirect discourse in which the entire process is relayed. Here, due to the diegetic dominance of the verbal gimmick as medium of expression and thought (whether as slogan, platitude, maxim, jingle, or catchphrase), the style and tone of narration stays remarkably consistent regardless of which character's subjectivity inflects it. The converging dictions of self-help and corporate management philosophy and the modular forms in which both are dispensed shape the rhythms of thinking and feeling in *Lightning Rods* to such a degree that all points of view seem to converge as well.

Thus evoking a world in which there seems to be a chronic deficit of language, the same stock phrases endlessly circulate among Joe, Steve, Mike, Ray, Al, Ed, Louise, Elaine, Renée, and Lucille,[74] as if, strapped together into something like the gag film's "connection device," they unknowingly constituted a single creature. DeWitt thus makes use of the language shared by pop psychology and business bibles as a sign of collectivity and alienation at once, pointing to a world in which, in spite of a heightened awareness of social differences in the workplace and their methodical functionalization by capital, every person—male or female, employer or employee, Lightning Rod or client, African-American or white—talks and thinks in exactly the same modular forms and in the same limited

repertoire of ways. These include addressing an ambiguous "you," as it oscillates between direct address and impersonal pronoun ("You're going to run into aggro whatever you do, so you might as well get paid for it" [Elaine]; "Suppose someone offered you the chance to go to Harvard Law School, and all you had to do was pick up a turd a couple of times a day, wearing plastic gloves, on top of your regular job" [Renée]); making generalizations from the perspective of "people" ("This is the kind of thing people want to hear from a role model" [Lucille]); and isolating the dominant traits of a type of person (*LR*, 130, 176, 157). Famously central to comedy, which "puts aside all subtleties of a situation or character, ignoring their psychological depths and motives, reducing them all to a few 'unary traits,' which it then plays with and repeats indefinitely" (*O*, 176), this last way of thinking and speaking predominates in the novel and is significantly tied to occupation: "*If you're in accounting*, it's your job to be skeptical, and that's not something you can just turn off" [Mike]; "*a salesman* has to see people as they are" [Joe]; "'*we're businessmen*, Al. . . . At the end of day, we've got to be realistic. We've got to deal with people the way they are, not the way we might like them to be'" [Steve] (*LR*, 76, 21, 100). DeWitt's doubling-down on the verbal gimmick thus does more than affect the novel at the level at which this experiment is deployed (that is, its discourse). It also affects the novel's character system. Because all characters speak and think in the exact same way, even as their social differences matter enormously to the comedy's plot (first as obstacles for Joe/capital to overcome, then as opportunities for him to harness), we get the impression of more than just a set of characters who are either personifications of capital or labor. As if to underscore the power of production as a socially binding activity, but one in which this sociality is created "behind the backs" of its agents, we get the impression of DeWitt's novel having *only one character* distributed across a multiplicity of nodes.[75]

In *Lightning Rods*, as in actual capitalism, the enhancement of productivity through labor-saving devices both presupposes and reinforces the permanence of temporary labor. And the link between higher levels of productivity and greater contingency of labor presupposes and reinforces contingent labor's articulation with *female* labor. A woman, we are not allowed to forget, lies in the core of the elaborate (or is it simple?) capitalist apparatus DeWitt's novel comically dissects for us. The innermost joke of *Lightning Rods* is thus one about the ambiguous temporality of capitalist development. At the beginning of the novel, female sex work implies or requires temping; by the end, female temping implies or requires

sex work. If this X suggests a fundamental stillness at the heart of capitalism's dynamism (and in a way that might explain why the novel's exact historical moment is so hard to pin down), DeWitt's implication is that regardless of the stage of technological progress, capitalism's main productivity-enhancing device remains what it has always been: contingent-because-feminized, feminized-because-contingent labor.[76]

Labor, time, and value: the contradictions that explain why the gimmick simultaneously irks and attracts us explain why it permeates virtually every aspect of capitalist life. With this in mind, let us conclude by noting one of the final touches in DeWitt's comic anatomy of the form. Even when Joe's productivity-enhancing innovation becomes standard for all workplaces, intercapitalist competition obliges him to continue innovating, differentiating his now generic product with some special feature. So Joe comes up with one last B2B gimmick. It is a service designed for companies who must continue using "bifunctional personnel" while wanting the edge that comes from cornering smaller client niches: in this case, religious conservatives. The hope for a new market capture thus lies in creating a fresh corporate subjectivity that will specifically appeal to this demographic: the family-friendly corporation, highlighting "traditional values" in their hiring and business practices. This calls for a product capable of *eliminating* Joe's efficiency-increasing gimmick from the workplace, where it has become so universal as to be undetectable, infiltrating the entire system of production. Joe's final innovation is thus a service enabling the new "family values" corporations to advertise that their workforces will be "100% Lightning Rod free": even when still composed, as they and their competitors must remain composed, of a permanent ring of contingent labor. What is this new specialized service? A regular old-fashioned temp agency. Offered exclusively as a product of Lightning Rods Corporation.

The gimmick is such a socially diffused, all-encompassing capitalist phenomenon, DeWitt's comedy of procedure suggests, that its form encircles even this antigimmick: capital's ability to turn the ultimate labor-saving device—a synthesis of the contingent and reproductive worker—into its finally desexualized but still gendered and contradictory antithesis.

Transparency and Magic in the Gimmick as Technique

When we say a work of art is gimmicky, we mean we see through it— that there is an uninvited transparency about how it is producing what we take to be its intended effect. This strikingly reverses Viktor Shklovsky's concept of "art as technique," in which exposure of how a work achieves its purpose is regarded as salutarily countering the "over-automatization" or "algebraization" of aesthetic response.[1] For Shklovsky, making technique transparent is a strategy for slowing down a perception inauspiciously sped-up by modern industrialization, resulting in a lamentable tendency to reduce artworks to "symbols" or "formula[s]" for "greatest economy of perceptive effort."[2]

Our encounter with the capitalist gimmick, however, is one in which we find this countertechnique of exposing technique ineffective. Perhaps this is because we no longer believe, as Michael Holquist and Ilya Kliger suggest, that defamiliarization or "estrangement" (*ostranenie*), whose "fundamental mechanism . . . is decontextualization," can get us back to the pre-alienated essence of things.[3] In any case, our experience / judgment of the gimmick in artworks turns on aesthetic doubt about the very strategy of "laying bare the device" and thus about Shklovsky's favorite technique for producing "estrangement." We rather say the work exposing its methods feels contrived: a pejorative term for "aesthetically unconvincing" but also an impartial one for the condition of simply having been made with purposive thought and design.

"Contrived" means gimmicky, but can also mean *engineered*. "Engineered" in turn can neutrally mean *produced*, or in a more evaluatively

tinged way, *manufactured*, if not always the full-blown depreciation *gimmicky*. The manufactured, contrived, or gimmicky artwork—note how this spectrum of terms hints at ambivalence about an entire mode of production—is thus an unstable object shifting between the dissatisfying and the innocuous. It confronts us with an artifact that would seem to undermine rather than enhance its aesthetic power by drawing attention to its process of coming into being—or to itself as a departure from, in a labor to realize, an initiating idea.

The goal of this chapter is modest: to track, across the writings of disparate, mostly non-Marxist thinkers, a latent theorization of the gimmick adjoining the Marxist one in this book. Its archive will enable us to think further about the gimmick as a conjunction of transparency and opacity, and about what is at stake when we perceive it as a technique for generating enchantment. Both questions come to the fore in Chapter 3, for which what follows might also serve as a freestanding prologue.

Techniques of Enchantment

In addition to an idea and a thingly device, the gimmick is a technique: a practical strategy for realizing a specific goal. It is also a judgment registering dissatisfaction with technique. Yet the fact that "gimmick" marks technique's coinciding with its own negative evaluation is not as paradoxical as it seems. For techniques flip into problematic gimmicks (and vice versa) with remarkable ease in artworks made, circulated, and consumed in capitalism. They sometimes do so simply by becoming visible as techniques, as tends especially to happen in artworks that make claims to being advanced.

There are also cases in which an artifact compels fascination even while everything about its procedures is familiar or laid bare. Just as "astonishment and surprise were not always the key attractions of magic shows," as Simon During writes, gimmicks maintain enigma even though self-exposure is essential to their form.[4] There is something mysterious about the routines of the stage magician, as contemporary artist Stan Douglas brings out in his faux portraits of "midcentury" illusionists, even when we know exactly what their props and gestures are for and perhaps even how they work (Fig. 2.1).

The gimmick thus points to how two features frequently conflated in aesthetic theory—enigma and perceptual novelty—are not in fact the same. As demonstrated by the films, buildings and music we rewatch,

84

FIGURE 2.1

revisit, and rehear, or even the magic trick that still delightfully stumps us even though we've seen it a million times, artworks can remain beguiling when they are no longer surprising. It is telling here that in *Aesthetic Theory*'s discussion of what Adorno calls art's "enigmaticalness"—its *Rätselcharakter*—he links this quality not to the lofty mysteries of the "ultimate" but to what is "absurd." The enigma with which art specifically confronts us, in other words, is less like a theological mystery and more like the everyday allure of the "newspaper picture puzzle."[5] It is not the enigma of art's beauty but of its "clownishness" and "ridiculousness" and thus captured best in children's chants and riddles rather than, say, Wagner's *Ring* (to reuse Adorno's own examples).[6] In other words, if the "cliché about the magic of art has something true about it," as Adorno says in *Aesthetic Theory*'s section on the "dialectic between mimesis and rationality [i.e., nonconceptual and conceptual thinking] immanent to art," the "magic" involved seems closer to that of a stage magician than any supernatural force.[7] One can thus trace a link between the Rätselcharakter of the artwork and the equivocal charm of the gimmick, which compels fascination in spite of its transparency.

To elucidate the relation between technique and aesthetic effect (including where this overlaps with ideological effect), or track the movement from one to the other, is therefore by no means to divest the work of enchantment. "There is an old opinion that with respect to works of art explanation is itself derogatory, as if to come up with an account of these works were to diminish our experience of them," as I. A. Richards put it.[8] As Nelson Goodman similarly notes in *Languages of Art*—and interestingly, during his discussion of artistic fakes—knowledge about a work not only enhances one's nonaesthetic relation to the work (one's forensic or historical understanding of it, for example); it affects and expands the way in which one perceives the work and thus our aesthetic experience as well.[9] This is also Adorno's position in *Aesthetic Theory*, where, for all the thinker's famous distrust of "ends-means rationality," his specific example of knowledge enhancing our specifically aesthetic relation to artworks is "technique": "Experience unfolds all the more richly the more deeply consciousness penetrates the artwork's technical complexion. Understanding grows along with an understanding of the technical treatment of the work. That consciousness kills is a nursery tale; only false consciousness is fatal."[10]

Gimmicks and criticism thus have something in common, as exemplified best when we consider Poe's "The Raven" alongside his cheerful

dissection of its contrivances in "The Philosophy of Composition," disclosing "the wheels and pinions—the tackle for scene-shifting—the stepladders and demon-traps—the cock's feathers, the red paint and the black patches, which, in 99 cases out of the 100, constitute the properties of the literary *histrio*."[11] Both hinge on the idea that the work explicitly inviting analysis into how its effects were produced remains capable, even after the fact of that analysis, of inciting curiosity and pleasure.

Techniques conjoined to affectively spontaneous evaluations of technique, gimmicks emerge at the intersection of "calculation and enchantment."[12] This was also, as we have learned from Neil Harris, an achievement of the "operational aesthetic" at work in the cultural productions of P. T. Barnum and other nineteenth-century showmen, who gleefully exposed their methods of aesthetic manipulation in order to stimulate their audience's capacity for pleasure in "information and technique":

> Barnum, Poe . . . and other hoaxers didn't fear public suspicion; they invited it. They understood, most particularly Barnum understood, that the opportunity to debate the *issue* of falsity, to discover how deception had been practiced, was even more exciting than the discovery of fraud itself. The manipulation of a prank, after all, was as interesting a technique in its own right as the presentation of genuine curiosities. Therefore, when people paid to see frauds, thinking they were true, they paid again to see how the frauds were committed. Barnum reprinted his own ticket-seller's analysis: "First he humbugs them, and then they pay to hear how he did it. I believe if he should swindle a man out of twenty dollars, the man would give a quarter to hear him tell about it."

The "opportunity to debate the *issue* of falsity, to discover how deception had been practiced, was even more exciting than the discovery of fraud itself."[13] Delight in judgment, its sociability, and unique way of moving us from spontaneous feeling to cognition, thus explains why the "experience of deceit was enjoyable even after the hoax had been penetrated" (Fig. 2.2). Hence while postcritical theory tends to associate suspicion with unhappily self-aggrandizing affects only (paranoia, aggression, pride), *Humbug* reminds us that it can be an occasion for humor. Just as it generally feels good, if in a way people no longer notice, to link perceptions to concepts, as Kant argues in his introduction to *The Critique of Judgment*—a text in which the pleasure of aesthetic experience, initially presented as special, is eventually and somewhat surprisingly revealed as that of cognition in

FIGURE 2.2

general—the judgment of the gimmick promotes a discursive intersubjectivity that can be enjoyed.[14]

Creators of both mysterious tales and riveting demystifications, Poe and Barnum highlight the interplay of hermeticism and accessibility at the heart of the gimmick. Art historian Jeffrey Weiss points to a similar dynamic as root of the "aesthetic disorientation" of French culture in the early twentieth century.[15] This disorientation or anxiety, a "kind of collective consciousness . . . of ambivalence," was primarily expressed in *blague*, a deadpan pranking practiced by both commercial culture-makers and artists like Duchamp. As Weiss puts it, "bad faith, abuse of confidence, and suspicions of hoax" were "a given of period experience" as well as "pervasive conditions of avant-gardism."[16] From humorist Alphonse Allais's 1897 composition of a silent work of music in twenty-four noteless measures, *Funeral March for the Obsequies of a Great Deaf Man*, to Henri Meilhac and Ludovic Halévy's boulevard comedy *La Cigale* (1877), featuring a painter offering unpainted canvases as representations of fog, the "proto-dada quality of late nineteenth century humor" suggested a "meta-phenomenon of instability in aesthetic life" that John Roberts ties to broader anxieties about artistic deskilling, anticipating future debates about the economic equivocality of artistic labor.[17]

In a rapidly industrializing society, this uncertainty about technical competence, and its way of indexing a widening rift between idea and execution, or even capital and labor, made the "new intellectualism" in French painting an "easy [and popular] mark."[18] Take the following "Echos" item, announcing "Une Nouvelle Ecole," in an October 1912 issue of the daily *Paris-Midi*:

> The Spanish painter "Fricasso," it appears, has decided to replace fugitive pigment with chemical and mathematical formulas, which he will inscribe on canvas. Next year, the anonymous critic promises, we can expect to see "in the *salle d'honneur* of the Salon d'Automne, magnificently framed white canvases on which formulas, written with care, will replace colors and forms. . . . The imagination of the visitors will do the rest.[19]

Yet the French avant-garde also came into own by parodying avant-gardism, Weiss stresses. Duchamp's first unassisted readymade, *Fountain* (1917), preceded by his performative "strike" or temporary abstention from painting in 1912, was thus a rejoinder to Cubism's outmoded fetishization of craft, as well as a way of acknowledging, by *internalizing*,

commercial culture's suspicions about artistic fraudulence. Both the "strike" and *Fountain* were in other words "prank[s] . . . almost overdetermined by the situation at hand"; "deadpan [answers] to [both] overproduction and avant-gardism—the congestion of words and paint, of craft, theory, *nouveauté* and *réclame*"; "gag[s] that [cut] . . . both conventional and avant-garde expectations of what art should be."[20] Together they show how the judgment of gimmick was not simply a weapon of popular culture against the swindles of avant-gardism but a form of skepticism that the avant-garde could make productively central to its own practices, reclaiming the popular suspicion of artistic swindling (and the comedic forms used for its expression) as an artistic tool of its own.[21]

In tandem with art's growing interest in and identification with "formulas," both Duchamp and Poe thus flirted with or deliberately courted accusations of gimmickry. T. J. Clark explicitly links the two *blagueurs*, describing Duchamp as "the Edgar Allan Poe of the twentieth century."[22] When fellow art historian Benjamin Buchloh suggested that Clark's ambiguous comparison was made in reactionary defense of a "traditionalist humanist" aesthetic epitomized in Picasso, tied to an older model of artisanal production and its values of craft and expressive authorship, he raised a criticism which no discussion of the gimmick in modernism can avoid addressing. With and after modernism, specifically, the invocation of doubts about artistic value and labor for which "gimmick" becomes shorthand seems inevitable.

Faced, then, with the "aren't you just an aesthetic conservative?" question, Clark doubles down on his use of Poe to insinuate Duchamp's equivocality. This happens in an open letter to Buchloh for a special issue of *October* titled "The Duchamp Effect" (1996) in which Clark attempts to clarify the point of his original comparison, as, indeed, contesting that Duchamp was the pure or unambiguous, uncompromised spirit of radical negation Buchloh and others want him to be. Because Clark's response goes straight to heart of the problem of the gimmick, the passage is worth quoting in full:

> Poe may or may not have been a good writer. Opinions differ, and maybe have to differ, violently. There will never be a middle-of-the-road evaluation of *The Raven* or *Tales of Mystery and Imagination*: not to be seized with the conviction either that they tell the appalling truth of the nineteenth century, or crank out its dreariest daydreams, is not, in my opinion, to have read them (productively)

at all. But that still leaves us with the fact, surely indisputable, that good or bad, *Poe was an instigation to work by others that lies at the heart of modernism*. We should not have had Baudelaire and Mallarmé—that is, we should not have had their particular (modernist) blend of pathos and extremism—without the cult of Poe in the first place. Of course, we should not have had a lot of Symbolist and sub-Symbolist trash as well. Or Wilkie Collins and Bram Stoker. But that is my point. Poe's being an endless instigator to nineteenth-century modernism seems exactly bound up with the question of whether he was a genius or a hack electing itself *as* the question, and never being settled by the court of history (or even of literature). And lest my point seem to be ending up almost comfortable, let me add: with the question of his influence being utterly benign or deeply malignant. It was both. [. . .] Stanley Cavell says somewhere that modernism in the arts is bound up with the "possibility of fraudulence." I would want to add: with fraudulence at key moments—*Purloined Letter* moments?—being obvious but for some reason impossible to detect. (225–26, my emphasis)

Fraudulence that is "obvious but for some reason impossible to detect." Transparent and yet still enigmatically opaque, the gimmick's aesthetic dubiousness is counterintuitively posited here as *generative* for modernism: "Poe's being an endless instigator to nineteenth-century modernism seems exactly bound up with the question of whether he was a genius or a hack."

The argument by Cavell to which Clark refers is from "Music Discomposed" (1965). Focusing as he is on other issues, Clark does not remark on a curious feature of that essay significant for our inquiry, which is the distinctive way in which Cavell defines "modernism": as a new structural intimacy between art and technique, resulting in the rise of an unprecedentedly *theory-driven art*.[23] It is art's excessive dependency on, or over-identification with both technique and theory, specifically, that makes the gimmick's suspicion of fraudulence central to modernism, and thus to the reception and ontology of all art in its wake.

Although usually remembered as a critique of advanced music, "Music Discomposed" is primarily about a crisis in criticism—stemming, in turn, from what Cavell perceives as music's overdependent relation to criticism.[24] This, we discover, is due to postwar music's absorption with the technical or compositional problems of its producers, which criticism ends up sharing as well: "A certain use of mathematical-logical descriptions of

tone-row occurrences is only the clearest case of these difficulties" (208). Yet as Cavell also makes clear, music criticism's increasing dominance by technical questions is in a sense unavoidable, since in the end, techniques in the arts do irreversibly advance. Rejecting the idea that it is only science that "progress[es], outmod[es], or summarize[s] its past," Cavell notes that "the succession of styles of art, though doubtless it will not simply constitute progress, nevertheless seems not to be mere succession either." As he puts it:

> Art critics and historians (not to mention artists) will often say that the art of one generation has "solved a problem" inherited from its parent generation; and it seems right to say that there is progress during *certain* stretches of art and with respect to certain developments within them (say the developments leading up to the establishment of sonata form, or to the control of perspective, or to the novel of the nineteenth century). Moreover, the succession of art styles is *irreversible*, which may be as important a component of the concept of progress as the component of superiority. And a new style [does not merely replace] an older one, it may change the significance of any earlier style; I do not think this is merely a matter of changing taste but a matter also of changing the *look*, as it were, of past art, changing the ways it can be described, outmoding some, bringing some to new light—one may even want to say, it can change what the past *is*, however against the grain that sounds. A generation or so ago, "Debussy" referred to music of a certain ethereal mood, satisfying a taste for refined sweetness or poignance; today it refers to solutions for avoiding tonality. (183–84)

Given "the *necessities* of the problems faced by artists, [and] *irreversibility* of the sequence of art styles," the technical focus of late twentieth-century music criticism is "hardly unusual, and it should go without saying that not all uses of such techniques are irrelevant, and that they represent an indispensable moment in coming to understand contemporary music" (210, 209; Cavell's italics).

The problem, therefore, is not that of criticism's preoccupation with technique or compositional methods per se but rather the creation of a bad loop in which the space between advanced music and criticism steadily diminishes. This in turn results in a situation in which one no longer knows how to respond to the music, because the discourse we turn to is responsible for the difficulty of the very artwork for which we seek help.

Criticism, in this situation, can no longer serve its historical function, which was originally set in place by the unmooring of artists from tradition. That unmooring, "from taste, from audience, from their own past achievement," made modern art reliant on the critic's judgments, including those of the "critic inside the artist," in a newly baseline and unproblematic way. As this initial intimacy intensifies to the point of overdependency, however, "the terms in which [artists] have learned to accept criticism will come to dictate the terms in which they will look for success: *apart from these, nothing will count as successful because nothing will be evaluable*" (208; my emphasis).

In short, when criticism is written entirely from the point of view of artists and their technical problems, it does not merely become dully technical; it ceases to be criticism, unable to exert judgment's pressure on art predefined by its terms. Art, meanwhile, can no longer be trusted, much less confidentially evaluated, since everyone knows it has been constructed to solve problems preset by the criticism, which is in turn destined to only affirm it. What results is a kind of inflation. For affirmation or praise can be the only response when art is entirely made as prescribed by theory, which has itself been reduced to finding solutions to technical problems involved in the production of art. The game is rigged—or just ruthlessly circular.

The aesthetic doubt we associate with the gimmick—a word unused in "Music Discomposed" but whose concept hovers over the entire text—thus arises at the site of a chiasmus: the intersection of criticism entirely absorbed by questions of technique, with art excessively driven by criticism. For Cavell, these problems are two sides of the same coin, giving rise to the fundamental suspicion of the artwork he refers to as the "modernist problematic":

> My impression is that serious composers have, and feel they have, all but lost their audience, and that the essential reason for this (apart, for example, from the economics and politics of getting performances) has to do with *crises in the internal, and apparently irreversible, developments within their own artistic procedures*. This is what I meant by "the burden of modernism": *the procedures* and problems it now seems necessary to composers to employ and confront to make a work of art at all *themselves insure* that their work will not be comprehensible to an audience. (187, emphasis mine)

The compulsory, "irreversible" development of *all* technique under conditions of capitalist production, artistic or value-productive, leads to a

temporally reversed relation between criticism and music. When criticism no longer comes "after the fact of art" but rather precedes it, both criticism and art change. Art becomes, we might say, fundamentally gimmick-prone: concern about fraudulence becomes essential to its ontology.[25] Criticism's role ironically transforms into "protect[ing] art against criticism," as evinced by the flood of "glosses" which Cavell claims become increasingly required for responding to late modernist and postmodernist artworks: "New theater is 'absurd'; new painting is 'action'; Pop Art exists "between life and art"; in serial music 'chance occurs by necessity'" (207). Criticism thus becomes at once newly empowered and weakened. On the one hand, it is now prior to art and the aesthetic encounter, logically shaping both in advance. On the other hand, it seems to do so only in the form of reified slogans.[26]

Although not explicitly brought out in Cavell's essay, post-atonal music's overclose relation to a belabored, excessively technical criticism points to a deeper uncertainty about the labor encoded in technically advanced artworks. If, with a "modernist problematic" first glimpsed as an illicit interchangeability in the functions of criticism and art, a fundamental distrust of all art is awakened, it is perhaps finally less a distrust awakened by "theory" per se than by a method of production generally required to internalize it, leading to increasingly rationalized procedures. At the same time, as evinced in the use of sampling, chance, and built-in surprises to offset its increasingly programmed nature, advanced music bears the mark of deskilled labor, which, as Roberts notes, Duchamp provocatively displayed conjoined to the artistic gesture in his unassisted readymades, staged sites of conflict between artistic and productive labor.[27] The gimmick-prone artwork overclosely identified with theory-saturated techniques thus implies a divided image of the artist as a simultaneously skilled and deskilled worker, which we will be revisiting in Chapter 3.

Corresponding to this image of the maker of the gimmick-prone artwork is the image of a similarly divided, ambivalent percipient. This aesthetic subject is an interesting figure. For while she will respond to the gimmick dysphorically, as a cheap, fraudulent, and compromised object, she will nonetheless find a strangely indirect way to take in its pleasures by delegating her enjoyment to others.[28] To see how this works we will need to pay closer attention to the gimmick as judgment, and through it, to the mode or style of aesthetic consumption projected by the relations of production encoded in its form.

Self-Bracketing Magic

Let us first recall the illusion perpetuated by all aesthetic judgments: spontaneous, feeling-based appraisals whose distinctive grammar generates the semblance of objective description. We are compelled to say "X is cute," as opposed to "I find X cute," even if the more subjective expression is a more accurate account of what is happening. As Jan Mieszkowski puts it, Kantian aesthetic judgment might look like a constative but is actually a performative and more specifically a *demand*: that everyone find X cute.[29]

Aesthetic judgments "sneak in" evaluation under the cover of description and thus come in a veiled form—one attempting to preempt, while in the very same gesture inviting, disagreement from other judges.[30] For in a way not immediately discernable from the judgment's meaning but rather its use, the rhetorical force of demanding points to the possibility of disagreement and even seems to provoke it. Why *demand* that everyone feel the way I do about X, with readiness to parry challenges implied, if there's no question of anyone *not* doing so? The assumption or even expectation of dissent seems primary. And why are the aesthetic pleasures or displeasures of other people, including strangers, so acutely felt as part of my own in the first place? Why should they enter into the way I relate to something as seemingly private and idiosyncratic as my pleasure or displeasure? What Kant's critique reveals as the deepest content of our aesthetic categories, the *sensus communis*—the attunement of judging subjects to one another, the sociality that is aesthetic experience's condition of possibility—is arrived at through a prior revelation of what Simon Critchley cleverly calls a *dissensus communis*.[31]

There is thus a prestidigitation in the speech act, "X is cute." On their surfaces, aesthetic judgments seem to be about objects they straightforwardly describe. Yet as thinkers ranging from Kant to Bourdieu show through widely disparate reasoning, at their deepest level aesthetic judgments are not about objects at all. As speech we are compelled to share or imagine ourselves sharing, at the risk of rebuff or even ridicule, they concern our relation to other judging subjects.[32] They "recall us to what is shared in our everyday practices," most often and vividly by first revealing what is *not* shared.[33]

All aesthetic judgments thus presuppose disagreement as the way in which their a priori intersubjectivity is revealed. Yet the gimmick stands out for the specific way in which it does so. Our judgment of something as gimmicky—as aesthetically unconvincing or unsuccessful, manufactured

or contrived—requires a concept of someone for whom the same object is convincing or successful and therefore *not* a gimmick. The judgment implies that while the subject who finds the aesthetic object gimmicky is not taken in by its promises, there exists another subject who is. This presupposition of a differently judging subject differs from the way that aesthetic judgments in general presuppose disagreement. I am not required to have a concept of a person who does not find my object cute in order for me to judge it cute. But to call something is a gimmick is to say: while this is something I am not persuaded by, enjoying, or buying, it is something enjoyed and bought by another. One must imagine or have tacitly presupposed a concept of this person who *is* persuaded, *is* enjoying, *is* buying into what the device promises, *in order to have a concept and experience of the gimmick as such.*

The judgment of something as a gimmick is thus a negation of its contradiction: an implicit refutation of another's assessment of it as a non-gimmick. This, like everything, may be related to invidious distinction, but is crucially not reducible to it. It is again not a feature common to all ambivalent judgments. One does not need to go through an initial step of negating the opposite of garish or interesting in order to have a concept of X *as* garish or interesting. The gimmick, however, is the negation of an aesthetic "positive" whose existence must be indirectly confirmed in the same judgment in order to make the moment of its negation meaningful. Ironically, the "positive" that the gimmick negates is describable only via negation. We have no distinct aesthetic term for that which is "not gimmicky," because in capitalism the device that is not a gimmick, that simply performs its function in an unremarkable way, is no longer an *aesthetic* object. It is just a device.

The judgment of the gimmick is thus marked by logical as well as affective ambivalence. The two are linked: if we are able to admire gimmicks while primarily despising them, it is because this judgment of aesthetic failure also implies success. Could this not be achieved through displacement, such that uncompromised enjoyment of the same object would always be taking place elsewhere, for others if not oneself? In this case, our aesthetic judgment would not merely refute conviction in the gimmick's claims to value. In a more complex maneuver, it would rather delegate that conviction to others. This in turn enables us to love the thing we hate: but indirectly, through a surrogate.

Our judgments of things as gimmicks thus not only presume disagreement in the way all aesthetic judgments do but in a way specific to what

Robert Pfaller calls "illusions without owners." For Pfaller, these illusions are ones that we must, by definition, attribute to someone other than ourselves, even as we continue acting in accordance with them. We read our horoscopes, erect Christmas trees, and wear special jerseys on game day, even when we "see through" these illusions, do not believe in them or think of them as "ours." Ownerless illusions are therefore "objective" illusions: systematically displaced to other agents and *in exactly this way* collectively realized.[34] As Pfaller writes, they are the "[specific] form in which illusions are able to exist in an enlightened society that considers itself beyond such illusions" (33): a form in which *belief no longer needs to take the form of conviction in order to be powerful or socially effective.*

Gimmicks like sitcom laugh tracks and "stupid plots" in porn films abound in Pfaller's examples, which fall into categories ranging from mindless entertainments to superstitious or compulsive actions.[35] "With illusions distanced by self-evident knowledge," writes Pfaller, "we often do not even notice *that we are dealing with an illusion*" (4). Here a subtle gap between the two phenomena emerges. Judging something a gimmick similarly involves knowledgeable distancing. But it is an experience in which we *do* notice we are dealing with an illusion: "seeing through it" while simultaneously recognizing its power for someone else. Including, quite possibly, ourselves at a different moment of time.

Pfaller points out that "knowing better" often increases the power of illusions without owners. Like fetishes, many are illusions that become possible for us to enjoy the first place, and that we continue to keep alive and circulate, precisely because we "know better." In a similar way, our intermingled skepticism and acknowledgement of the gimmick's aesthetic powers involves conflicting affects of contempt and admiration, which when combined have the effect of intensifying our fascination. It is a case of Freud's "strong" theory of ambivalence, as Pfaller notes, in which the copresence of negative and positive affects in our relation to an object does not result in psychic arithmetic. Our psyche does not "subtract" the lesser amount of one feeling (say, the negative) from the greater amount of the other, leaving us to experience the balance (as, say, weakly positive).[36] Rather, the copresence of positive and negative feelings increases the overall intensity of our affective attachment, which is why there is a link between the gimmick's aesthetic logic and the structure of addiction.[37]

Our judgment of the gimmick does not simply refute aesthetic belief or conviction but delegates it to other agents. Elsewhere Pfaller also refers to this expropriation of conviction as an act of "interpassive magic," or

"interpassivity," describing it as "the creation of a compromise between cultural interests and latent cultural aversion" (27). He cites Žižek on laugh tracks and Pascal on mechanical praying devices as examples. Here, external agents become "the ones who are moved for us . . . and who laugh [and pray] for us." Cultural enjoyment can thus be delegated not only to imaginary people but to physical things. Pfaller's own favorite example of interpassive magic, "'Do-It-All Artworks' that even include their own reception," supply ideal objects for ambivalent aesthetic subjects who not only lack any compunction against, but have a positive desire for, being "replaced by something that consumes in their place" (20). As he notes:

> [There] are artworks that already contain their own viewing and reception. And there are viewers who want it that way. [. . .] These are thus artworks and viewers who present us with exactly the opposite of what the theory of interactivity so persistently preaches. Whereas interactivity entails shifting a part of the artistic production ("activity") from the artwork to the viewer, here the opposite occurs: the viewing ("passivity") is shifted from the viewer to the artwork. I have decided to call this type of displacement "interpassivity." (17)

Prefigured in Greek tragedy's chorus commenting on the tragedy's events, "Do-It-All-Artworks" tend to be transparent about what they are doing. The desire for artworks that view and enjoy themselves would moreover seem to encourage the production of works in which work and commentary are conveniently rolled into one, like Villiers's "Glory Machine" from Chapter 1, churning out "Critical Articles" for plays in simultaneity with their performance on stage.[38]

If what Pfaller calls interpassivity is "an unobtrusive magic appearing in everyday civilized life," enabling those averse to its culture to express attraction, Simon During's *Modern Enchantments* reminds us that magic performances—in which gimmicks figure prominently—bring out this ambivalence as well.[39] During points this out in the course of arguing against the "compensation theory" of modern enchantment, in which "modern culture (which turns around fiction and spectacle)" is said to "[nourish] secular magic as a substitute for loss of supernatural presence," surrogating for the "eviction of God from the world."[40] Whereas for the ancient Greeks, belief and distance, like myth and logos, were not opposites but complements (as Paul Veyne argues), compensation theory cannot entertain the ambivalence underpinning Pfaller's ownerless illusions and interpassive devices, which point to a distinction between "cultures of

faith" and of (displaced) belief.[41] While in cultures of faith, beliefs are claimed as the individual's own, in the latter, convictions are delegated to others who supposedly really do believe, or "do" the believing for us mechanically. In both cases, surrogacy makes the belief socially efficacious, regardless of whether the stand-in is a human or a machine, a theoretical construct or empirically real.

What Pfaller, During, and our own theory of the gimmick are providing are thus examples of self-bracketing kinds of capitalist enchantment. As During points out, one of the main weaknesses of "compensation theory" is that it makes "it easy to forget that magic performances are not just spectacles that elicit wonder or amazement":

> Members of the audience are called on to choose under which cup the ball is now. They are also invited (at least implicitly) to unmask the trickwork: to figure out how a routine is really put together. Since audiences often succeed in figuring out a show's secrets and tricks, this discomforting success is part of the fun. Audiences are often invited to enjoy their own discomfort too: the humiliation of seeing one's watch (apparently) smashed to pieces or one's shirt (really) wafted from one's body can be part of the show. Finally, magic shows can be deliberately ridiculous. They are comic in the sense that they are often recognizably silly and openly trivial; like failed tricks, this can be funny too. In sum, entertainment-magic audiences seek experiences which are not merely surrogates for supernaturalism. They engage with performances through secular and heterogeneous skills and pleasures, most of which do not come anywhere near fulfilling the needs and aspirations satisfied by religion. (63–64)

What we seek from magic performances, During implies, is a way to distance ourselves from an illusion while enjoying it simultaneously. A way to make the illusion transparent *as* an illusion—exposing its process, its technique or its "trickwork"—without questioning its effectivity or ability to enchant.

"Halo-Effect of Technical Difficulty"

From Adorno on art's Rätselcharakter, to the enjoyable suspicions activated by Poe and Duchamp, to the remarkable inventory of examples gathered in *On the Pleasure Principle in Culture*, we have repeatedly seen how "there is a form of illusion that is not that of conviction" (Pfaller, 61).

Strangely weak and powerful at once, this form of self-bracketing enchant-ment returns us to the intersection of technique and magic in the capi-talist gimmick. It is the same intersection anthropologist Alfred Gell fore-grounds in his classic paper, "The Technology of Enchantment and the Enchantment of Technology" (1992), which I will offer as this chapter's last example of a proto-theorization of the gimmick, without its explicit naming:[42]

> The power of art objects stems from the technical processes they objectively embody; the *technology of enchantment* is founded on the *enchantment of technology*. The enchantment of technology is the power that technical processes have to casting a spell over us so that we see the real world in enchanted form. Art as a separate kind of technical activity, only carries further, through a kind of in-volution, the enchantment which is immanent in all kinds of tech-nical activity. (44)

We are specifically "enchanted" by art, Gell argues—as opposed to being, say, comforted, amused, or educated by it—in the same way as we are by other products of knowledge-informed production or processes of making.

In a section subtitled "The Halo-Effect of Technical Difficulty," Gell brings this point home with an anecdote describing how, when taken at the age of eleven to visit Salisbury Cathedral, the Early English Gothic marvel left no impression on him: "I do not remember it at all." What Gell does remember "very vividly," he tells us, is a "display which the cathe-dral authorities had placed in some dingy side-chapel, which consisted of a remarkable model of Salisbury Cathedral, about two feet high and ap-parently complete in every detail, made entirely out of matchsticks glued together." Confronted with this gimmick "functioning essentially as an ad-vertisement" for the real cathedral, Gell finds himself experiencing "feel-ings of the deepest awe":

> Wholly indifferent as I then was to the problems of cathedral upkeep, I could not but pay tribute to so much painstaking dexterity in objec-tified form. At one level, I had perfect insight into the technical prob-lems faced by the genius who had made the model, having myself often handled matches and glue, separately and in various combina-tions, while remaining utterly at a loss to imagine the degree of ma-nipulative skill and sheer patience needed to complete the final work.

From a small boy's point of view this was the ultimate work of art, much more entrancing in fact than the cathedral itself, and so too, I suspect, for a significant proportion of the adult visitors as well.

Here the technology of enchantment and the enchantment of technology come together. The matchstick model, functioning essentially as an advertisement, is part of a technology of enchantment, but it achieves its effect via the enchantment cast by its technical means, the manner of its coming into being, or, rather, *the idea which one forms of its coming into being*, since making a matchstick model of Salisbury Cathedral may not be as difficult, or as easy, as one imagines. (47, my italics)

What excites and draws the aesthetic subject to this (compromised) object is precisely its combination of enigma with transparency. And what this combination of enigma and transparency surrounds is a process of production: "At one level, *I had perfect insight* into the technical problems faced by the genius who had made the model . . . while [on another level] *remaining utterly at a loss* to imagine the degree of manipulative skill . . . needed to complete the final work." Gell implies that what we find "entrancing" in not just art but any product of technical activity—what "[casts] a spell" over us, as opposed to comforting, amusing, or intellectually energizing us—is a conjunction of what we know, *but also know that we don't or can't entirely know*, or at least not on the same level, about how an object was brought into being.

Gell is thus suggesting something more complex than that collective knowledge of how to produce things, objectified as a kind of immediately visible gestalt in works, is what makes those works enchanting. If we read his account of the matchstick monument more carefully, the more specific cause of our captivation by "technique" is the oscillation between knowledge and nonknowledge. Recalling Barthes's argument about "intermittence" or the "staging of an appearance-as-disappearance" as the true allure of striptease (and also literature, given *The Pleasure of the Text*'s own oscillation between erotics and aesthetics), this flicker between the socially transparent and opaque is perhaps most pronounced in the case of gimmicks: commodities produced in a system in which labor is separated from means of production, in which the continual transformation of technology toward increasing productivity is compulsory, and in which social exploitation is hidden in the very forms that express it.[43]

To be sure, Gell's essay is not about capitalism—or at least not on the face of things. Aside from the excursus on the matchstick gimmick, his main examples of the "enchantment of technology" are drawn from field-work on the "pre-scientific" cultures of the Trobriand Islands, with a focus on the carved canoe-boards used in the Kula exchange ring. As he writes, "The canoe-board is not dazzling as a physical object, but as a display of artistry explicable only in magical terms, something which has been produced by magical means. It is the way an art object is construed as coming into the world which is the source of the power such objects have over us."[44] But once again Gell is implying something different from what the last sentence literally states. For it is not technical process that is being "construed" when we find ourselves fascinated by an work in a way that compels us to imagine it in terms of "magic." What we are rather registering is how something about that process is *not* being construed—and in fact, is not possible *to* construe—directly from our perception of the object itself. This would seem to be why the language of magic is used.

But why are we compelled to speak of complex, only partially understood processes in terms of enchantment at all? For while "magic" arguably remains a baseline concept across cultures for "the action of forces in nature of which we are partially or wholly ignorant," there are plenty of things we know we do not fully know that we do not feel compelled to frame this way (58). It is not even the case what confronts us as beyond our understanding automatically becomes an object of affective intensity.[45] One begins to suspect here that the auratic excess which Gell is ascribing to artworks foregrounding technical processes has less to do with their opacity to cognition per se. It seems rather involved with the way in which that opacity implies a force that is supersensible: not because it is *supernatural*, but because it is *social*.[46]

And why "technique"? Why does our lack of intellectual access to the process of production objectified in an artifact—as opposed to, say, its history of ownership, or the psychology of its maker—compel us to use the language of magic when describing the lack's affective impact? Why is it only the former that generates a "halo-effect," affecting us as more than just a limitation of knowledge?[47] Gell's answer is that what lies behind objectified technique is productive activity that is implicitly measured for efficacy against an idealized standard of "zero work." It is this utopian concept, lying *behind* the image of labor encoded in our flickering perception/nonperception of objectified technique, that compels us to speak of "magic." "Actual Kula canoes . . . are evaluated against the standard

set by the mythical flying canoe, which achieves the same results instantly, effortlessly, and without any of the normal hazards. . . . Magic haunts technical activity like a shadow; or, rather, magic is the negative contour of work, just as, in Saussurean linguistics, the value of a concept . . . is a function of the negative contour of the surrounding concepts" (59).

What "enchants" us finally in the artifact reflexively drawing attention to its techniques is thus the idea of the disappearance of work, understood as a "cost" or even harm to the worker:

> All productive activities are measured against the magic-standard, the possibility that the same product might be produced effortlessly, and the relative efficacy of techniques is a function of the extent to which they converge towards the magic-standard of zero work for the same product. . . .
>
> If there is any truth in this idea, then we can see that the notion of magic, as a means of securing a product without the work-cost that it actually entails, using the prevailing technical means, is actually built into the standard evaluation which is applied to the efficacy of the techniques and to the computation of the value of the product. Magic is the baseline *against which the concept of the work as a cost* takes shape. (58, my emphasis)

At this point, Gell's theory of enchantment starts to look uncannily like a theory of the labor-saving gimmick. If the "relative efficacy of techniques is a function of the extent to which they converge towards the magic-standard of zero work," the gimmick is a technique coupled to a skeptical judgment of technique's ability to deliver on this very promise. "Zero work," of course, is an equivocal concept in mature capitalism, referring to both the utopia of full automation and to structural unemployment (as we will see in more detail in Chapters 7 and 8.)

Indeed, although Gell at first seems to view the "magic-standard of zero work" as a feature of prescientific societies, he eventually suggests that this ideal explicitly triggering our association of technique with magic is shared by capitalist societies. For "the technological dilemmas" of these societies "can in fact be traced to the pursuit of a chimera which is actually the equivalent of the magic-standard: ideal 'costless' production." "Costless" production is not truly costless, Gell notes; it is rather the "minimization of costs to the corporation by the maximization of social costs which do not appear on the balance sheet, leading to technically generated unemployment, depletion of unrenewable resources, degradation of

the environment, etc." (62n3). More equivocal than its prescientific counterpart, this "chimera" however remains as efficacious as an ideal, and just as implicit in our perception/nonperception of objectified social labor, as the "magic-standard." For this reason, Gell implies, technique's imbrication with the discourse of enchantment continues, even in late and very late capitalism.

It does so with a significant shift, as "magic" comes to mean a performance with no claim to the supernatural and that calls attention to its props and devices. In tandem, the feeling of enchantment undergoes a separation from conviction or begins to include a dissonance that does not finally dissolve it. Indeed, it could be argued that technique can only continue being construed as magic when enchantment takes this self-distancing turn. One name we have already given to our perception of technique as this bracketed sort of magic is "gimmick." Conversely, we might define capitalist enchantment as a fundamentally equivocal enchantment, inextricably bound to the duck/rabbit of gimmick/technique.

The features of the gimmick illuminated by our focus on its see-throughness as a productive strategy can now be swiftly summarized. Far from being artistically marginal, the gimmick lies at the heart of modernism and the "modernity" that gives rise to it (Clark, Cavell). The suspicion it triggers stems from art's identification with technical problems and convergence with theory (Poe, Adorno, Cavell); at the same time, it emerges as a source of creativity and pleasure (Barnum, Weiss, Clark). The conjoining of enigma and transparency in the gimmick points to a key shift in the way illusions become socially effective (Pfaller, During). It ultimately reflects our simultaneous recognition of what we can but also cannot grasp about a productive process from an artifact's appearance (Gell), as well as a double-sided gestalt: "work" conjoined to an equivocal "zero" or disappearance of work (Gell). In Chapter 3 we will consider how doubts surrounding theory-driven art index deeper questions about artistic labor's relation to productive labor in contemporary capitalism, particularly when dominated by "immaterial labor" that is both skilled and deskilled. We will also shift our focus to literature, pursuing two questions that will allow us to deepen the ones rudimentarily posed here. Why are the techniques relied on by the "novel of ideas" for the integration of concepts so liable to come across as tricks, casting the gimmick's shadow over the genre as whole? And what, exactly, might this ratiocinative genre want from the theme of magic?

Readymade Ideas

If artworks transparently promising "ideas" seem particularly vulnerable to charges of gimmickry, this relation does not seem difficult to parse. As the *Oxford English Dictionary* informs us, the gimmick *is* an "idea," especially "one adopted for the purpose of attracting attention or publicity." This intimacy arguably comes to the fore in a culture relying on slogans like "knowledge work," "cognitive capitalism," and "semio-capitalism" to characterize its de-industrializing present.[1]

The integration of knowledge into production is however one of capitalism's general features, ensuring that artistic labor has followed productive labor in becoming increasingly reliant on concepts, signs, and information in what is sometimes the same process of becoming deskilled.[2] Advertising, necessitated by the overaccumulation of commodities whose values cannot be realized until sold, simultaneously promotes an overarching reification of the "idea" in the form of the promotional shtick. Already by the rise of marketing departments, the gimmick is a commodified thought designed to draw investments of capital. As John Roberts argues, the suspicion attached to idea-driven artworks since the early twentieth century, from Duchamp's *Fountain* to Robert Barry's exhibitions of exhibition announcements, may thus have less to do with antimodernist reactions to violations of traditional expectations about aesthetics or authorship than with the economically ambiguous image of production and circulation these artifacts encode.[3]

Two kinds of concept-driven art seem to dominate in cultures of advanced capitalist production. In the first, art takes the form of what Roberts

calls a "nominative act," as in the Duchampian readymade and work of "poststudio" artists like Sherrie Levine, Louise Lawler, and Fred Wilson, who resign, rearrange, or recurate the works of other artists as art.[4] In the second, which will be our primary focus here, "ideas" are utilized as preexisting discursive materials or objets trouvés. Such is the case with the passages of Lacanian theory Mary Kelly displays in the Perspex boxes of *Post-Partum Document*; the reductionist/nonreductionist debates about consciousness J. M. Coetzee inserts into *Elizabeth Costello*; the meditative aphorisms from Fernando Pessoa's *The Book of Disquiet* that filmmaker Peggy Ahwesh appropriates for the soundtrack of *She Puppet*; and the paragraphs from Theodor Adorno's essays on Schoenberg and Beethoven in *Philosophy of Modern Music* that Thomas Mann liberally splices into *Doctor Faustus*. In these artworks, the idea takes the form of a "transportable intellectual unit," a *déjà-là* or self-standing proposition.[5] If an idea (say of what art is) or judgment (say of what is aesthetically interesting) can be what turns a urinal, matchbook, or invitation into a readymade, ideas can function as "readymades" in artworks, too.

The relativism of taste ensuring that people judge different works gimmicky never turns out to be the scandal it initially seems to present. All subjects in capitalism find something gimmicky. When asked to explain why they are characterizing their specific object this way, their responses become tellingly similar: because it is trying too hard, because it is not working hard enough, because its promises of value are unconvincing, because it is instructing me exactly how to consume it (and so on). It is here that the objectivity of the gimmick resides: not in the ontology of the things judged but in the justifications subjects supply to other subjects and the specific way in which they are communicated. The gimmick's objectivity is in other words not one of objects but of the intersubjectivity of evaluation, a sociality mediated by discourse, affect, and history.

This is however true for all aesthetic judgments. What this chapter wants to unfold, taking up a line of inquiry pursued by Timothy Bewes, is why the suspicions of illegitimacy and meretriciousness surrounding value, time, and labor, which I am arguing the gimmick indexes, have concentrated around artworks "of ideas" in particular.[6] Why have works with a conceptualist bearing, and especially those in which "ideas" imported from criticism or philosophy are incorporated as independently existing materials, existed in such close relation to this aesthetic judgment/form?[7]

We might look beyond the sociology of taste to answer this question, if only because, like anything, it doesn't explain everything. Certainly

middlebrow aversion to avant-garde experimentation will figure prominently in a story about idea-driven art after modernism, and even as that aversion has mutated into what is far more common today: mass indifference to a swarm of neo-avantgardes much more likely to be aligned with (or even indistinguishable from) commercial aesthetics than not. Yet the problem of the capitalist gimmick, given the interconnected issues of labor, time, and value at its core, points to something broader underlying these position-takings and the different alignments of economic and cultural capital they represent. Even Theodor Adorno hints that class-based "anti-intellectualism" might be too pat an explanation for the widespread suspicion surrounding theory in modern music. Given how "tenacious" this "reproach of intellectualism" is, he writes, it seems "more useful to incorporate into our overall understanding the facts on which the reproach is based rather than to contentedly counter dumb arguments with more intelligent ones."[8]

We sense that a broader set of "facts" might underlie this widespread distrust of "ideas" when we hear it vocalized by Marcel Proust—author of a novel that appropriates existing essayistic materials and hardly a philistine.[9] In *Time Regained*, chunks of Proust's work of literary criticism, *Against Sainte-Beuve*, are smuggled in as the interior monologue of the narrator—who in the same novel disparages writers who fall for the "impropriety" of creating "intellectual works": "A work in which there are theories is like an object which still has its price-tag on it."[10] Expressed by one of its own practitioners, here the distrust of idea-driven art seems less like a distrust of intellectualism, per se, than the suspicion surrounding an unsold commodity.

If Proust thus invokes stalled circulation to depreciate theory-driven literature, others use an image of "healthy" circulation to appreciate it. "The essayist is a sort of 'supply station,' to which the novelist has recourse," writes critic Frederick Hoffman vis-à-vis Aldous Huxley. "He is the 'port of call' at which the novelist stops, to take on necessary and staple goods. Just as [characters in the novel of ideas] are often subordinate as persons to the ideas or points of view they express, so his novels as a whole are often mere carriers for the cargo of ideas which their author must retail."[11] "Ideas" here are finished commodities that the novelist picks up to sell elsewhere at a higher price. Note, however, that the metaphor does not align the novel with the merchant but rather the "carrier" mechanically transporting his "cargo," underscoring the art form's aesthetic subordination to the exogenously produced "ideas" it conveys. Even in this generally positive take on the "novel of ideas," we sense doubts

about the value of an aesthetic form used as a "mere carrier" for ideas generated elsewhere.

What we should ask, Roberts suggests, is why these doubts continue to surround idea-driven works in a late capitalist present in which the image of the artist as an "ideas-manager" is entirely familiar—dulling the critical edge once inhering in Warholism and conceptual art's claims for the "'post-expressive' artist as a kind of art-replicant," a "mirror" or "machine" for circulating already-existing signs.[12] The fact that concept-driven works remain haunted by the gimmick *today*, almost sixty years after these neo-avantgarde interventions, supports Roberts's claim that it is finally not a de-idealized image of The Author or The Artwork causing unease about art with a will to "ideas" but something about the labor-based sociality implicit in both. Put simply, the gimmick indexes the persistence of a postartisanal "crisis of labor in the artwork" in capitalism. For Roberts this becomes epitomized in the "fast artwork," an "artwork as commodity that disappears into the flow of all other commodities," which in a digitized world takes the form of "The Beauty of the Spontaneous Idea."[13]

Jasper Bernes notes that the crisis testifies to especial ambivalence about the rising prominence of "immaterial labor" across sectors, as work requiring the manipulation of signs and information becomes common to all. For as Bernes reminds us, immaterial labor does not only comprise the skilled, well-paying intellectual labor foregrounded in accounts of "cognitive capitalism" offered by post-Marxists and popular business literature (the labor implied by the image of the artist as entrepreneurial "ideas-manager"); it also comprises deskilled, poorly-paid, feminized immaterial labor: entry-level computer work, clerical work, the work of cashiers and call center operators (the labor implied by the image of the artist as "data compiler" or "secretary").[14] Bernes makes this important if easily overlooked divergence central to his compelling explanation of why "the work of art in the age of deindustrialization" takes on the full and specific range of forms and affects it does. It is worth adding that the split between skilled and deskilled immaterial labor aligns with a forking path in the institutional history of conceptual art, which could be described as the divide between "the Conceptual Artist as an Entrepreneur of the New Capitalism" and "Abject Conceptualism."[15] If the highly paid immaterial labor encoded in the former prevails today in the style-oriented, neoconceptual work of Liam Gillick, Rirkrit Tiravanija, Philippe Pareno, and Superflex, the deskilled kind arguably takes precedence in works by

Art and Language or poet/data-compiler Juliana Spahr. Both "entrepreneurial" and "abject" images of the artist qua immaterial laborer can of course also be projected by one artist.

Uncertainties about conceptual art's potential dissolution into theory or information, entrepreneurial creativity or data processing, are thus uncertainties about artistic labor's relationship to productive immaterial labor in a displaced mode. Postconceptual participatory art's more recent intermingling with leisure activities involving aesthetic judgment (fashion, design, lifestyle, food), and identification with a generalized will to "style," as in the case of the idea-driven works of relational aesthetics Ina Blom surveys in *On the Style Site*, are arguably indirect meditations on this question about immaterial labor, too. As nonchalant as so many of these projects make a stance of being, their equal vulnerability to charges of gimmickry points to how much the sociality of capitalist leisure *and* labor—as Lauren Berlant reminds us, the two are always tied together—continues to register as profoundly equivocal.[16]

As a way to continue thinking about these questions, but also for the shift of perspective it offers on a topic taken up predominantly in the history of the visual arts, this chapter will offer an anatomy of a comparatively underdiscussed mode of literary conceptualism: the so-called novel of ideas. My anatomy builds toward a reading of a novel of ideas about late capitalist magic—which is to say, the transparent yet enigmatic form of the gimmick itself—hinging on suspicions of fraudulence circulating around a postconceptual artwork.

The Novel of Ideas

Arising by most accounts in the last decades of the nineteenth century, the novel of ideas reflects the challenge posed by the integration of externally developed concepts long before the arrival of conceptual art. Although the novel's verbal medium would seem to make it intrinsically suited to the endeavor, the mission of presenting "ideas" seems to have pushed a genre famous for its versatility toward a surprisingly limited repertoire of techniques. These came to obtrude against a set of generic expectations—nondidactic representation; a dynamic, temporally complex relation between events and the representation of events; character development; verisimilitude—established only in wake of the novel's separation from history and romance at the start of the nineteenth century.[17] Compared to these and even older, ancient genres like drama and lyric,

the novel is astonishingly young, which is perhaps why departures from its still only freshly consolidated conventions seem especially noticeable.

The techniques that stick out against the generic norms listed above appear across modern and postmodern texts with striking regularity. They are: direct speech by characters in the forms of dramatic dialogues or monologues (*The Magic Mountain, Point Counter Point, Tomorrow's Eve, Iola Leroy, Elizabeth Costello, Babel-17*); overt narrators prone to di-dactic, ironic, or metafictional commentary (*The Man without Qualities, Tristram Shandy, Elizabeth Costello*); and flat allegorical characters (*Faith and the Good Thing, The Man without Qualities, Against Nature, Moby-Dick*). Also prevalent, to a lesser extent, are experimental formatting (*Moby-Dick, Tristram Shandy, Diary of a Bad Year*); sudden, unexplained, narratively isolated outbreaks of magic in a predominantly realist frame (*The Magic Mountain, Elizabeth Costello, Artful*); and even a curious the-matization of the "device" or gimmick as such (*Tomorrow's Eve, Magic Mountain, Clear: A Transparent Novel*).

Whether executed as science fiction, bildungsroman, or more recently, the satirical form Nicholas Dames calls the "theory novel," the novel of ideas is "artful," with all the equivocality this term brings.[18] Willingness to court the accusation of relying on overly transparent stylistic devices is a consistent, perhaps even cohering feature of a notoriously unstable genre. Scholars have therefore obliquely acknowledged the novel of ideas's pre-dilection for contrivances. Claire De Obaldia's groundbreaking study of the "essayistic novel which appropriates existing material," for example, describes it as a "fundamentally ambivalent product," confronting its au-thors with unusual "demands of literary integration."[19] For all of their "tremendous size," the novels of ideas of Proust, Musil, and Broch are paradoxically "fragments," sharing German Romanticism's divided loy-alties to a "uniquely self-conscious intellect and an equally self-conscious anti-intellectualism" (200). Even in magisterial (if tellingly unfinished) works like *The Man without Qualities*, the inclusion of essayistic excerpts induces "a mutual interruption of theory and fiction," a disruption of "narrative continuity and totalization" undermining the systematic spirit of the "conceptual" as much as the imaginative pleasures of mimesis (200).

Focusing on the labor that the effort to synthesize fiction and ideas re-quires, De Obaldia comes close to instating the gimmick at the heart of the essayistic novel. If this move never happens, we can understand why. Predisposition to gimmickiness is just that: a predisposition. It hovers at

one crucial degree of remove from gimmickiness itself, which already presents its own complications. Historical arguments about genre, such as that the "novel-essay" is a response to a European crisis of modernity, as Stefano Ercolino maintains, or an "art form . . . peculiar to twentieth-century literary history," as Hoffman argues, are contestable, as they should be; aesthetic judgments made about entire genres inevitably prove more so.[20] But aside from ontological difficulties posed by its virtual and aesthetic character, the gimmick-proneness of the novel of ideas seems to have been avoided primarily because it is an intellectual embarrassment. Philosophical fiction should be a serious enterprise, we think, impervious to the gimmick's compromised form. But what if a susceptibility to the gimmick—and to the comedy that so often attends it—is finally the one feature that consolidates this equivocal genre?

In *Point Counter Point*, Aldous Huxley places this doubt in the mouth of a character who is a novelist, commenting on the "tiresome" device of the character used as "mouthpiece."[21] In one of the several chapters titled "From Philip Quarles's Notebook," freestanding mini-essays on the craft of fiction, "modern intellectual" Quarles gives us a quick rundown of the genre's "defect[s]":

> Novel of ideas. The character of each personage must be implied, as far as possible, in the ideas of which he is the mouthpiece. In so far as theories are rationalizations of sentiments, instincts, dispositions of soul, this is feasible. The chief defect of the novel of ideas is that you must write about people who have ideas to express— which excludes all but about .01 per cent of the human race. Hence the real, the congenital novelists don't write such books. But then, I never pretended to be a congenital novelist. (294–295)

The novel of ideas is characterized here as an intrinsically un-novelistic, "made-up affair" (and once again, by one of its own practitioners): "the real, the congenital novelists don't write such books." As the "mouthpiece" puts it, "People who can reel off neatly formulated notions aren't quite real; they're slightly monstrous" (295).

Even late modernists undertaking the integration of "neatly formulated notions" into fiction feel compelled to highlight the novel of ideas's equivocality *as a novel*. It is an equivocality that therefore cannot be entirely chalked up to antimodernist reactions to violations of classical narrative, bourgeois preferences for culturally consecrated forms, or mass audience

preferences for literary entertainment. Let us therefore see if we can cast the genre's predisposition to gimmicks in different relief by looking at how the problem arises in a different medium.

Ideas → Techniques

If what makes a novel properly novelistic for György Lukács is narration, as opposed to description, argumentation, or direct speech, what makes drama properly dramatic for Peter Szondi is dialogue, used as a vehicle or catalyst for action.[22] Signs of a crisis in European drama thus emerge, Szondi argues, when with the rise of new topics difficult for the traditional form to accommodate—the political situation of women, industrialization, the impact of historical memory on collectives, existential alienation—late nineteenth and early twentieth-century playwrights began to deemphasize interpersonal interactions between characters on stage. In place of dialogue, dramatists turned to a set of techniques borrowed from or influenced by other genres and media: expository asides, unusually long detailed stage directions, interior monologues, revue-like formats, representation of simultaneous points in time via multiple staging or filmed images, radically compressed plays newly foregrounding "situation" over "action," and sociologically observing, narrator-like figures (the Stranger in Maeterlinck's *Interieur*, the researcher in Hauptmann's *Before Sunrise*, the Stage Manager in *Our Town*). The bulk of *Theory of the Modern Drama* is Szondi's cataloging of these techniques, which lend themselves to diverging uses: on the one hand as "rescue attempts," conservative efforts to save the old drama from "novelization" (Strindberg's naturalist dramaturgy); on the other, as efforts to embrace and radically accelerate the crisis, giving rise to new forms (Brecht's epic theater, Bruckner's montage, Pirandello's metadramas about the "impossibility" of drama).

When techniques applied to resolve a conflict between form and content become unduly conspicuous, something like the gimmick appears on the horizon. We can see how exogenously developed ideas—"content" in its most reified guise—might pose this problem in any medium. Discussing the problematic "statements" in Mahler, Adorno notes: "Ideas that are treated, depicted, or deliberately advanced by a work of art are not its ideas but materials—even the 'poetic ideas' whose hazy designations were intended to divest the program of its coarse materiality." Music's effort to use literary concepts is even more contrived, Adorno implies, than program music's famously crude efforts at representational mimesis: "The fatuous

sublimity of 'What death told me,' a title foisted on Mahler's *Ninth*, is even more distasteful in its distortion of a moment of truth than the flowers and beasts of the *Third*, which may well have been in the composer's mind."[23] Szondi expresses a similar suspicion about preset ideas in the form of the "situation" used in the one-act play, a device "called upon to help provide the theater with an element of tension that is not derived from interpersonal relations."[24] Replacing conflict between individuals developing in time, the readymade situation is a spatializing "given." It is also almost always "catastrophic" in a way that makes the struggles of characters irrelevant: "in the one-act, the situation itself must provide all the necessary information" (56).

"Conceptual thought (there is no other kind) is by definition inadequate and vulgarizing," Bewes writes glossing Adorno in *Reification*; for this reason, in art the "only true ideas are those which transcend their own thesis."[25] Yet the idea-driven novel is a case worth special attention. For in contrast to the problem raised by Mahler's "poetic ideas," or sociological ideas in painting or dance, it involves a form strained by the techniques needed to integrate concepts in a medium that is already conceptual. The novel shares the same verbal medium as philosophy, science, history, and criticism.[26] Why then does its effort to integrate ideas originating in these discourses end up courting as much skepticism as the inevitably more awkward efforts on the part of music? Is it precisely because of the concordance of mediums, which dulls the frisson of the "conceptual turn" when taken by nondiscursive art forms?

Counterintuitively, the effort to integrate theories into narrative fiction has hung with remarkable consistency on three techniques that, from the perspective of the novel's own insistent claims to modernity, obtrude as archaic even when deployed in an experimental way. Allegory with its personified abstractions and "curiously inwrought" symbolism; direct speech by narrators, often for the purpose of providing critical commentary; and direct speech by characters were all prevalent in ancient drama and philosophy.[27] These techniques are also significantly associated with didactic impulses in the novel in its earliest stages, when the genre was still difficult to fully separate from romance and history.

Due to the anti-absorptive effect of this archaism, the will to ideas in the novel often makes itself felt as an exaggerated will to manner or even mannerism. Hence it is worth noting how many novels of ideas were penned by symbolists, decadents, or late Romantics avant la lettre: Remy de Gourmont, Jules Barbey d'Aurevilly, Joris-Karl Huysmans,

Walter Pater, Herman Melville, Marquis de Sade.[28] Interfering with story-telling, mimetic representation, and character development, the novel's will to "ideas" seems to repeatedly violate *some classic theoretical conception* of its most important or defining formal achievement, regardless of whether we agree with that particular conception or not.[29] To appreciate the import of this, let us take a brief run through these major conceptions as formulated by some of the novel's most prominent theorists and practitioners.

Unschematized Ideas; Fragile Embodiments

In *The Philosophy of the Novel*, J. M. Bernstein describes the novel as "a vast schematizing procedure, a search for modes of temporal ordering which would give our normative concepts access to the world" and thus a "constitutive role in our comprehending experience."[30] This joins two ideas: Kant's claim in the *Critique of Pure Reason* that pure concepts like "freedom" can only be made accessible to experience if given a temporal structure; and Lukács's opposition of "conceptual form" to "life" in *Theory of the Novel*.[31] Since Lukács thinks of "form" in the novel as "abstract and conceptual," and the "life" it seeks to represent as "secular and causal," "in order for conceptual forms *to attach themselves* to empirical life they must be . . . routed through a temporal sequence which can be matched to empirical events which possess a different order of determination." The problem finds its solution in the relation between story and discourse, in which the novel shifts between two orders of event determination, a "causal order of events" (succession or discourse) and a "narrative (formally figured) order of events" (totality or story).[32] Arguably the essence of narrative, the story/discourse relation underscores Lukács's account of the novel as a "dialectic of form-giving and mimesis, where form demands immanence and the world mimetically transcribed resists form" (107).

But the novel of ideas throws a wrench in this dialectic. Because it is uncertain whether the presentation of an "idea" in the discourse of a novel like *The Magic Mountain* counts as an event in a sequence existing independently of the representation of events, the genre tends to short-circuit or simply dissipate the tension between story and discourse that makes narrative so inexhaustibly rich.[33] Discussions of time, suffering, justice, and so on are part of the "life" represented in *The Magic Mountain*; the same goes for the discussions of vegetarianism and animal consciousness in *Elizabeth Costello*. Yet for all this, it is hard to think

of the ideas presented in either novel are constituting plot. As Bernstein writes:

> [The] more reified the represented world of the novel, the greater will be the distance separating event and plot, which is to say, the more difficult it will be make a plot (and hence a theme) out of the presented events; and the more difficult this primitive narrative act *the more meaning will come to reside at the level of form alone,* and hence the more questionable will be the authority of the narrative or, at least, the less verisimilitude will be a possible source of authority. (110, my italics)

The "more the divorce of form from life becomes manifest in the novel, *the more fragile, artificial, or purely literary will novelistic schemata appear*" (113, my emphasis). Here the relation between story and discourse, or the reader's ability to shuttle between events and the representation of events, begins to feel weak or oddly irrelevant. Perhaps this is why novels of ideas tend to be serial rather than chronologically textured, as reflected in the disconnected, interchangeable "Lectures" in *Elizabeth Costello*, or the picaresque episodes of *Faith and the Good Thing*. Perhaps it is also why in *The Magic Mountain*, a "time-novel" featuring characters tellingly "withdrawn" from time, Mann devotes the majority of his narrator's didactic speeches to the literary handling of temporality, including the contrivances this manipulation demands.[34] Here and elsewhere, unschematized ideas reflect the social fact of reification. The very "life" or experience that each novel "mimetically transcribe[s]" is dominated by abstractions, resistant to temporalization and thus narrative integration.

Northrop Frye puts it bluntly: an "interest in ideas and theoretical statements is alien to the genius of the novel proper, where the technical problem is to dissolve all theory into personal relationships."[35] The novelist who "cannot get along without ideas" or who "has not the patience to digest them the way [Austen and James did] instinctively resorts to . . . a 'mental history' of a single character" (308). Perhaps accounting for the reduced character systems of novels like *Against Nature*, the use of the often solitary "intellectual hero as mouthpiece for authorial justifications" also commits the novel to what Hermann Broch contemptuously calls "conversational padding."[36] As De Obaldia glosses:

> The term essayistic novel calls into question the idea of progression; it suggests that the (initial) essayistic material has not been

"dissolved" into the fabric of the novel after all, but plainly stands out of the narrative strand. The offence is not so terrible when the essayistic reflections are "motivated": in most novels, the essayistic appears in the form of reflections or digressions which are taken over by the characters. [. . .] Yet this is the procedure which Broch, precisely, rejects. His contempt for the choice of the intellectual hero as mouthpiece for authorial justifications is unreserved: he regards this strategy as "conversational padding" and "absolute kitsch," and accuses not only Musil, but also Gide, Mann, Huxley of indulging in it. (194–95)

It is here again a modernist author of a novel of ideas who is pointing out its tendency toward "absolute kitsch."

"Realism has never been comfortable with ideas."[37] In this outbreak of direct address by the recessed narrator of *Elizabeth Costello*, in which Broch's disliked "mouthpiece" technique is unapologetically embraced, our attention is drawn once more to the problematic nature of the novel of ideas by a practitioner. The narrator's interruption happens in our reading of what we assume is a story but are eventually told is a "lecture," implicitly performed to an undescribed audience into which the reader suddenly finds herself conscripted. At the same moment, the narrator is vanquished by an undescribed lecturer, enacting the very strain on novelistic realism described: "It could not be otherwise: realism is premised on the idea that ideas have no autonomous existence, can exist only in things. So when it needs to debate ideas, as here, realism is driven to invent situations—walks in the countryside, conversations—in which characters give voice to contending ideas and thereby in a certain sense embody them" (8).

Yet "embodiment" often replicates the problem Coetzee's self-cancelling narrator identifies. For this solution cannot do much when characters are as abstract as the ideas they personify. Perhaps this is why Mann's paradigmatic novel of ideas puts bodies rendered inert by ambiguous illnesses at the center of its story, highlighting the etiolation of the aspect of character Lukács calls "intellectual physiognomy."[38] Ideas and illness are thus not only provocatively coupled in *The Magic Mountain*, as Eugene Goodheart argues. The theme of physiological weakness points to the weakness of the very appeal to characterological embodiment as a solution to the problem "ideas" pose to narration.[39] No character in either of these novels develops, least of all the protagonists: Coetzee's allegorical double Costello and Mann's "grotesque innocent" Hans Castorp.

Nondevelopment is, in fact, one of *The Magic Mountain*'s official ideas. Indeed, its paradoxical narrativization and the temporal monotony ensuing from it, reflexively discussed in chapters titled "Eternal Soup" and "The Great Stupor," brings out *The Magic Mountain*'s experimental comedy. As Goodheart notes, the world of Mann's characters is an "achieved" world, in which the "ideas that circulate . . . represent forms of existence for which there is no real future." Hence the "irony of Settembrini's progressivism," which takes the form of "an obsolete idea with no prospects" (51). Mann's novel of modern, progressive ideas is in short a novel about the "failure of ideas." It is not just that "[if Hans] and the reader learn anything, it is that the ideas that occupy such a large space in the novel are untrustworthy or worse." The narrator's irony seems to ultimately target "the character of ideas per se" (46).

Something wrong about "ideas per se" also seems hinted by the late irruption of the supernatural in Mann's novel.[40] In "Highly Questionable," featuring the séance in which a medium calls up the ghost of Hans's cousin Joachim, the rationally inexplicable event is as paradoxically striking for its curious lack of impact on the narrative, which simply resumes after the incident, undisturbed. The inorganic imposition of supernatural (but narratively inconsequential) magic seems to almost ensue from the buildup of technical contrivances that the novel finds itself forced to use in its efforts to integrate similarly externally imposed "ideas."

I will say more about magic as a deus ex machina shortly. For now, we need to entertain a more basic reason for why the "novel of ideas" remains an object of critical skepticism. As Mary McCarthy asks: Aren't all novels "of ideas"? Can one intelligibly speak of a novel *without* ideas? If not, why pretend to a subgenre that is somehow special for having them?[41] In an enactment of this problem, Lionel Trilling's essays show him wavering between treating the "novel of ideas" as exception and norm: at times as an emerging form endemic to late twentieth-century "mass-ideological" society; at others as a synonym for the novel per usual, rooted in class conflict since the dawn of the nineteenth century.[42] Like the gimmick on which it so frequently relies, the "novel of ideas" is an equivocal thing. *Is* it really a thing?

But it seems time to embrace rather than continue circling cautiously around this genre's "Highly Questionable" nature. Rather than hunting for less embarrassing ways to stabilize it, we might define the novel of ideas precisely by its intimate relation to the gimmick form.[43] Incorporating the suspicion that attends a genre into its definition has benefits, including that of making the definition more concrete. And so: there is a

will to ideas on the part of some novels that drives them toward the use of three obtrusive techniques—techniques that *cannot help but* obtrude by working directly counter to the genre's diachronicity, flexibility, and other oft-noted strengths. Allegory, direct speech by narrators, and direct speech by characters: these ancient didactic devices undermine the novel's claims to contemporaneity. They distance the novel from its métier—narration—and systematically push its form closer to those of the essay, lecture, or play. Moreover, as a genre in which storytelling strains to accommodate synchronic concepts—inverting Hegel's *Phenomenology of Spirit*, in which philosophy rediscovers its reliance on diachronicity, narration, and a kind of free indirect style—the novel of ideas recalls one of gimmick's fundamental features: its appearance of "working too hard."[44]

Direct speech by characters involves privileging what narratologists call scene, in which story and discourse time coincide. This dramatic tempo contrasts with those at which the novel uniquely excels: summary (fictional events unfolding over years are briskly accounted for in a single paragraph or even sentence) and stretch (a story event taking up less than a second is recounted over several pages of text). Theater cannot do stretch without recourse to special effects like film, which has to rely in turn on special effects like slow motion. Film struggles with summary, resorting to devices like montage or peeling calendars.[45] Summary does not come easily to theater either, which manages it through expository speeches by characters.[46] In short, when the novel's dominant temporality becomes the "real time" of scene, as opposed to psychological stretch or historical summary, the novel is no longer in its technical wheelhouse but that of another genre. Indeed, stretch and summary are the only temporal modes in which an innovation entirely unique to the novel has been able to develop.[47] Free indirect discourse, in requiring the grammatical third person, cannot take place at moments of direct speech by characters. Nor can it take place in the direct speech by narrators which gives rise to the "pause," in which discourse time is maximal and story time is null.

Do the techniques the novel becomes compelled to adopt to incorporate preexisting "ideas" inevitably push its form closer toward the play? Hoffman comes close to suggesting this, noting that the novel of ideas brings out the "drama [already] implicit in an idea," when understood as "point of view which a person holds and upon which he acts."[48] The fact that the novel of ideas is more of a "drama of ideas rather than of

persons" commits it, moreover, to one remarkably simple contrivance that might well remind us of the default setting of the well-made play:

> Each character . . . has given him (if little else!) a point of view drawn from the prevailing intellectual interests of his creator. On this point of view the character stands, wavers, or falls. Thus, implicit in this type of novel is the drama of ideas rather than of persons, or, rather, the drama of individualized ideas. The structural requirements of such a novel are perhaps simpler than they at first appear. *One requirement is to get these people, or as many of them as is possible, together in one place where circumstances are favorable to a varied expression of intellectual diversity. The drawing-room, the party, the dinner*—these are all favorite points of structural focus. (133, my emphasis)

Similarly, in *The Drama of Ideas*, Martin Puchner notes that if we broaden the definition of drama from dialogue written for performance to a looser "family of forms" privileging "character, direct speech, scene and action, to the exclusion of narration and interiority," one can "claim that the dramatic is realized not only in plays but also in certain novels."[49] If one example of this is the experimental novel, such as Melville's *Moby-Dick* with its Shakespearean monologues, or Joyce's *Ulysses* with its 150-page Circe episode, the other is the "novel of ideas."

> Another group would include the novel of ideas, from Fyodor Dostoevsky to Thomas Mann, which depends heavily on dialogic scenes of intellectual discussion in the tradition of Plato. Rather than calling those moments examples of "typical" novelistic hybridity, it is more appropriate to think of them as dramatic moments in the novel, with the narrator, retreating into stage directions, giving over the scene to the pure action (and dialogue) of characters. If from one perspective this looks like the incorporation of drama by the stronger novel, from another, it looks like the invasion of the novel by a newly resurgent drama. (125)

Reversing a more familiar account of the novel as a form uniquely capable of assimilating others, Puchner sees the novel of ideas as a subset of an older, larger tradition he calls "dramatic Platonism" (124). In a sense, the novel's desire for "ideas" makes it not so much philosophical as dramatic.[50]

Canned Opinions

So is it its tilt toward drama, then, that makes the novel of ideas dispositionally gimmick-prone? Is gimmickiness synonymous with theatricality? Not entirely. Direct and often didactic commentary by narrators and authors, as when *The Magic Mountain* lectures on techniques used for the fictional manipulation of time, rather evoke the form of the argumentative essay. We have already encountered De Obaldia on the "essayistic novel." For Stefano Ercolino, the "novel-essay" is an even more specific subcategory of European fiction. Rising as an outgrowth of late naturalism transforming into symbolism and decadent literature, and disappearing after the Second World War, it presents an "organic" integration of freestanding concepts into narrative, seemingly unhaunted by the spectre of the gimmick.

Yet as it turns out, the main effect of the essay's infiltration of the novel for Ercolino is how it enables the latter's isolation from "historical time," which is why the resulting hybrid ("novel-essay") "present[s] itself as the symbolic form for the crisis of modernity." The novel's incorporation of the "atemporal" essay slows down narrative and in doing so performs a "formal exorcism" of "historical time" in response to the latter's "increasing pressure . . . in the last quarter of the nineteenth century . . . an epoch in which one witnessed not only the greatest economic expansion and cultural development of the modern era, but also the first huge modern economic crisis, the Great Depression of 1873–1896, a crisis of overproduction." Thus while emphasizing the seamless "interpenetration of concept and narration" as the novel-essay's distinguishing feature, Ercolino allows that there is something about its project that "resoundingly stunt[s]" character interaction and plot, eventually conceding that the novel-essay's integrations of idea and narrative are not as morphologically smooth as the term "organic" implies.[51] Ercolino himself supplies evidence for this partial retraction in noting the images of forced, outlandish, or unsustainable hybridity that appear in the diegetic worlds of Huysmans and Strindberg. The outbreak of occult themes and "compromise aesthetics," such as the "supernatural realism" of *Là-Bas* and "rational mysticism" of *Inferno*, point as much to the disconnection as interweaving of mimesis and philosophy. "Mimesis can assume abstract entities and categories as the object of representation provided that they take a 'sensible and episodic shape,'" writes Ercolino, recalling Bernstein's remarks about schematization as the novel's strategy for integrating concepts and "life."[52]

If this structuring does not take place, Ercolino notes, the "universality of concepts" takes center stage and one registers a disconcerting "code leap" (92). Broch's *The Sleepwalkers* thus ends up with a "gaudy structural asymmetry" due to the ten-part essay, "Disintegration of Values" inserted in the trilogy's final novel. Attributed as the work of the mind of a single character, doctor of philosophy Bertrand Müller, this "gathering of the 'immense metaphysical remainder of philosophy'" seems to "trigger an irrationalistic short circuit" in the novel as whole, which ends dubiously on a gesture towards "messianic hope for historical and individual redemption" (115).

Although he is careful to say, "we are not making a value judgment," the unspoken concept of "gimmick" looms over Ercolino's account of the novel-essay in the same way as it haunts De Obaldia's study of the essayistic novel. As he admits, "doubts have been raised [about] the overall quality of *The Sleepwalkers* trilogy" (114). Like De Obaldia, Ercolino notes that Broch himself worried about the project's gimmickiness, making efforts to avoid using "men of science as the novel's characters" and the novel's characters as "mouthpieces." It was exactly for this reason, Broch writes, that he inserted the "Disintegration of Values" into *The Sleepwalkers* in alternating chapters, *highlighting* the isolation of the essayistic passages from the fiction. Yet this strategy produced the same result: a compartmentalizing treatment of the "scientific element" as a "block" set "beside" the novel, as opposed to "emanating from the novel itself" (cited in Ercolino, 114). "Essayistic inserts" remain a problem that cannot be easily solved, underscoring that the novel of ideas's gimmick-proneness is not reducible to theatricality.

Then there is allegory, which arguably works against the spirit of drama *and* the novel.[53] For due to its rigid, compartmentalizing, and externally imposed symbolism, allegory tends to produce just types rather than characters who develop through interpersonal dialogue. The abstract discussions of war in Racine's *Mithridates*, Lukács notes, do not change the characters who participate in them; these static personifications thus lack the "intellectual physiognomy" he attributes to characters like Hamlet, whose typicality resides in what individualizes them.[54] Citing Marx's similar dissatisfaction with characters in Schiller's plays, Lukács concludes that allegory flattens all fictional beings into "mouthpieces of the spirit of the age" (152).

Allegory's "too pat" universality, as Lukács describes it, echoes the curious convergence of "universe" and "ornament" in the rhetorical concept Angus Fletcher privileges in his theorization of allegory.[55] What draws

Fletcher to *kosmos*, one of the eight types of poetic diction taxonomized by Aristotle in *Poetics*, is its contradictory signification of both "cosmos" and "embellishment": system or large-scale order, on the one hand; and thinglike signs of that order, on the other (111). In keeping with this view of allegory as both abstract *and* concrete, "ideas" in the novel of ideas have a tendency to seem at once grandiose and trivial. Often they have a decorative quality, of being grafted on what we become subsequently compelled to call the "rest of the text," like the jewels glued on the tortoise in *Against Nature* (who dies shortly thereafter).

"Allegory does not learn as it progresses. It knows the answers from the start and they are relatively straightforward."[56] For this reason, T. J. Reed notes, *The Magic Mountain* is not in any straightforward fashion the bildungsroman it is so frequently said to be. Indeed, we could think of allegory and the turn to "ideas" in this text as strategies for producing a comic requiem for a tradition Mann hints may no longer be historically possible. But as we have seen Goodheart suggest, Mann also implies something bolder: it is not allegory per se, but something about the very nature of the ideas it is used to transmit, that stultifies *Bildung* in *The Magic Mountain*.[57] Take the way thoughts circulate between the novel's two officially designated intellectuals, whose conversations become increasingly vehement as the ideas they debate become increasingly lifeless. The more reified the ideas, the more violent the exchange:

> "Form!" [Settembrini] said. And Naphta grandiloquently responded, "Logos!" But he who would not hear of the logos, said, "Reason!" And the man of the logos defended "Passion!" Confusion reigned. "Objective reality," shouted one; "The self!" cried the other. Finally one side was talking about "Art!" and the other about "Criticism!"[58]

These "ideas" are static, yet a source of meaningless violence. Indeed, it is as if their static quality *gives rise* to that violence. "One certainly hears in the impassioned debates between Naphta and Settembrini the sounds of 'passionate struggle,'" as Goodheart writes. "But they are not 'struggling into conscious being.' They have already achieved it—and their intellectual passion is, so to speak, the epiphenomenon of their achieved beings. . . . Neither Settembrini nor Naphta tests ideas: they inhabit closed systems to be fought for and defended."[59] Hence Mann presents the "paradox of a novel of ideas which dramatizes their ineffectuality," or inability to either "explain or transform the world" (Goodheart, 47). Indeed, what is on display is not just the "ineffectuality of Reason" but its all too effec-

tive "destructiveness" (48). The pistol duel between the two men, culminating in Naphta's suicide, thus arrives with a sense of logical finality.

The ethos of *The Magic Mountain* is less philosophical than theatrical, Goodheart concludes, with "ideas" dramatically presented as opposed to explored (49). But, we might add, in a way that contradicts Hegel's explanation for why "the completely dramatic form is the dialogue." Drawing on Creon and Antigone's exchange in Sophocles's *Antigone*, Hegel argues that direct confrontations in tragedy increase the determinateness and "cultivated objectivity" of speech (*gebildete Objectivität*).[60] Yet the "face to face" exchange between Naphta and Settembrini does the opposite. "*The man of the logos*"; "*He who would not hear of the logos*": at the climax of their struggle, it is no longer clear which "side" is personifying which abstraction or why. The exchange between Settembrini and Naphta is thus an instance of the stichomythic flattening that Franco Moretti argues is what truly takes place when Creon and Antigone confront one another.[61] An even more radical contraction happens in the former, turning ideas into both empty abstractions *and* physical things. Settembrini and Naphta's slogans thus resemble the "isolated emblems" that for Fletcher, epitomize allegory's interest in revealing highly organized (or systematic) powers, forms of what he calls daemonic (or suprapersonal) agency.[62] But in this case, the isolation normally signaling the allegorical emblem's power of revealing agency seems to highlight the idea's powerlessness to do so.

Facilitating this emphasis on the idea's inertness is *The Magic Mountain*'s narrator's irony, which is shared by the narrators of virtually every text we've discussed. When the novel turns its gaze to the reification of ideas, or to their overarching condition rather than intellectual content, what Wayne Booth calls a "special mocking tone" precipitates.[63] Booth suggests that the novel of ideas might as well be defined by this tone than anything else, underscoring its generic instability:

> I use the word "philosophical" for this kind of irony with some misgivings. It is certainly not coherent philosophizing, yet no one who lacks an interest in philosophical ideas can ever enjoy it very much. I feel equal diffidence in calling the whole of [Anatole France's] *Thaïs* a "novel of ideas," though that's the only term we have for works (actually of many different sorts) in which our attention is more on thoughts than on the fate of characters. The trouble is that, though the author pretends that the ideas matter very much, *they matter to him and to us very little as ideas, since they are . . . subordinated*

to the intellectual pleasure of hearing at least two voices talking at once, one of them betraying itself to the other.

We have no name, I think, for the kind of work in which the central interest is a philosophical conversation with the implied author, conducted "behind the main character's back," with the author presenting himself as "the ironic man." It might be described as a subvariety of that large class of works that Sheldon Sacks has named the "apologue"—works in which the invention and disposition of characters and episodes are determined more by a pattern of ideas than by the development of characters and their fate. But the trouble is that here we have no real pattern of ideas. (338–39, my italics)

The distinguishing feature of the novel of ideas is surprisingly affective: an undertheorized mode of irony as difficult to codify as the genre itself. What makes the novel of ideas "of ideas" is, in other words, *not ideas*. Yet we have "no [other] name" for narratives distinguished by the formal trick performed by *Thaïs* and *The Magic Mountain*. Both novels alert the reader to the possibility that their ideas officially presented for reflection are specious, *precisely in order* to redirect the reader's focus to a conversation with the implied author, "conducted 'behind the main character's back'" (338). The "intellectual pleasure" we take in the genre thus comes less from cognition than heightened alertness, which in turn stems from "hearing two voices talking at once, one of them betraying itself to the other" (338). The fact that we call the texts in which this bait-and-switch happens "novels of ideas" is thus doubly ironic, since our recognition of the tone that defines them hinges on realizing that their ideas "have no real pattern." In lieu of "pattern," what we are offered is a string of unschematized "ideas" that stay at the level of "succession" only. Even if we decided to count their presentation as events, they do not seem capable of adding up to story, the more complex temporal order through which "we reinterpret beginnings from the perspective of the end, eliciting from this totality a theme, a thought, a meaning."[64]

Yet there are cases in which the novel wants to represent the capitalist reification of thinking and embraces the gimmick as ideal form for the purpose. One thinks here of Coetzee's *Diary of a Bad Year*, in which the novel's "Strong Opinions," by professional writer and critic C, are cordoned off with horizontal lines from the first-person narratives of C and his typist Anya, located at the bottom of the page where the official plot

of the novel unfolds. "Hover[ing] in the air unrooted in passions," as Lukács writes of the topics debated in *Mithridates, Diary*'s essays on "The Nature of the Good" or "The Origin of the State" are pointedly separated from the interactions between its characters, pointedly presented as disembodied or abstract thoughts. The emphasis with which the novel seems to want to detach its Opinions from the developing story of C and Anya's complicated relationship is all the more interesting when we consider that it is a relationship in which the Opinions figure prominently and which they in fact bring into being and mediate (we learn that they have been typed and therefore read by Anya, who also begins commenting on them). Fascinatingly, Coetzee presents *Diary of a Bad Year*'s "ideas" as *more reified than they actually are*. In doing so he suggests reification's centrality to the novel of ideas as a problem, even when it does not finally triumph. Unlike Mann's novel, Coetzee's has a happy ending. Both novels are however compelled to reenact, in their efforts to comment on, the becoming-gimmick of capitalist thought.

Sitting on the top of the page like jars on a shelf, and isolated from one another as much from the novel's official plot, the *Diary of a Bad Year*'s officially designated "ideas" recall the blanket-wrapped, time-removed, "pickled" denizens of the Berghof Sanatorium. This preserving motif is in fact introduced by Hans Castorp in his one of his eager efforts to contribute to a discussion between Naphta and Settembrini on "occult science" that pursues the "purification, mutation, and refinement of matter."[65] For Naphta, this process involves "hermetism," referring to the "vessel, the carefully safeguarded crystal retort, in which matter is forced toward its final mutation and purification." Hans jumps in to offer his own homegrown illustration of Naphta's theoretical concept, inadvertently supplying us with a hilarious image for the novel's approach to both its ideas and characters:

> "Hermetism"—that's well put, Herr Naphta. "Hermetic"—I've always liked that word. It's a magic word with vague, vast associations. Forgive me, but I can't help thinking about our old canning jars, the ones our housekeeper in Hamburg—her name's Schalleen, with no Frau or Fräulein, just Schalleen—has standing in rows on shelves in her pantry, hermetically sealed jars, with fruit and meat and all sorts of other things inside. There they stand, for months, for years, but when you need one and open it up, what's inside is fresh and intact, neither years nor months have had any effect, you

can eat it just as it is. Now, it's not alchemy or purification, of course, it's simple preservation, which is why they're called preserves. But the magical thing about it is that what gets preserved in them has been withdrawn from time, has been *hermetically blocked off* from time, which passes right by. Preserves don't have time, so to speak, but stand there on the shelf outside of time. (501–502, my italics)

"Magic," Hans tells us, is the act of withdrawing organic matter from time—which is exactly what *The Magic Mountain*'s "conjurer" does to the residents of the Berghof in his "time novel."[66] "Preserves" underscores how the canned idea enables Mann's novel to conduct its remarkably successful experiment in narrating nondevelopment, comically highlighting the obstruction that both "ideas," and the gimmick-like techniques used to accommodate them, pose to storytelling and philosophical reflection alike.

Ironically through its transparency (given the theme of "hermetism"), the eureka moment of Hans's reflection on the "magical" isolation of living things from time—on "sealed" or "blocked off" ideas and characters—brings out a curious glitch in *The Magic Mountain*'s use of allegory. Withdrawnness from historical time and its "occult" or "fairy tale" effects on narrative are *official themes* in *The Magic Mountain*, announced as such in its foreword and discussed in the narrator's didactic addresses. Allegory however requires a text's dissonance or ultimate nonidentity at some level with the ideas literally expressed in it.[67] This dissonance is what Mann's novel increasingly lacks as it sets out to problematize the reification of ideas and makes use of the reifying effects of gimmicks to do so. Just as we have no term other than "novel of ideas" for the kind of novel in which we come to suspect the official "ideas" are traps (in a way that reroutes our attention to its double voicing), so have we also no name, other than "allegory," for a text so transparently allegorical that at a certain point it stops being so. Far from asking us to keep two discordant registers in sight at once, or to bend our imaginations beyond its represented world to access its true signification, the text morphs into a self-interpreting, "Do-It-All artwork."[68]

Mann thus deploys the three strategies of the novel of ideas—dialogue between characters, direct speech by narrators, old-fashioned allegory—in ways that point up the *failure* of each technique to achieve the integration for which it was summoned. Using each in a way that deliberately renders it questionable, *The Magic Mountain* enacts the becoming-gimmick of technique—explicitly deploys its techniques *as* gimmicks—in ways resonant with the theme of "magic" running through it as a whole.

Techniques → Gimmicks; Gimmicks → Magic

The reified abstractions circulating among *The Magic Mountain*'s characters are comically redoubled by a pileup of "amusing gadget[s]" in the novel's object world, like unnecessary correlatives for concepts that have already become thinglike. These include toy media, such as the "stereoscopic viewer, the tube-like kaleidoscope, and the cinematographic drum" laid out for the amusement of guests in the lobby of the Berghof, as well as the novel's famous gramophone. Introduced only a few pages earlier as a fleeting obsession of Hans Castorp's, this device becomes an important prop in the séance that brings Joachim back from the dead. Much like the compartmentalized irruption of supernatural magic, however, the gramophone is never mentioned again. Contrary to what Hans's obsession with it seems to promise, it never gives rise to a succeeding story-event, never even thickens into a proper motif.[69]

As if to prepare us for the carefully staged, heavily gimmick-mediated, yet finally rationally inexplicable séance, the novel's gadgets accrue with noticeable rapidity in the chapters immediately preceding it. They do so in conjunction with a swarm of "intellectual crazes" that also temporarily take over the Berghof residents: "geometric teasers," "earth-saving ideas," "sketching pigs with eyes closed," solitaire, photography, stamp collecting, and Esperanto. The fact that the outbreaks of fads and magic both occur near the final chapters of *Magic Mountain* is important. Deploying both, Mann's "time-novel" seems to highlight its own craving for a "device" to bring an end to its endlessness (in part because the ideas presented in the flow of its pages do not properly constitute story) as the novel moves with increasingly frequent irruptions of narratorial commentary toward the magical séance, the melodramatic pistol duel, and finally the war in which Hans Castorp is killed.

It is as if when technique is pushed too hard to solve a problem it cannot solve on its own—a problem introduced by content externally imposed on, as opposed to developed through or in dialectical relation with form—it turns into gimmicks which multiply until "magic" erupts: a metonymic extension of both the overtaxed techniques and of the reified ideas that forced them to become so. The initial problem for the novel posed by its effort to integrate readymade "ideas" is thus redoubled by the precipitation of "magic," which emerges as a second, equally out-of-place content that its form will similarly struggle to integrate. (Or, in the case of *The Magic Mountain*, *not* struggle to integrate, since the magical outbreak has

no narrative consequences). In both the novel of ideas and the society on which it comments, magic and ideas are mirror images. Indeed, *The Magic Mountain* seems to present supernatural *and* performed magic—its indifference to the distinction between them is striking!—as the revengeful double of the reified idea. The externally imposed content that the novel is initially pressured to use gimmicks to accommodate boomerangs back, in a more archaic, more suspicious, even more difficult to synthesize form. Yet this return is one to which Mann's novel seems to accept and roll on as if nothing important has changed (for it hasn't).

Notice the pattern: "ideas" (externally imposed content) → "gimmicks" (techniques that become strained in their effort to process that content) → "magic" (reappearance of original content). The eruption of magic in the logos-oriented novel of ideas is thus utterly logical. For when overstretched techniques become contrived, what do they resemble if not the tricks in a magical show? Spectacular, and yet gratuitous; explosive, yet narratively inconsequential, the isolated episodes of magic ensuing from the becoming-gimmick of novelistic technique echo the structure of the capitalist gimmick itself.

The Magic Mountain is not the only example. One might think of the climactic coming to life, followed by abrupt suicide, of the "female" neural network in Richard Powers's novelistic inquiry into the intersection of literary scholarship and big science, *Galatea 2.2.* In a similar spirit, the last chapter of *Elizabeth Costello*, "At the Gate," abruptly breaks with the novel's self-conscious realism by sticking its main character in front of a fenced-off heaven, forced to make a "statement" about "belief" to a panel of spiritually superior judges. What is the narrative logic of this theological swerve? To punningly underscore its function as deus ex machina, transparent contrivance for bringing things to an end? Here, as when Mark Twain suddenly revives Merlin's powers to restore Hank Morgan to the nineteenth century, Coetzee steps into the role of "magician" by showing his manipulating hand. In both cases, the last-minute demonstration of authorial power under the pressure of producing closure is explicitly aligned with "magic." Serenus Zeitblom could thus be speaking not just for *Doctor Faustus*, but for the genre of the novel of ideas as whole, when he says to Adrian Leverkühn about the latter's theory-driven music, "The rationalism you call for has a lot of superstition about it—of a belief in something impalpable and vaguely demonic that's more at home in games of chance, in laying cards and casting lots, in augury. Contrary to what you say, your system looks to me as if it's more apt to resolve human reason into magic."[70]

The unexpected return of the novel of ideas's unsuccessfully assimilated content—the thematic doubling of externally imposed "ideas" by rationally inexplicable "magic"—points up the obtrusive nature of the techniques overtaxed by this content. Idea, gimmick, and magic begin to look like points on a continuum—or stages in a devolution. *Elizabeth Costello* in particular shows how gimmicks lubricate its slide from metafictional commentary to magic ("Realism" to "At the Gate"). In a way akin to Duchamp's staged collisions of artistic and value-productive labor in the readymades, we are thus given a curiously equivocal image of the novelist's activity: as not the craft of an artisan but a magician's "prestige," which is at once a skill we admire and a trick we disparage.

The dodgy "artfulness" of the novel of ideas is of course the highlight of Ali Smith's *Artful*, in which the effort to fuse literature and essayistic material once again relies on a magical supplement. Here it is the ghost of the narrator's dead lover, a scholar whose unfinished lectures on literature appear between stretches of first-person narration. But comically, in a way analogous to the inconsequentiality of supernatural magic in *The Magic Mountain*, what is most striking about *Artful*'s ghost is its superfluity, both to the novel's story and its official ideas. From beginning to end, traces of the dead partner are so present in the survivor's narrative (the bulk of the "ideas" in *Artful* come from the partner's writings) that the actantial function of "ghost" is fulfilled before it arrives. It is fulfilled, we might say, by nothing more than ordinary narration, by which the thoughts and ideas of the lost partner are preserved. Indeed, when the ghost who is drolly more like matter than spirit quietly disappears from the story (it sheds grit, loses a nose, and generates a smell prompting neighbors to inquire about the narrator's drains), the reader almost does not notice. *Artful* meanwhile refers from start to finish to Dickens's Artful Dodger, the pickpocket whose virtuosity at appropriation makes him the perfect mascot for a novel which, like *Elizabeth Costello*, originated as a series of invited university lectures. The reference to the Dodger invites us to read Smith's novel as one of artful thievery as well or a work that deliberately courts and flirts with the suspicion of trickery. "Ali Smith melds the tale and the essay into a magical hybrid form," reads the back cover.[71] "Magic" (or gimmick) once again seems required to suture "ideas" and absorptive storytelling.

If the will to "ideas," mediated by the technique of metafictional reflexivity, finally drives *Elizabeth Costello* into a supernatural dimension, a similar logic operates in *The Magic Mountain*. Mann's novel announces its investment in "magic" from the very beginning, through its opening

description of the storyteller as a "conjurer who murmurs in past tenses."[72] Yet the mounting obtrusiveness of the narrator, whose commentaries on time and its manipulation via the story/discourse relation become increasingly frequent as the novel progresses, accelerates the novel toward "Highly Questionable" and its outbreak of the supernatural. It is thus the "philosophical" rather than "fictional" pole of philosophical fiction that pushes the genre toward magic, if only because the integration of ideas requires so much painstaking artifice. The reason for why the novel of ideas requires the ultimate gimmick that is the magical supplement, even when operating in the highest of high-realist modes, thus intersects with Gell's discovery of "costless production" as the root of our enchantment by technology (as we saw in Chapter 2). Magic thematically erupts when overstrained techniques turn into gimmicks. Conversely, the gimmickification of techniques, in direct response to the strain posed by reified ideas, becomes a harbinger of magic's paradoxically rational eruption.

With this anatomy of an equivocal genre whose conceptual stability paradoxically inheres in gimmickiness, we are ready for a closer look at a novel of ideas explicitly about the late capitalist gimmick as judgment and form, hinging on the aesthetic suspicion surrounding around a "magical," neoconceptual artwork.

Clear: A Transparent Novel

The judgment of *gimmick*, while never uttered explicitly, silently hovers over every page of Nicola Barker's *Clear: A Transparent Novel* (2003): a stylized, pop-experimental novel of ideas circulating around a "Highly Questionable" work by a professional illusionist. Dangling at the center of *Clear*'s fictional world, this is David Blaine's "Above the Below" (2003): a media conglomerate sponsored event in which the American magician starved in public for forty-four days in a transparent box suspended from a crane above a public park in London. *Clear*'s gimmick is Blaine's act—he is "the prompt, or the *twist* which makes the plot start moving"—and Blaine's gimmick is clearness: a pointed nonperformance of magic paradoxically offered as an auratic object by a skilled magician.[73]

Clear stands out among this chapter's examples, then, as a novel of ideas not only about but more riskily identified with the gimmick as capitalist form. Indeed, the novel seems to hug its accessible/hermetic, attractive/repulsive readymade, enclosing the "boxed-up Illusionist" in a second box, frame, or parergon of commentary (19). Made as if in response to

an art school assignment challenging students to produce an illusionless, yet still enigmatic work, Blaine's display of "see-throughness" is the object of cathexis, judgment, and interpretation around which Barker's own "transparent" artwork revolves.[74] It is an object that the novel strives to some degree to emulate, through its own manipulation of framing and mix of commercial with experimental styles.

Public suspicion of "Above the Below" stemmed in part from its contradictions. Site-specific, yet mediated; free and open twenty-four hours a day to the London public, yet financed by Sky Television, Blaine's transparent/enigmatic gimmick was squarely a product of the twenty-first century entertainment industry. Yet as a performance of endurance in the tradition of body art, in a Perspex vitrine evoking conceptual art's favorite vehicle for displaying materials as well as minimalism's iconic box, it wore the overarching "look" of the late twentieth-century, neo-avantgarde artwork indebted to the legacy of Duchamp's readymade. The gimmick in *Clear* thus calls attention to the transformation of art movements into vernacular styles and to the thinning border between art and aesthetic activities such as cooking, entertainment, architecture, fashion, journalism, gardening, and design. As critics have noted, the zone of blur between art and general aesthetic culture—long visible in the miscellany of things compressed in the lifestyle sections of newspapers—has been increasingly taken up as a topic in contemporary visual art and literature; becoming, in Ina Blom's words, a "site of artistic activity in its own right."[75]

Transparently reframing a framed transparency, *Clear*'s identification with Blaine's gimmick is strikingly morphological. It was also temporal, with the novel's production coinciding almost exactly with the duration of the performance it depicts.[76] Opening on the second week of "Master Illusionist David Blaine's spectacular Public Starvation Pageant" in the fall of 2003 and ending on the hour Blaine stepped down from the box, the time represented in the novel covers thirty-seven days. Barker wrote *Clear* in roughly the same period, publishing it at the end of the year.[77] Her "up-to-the-minute" novel of ideas—a phrase which, appearing on its description on the back cover, became part of its advertising—is thus an index of the time of its overhanging gimmick, which acted as a kind of "clock" for its production as well as for characters in the story.

What inspired her unusually fast pace of writing, Barker notes in interviews, was the simultaneously unfolding response to Blaine's 24/7 performance on the part of the British public, which was avidly reported on by a 24/7 media and especially the *Guardian*.[78] We have seen how the

novel of ideas results from efforts to synthesize the novel with dramatic philosophy (*The Magic Mountain*), the essay (*The Man without Qualities*), and the academic lecture (*Artful, Elizabeth Costello*). With *Clear*, we have an instance in which the genre's hybridity involves journalism, and in particular the still primarily judgment-oriented subgenre of lifestyle or arts and culture journalism that is the review. *Clear*'s conditions of production thus make it an interesting literary exemplar of Roberts's "fast artwork," corollary in the postconceptualist art world of the "fast thinking" encouraged by the "vast penetration of the commodity form and the development of telecommunications since the 1960s."[79]

If the novel's readymade is a boxed illusionist, its narrator is a cheery Hans Castorp-like hipster, whose interest in the transparent/enigmatic object's meaning intensifies with the debates on its fraudulence. From the novel's start to finish, University College London graduate Adair Graham MacKenny—a figure as characterologically slight as he is rhetorically garish—directly addresses the reader in the voice of a standup comedian:

> This preposterous magician (Jesus Christ! How'd he *do* this trick?) has *reanimated the vista.*
>
> Everyone's feeling it. The lovers are loving it. The angry people are getting angrier (I mean he's a foreigner, a fraud, an affront, a squatter, eh? How *dare* he take on this noble landmark—out of his depth? Out of his *depth*?!—and then causally twist it around him like it's his own private ampitheatre?)
>
> Fact is, it almost seems like the quieter *he* gets, the more vibrant his surroundings grow. His weakness (his "hunger") kind of *vivifies* the whole area.
>
> *Yup.*
>
> So where's this strange, new N-R-G coming from, exactly? Us? Him? . . .
>
> How'd he *do* it (any clues out there?)?
>
> Number 1 (in my opinion): Passivity. The dude just *sits* (this part comes from him). Number 2:
>
> Raw *emotion* (and this is *our* contribution). Love and hatred. Empathy and bile. Fury and benevolence (a great, uncontrollable fucking *wave* of reaction), and all—so far as I can tell—in fairly equal measure. The stuff of *life*, no less. The stuff of art and cinema and fiction. The stuff of all great narrative—comedy, horror, farce tragedy.

It's the whole package (Blaine is merely the prompt, or the *twist* which makes the plot start moving).

And *we're* bringing it along. We're getting all Dickensian again, all Rabelaisian, all "how's yer father." We're reconnecting to a long social *history* of public *spite* (and—credit where credit's due—public adoration).[80]

Note the pleasure *Clear*'s narrator takes in describing the "preposterous" and "affront[ing]" object, the mistrust it arouses, and the politically ambiguous sociality it activates, bringing this especially to the fore for contemplation. It is a second aesthetic object generated by the judgment of the first one, the gimmick.

Clear's identification with the dubious "magic" at its center underscores that evaluating gimmicks is a public activity people enjoy, unleashing their critical and comedic capacities. There is thus a striking affinity between the tone of Barker's writing and that of the journalistic review: the one genre in contemporary culture that has remained unambiguously devoted to aesthetic judgment, and quite specifically qua *detection of gimmicks*. It is this evaluative activity—gimmick detection—that "vivifies" the language of one *Guardian* critic reviewing a three-star Michelin restaurant, in a style strikingly similar to Adie's narration:

The canapé we are instructed to eat first is a transparent ball on a spoon. It looks like a Barbie-sized silicone breast implant, and is a "spherification," a gel globe using a technique perfected by Ferran Adrià at El Bulli about 20 years ago. This one pops in our mouth to release stale air with a tinge of ginger. My companion winces. "It's like eating a condom that's been left lying about in a dusty greengrocer's," she says. Spherifications of various kinds—bursting, popping, deflating, always ill-advised—turn up on many dishes. It's their trick, their shtick, their big idea. It's all they have.[81]

The swiftness of the flip from advanced technique ("spherifications of various kinds") to the gimmick and its letdowns ("popping, deflating, always ill-advised") reinforces our sense of euphoric deflation. Assessments of the gimmick in *Clear* and the food review ("It's their trick, their shtick, their big idea") involve the same constellation of affects. Particularly in its claims to advancement, the gimmick provokes annoyance and even anger. Yet its detection is almost always counterintuitively joyful: "The dining room, deep in the hotel, is a broad space of high ceilings and coving,

with thick carpets to muffle the screams. It is decorated in various shades of taupe, biscuit and fuck you"; "We're getting all Dickensian again, all Rabelaisian, all 'how's yer father.'"[82]

What finally compelled Barker to write her "Transparent Novel" was thus not just the transparent object in "Very Bad Taste." It was the London public's evaluation of it as a gimmick, specifically:

> It's a tragic fact, but Blaine is definitely bringing out the worst in we Brits. I don't know if this is what he wants (if it's all part of the buzz for this American Christo-like) or it's what he expected, but he's headlining it in most of the tabloids today. They're calling him a fake, a cheat, a freak, a liar. They're up in bloody *arms*, basically. And it's a *moral* issue, apparently. Because it's in Very Bad Taste to starve yourself when you have the option not to . . . especially (*especially*) if you're calling it Art (and pocketing a—purely coincidental—5 mill. pay-out).[83]

The satisfaction that lies in recognizing or disliking the gimmick and speaking of it to others galvanizes the public's sense of its publicity in *Clear*. Improvisatory acts of aesthetic response take place around the borders of the magician's spectacle: carnivalesque actions in which spectators became performers, directing their actions not just to Blaine but each other. Here aesthetic judgment becomes stylized performance in its own right, at times upstaging the artwork by diverting attention to its frame. These performances run the gamut from verbal to nonverbal, passive-aggressive to sadistic: yelling jokes, eating fast food, flying drones, pelting the box with rocks, using laser beams to wake the magician from sleep. Positive aesthetic responses assume equally diverse forms: music, dancing, flower arrangements, handwritten signs of encouragement.

Clear suggests that in a sphere of mutual visibility enlarged by a "Highly Questionable" artwork—that is, a public sphere recharged by the obtrusion of a gimmick—acts of evaluation could become as worthy of aesthetic attention and analysis as the cultural objects inciting them. Aesthetic judgment was freshly and acutely experienced *as* public by subjects freshly aware of themselves as judges, appraising in the presence of other appraisers. In *Clear* this revelation stimulates a flood of speech acts.

What captivated Barker was thus the sociality of aesthetic judgment in general, as unleashed by the judgment of the gimmick in particular. Which, as *Clear* shows us, comes in a rainbow of expressive forms. And yet across

these forms, the judgment is shown to have an interestingly consistent tone—comedic, anarchic, irreverent, excitable, angry—underscoring its difference from our judgments of the interesting (in which our tone is cool), cute (in which our tone is tenderly condescending), or beautiful (in which our tone is respectful). Here we begin to see how aesthetic judgments are verbal performances correlated with affects not identical to, yet *echoing or amplifying*, the affects that give rise to them. To be felicitous as a speech act, the judgment of the sublime must *not* be shared in the condescendingly affectionate tone in which people judge things cute. If I proclaim X sublime in a tender, condescendingly affectionate way, I apparently do not understand what the concept means; the same holds true if I perform my judgment of X as cute in a tone of fearful awe.[84] *The affective style of an aesthetic judgment's verbal performance matters for our determination of the judgment's felicity.*

An aesthetic judgment like the gimmick is thus always more than just the judgment, yoked in a specific relationship to a perception of form. It involves an affective style of judging, intimately related to what the judgment means. It is telling here that performances of aesthetic evaluation generate aesthetic consequences or aftermaths, and that these aftermaths are not random but specific in character. Neither the judgments of the beautiful nor the sublime, for instance, unleash irony, or promote satire, in the exact way the gimmick does. And no place seems better to see this in action than in pop journalism and its gimmick-detecting reviews:

> Of all the amazing sentences and couplets and paragraphs in this wonderful Bloomberg story about the troubles of a juice and juice-press technology company called Juicero Inc., I think the following is my favorite: "[Juicero founder Doug Evans] said he spent about three years building a dozen prototypes before devising Juicero's patent-pending press."
>
> This sentence is like a million-carat diamond. It is like a vision of the Blessed Virgin Mary. Print out this sentence and put it in the Louvre. Here is the device Doug Evans spent three years laboring to invent:
>
> The device Evans spent three years laboring to invent is a $400 WiFi-enabled tabletop machine that squeezes juice . . . out of a bag of Juicero-brand juice. It squeezes bags of juice. It is a juice press that squeezes the juice . . . out of bags of juice. Bags . . . with built-in spouts . . . that are filled with juice. Juice that comes in bags.

What is being evaluated is not the juicebag squeezer but the journalism which exposed its gimmickry. But this involves a gush of praise ("million-carat diamond") that ends up figuratively re-inflating the gimmick, testifying to its remarkable ability to persist in the moment of denunciation.[85]

Responses to the boxed illusionist in *Clear* are reported in a voice strikingly similar to what we hear above, even as the forms of responding vary. Providing the novel with its official "ideas," these spin off into desultory conversations on a range of other aesthetic topics: the underappreciated perfection of Jack Schaefer's western *Shane*, the British music industry's late embrace of rap and its consequences for black artists, the semiotics of cut flowers, modernist chair designs, the flattening of sound when compressed for MP3s on an iPod, vintage shoes, Asian cooking techniques, the films of Harmony Korine compared to those of Werner Herzog, the cultural politics of hard liquor preferences, and the fashion choices of the various social groups who gather at the site of the novel's gimmick. While the objects discussed seem chosen at random, together they constitute a remarkably comprehensive picture of what Barthes called the "cultural system."[86] Covering virtually every "quadrant" formed by combinations of high and low economic and cultural capital in a Bourdieuian grid, they suggest a surprisingly ambitious wish on the part of Barker's stunt-like artwork—a politically unconscious wish, played out only on this formal/symbolic level—to grasp the late capitalist world it depicts as an aesthetic totality.

Underscoring this is the sociological analysis Adie provides of the four groups into which spectators of Blaine's performance sort. Categorized by spatial proximity to his box, there are Insiders (mostly Lovers), Outsiders (mostly Haters) who further split into Eaters and more aggressive Haters or Bridge people. Each group has its own style of appearing to others in public and its own style of expressing aesthetic judgment. Eaters are mostly "polite-seeming," "women of late middle age standing around and devouring fast food." Adie ventriloquizes their passive-aggressive response to the gimmick for us: "'We are London's mothers,' their smug, munching faces seem to announce, and 'while our fundamental instincts are to provide and to nurture, in your particular case we simply don't care. . . . We despise your *Art*, your Magic, your deceit, your *pretension*" (59). Bridge people are "crazy-angry types" who throw rotten fruit. Outsiders are visibly uncertain in front of the gimmick and its other spectators, though also most rigid in their response to it. They "come off seeming just that little bit buttoned-up . . . [and terrified by] the prospect of being

'caught in a lie.' Or of being duped. Or diddled. Or bamboozled" (61). Insiders favor cuteness as their flavor of evaluation:

> [The] gerbera is currently the Number One flower of Insider choice. I can only guess that this is (a) because of their cheerfully lurid— almost fluorescent—colours, (b) because of the big flower-head, which means that when you poke them through the wire—to suspend them, *for* David—they stay in place more easily, and (c) because these people are so obvious, so benign, so *craven*, and the gerbera has exactly that classic child-drawing-a-picture-of-a-flower-style-quality—a visual naïveté—which these credulous folk—in my lofty opinion—would instinctively go for.
> *Aw.* (61)

Rotating us through what feels like a complete system of position-takings, Barker's novel of ideas shares the "synthesizing-totalizing" ambition of De Obaldia's "essayistic novel"—even as there is an unrelenting vapidity to the observations about art, style, and culture it offers.[87] Here is a characteristic exchange, for example, between Adie and the novel's most devoted watcher of Blaine, Aphra:

> She turns and appraises me closely for a second. "You wear Odeur 53," she says. "Comme de Garçons. It's very sweet. Very feminine. I noticed it the first time you walked past. They marketed it as a scent with a *gap* in the middle of the aroma . . ." She grins. "Like an *anti*-scent. It was very clever. I mean *complete* bullshit . . ."
> She pauses. "But *you* fell for it, *eh*?"
> Before I can respond she lifts up her left leg. "D'you like my shoes?" (161)

There are ideas in this late-capitalist novel of ideas, as we will see. But unlike the others in this chapter it is awash with opinions, marketing concepts, and brand names, each swiftly succeeding the other in a rhythm evoking the production and pacing of internet journalism.

To reflect on the gimmick, *Clear* involutes the parergonal relationship between artwork and commentary. Here aesthetic judgment constitutes the interior of the artwork, while the "Highly Questionable" artwork frames or directs focus to these acts of evaluation. Barker's novel is thus an instance of more than just the practice of artworks commenting on other artworks (intertextuality, as often noted, is a transhistorical phenomenon). What *Clear* by contrast reflects is a more recent trend, specific to

late capitalist culture, in which people's affective/evaluative responses to art or culture become the substance of art.

One sees this in examples high and low: from Hans Haacke's questionnaire-based *MoMA Poll* (1970), a piece for the museum comprised of surveyed responses of visitors to the museum; to Bravo TV's *The People's Couch* (2013–2016), a television show based entirely on people affectively responding to television shows, including shows explicitly turning on aesthetic evaluation such as *Project Runway, American Idol, So You Think You Can Dance?, Top Chef*, and of course, *Work of Art: The Next Great Artist*. Over the last half century, aesthetic production and reception have become each other's form as well as content. Their convergence flouts the supposedly irrevocable split between virile artist and impotent "man of taste" which Giorgio Agamben mournfully claims inaugurated modern aesthetics in the eighteenth century, leaving us with aesthetics under the "passive," reception-oriented sign of Kant, as opposed to the "active," production-oriented aesthetics of Plato.[88]

In comparison to art's "spillover" into general culture, or uptake of commercial culture into art, which have both been "anxiously debated and euphorically celebrated," not much has been said about art's increasing use of aesthetic judgment as its material, or about the becoming-ergon of the parergonal discourse of evaluation.[89] Art's internalization of what is conventionally thought of as its external border is, I think, a distinctively late capitalist development.[90] Doing justice to its specificity will thus require bypassing a temptation to reduce it to the general intimacy between art and consumer culture, even as this phenomenon also surely informs it. How else might we think about the way in which contemporary art wants to be about or constructed out of aesthetic judgments? Via *Clear*, a particularly self-conscious instance of this?

The fact that "art has adopted the techniques and processes of . . . design practices . . . subsumed by capital" does not mean that artistic labor is value-productive, as Dave Beech argues in *Art and Value*.[91] However much art blurs into fashion, advertising, and other commercial activities, and however much artistic labor formally resembles immaterial labor, it has not been transformed into wage labor paid for by capital for the purpose of extracting surplus labor. Wage labor is involved when an artist hires assistants, but as Beech notes these wages are paid not by productive capital but revenue, and the labor it pays for is not the source of the artwork's value. Contrary to arguments made by neoliberal economists like Gary Becker and some Marxists, whom Beech notes become strange

bedfellows on this issue, the "real subsumption of art" has not taken place. Even in a deindustrializing economy marked by the intensified exploitation of what Marx calls general intellect, artists do not produce surplus value simply when their artworks take the form of the manipulation of signs and information (a media campaign, for example) or a service (odd jobs, maintenance work, retail, education, health care).[92] Artists sell commodities, but not the commodity of labor power. Art can moreover be consumed in multiple ways without sales. For all these reasons, Beech argues, art in very late capitalism remains "economically exceptional" even if it has been indelibly reshaped by capitalism: aesthetically, politically, and indeed economically.

Artists are not wage laborers, art consumers generally not capitalists, and no productive capital is involved in the making of art. What should our model for art's rationalization by capitalism be, Beech asks, if it is therefore not commodity production? Should we look to circulation, where merchant and financial capital dominate? Should we derive it from theories of "semio-capitalism," where forms of "differential rent" are extracted from the "non-productive activity of social and cultural intercourse" (338)?

Beech is wary of discourses that use the "free labour, precarity, and cognitive exchanges of art" to account for the production of value in capitalism. Yet he does note that there is one kind of "social and cultural intercourse" that directly impacts the value of art, if not the valorization of commodities produced with productive labor.[93] This activity is aesthetic judgment and commentary:

> [Art] production, by itself, even when it is produced directly for the art market, is not commodity production according to the labor theory of value. However, we can see in the second phase that the labor of others in the field contributes to the value of a work when they write about, exhibit it, or are influenced by it. The value of artworks appreciates proportionally to the growth of information and judgment. The value of this intellectual labor does not disappear without being expressed in prices somehow, but the collector or investor does not pay for the labor of those who increase the value of their holdings, hence the capitalist benefits from it *gratis*, and the escalating prices of artworks are not reflected in the incomes of either artists or academics. In neoclassical economics these can be counted among the externalities of art. In Marxist economics we can say, perhaps, art historians, critics, scholars, academics, curators and other artists produce relative surplus value for art. (311)

The value of artworks "appreciates proportionally to the growth of information and judgment." For this reason there is always a possibility of inflation or manipulation. Does this concern indirectly inflect *Clear*'s meditation on the gimmick? As a work of art isomorphic with "information and judgment," does it unconsciously model the exceptional way in which art's value increases? If so, its explicitly artistic preoccupation with judgment is also a preoccupation with the economic relationship between judgment and artworks, in which the "market mechanism" uniquely resides in a "broader social and cultural framework in which non-market mechanisms [dominate]" (308).

Beech's main example of how discourse affects prices in the art world is "lot notes": a file of descriptive and evaluative texts accompanying the sales of art at auctions. In its assemblage of journalistic comments surrounding Blaine's performance, *Clear* bears a striking resemblance to this paraliterary genre.[94] Barker's novel of ideas, a neoclassical economist might say, is an experiment in the internalization of art's "externalities." It suggests that the gimmick lies latent in our encounter with every artifact in capitalism, fabricated with or without productive capital, as an aesthetic judgment diagnosing a deficiency of value.

Coda

Barker's novel of ideas is finally more about the gimmick as judgment, and its affective styles of expression and intersubjectivity, than the gimmicky work that inspired it. To say this might however leave the erroneous impression that the novel offers no thoughts about the object at its center. Certainly, a number of interpretations of Blaine's box are floated by characters in the novel. Of all of these, the most serious proposes the relevance of the Holocaust and its imagery to reading the magician's act of starving in public, and of anti-Semitism to understanding the vehemence of negative reactions to the performance. This is the case particularly as over the course of the performance, the magician's growing beard and darkening skin make him increasingly resemble, in Adie's words, an "Arab." The idea of historical trauma as key to Blaine's performance seems entertained seriously at first. Yet the novel goes to pains to show that it has been thrown out as a lure: a trap for university-trained readers seeking interpretations that might rescue us from the gimmick's embarrassment by casting suspicion on our very suspicion of the boxed illusionist.

The idea that Blaine's performance is about anti-Semitism is originally suggested to Adie by Jalisa, a girlfriend of his roommate Solomon. Adie, a former media studies and English major, is intrigued by the interpretation, orders a number of classics in Jewish literature and starts reading and taking notes. Jalisa however later confesses that this reading was based on "no concrete reasons," rather made up on the spot to show off her ability to generate interpretations of culture off the cuff. Her eventual disclosure to Adie during a phone call that her interpretation was a stunt, a trick, or contrivance causes Adie some consternation, as it also did, I must confess, to myself:

> "So I read the Kafka," I blurt out, "and it was fantastic. The Jew stuff's really put this whole thing into perspective for me."
> *Another pause.*
> "I just wanted to say Thank You," I gush.
> "You do realise," she says carefully, "that my entire diatribe the other night was simply for effect."
> *Longer pause.*
> "You *don't* realise that," she says eventually. "Oh dear."
> . . .
> Before I can really respond to this bombshell, she adds, "Of course I have no concrete reasons for even believing that Blaine *is* a Jew."
> . . .
> "He's a *Jew*!"
> "Why?"
> I'm clutching my head, derangedly. "Because that's what makes *sense*. That's how it all adds up. Because I *like* him Jewish. I understand him better as a Jew, *and* the hostility he's generating."
> "Well, that's your problem," she snaps. (196–97)

Adie goes on with his research even after Jalisa's confession, discovering that Blaine is, indeed, half-Jewish and has a six-digit tattoo on his arm matching the tattoo given to Primo Levi. Yet his motivation eventually peters out. Indeed, the most we see Adie (and the novel) finally "do" with Jalisa's idea is draw the following correspondences between Blaine and Kafka's starvation story:

(1) [The Hunger Artist's] dressed in **black** (*tick* for Blaine).
(2) He is "**self-contained**," and "**courteous**" . . . (*tick, tick*; Blaine's nothing if not both).

(3) He answers questions with a "**constrained smile**" (big *tick*).

(4) Every so often he withdraws, into a kind of **thoughtful trance**, where nothing can distract him (*Tickus Majorus*).

(5) Next to him is a large **clock** (*tick*—although Blaine's is digital).

(6) Every so often he takes a small, restrained sip of **water** from a cup (*tick*, Blaine swigs his straight from the bottle). (122–23, original emphases)

In the end, the novel's "ideas" about its "boxed-up Illusionist" reduce to these "ticks," reinforcing our sense that it is the *judgment* of the gimmick, qua stylized performance, rather than *the object* at which it is directed, that *Clear* wants to think about.

Other interpretations are provocatively introduced or just casually floated by other characters without follow-up or commentary. Blaine wants to represent Christ (Adie, 9, 293); he wants to be black (Solomon, 46); he wants to make the "ultimate Capitalist gesture of *Anti*-Capitalism. . . . No *wonder* we're so pissed off" (Adie, 144); he wants to be Houdini (Adie, 224–27); he wants to imitate Werner Herzog's use of physical extremity in cinematic works like *Fitzcarraldo* (Jalisa, 81–90); he wants to explore, through his collaboration with Harmony Korine who is filming the event, an "Art/Celebrity union" (Jalisa, 84–85); he wants to be a "blank canvas" for all viewers to "project everything they're feeling on him," or a "mirror in which people can see the very best and the very *worst* of themselves" (Bly, 311). At one metafictional point, Adie reflexively wonders if a novelistic structure built upon ideas like this is going to hold up, drawing on one of Western culture's most clichéd images of beautiful art in a way that comically invokes the gimmick instead.

> I guess you could just say that I'm gradually building up some kind of basic, three-dimensional *jigsaw* inside my head, piece by tiny piece (as if David Blaine, the *rage* he's generated, the logistics of his actual "stunt," are some kind of magnificently fractured, profoundly perplexing, antique ceramic *pot*. . . .)
>
> So will it hold together when I'm finally done? Will it be water-proof? Are all the fragments in place? Are my fingers clean? Is the glue strong enough? (112–13)

Clear is not trying to be a Grecian urn.[95] If its ideas about Blaine's object are potted, it is because they are thoughts, in the end, about a media conglomerate's gimmick. Yet this surprisingly means that they cannot float

off as abstractions, as Settembrini and Naphta's theses do. Grounded in an object of collective suspicion organic to its story, *Clear*'s ideas are not inert. Thin as they are, they strangely *do* facilitate interpersonal interaction and the development of plot.

Plotwise, what happens? In a way reminiscent of *The Magic Mountain*, the events in this novel overshadowed by a gimmick that is also a man transparently starving in public are all in some way related to the theme of people informally caring for others weakened by illness. When we first meet Adie, he has just returned from a clinic, pronounced "clear" of the sexually transmitted disease he contracted by hooking up with strangers at Blaine's site. Adie helps escort another stranger home from "Above the Below" when she is overtaken by a migraine there. Urged to do by a porter from a nearby hospital who happens to be visiting Blaine at the same time, he takes the stranger to her apartment, washes her face when she throws up, and puts her to bed. This stranger is Aphra, a Blaine fan whom Adie notices is bringing elaborate home-cooked meals to someone ailing in a hospital nearby. In the end, the novel's main "event" is Adie's decision to read to yet another stranger in a hospital—a dying rich man, and the recipient of Aphra's food.

Mediated by the gimmick—but also the hospital, whose contiguity to the site of Blaine's performance becomes increasingly central to the story—the relationships between Adie and Aphra, and Adie and the dying man, end up as fleeting as Blaine's performance. The man, whom Adie discovers is Aphra's estranged husband, dies shortly before the conclusion of the magician's stunt—which roughly also coincides with Adie being sacked from his part-time clerical job. At this point it becomes clear that Adie's ties to Aphra are similarly temporary; they will not stay in contact and she, like her husband, will disappear from his life. Adie's feelings about the dissolution of these acquaintances, as about the ending of Blaine's performance, are not represented, in part because their culmination and the novel's are almost coeval. Like many of his counterparts in the novel of ideas, Adie is a "flat protagonist," strangely recessed by the novel's ending.[96] As it moves toward the end of the magic trick and Adie's transient employment, the novel slowly transforms him into a minor character, of no greater or lesser interest to us than the others.

Clear's characters are flat, and their conversations about Blaine's performance are superficial. Yet in striking difference to the novels discussed so far, these "ideas" arise from the world of the novel's story. They are not cordoned off from the rest of the narrative. Nor are they formulated

elsewhere as essays or lectures, only to be imported into a novel afterwards. Characters are therefore not mouthpieces for the circulation of extrinsically generated ideas, and the techniques used in their presentation do not obtrude. Certainly the conversations in Barker's novel, like the dubious object they revolve around, lack the weight of topics discussed in *Elizabeth Costello* or *Doctor Faustus*. But due to their inseverable connection to a concrete object—the extravagantly impoverished gimmick—they are in a remarkable sense less reified.

Barker's meditation on the transparent gimmick is thus a paradigmatic but also exceptional example of the novel of ideas. Let us therefore end by noting the character system on which her achievement rests: a network of equally minor characters bound by transient ties. Transient—yet memorable. Not deep—but not meaningless. Not involving love or friendship but always involving care: nursing, cooking, cleaning. These ties evoke the image of a society in which the paradigmatic relation is that of people tending to unwell people who are neither friends, colleagues, or kin.

Like Holbein's painting *The Ambassadors* with its hidden skull, does *Clear*'s totalizing representation of late capitalist culture therefore contain an anamorphic image of socialized medicine? Or of informal caring labor as its increasingly frequent supplement? If so, it reminds us that capitalist valorization depends on a system of social reproduction that the former directly jeopardizes, affecting the reproduction of capitalism as a whole.[97] Should we therefore read *Clear*'s politically ambiguous image of strangers voluntarily caring for weak or dying strangers—inspired, it seems, by the overhanging presence of a slowly starving illusionist—as a phantasmatic solution to the "care gap" produced by the etiolation of state-managed capitalism's social protections?[98] And thus as anticipatory nostalgia for a reproductive institution born in a past age of expanding accumulation? The deep structure of this gimmick-driven novel suggests the incompleteness of any picture of capitalism as a system consisting solely of productive workers and capitalists, disregarding the ways in which "the daily and generational reproductive labor that occurs in households, schools, hospitals, [and] prisons" maintains the valorization of value.[99] It also reunites us with the theme of economically ambiguous labor fundamentally underlying the gimmick and thus the problem of idea-driven art.

It Follows, or Financial Imps

We have been focusing on the gimmick as an aesthetic reflecting the binding of value to labor under conditions transforming its processes towards increasing productivity—the variable on which capitalist accumulation has most depended since the second half of the nineteenth century, when limits were imposed on the length of the working day. This chapter turns to the financial gimmick: a technique that, in its apparent distance from this sphere of production and its struggles, might seem to call for a separate theory. Yet as a device for managing deficiencies and excesses of money by structuring time (and in so doing, as we shall see, labor), finance confronts us with an interestingly amplified instance of the gimmick's structure and ambiguities.

Epitomized in its uncertain relation to crisis—Is it a harbinger? the agent? an intensifier? an ameliorator?—finance's role in capitalism has been debated across economic schools of thought. In the classical and heterodox economics of David Ricardo, Pierre-Joseph Proudhon, Thorstein Veblen, and John Maynard Keynes, finance is viewed as economically counterproductive—at times the financier is described as a usurer or rentier rather than capitalist proper—while Marxists generally view financialization as a response to capitalism's inability to absorb its own surpluses.[1] For David Harvey, Robert Brenner, Anwar Shaikh, Annie McClanahan, and others, credit and/or debt have proven unstable solutions to more endemic, deeper-seated stagnation tendencies such as overproduction, low profitability from overcapacity (the rising organic composition of capital), falling rates of profit, and stagnant wages. In a similar vein, Giovanni Arrighi argues

that in the course of its quest for sites of greatest profit over the centuries, capital's historical pattern of rerouting its flow from production and commercial activity to banking and finance has repeatedly signaled the downturn of a systemic cycle of expanded accumulation and the incipient decline of the geopolitical order that sustained it.[2]

Other Marxists, such as Randy Martin, view finance as more finely ingrained in capitalism.[3] Dimitris Sotiropoulos, John Milios, and Spyros Lapatsioras suggest that it might be understood as a key factor in the extraction of relative surplus value, since, in a way interestingly analogous to unpaid domestic labor, reliance on credit by households for the purchase of goods used for the reproduction of labor power lowers the cost of the average wage basket and the average cost of labor-power.[4] As they note, this claim reverses the causality prevailing in other Marxist accounts: "Increased indebtedness, based on competition-driven financial innovation, makes room for lower real wages and not vice versa."[5] Here finance resides at the heart of the relation between labor and capital distinctive to capitalism, which "falls apart without a system of mass indebtedness," as Leigh Claire La Berge writes: "One only gets paid after one works, and the time before payment is always possibly a time of debt, whether from the company store in older days or from the credit card in our own time."[6] Credit is similarly essential, from the side of capital, for the extraction of surplus labor. In the "bank financing of production," as Marx writes in the *1857–8 Manuscripts*, where he refers to money as a "command of future labour," money functions as a "guarantee of the very existence of a nexus between value and labour"—and in a much more straightforward way, Riccardo Bellofiore notes, than in value-form theories grounded in Marx's analyses of the commodity.[7]

Yet value-form theory also offers an auspicious way of understanding finance as immanent to the relation between labor and capital, Sotiropoulos and colleagues argue.[8] For it is Marx's emphasis on money as value's "necessary form of appearance" that discloses its substance as abstract labor, and in doing so, the fetishism underlying all of capitalism's central categories.[9] The "proposition that money is the necessary form of appearance of value ... means that the price-form *is* the value-form," as Patrick Murray glosses: and that "commodities, value, exchange-value, money, and prices constitute, for Marx, a whole from which no moment can be extracted."[10] "Interest bearing capital," Marx writes, in which "capital as capital becomes a commodity," is thus the form in which the commodity qua "fetish" becomes "elaborated into its *pure* form, self-valorizing

value, money breeding money" (M-M').[11] The "fetishism that lies at the heart of finance" is thus an intensified version of that which already lies at the heart of the price-form, which is to say, the monetary form of appearance of value *and the concept of abstract labor that its necessity implies*. Rather than constituting its own autarkic system of categories shaped by relations among capitalists, finance emerges here as part of a continuum of appearances generated in the realm of productive labor.[12]

But does the intensification of fetishism in M-M' matter and if so how? Should it make us more wary of fetishizing finance? Is finance the ultimate gimmick, trapping us into either understating or exaggerating its role in capitalism writ large? This uncertainty mirrors the divided structure of the gimmick as aesthetic category: a form of appearance making aggrandized claims to value which its judgment side refutes.

With the goal of seeing how finance might expand our understanding of the gimmick, in what follows we will look at two texts mobilizing gimmicks to represent finance. The first is Robert Louis Stevenson's "The Bottle Imp" (1891), published a year after the Barings crisis, the nineteenth century's biggest sovereign debt crisis leading to international recession, which was triggered by the insolvency and forced bailout of the "zombie bank" due to bad investments in Argentina.[13] (The same Barings bank would collapse and be bailed out once again in 1995, after derivative-based gambles on the direction of Japanese stock prices set off a global market crash).[14] The second text is the film *It Follows* (2014), written and directed by David Mitchell in the wake of the 2007–2008 "subprime debacle." Both texts route their depictions of finance through the compromised form of the gimmick, underscoring their isomorphism. In *It Follows*, in particular, finance and the gimmick converge as twin faces of an ambiguous interval defined by crisis—but also by the continuing deferral of crisis. This epochal ambiguity is paradoxically specific, Wolfgang Streeck argues, to an era marked by the dramatic expansion of finance in tandem with three secular trends in the world's richest countries: decline in rates of economic growth; rising overall indebtedness testifying to "vanishing macroeconomic manageability"; and rising economic inequality of both income and wealth.[15]

"The Bottle Imp" and *It Follows* focus on a financial device, rather than the culture of financiers and their manic activities, which is the route taken by rival texts like *The Pit* (1903) and *The Wolf of Wall Street* (2013). What is most striking about both stories is the representation of that device. Running against the grain of today's prevailing imagery of finance

as "non-linear," "complex," "stochastic," "virtual," "abstract," and "volatile," the financial gimmick in both narratives is peculiarly crude, stiff, and slow. What could be at stake in such a contrarian representation of M-M'? And especially at a moment in which derivatives, credit default swaps, and synthetic collateralized debt obligations have become familiar protagonists of so many "globalist discourses that breathlessly imagine the fluid, weightless, lightning-fast exchanges of commodities and information across the planet"?[16]

"Little Device"

In the late 1880s, as Great Britain's role as global leader in manufacturing and exports showed its first signs of being eclipsed by the United States and Germany, Robert Louis Stevenson began experimenting with financial gimmicks as ways to jump-start fiction.[17] "The Misadventures of John Nicholson: A Christmas Story" (1887) narrates the shenanigans that ensue from a bank's failure to keep track of its own bonds. "The Wrong Box" (1889), cowritten with Stevenson's stepson Lloyd Osbourne, highlights the old-fashioned tontine, a cross between a lottery and an annuity. One buys into a tontine with other investors to receive regular income streams until death; as investors die, their portion is redistributed to those still living, which is why the tontine has been a popular setup for murder mysteries. "The Wrong Box" pointedly opposes this financial device to productive capital by making the former the obsession of an aging manufacturer faced with repaying debts owed to his nephews and female ward after he has borrowed their inheritance in an unsuccessful effort to save his failing leather factory. The story of capital diverted from production to finance leads to a veritable explosion of narrative gimmicks: train accidents, faked deaths, confused identities, forged checks, and the sending of the "wrong box" to multiple destinations. In both "Misadventures" and "The Wrong Box," finance gives rise to almost ridiculously convoluted plots turning often on random coincidences, underscoring its associations with risk, speculation, and temporal complexity.[18]

"The Bottle Imp" (1891), by contrast, presents the financial device in radically simplified form. A Native Hawaiian named Keawe ships on a vessel to visit San Francisco and becomes dazzled by its real estate: "'What fine houses these are!' he was thinking, 'and how happy must those people be who dwell in them, and take no care for the morrow!'"[19] Dreaming thusly of real estate as a mode of social insurance, Keawe encounters an

elderly man who sells him a magic bottle containing an imp, explaining that it is the device by which he was able to gain his fortune and buy his exquisite house. The catch is that the imp, which grants all wishes to its owner other than that of immortality, must be sold before the owner dies; if not, the owner goes to Hell. More specifically, the imp must be "sold at a loss." The use of this instrument must finally cost something, cannot have been had for free. If the imp's owner sells it for a higher or for the same price, or if he tries to throw or give the device away, "back it comes to you again like a homing pigeon." The final "peculiarity," the old man continues, is that the transaction has to take place using "coined money"— no checks, discounted bills, or paper money allowed:

> "It follows that the price has kept falling in these centuries, and the bottle is now remarkably cheap. I bought it myself from one of my great neighbours on this hill, and the price I paid was only ninety dollars. I could sell it for as high as eighty-nine dollars and ninety-nine cents, but not a penny dearer, or back the thing must come to me. Now, about this there are two bothers. First, when you offer a bottle so singular for eighty odd dollars, people suppose you to be jesting. And second—but there is no hurry about that—and I need not go into it. Only remember it must be coined money that you sell it for."

Learning finally that all these risks must be made transparent to the next buyer, Keawe buys the imp for the sum of money he happens to have in his pocket: fifty dollars.

As Kevin McLaughlin notes in his essay "The Financial Imp," the allure of Stevenson's device is that of virtually infinite credit for a price steadily approaching zero as it circulates over time.[20] Another feature of the financial arrangement is that of not knowing exactly what one owes until one owes it, since the price of the "line of credit" is not set in advance but established by what the next buyer is willing to offer. The old man ends up paying 44.4 percent interest for his time with the imp, for example, when he sells it to Keawe for fifty dollars after buying it for ninety. If Keawe had happened to have 89.99 dollars in coins in his pocket, the old man's interest rate would have been 0.0001 percent. The "fundamental law" of Stevenson's gimmick—akin in some ways to an adjustable rate mortgage, or any loan with deferred interest—is that it "must be passed off," must stay in motion, must be circulated through the medium of money (177).

If the gimmick of the story is a circulating deferral of payment for credit, it is also a source of guilt and a curse: a risk one must spread to others in order to avoid surrendering collateral. The term "imp," McLaughlin underscores, is explicitly financial: "Stevenson seems to be reworking, or putting to work, the particular connotations the word 'imp' had acquired in English culture at this time. An imp, the *Oxford English Dictionary* informs us, is a 'little device or demon.' ... Imp, however ... can also be used as a verb meaning 'to engraft feathers in the wing of a bird so as to make good losses or deficiencies, and thus to restore powers of flight—hence, allusively, with reference to "taking higher flights," enlarging one's powers.'" McLaughlin notes, "This second meaning is the one that concerns us most here. ... For, it is in this sense that the term 'to imp' became associated in English with what many saw as the evil of financial credit and in particular paper money" (175). A technique for enhancing the ability of a thing to circulate, for patching over its "deficiencies" by a dubious act of "en[grafting]": the "imp" or "little device" is clearly also more than an economic form (finance). It is an aesthetic form as well (gimmick).

The first thing Keawe wishes for using the imp is a house. He returns to Hawaii where he discovers, to his horror, that his wish has been granted through the accidental death of his uncle. Keawe uses the inheritance to build his house, but, disturbed, sells the bottle to a friend afterwards. The twist comes when, years later, Keawe discovers he has contracted incurable leprosy. To save his life and upcoming marriage to a woman named Kokua, Keawe tries to track down the imp, which turns out to have been sold multiple times to a long chain of buyers on various Pacific islands, ending up finally in the hands of a young Haole in Honolulu who, having found himself in dire straits like Keawe (in his case, facing jail time after being caught at embezzling), purchased it for two cents. "'What?' cried Keawe, 'two cents? Why, then, you can only sell it for one. And he who buys it—' The words died upon Keawe's tongue; he who bought it could never sell it again, the bottle and the bottle imp must abide with him until he died, and when he died must carry him to the red end of hell." Keawe buys the imp back anyway out of love for Kokua, with the ironic result that his subsequent depression about impending damnation distances him from her and causes mutual unhappiness.

The disturbance around which Stevenson's story consolidates ultimately concerns credit that becomes too cheap. The price of the "little device" ends up shrinking with each transaction, finally sinking too low for any existing means of payment to express and/or circulate it. After

Keawe finally confesses his situation to his new wife, Kokua hits on an ingenious financial solution to their financial problem. The way to keep the structure of debt in circulation will be to find a place in the world with smaller units of money.

> "What is this you say about a cent? But all the world is not American. In England they have a piece they call a farthing, which is about half a cent. Ah! sorrow!" she cried, "that makes it scarcely better, for the buyer must be lost, and we shall find none so brave as my Keawe! But, then, there is France; they have a small coin there which they call a centime, and these go five to the cent or there-about. We could not do better. Come, Keawe, let us go to the French islands; let us go to Tahiti, as fast as ships can bear us. There we have four centimes, three centimes, two centimes, one centime; four possible sales to come and go on; and two of us to push the bargain."[21]

Kokua's solution to the problems caused by the imp is thus further "imping": an amplification or extension of the circulatory powers of the initial device (which needs enhancement fairly quickly).

When Keawe and Kokua arrive in Tahiti, however, they find themselves surprised by a simple obstacle (of which Keawe was already warned). As the device cheapens, it becomes harder to sell—but not only because of the shrinking pool of currencies for facilitating exchange. A yawning discrepancy between the price of a commodity and its advertised value makes any commodity seem dodgy. In short, the more the device circulates/cheapens, the more of an object of suspicion and joking it becomes. Keawe and Kokua discover this "fundamental law," not just of cheapening commodities but of rising gimmickiness therein, as soon as they try to "push the bargain" to Tahitians. As the narrator tells us matter-of-factly,

> You are to consider it was not an easy subject to introduce; it was not easy to persuade people you were in earnest, when you offered to sell them for four centimes the spring of health and riches inexhaustible. It was necessary besides to explain the dangers of the bottle; and either people disbelieved the whole thing and laughed, or they thought the more of the darker part, became overcast with gravity, and drew away from Keawe and Kokua, as from persons who had dealings with the devil. (166–67)

If the story "imps up" the initial imp to make its financial device go further, this move ends in deflation. Stuck with a commodity she can't sell

because the extravagant gap between price and value makes everyone *immediately perceive it as a gimmick*, Kokua decides to sacrifice herself for Keawe by keeping it. Convincing an "old and poor [man who was] a stranger to the island" to buy the bottle from her for four centimes, she buys it immediately back from him for three.

There are two centimes left. How will Stevenson end this tale of caution about the dangers of over-cheap credit, or about an increasingly difficult, eventually impossible-to-circulate commodity whose appearance of gimmickiness intensifies with each (nonetheless compulsory) exchange? The answer is, starkly, with a "surplus" or socially abject person: "an old brutal Haole" who had once been "a boatswain of a whaler" and a "digger in gold mines" but most recently "a convict in prisons." Learning that Kokua has taken on the curse for him and resolving to take it back from her for good, Keawe makes a deal: if the convict will buy the imp from Kokua for two centimes, Keawe will buy it back from him for one. The concluding twist is that the convict finally refuses to part with the gimmick, even fully knowing the terms of the contract. A man with "a low mind and a foul mouth . . . [who] loved to drink and to see others drunken," he is so far beyond salvation (and employment) that the loss of collateral doesn't matter to him: "I reckon I'm going [to Hell] anyway," he rationalizes. "So off he went down the avenue towards town, and there goes the bottle out of the story" (181–82). Keawe and Kokua have a joyful reunion—"The Bottle Imp" turns out to be a remarriage comedy, tinged with horror—and The End.

Endings pose a challenge for stories about circulation. In Stevenson's story of the dissemination of an ever-cheapening gimmick, the buck finally stops at a nonproductive person: one whose life, laid down as collateral, seems excluded from social protection. Let us keep this in mind as we turn to our next story about the circulation of deferred reckonings.

"It's Very Slow"

Set in contemporary Detroit, It Follows is also about a curse that takes the form of a deferral that must be circulated or else.[22] The medium of circulation here is not money but sex. Sex is however rendered metonymic with cars and driving, which in turn function as figures for circulation and credit, which returns us to our economic theme in a circular movement evoking the film's signature 360° pan.

Nineteen-year-old Jay is first introduced to us floating in an aboveground pool in the backyard of a house in what seems to be a white

FIGURE 4.1

Detroit suburb. Jay goes on a few dates with Hugh and eventually has sex with him in the back of his '67 Ford Galaxy, parked outside a dramatically lit gigantic ruin that looks like an abandoned factory (Fig. 4.1). While identified as such in the screenplay, the building is really an abandoned hospital. It is Northville Psychiatric Hospital, to be exact: one of the last state mental hospitals remaining in Michigan in the 1990s after several decades of downsizing and efforts to move patients into "community-based support systems and halfway houses."[23] The film's image of this institutional ruin is, in any case, like the "most photographed barn in America" in DeLillo's *White Noise*, a meta-image: the representation of an icon of post-Fordist, post-Golden Age, Rust Belt decline.[24]

Soon thereafter, in the gutted-out interior of the building, Jay learns their sexual exchange has surreptitiously entailed the passing on of a curse/debt. She now has a limited period of time, a few days or so, to have sex with someone else and pass the curse on to them in turn. If she fails to do so, she will be followed by a zombie-like creature—"-like" because of the creature's uncharacteristic singularity—capable of taking on the appearance of any other person: either a complete stranger or someone Jay knows. The imp will proceed to take her life as what turns out to have been retroactively constituted collateral, following the act of sexual exchange.

The moment of collection for a debt that in this case, was not explicitly contractual—indeed, that the debtor could not know she owed until the completion of the surface transaction in which it was hidden—is again deferred. Because the collector of what is suddenly revealed as owed can

only walk toward the victim slowly, what gets passed on is a strikingly stretched-out reckoning. Slowness, as opposed to steadily increasing cheapness, is the main feature of this financial imp: "It's very slow but it's not dumb," Hugh tells Jay.[25] One can put off the settling of accounts still a bit longer, he advises her, by getting in a car. In a key parallel to the effort to enhance the financial gimmick in "The Bottle Imp" by finding smaller currencies in which to circulate it, driving prolongs the original gimmick of narrative deferral.

Hugh's advice ensures that much of the film consists of scenes in cars moving around Detroit.[26] Against a moment of reckoning for a debt surreptitiously embedded in another exchange, a debt the individual did not knowingly take on but for which she will owe collateral anyway, it is as if the credit-like device of extended circulation as solution for buying time is introduced for the sole purpose of motivating these driving scenes with their mesmerizing feel. Camera movements in this film are generally slow. Slow 360° and occasionally 720° pans, in particular, on the kind of wide image we associate with westerns, showcase, between rotations, incremental distances gained by an ominous figure walking toward the camera in the background.

The point of all this slowness and circularity seems to dramatize that, thanks to "credit" qua way of extending time, "crisis" takes longer than one might think to arrive—even when it is clear that it has already happened (or is already happening?). In an important departure from "The Bottle Imp," it comes with the calling in of a debt never explicitly agreed to by the individual but which is transferred to her regardless, due to having been, as we discover, *always already distributed*, shot through the pores of an entire system. The revelation of indebtedness, more or less simultaneous with that of having been extended "credit," thus coincides with an unhappy confrontation with social totality.

Even when one passes on the curse by having sex with another person, there are no guarantees: if that person dies before having sex with another person in the twilight grace period, the debt / curse returns to the holder who deferred it and she must start all over again. "When credit works," writes Annie McClanahan, "it lives only in the future, transfixing in its seemingly magical power to move itself ever forward. But when it fails, credit is pulled back into its own uncanny past . . . confronted with the material limits it thought it had overcome."[27] Credit can also reflexively obfuscate whether it is "working" or not, as Marx notes—and therefore what temporality it in fact inhabits.[28]

At first, Jay's strategy is simply to try to outrun the collector for as long as possible. She ends up relying on her little sister, Kelly, and Kelly's high-school age friends Yara and Paul, all of whom grew up and still live in the same middle-class neighborhood. Her younger friends are supportive of Jay if uncertain about whether to believe her, since they cannot see the zombie—it is visible only to those who currently have or have recently just passed on the curse/debt. The motley crew eventually widens to include Greg, an older boy closer to Jay's age whom she once slept with. Greg lives across the street, and most importantly, owns a car. Together the group learns that Hugh has given Jay a false name and address, but succeed in discovering his real name (Jeff) and tracking him down at his mother's house in a wealthier suburb across town. When they confront Jeff there, he again presses Jay to solve her problem by sleeping with someone else as soon as possible, reminding her that if she does not and dies, the zombie will return for him: "If it kills you, it comes back to me and then all the way down the line to whoever the hell started it."

After this, the group decides to drive to the farthest place they know: Greg's mother's lakeside cabin. This proves futile in avoiding the collector, who shows up for Jay the next afternoon, looking first like Yara, then like the prepubescent peeping tom from her neighborhood, then a much older man. During the fight that ensues, in which the zombie, while invisible to the other teenagers, thrusts Paul away with a force that opens a conspicuous wound, Paul, Yara, and Kelly become convinced that the story Jeff and Jay are telling is true (Figs. 4.2 and 4.3). Greg, having missed this moment, remains skeptical. Fleeing the zombie in a panic, Jay crashes Greg's car and ends up in the hospital with a broken arm. Shortly thereafter she

FIGURE 4.2

FIGURE 4.3

and Greg have sex. He claims he does not believe in the curse, and therefore doesn't care about the so-called risk. Three days go by, and nothing seems to happen to Greg—until it gruesomely does. The zombie here takes the form of Greg's single mother, who grinds obscenely against his leg.

Witnessing it all first-hand, Jay runs to a car and drives through the night, ending up once again at Lake St. Clair, where she sees several men in a boat in the water. We see her tempted by the thought of passing "it" on this way, but she decides against it and returns home. Paul confesses a longstanding crush and offers to take the curse from her; Jay declines, despondent. Some readers here might wonder, as I did when I first saw the film, why monogamous coupledom could not be a solution to the problem. If one keeps passing the curse back to the other, who then passes it back, who then passes it again, and so on, the zombie could be kept swerving back and forth and the deferrals could go on until one partner dies or they stop being able to have sex. As it turns out there is a dialogue from one draft of the screenplay, cut from the film, which considers this possibility and then rules it out. "Why don't you give it back to him again?" Kelly asks Jay. "It doesn't work that way," says Hugh.[29]

At this point, hope revives with Paul's formulation of a kooky, Rube Goldberg-esque plan involving teamwork, old electronic equipment, and going across town to a large indoor swimming pool that all of the characters associate in some way with the beginning of adolescence. The drive to the pool through Detroit streets is the only moment in this film in which African Americans are visible onscreen—at a distance, being driven by, through the car windows. The image of literally bypassed black figures

156

generates the film's one and only conversation about racialized economic inequality, in which that racialization is at once alluded to and immediately displaced.[30]

A ceremonial scene with the pool at its center follows. It is one of the longest scenes in the film, filled with silence and waiting. Jay walks into the middle of the pool, as bait; the others wait around the sides for the collector to arrive, with their electronic equipment (hair dryers, desk lamps, a typewriter, an old television, and so on) plugged into multiple outlets behind them. Though they cannot see the collector, they can see the traces of its movement in the water. The plan seems to be to lure the zombie into the pool, pull Jay out, and then electrocute it by hurling the electronic devices inside.

When the zombie comes this time, it assumes the appearance of a bearded man to whom Jay reacts strangely, for a reason unclear to us. The plan immediately goes awry, with the zombie pulling Jay back in the water. Paul manages to shoot the zombie while it is underwater using a gun taken from the lake house. There is a stylishly photographed image of blood blossoming inside the pool, which reappears in the film's paratexts and promotion materials. Arresting as the image is, it is apparently insufficient for narrative closure. The movie feels like it should end here, but continues on for four strikingly short, strikingly dialogueless scenes following one another in rapid succession. It is this series of brief scenes which holds, I think, the key to the film's ultimate take on finance.

The end of the stretched-out pool scene seemed hopeful because the zombie, when shot, bleeds in a way it never did before. But apparently the plan didn't work. For the film abruptly cuts from the cloud of blood to Paul and Jay during what appears to be the same night, in the basement of Paul's house, having sex. The act is depicted as not particularly sexy. In the morning, another short, dialogueless scene depicts Jay asleep near an old family photograph, through which we come to realize that the bearded man whose appearance the zombie assumed when it attacked Jay in the pool was Jay and Kelly's absent and otherwise unmentioned father.

In the next, similarly short and dialogueless scene, which feels like a second climax to the film, we are shown Paul at twilight in a car, driving very slowly on a quickly darkening street outside the sprawling industrial ruin of the Packard Plant, peering anxiously out the passenger side window the entire time (Fig. 4.4). A reverse shot confirms that he has been scoping out two female sex workers, who catch his gaze and

FIGURE 4.4

stare back. The language in which this moment is described in one of the screenplay drafts is worth noting:

INT. PAUL'S CAR - DUSK

Paul drives through a run-down neighborhood within the inner city. He stares at a row of prostitutes. Tight skirts. Revealing tops.

They eye him. Paul watches them as he passes. The women appear to move in slow motion.[31]

Due to the brevity of the take, it is hard to tell if we are seeing an image of people moving slowly or a slowed-down image of people moving, either by the scene being "overcranked" (filmed at a faster speed than subsequently projected) or subjected to a post-production technique called "time-stretching" (digitally duplicated frames inserted between photographed frames). This is in part because the motion depicted consists only of micromovements: all that there is to see is the lowering of a cigarette, a jaw muscle moving (Fig. 4.5). Once again, the film shows its aesthetic commitment to slowness, but right as the shortness of dialogueless scenes, and abruptness of the transitions between them, are giving us a sense of *time moving faster* in the world of its story. This juxtaposition of slowness and acceleration offers a curious kind of contrapuntal special effect, not unlike the famous simultaneous track-out/zoom shot in Hitchcock's *Vertigo*. The motion captured in the take is slow, but the effect of speed is conveyed through editing or the relation established between successive images. As soon as the "stretched out" scene of Paul driving past the sex workers begins, then, its shortness makes it seems like it is already ending.

FIGURE 4.5

FIGURE 4.6

Jump to the next equally short scene, of Paul asleep in a chair next to Jay, while both are visiting Yara in the hospital, where she is convalescing after being accidentally shot in the leg by the gun at the pool. Once again, there is no dialogue; the only person who speaks is Yara, who recites a few lines from Dostoyevsky's *The Idiot*. Cut then to the final, short, dialogueless scene of the movie: Paul and Jay, walking down one of the sidewalks in their neighborhood holding hands. The way they are dressed suggests a bride and groom: she's wearing a white lace dress, his black jacket over a white hoodie hints at a tux. Trailing behind them, at just far enough a distance that we can recognize a human form, but not a face or gender, is—another person, walking slowly (Fig. 4.6). "Marriage," or monogamous coupledom, while not explicitly ruled out as the obvious

solution to the film's economic problem as we saw it done in the screenplay, is left with a giant question mark hanging over it. Cut to the title of the film (not previously shown) and The End.

Idiotic Doodad

One thing is certain: finance is nowhere to be found in the diegesis of *It Follows*. We detect its form rather in a narrative structure of seemingly endlessly transferrable deferrals as well as in the content of what is deferred: reckoning for a debt that was not knowingly assumed by anyone, but for which everyone faces the consequences of default; a debt embedded in an ordinary exchange that renders it invisible. In the United States, this kind of debt is something in which most people are involved simply by having a professionally managed retirement plan or an account at a bank that invests in asset-backed securities.[32] It is part of what Randy Martin calls the "financialization of daily life," in which the widespread availability of credit and policies encouraging asset ownership to make up for shortfalls in social insurance encourage ordinary citizens to perceive themselves as shareholders, investors, and professional risk managers.[33]

Elegantly surveyed by Annie McClanahan in *Dead Pledges: Debt, Crisis, and Twenty-First-Century Culture* (which also features a reading of a horror film), it is the kind of debt that underlies the now infamous products associated with the financial crisis of 2007–2008: securities based on massively pooled household loans for education, cars, housing, and personal spending; credit default swaps involving pools of these asset-backed securities (available in specialized "tranches" or levels of risk); and contracts to buy or sell securitized bundles of these credit default swaps for specific prices on specific dates. As is now well-known, the deferred payment agreements of thousands of households remained part of all these financial transactions even as they became increasingly difficult to distinguish therein. Securitization—the flip side of risk pooling in social insurance—seemed to make these financial assets inherently safe investments due to the laws of averages and safety in numbers; the logic here was "even if some loans did default, the others wouldn't; they would keep the stream of revenue going, and thus the risk of default would be spread and minimized."[34]

The paradox of an isolated zombie thus embodies the distinctively asocial sociality of the curse. Simply by being part of a household making monthly payments for debts whose income streams can be sold (and in

which the risks of default can be calculated for pricing though the collection of data), one becomes part of the larger circulation of deferrals that is finance. The way this happens behind the backs of "people merely paying household bills, unaware that they are building critical asset classes for securities" is akin to the way the curse is sexually contracted in the film.[35] Simply by having sex, one becomes, without knowing, part of the larger circulation of deferrals that is the narrative system of *It Follows*. And since the basic building block of every complex financial commodity is a circulatable promise to pay later, it could be said that deferral is finance's bottom line. This way of generalizing finance is pretty drab in comparison to those that highlight its more exciting features: "volatility," "risk," "performativity," "time travel," "alternative futures," "second-order observation."[36] But it is entirely in keeping with the spirit of Mitchell's film.

Comically slow, primitively linear, and fixated on the retrieval of a significant collateral, the representation of the financial gimmick in *It Follows* seems designed to counter the allure of contemporary financial products almost point for point. Its anchoredness to a significant collateral counters the allure of cheap credit with little or no surety required (as epitomized in the subprime mortgage). Its linearity counters the allure of techniques purporting to not just hedge but entirely eliminate risk by inventing insanely clever new ways to measure and socially distribute it (as epitomized in synthetic collateralized debt obligations and portfolio insurance). Its slowness counters the allure of gains promised by the sheer speed of computerized transactions involving complex temporalities (as epitomized by the infamous "margin call" on derivatives). Like the financial imp in "The Bottle Imp," which similarly isolates individuals in the very act of linking them, debt/credit in *It Follows* "comes [back] again like a homing pigeon" to those who do not successfully circulate it. Indeed, in both narratives it boomerangs back for its collateral even when the debtor *does* circulate it. Both "The Bottle Imp" and *It Follows* thus deploy exaggeratedly crude devices to depict credit's jerking back to its "mooring point" after a prolonged stretching away.[37] Perhaps nothing less than the blunt force of the gimmick is needed when it comes to returning imped-up finance to more solid economic ground?

We will soon see why this interpretation will not entirely suffice. In the meantime, it is important to see that our two financial fictions have another feature in common: both depict space in an exacting fashion while being vague about time. One of course expects this from a fantastic tale like Stevenson's, based on a "timeless idea" used by writers ranging from

Goethe and the brothers Grimm.[38] It however stands out as a more curious gesture in Mitchell's horror film about young white adults punished for their sexuality by pathological figures.

This is not because Mitchell's story is any less fantastic but because of the genre's strong association with the 1980s, in which "Final Girl" films like *Friday the 13th* and *A Nightmare on Elm Street*, alongside nostalgic preteen "gang" adventures like *E.T.* and *The Goonies*, became signposts of the Reagan era.[39] In spite of this affiliation, the decade in which *It Follows* is set is ambiguous. Indeed, we are given temporal cues pointing in explicitly conflicting directions. The colors of fabrics and building interiors (mustard, beige, maroon, dull green) suggest the 1970s. Styles of clothing suggest the 1990s but possibly also the 2010s. Every cultural object we could conceivably turn to in order to pinpoint the present of the film's story ends up being unhelpfully retro: a Hollywood film from the 1940s screened in a vintage theatre, a sci-fi movie from the 1950s shown on TV (Fig. 4.7). Technology, that reliable "sign of a time," is where we most realize that the film's obfuscation of its present is systematic. Aside from an opening prologue or frame story disconnected from the rest of the film, there are no cell phones or computers. When Jay and her friends try to track down Hugh/Jeff, they drive to his high school to look through a stack of old yearbooks. There doesn't seem to be an internet. In all of these ways, *It Follows* dangles what Ted Martin calls the periodizing temptation of the decade before us while making it impossible to locate its story in one.[40]

The film's most compelling way of signaling epochal ambiguity, however, resides in an ostentatiously pointed-up prop I would describe as the

FIGURE 4.7

FIGURE 4.8

gimmick en abyme, whose aesthetic intensity is as great as its narrative irrelevance. This doodad is almost like but not finally what Hitchcock calls a McGuffin: unlike the unnamed object pursued by the spies in *North by Northwest*, or Hitchcock's example of the package placed in the baggage rack of the train compartment, it does not generate suspense or launch an investigation.[41]

Throughout the film, Yara is shown intermittently reading Dostoyevsky's *The Idiot* on an electronic device shaped like a pink seashell resembling a mirrored makeup compact (Fig. 4.8). What makes the device seem technologically backward and futuristic at once—and therefore strikingly unhelpful for fixing the dates of the film's story—is the fact that, in spite of having a screen, battery life indicator, and network signal, it is conspicuously not a smartphone. Nor is it a cell phone, even as the clamshell design alludes to an obsolete style of one.[42] In keeping with the systematic elimination of all 2K technology from the diegesis (no internet, no GPS, no laptops, etc.), Yara never uses it to make a call or send a text.[43] The little device is thus the incarnation of a pointed negation: it is a non-smartphone. The nonsmart device is almost unbearably uncanny, in part because it manages to look old-fashioned, contemporary, and futuristic at once.

Oddly, the device looks futuristic *because of* what makes it look retro. While it is normal for high-tech gadgets first marketed in the "sharper image" of male early adapters to undergo cutification over time, Amazon still has yet to produce an electronic reader that looks like a 1950s-style cosmetic case. Maybe this object awaits in the future. But how futuristic can this future be when the feature that gives Yara's device its alien quality is not technological but cosmetic—pink plastic cladding encircling an

FIGURE 4.9

already incipiently obsolete gadget? It is precisely the toylike, childishly simplified quality of the device that makes it look advanced. And it is the dissonance of mixed temporal signals—futuristic, contemporary, old-fashioned—that gives the doodad its auratic hold on our attention, almost as if it were daring us to try to periodize it.

The nonsmart device from which Yara reads *The Idiot*—an "idiot box"—plays no role in the film other than to highlight the ambiguity surrounding its historical present. One could even say, with the form's temporal antinomies in mind, that it plays no role other than calling attention to itself as a gimmick, inviting us to meditate on the category as such (Fig. 4.9). The extreme close-up in which the device is first showcased and the film's ceremonial featuring of it at key moments in the narrative reinforce its insistent claim on the viewer's attention. Our last glimpse of the idiotic doodad is in the film's penultimate scene, when Yara reads aloud from it to Paul and Jay:

> "When there is torture there is pain and wounds, physical agony, and all this distracts the mind from mental suffering, so that one is tormented only by the wounds until the moment of death. The most terrible agony may not be in the wounds themselves but in knowing for certain that within an hour, then within ten minutes, then within half a minute, now at this very instant—your soul will leave your body and you will no longer be a person, and that this is certain; the worst thing is that it is certain."[44]

Mirroring the temporal contradictions of the doodad, the striking thing about the punctuality of crisis in this passage is its paradoxical dilation,

which *The Idiot* passage not only describes but enacts. It is as if the prevalence of gimmicks of circulation at the level of structure has led to an idiotically literal, thing-like materialization of one in the film's object world after all. Taken together, the film's contradictory signals work against a tendency to associate the devastation wreaked by the surreptitious circulation of socially diffused debt that it depicts exclusively or even primarily with the global financial crisis of 2008.[45] By making it difficult for us to attribute the film's representation of suffering to a single event, *It Follows* also makes it difficult for us to see "crisis" in the world it depicts as engendered by finance alone. Punctual and fast-acting, stock market crashes have proved more amenable to cinematic representation than economic stagnation, as McClanahan notes. Yet because financial transactions and the debts underlying them are interspersed throughout the circuit of production and circulation, one cannot finally align finance with a temporal logic of the instant as opposed to duration. The action of finance blurs the very distinction between the punctual and the structural, short-term and long-term crisis, just as it does distinctions between productive and nonproductive activity, which is perhaps why its representation in *It Follows* involves so many temporal contradictions.[46]

In his Arrighian work on the "late style" of empires, Nathan Hensley offers us another way of understanding the peculiar way in which *It Follows* at once periodizes but also seems to resist periodizing. Reading Stevenson's "The Strange Case of Dr. Jekyll and Mr. Hyde" with Jonathan Franzen's *The Corrections*, Hensley experiments with a "model of discontinuous historicism" based on the comparison of cultural forms emerging in "structurally cognate" moments of different world-historical circumstances: Great Britain in the 1880s, the United States in 2001.[47] If artistic works responding to analogous historical situations such as macroeconomic shifts from manufacturing to speculation can be said to have meaningfully similar morphological features, as Hensley argues—if geopolitical hegemonies can be said to have a "late style"—he suggests it is one with two primary features: (1) a representation of "atavistic or naked physicality [reemerging] through the forms that once contained [it]"; (2) the use of allegory to "frame a 'timeless' story" which texts then "date with sometimes fanatical specificity to historically particular 'late' moments, as power fades and violence lurches into the light" (279).

It Follows inverts this second claim in an interesting way. Instead of providing a timeless story about the outbreak of "pathological phenomena" that the text then strives to temporalize through particularizing

dates, it offers a story of crisis to which viewers will be tempted to fix a specific date while mustering all of its signifying powers to prevent this. This counterpoint echoes the financial gimmick's way of both alerting us to crisis but also generating ways to defer it, of both turning our faces toward an ending and stretching out the period before. As in Henry James's allegory of crisis in the metanarratological "The Beast in the Jungle," another instance of late imperial style falling nicely inside Hensley's paradigm, we will have been continuously warned and yet shocked anyway. Indeed, the "surprise" here is that Marcher's narrative will continue ending after the end has already arrived (and even as "a positive definite occurrence, with a name and a date"; "oh with a date," as May Bartram says).[48]

If crisis is the moment when "debts are called in and claims for collateral filed," or that of the violent reconnection of M-C and C-M, discrete phases of accumulation whose separation finance widens precisely by offering strategies to bridge them, both stories are about an effort to hold crisis off.[49] At the same time, there is a paradoxical sense in which, for Jay and Keawe, crisis *is* the terrifying and exhausting effort to fend off crisis: it is the endless driving in flight from the zombie, the flight to Tahiti in desperate pursuit of the world's smallest metal currency. Just as the Beast in Marcher's jungle is both about to spring, already sprung, and always already springing (perhaps even in the text's first sentence, Alex Woloch has suggested), the "calling in of debts" in both stories seems to takes place in three tenses at once.[50] Crisis is what is *about* to happen: hence still deferrable by tricks like driving further or smaller currencies. It is also what has *already* happened and what is *currently* happening.[51] In *It Follows* and "The Bottle Imp," there seems to be no protection from this temporal saturation other than making sure that the circulation of deferrals ends with a person other than oneself or one's spouse. According to the logic of both gimmick-driven, debt-driven tales, this person must be an economically unproductive, figuratively kinless person: the convict and the sex worker.

Final Gimmick

In a way reinforced by how both stories end by shoring up marriages (literal and symbolic), by what reasoning does this unproductive/nonreproductive figure come to serve as a device for closure, providing the "logical" solution for a formal problem that the initial gimmick—transferrable debt—initiates?

Let us recall here the strangely late-breaking theme of the missing father in *It Follows*. The final dramatic appearance assumed by the zombie, qua undead embodiment of a terrifyingly invisible, because socially diffused debt, suddenly seems to link the financial curse to families headed by single mothers. Fathers are, as it turns out, absent from the households of not only Jay and Kelly but also Greg, Jeff, and all teenagers in the film.[52] What is interesting is that the absence of the male Fordist breadwinner is not presented as a scandal, or even as particularly remarkable, until the very end. Female-led households are part of the ordinary life all the characters are living until the arrival (or rather exposure) of the circulating debt. This very fact makes the film's decision in its final moments to problematize the male breadwinner's absence, in what seems to be a figuratively supportive relation to our introduction to the sex workers in the following scene, seem all the more contrived.

But what do questions of marriage, kin, or sexuality have to do with finance? More specifically, why does a representation of finance routed through the gimmick lead us here, as is also the case in "The Bottle Imp"?

Taking us straight to the underexamined relation between sexual reproduction and the role of finance in the reproduction of capital, Melinda Cooper's sociology proves essential here. In her study of the shifting political landscape of the postwar United States, Cooper shows how, towards the goal of eroding welfare and other social redistribution programs designed to offset rising economic inequality, neoliberals piggybacked on neoconservative revivals of fundamentalisms concerning gender, sex, and race. Cooper's account of the explicitly antiredistributive dimension of "family values" is thus an implicit refutation of arguments in which "merely cultural" battles around issues related to race, sex, and gender are a distraction from the "real" problems of capitalism, whose ideology is perceived as reducible to liberalism, and its essence to "the market."

Cooper shows how the convergence of neoconservative and neoliberal agendas was enabled by the "democratization" of finance, through the radical expansion of consumer credit markets under the Clinton administration in the early 1990s—the same period that "saw the promotion of 'asset-based welfare' as an ideological alternative to the 'income-based welfare' of the New Deal."[53] This far-reaching reform "dictated that welfare should no longer function as a substitute for the wage but as an instigation [to workers] to participate, as fully fledged investors, in the speculative appreciation of capital."[54] In conjunction with George W. Bush's call for "universal home ownership," as Cooper writes, "foreign investors'

seemingly insatiable appetite for US debt (bills, bonds or securities), highly liquid capital markets and cheap credit, all . . . created the conditions for the mass marketing of financial products," including loans to households which were then "repackaged into tradable [asset]-backed securities or collateralized debt obligations and sold to investors."[55] Monetary stimulation of asset inflation, in conjunction with financial incentives for increasing the purchase of assets by individual households, resulted in the "reassertion of the private family as a vector of wealth transmission."[56]

Asset-based reform—the "financialization of daily life"—was thus not only an outgrowth of liberalized credit but of an attack on redistributive welfare. Driven by the defense of free market wages, neoliberals found it expedient to align with a neoconservative campaign against advances gained by feminist and civil rights movements challenging the Fordist family wage, which patrolled separations between the work of women and men and the labor of white and black men.[57] Neoliberalism and neoconservativism's meeting at the site of "family values" was thus a profoundly economic convergence, resulting in the resurrection of "poor laws" popular during Reconstruction. These laws made family members— siblings, aunts and uncles, grandparents—legally responsible for the care of sick or indigent individuals, effectively as a replacement for federal relief. A hundred years later, citizens would see the racially coded ethic of "family responsibility" revived as a substitute for welfare on behalf of private insurance and free markets (which in turn pleased neoconservatives eager to override Johnsonian-era legislation expanding welfare to unmarried women) at exactly the moment when cheap consumer credit stepped in to compensate for declining real wages.[58] Debt helped households continue making the monthly payments on which, behind everyone's backs, new financial securities for the investor class were being built. It made the very idea of "asset-based welfare" seem practical and attractive.

For all its appearance of autonomy, then, finance played a direct role in the revalorization of the Fordist family and concomitant reduction of welfare on behalf of liberal contracts and privatized care. Such were the historical conditions responsible for the closure of places like Northville Psychiatric Hospital, the "ground zero" in which the curse/debt/financial object is first passed on to Jay. The logic by which It Follows links its terrifying system of circulating deferrals to its not entirely convincing nostalgia for missing fathers is thus the same logic interlocking the penultimate and final scenes, in which with Paul we are asked to ponder the economic

role of sex workers; and in which Paul and Jay walk down a public sidewalk as if it were a wedding aisle. As true also in Stevenson's allegory of finance (which begins with Keawe thinking about asset ownership as form of old age insurance), the family must be wordlessly and rapidly reaffirmed as a capitalist foundation: not simply because it presents the ideological opposite of the image of nonreproduction, but because it has become the place in which a society marked by financial expansion offloads those it economically expunges. If the formal problems posed by financial gimmicks can be narratively "fixed" by a convict or sex worker, the family form must be implicitly resurrected to "fix" the unproductive and/or nonreproductive worker.[59]

Reinstating premodern ways of distributing wealth, finance-based reform proved "doubly marginalizing to those who both resisted the family as a sexual institution and were deprived of family wealth."[60] And so it is not an accident to find these two categories converging in the *dei ex machina* which *It Follows* and "The Bottle Imp" use to stop the havoc produced by "imps" that threaten reproductive families. If the lumpenproletariat provides a solution to narrative problems posed by the financial device, it is the family which must provide an economic solution to the problem of the lumpenproletariat.

The Final Gimmick is thus a homeopathic countergimmick as well as two-sided coin. One side takes the form of the person engaged in "behavioral risks," a social category from the poor-law tradition revived during the AIDS crisis to provide grounds for relieving states from responsibility for care.[61] Its other side takes the form of the heterosexual marriages enabled through this social penalty paid for by the behavioral risk-taker. Laminating these negative and positive images of family, the Final Gimmick suggests that finance is never as self-propelled by its own innovations as its own discourse suggests.

Coda

What do our representations of finance channeled through the gimmick underscore about the latter? In each case, the "little device" introduces a cartoonish streak into a horror story.[62] Both narratives, we might therefore say, use their devices to take the sublimity out of finance. Gimmicks can cause other aesthetic qualities to mutate.

Yet saying this ascribes enormous efficacy to an intrinsically stupid form. Both fictions thus go to lengths to remind us of the gimmick's ineffectuality.

Hence the foregrounding of an idiotic doodad's inertness. Hence the demonstration of the impotence of "imping," a circulationist fix that simply magnifies what is already not working. Hence the late swerve from these techniques to each story's Final Gimmick, which looks like a stab at something like a "return to foundations" from credit-based deferral to the "real economy" of working families. It is as if our comedy-horror hybrids want to do two conflicting things at once: deflate an aggrandized image of finance as primary agent of economic crisis; guard against a counter-image of finance that, misrecognizing it as a "fringe" phenomenon, underestimates the extent of its social diffusion. For precisely this reason, the aesthetic form through which both texts route their representation needs to be simultaneously powerful and weak.

In both stories, the gimmick seems specifically mobilized to counteract the "aspirational promise" of cheap financing with little or no collateral by dramatizing the harsh jerking back of credit to its material bases. "If the relationship between the foundational value of collateral and the aspirational promise of credit can seem tenuous, even infinitely elastic, in the throes of asset appreciation," Cooper writes, "it appears as slavishly referential when the bubble deflates, tethering credit back to the mooring points of 'real values' and stable ownership rights."[63] Yet as Cooper hints in her emphasis on "appears," and as our imp stories suggest, one needs to be wary about a certain use of this argument. For in dramatizing this dynamic through the problematic *gimmick*, what both narratives put into question is precisely the idea of a sober return from the irrational flights of finance to a crisis-free capitalism grounded in productive labor and the reproductive labor of families. The *instability* of the gimmick form, in which both the original financial problem and its (seemingly) antifinancial solution appear, enables each story to underscore what is dysfunctional about finance while mitigating against an image of it as *mere* dysfunction. For the latter can imply that crisis can be simply averted by better discipline: "re-embedding" markets (as Karl Polyani, Wolfgang Streeck, and New Keynesians argue) or getting "back to the basics" of the mode of production (the white Fordist wage).[64]

What new insight does this offer about the gimmick? That its aesthetic and critical capacity to act on other forms lies as much in weakness as power. Our two financial allegories written in the historically ambiguous aftermath of crises seem to call on the extravagantly impoverished aesthetic for precisely this reason: to register a fundamental hesitation about the status of a capitalist form, M-M', embodying the time, labor, and

value-related contradictions of the gimmick writ large. For if the gimmick in commodity production makes dubious promises about the expansion of value, the financial gimmick promises to increase it by the mere exchanging of promises.[65] If the former makes claims to "saving" labor, the financial gimmick purports to make labor vanish: indeed, it creates the illusion of value generated by one capital relating exclusively to another capital. And if the labor-saving gimmick insists on its contemporaneity with its perceiver, the financial gimmick always seems proleptically ahead, in a virtual time to which our own is always forced to catch up.[66] Hence the widespread idea of the "performativity of finance," still the prevailing approach to the study of finance in the social sciences today.[67]

"The further we trace out the valorization process of capital, the more is the capital relationship mystified and the less are the secrets of its internal organization laid bare," writes Marx.[68] For this reason, the financial gimmick presents as the gimmick of gimmicks. This is already the case with simple "interest-bearing capital," the progenitor "of every insane form," which "makes any definite and regular monetary revenue appear as the interest on a capital, whether it actually derives from a capital or not" (596, 595). Ordinary bank credit thus ensures that "the appearance of very solid business with brisk returns can merrily persist even when returns have in actual fact long since been made only at the cost of swindled money-lenders and swindled producers," which is why "business always seems almost exaggeratedly healthy immediately before a collapse" (616).

What is illusory for Marx, however, is never for that reason unreal or peripheral:[69]

> We have seen that the average profit of the individual capitalist, or of any particular capital, is determined not by the surplus labour that this capital appropriates first-hand, but rather by the total surplus labour that the total capital appropriates, from which each particular capital simply draws its dividends as a proportional part of the total capital. *This social character of capital is mediated and completely realized only by the full development of the credit and banking system.* (742, my italics)

Sotiropoulos and colleagues draw on moments like this to argue that "Marx placed finance at the heart of capitalism, regardless of the historical phase of the latter."[70] Credit enables the capitalist class of industrialists, merchants, bankers, and landowners to subdivide social surplus in a way that *unifies* them as capitalists. It ensures reproduction across gaps

introduced by production on a large scale, "grow[ing] in volume with the growing value of production and . . . in duration with the increasing distance of the markets."[71]

Finance can thus, in a way akin to other kinds of nonproductive "maintenance" work on which productive labor depends—from nannies providing childcare to circulation workers in warehouses—maintain reproduction while also producing its appearance where it no longer exists.[72] As our two tales show, credit buys time, stretches already overextended resources out. In so doing it not only puts off but elongates the temporality of crisis and/or culmination, making "the end" into a duration as opposed to a point. In Marx's words, it enables the "stretching of productive consumption," a key to the "stretching of the reproduction process itself."[73] Financialized consumer credit thus continues to prop up the United States economy as it has since the mid-1970s in compensation for stagnant wages and accumulating cutbacks in social insurance.[74] It has been able to do so in part because the form of the financial commodity is uncannily good at obscuring its relation to wages and welfare, even as rich capitalist democracies promote the belief that financial markets are the "welfare institutions of the future," resulting in plans to "reinvent Social Security for the 21st century" through individual investment accounts.[75]

"'The stage of financial expansion' is always 'a sign of autumn,'" Arrighi notes, citing Fernand Braudel.[76] Hence the fact that crisis follows financialization, in the way winter follows autumn, does not mean that the latter is the former's cause.[77] In fact, it is often crisis that stimulates financial innovation and not the reverse: central banks, deposit insurance, and stock exchanges "were not the products of careful design in calm times, but . . . cobbled together at the bottom of financial cliffs."[78] Yet the tendency for finance to seem autonomous, the root cause of its own expansion, and even a viable stand-in for "the economy" as such, seems wellnigh unavoidable in a moment framed by the "ascension of finance to a site of representational dominance."[79] For La Berge, this is all the more so because "representational narratives are fundamental to the efficaciousness of finance . . . in a manner that differentiates it from other forms of value"; this is a "unique property of finance . . . not yet fully accounted for in political economy."[80]

Overestimating finance draws us into the gimmick's hyperbole while the temptation to write its devices off as peripheral phenomena, disconnected from capitalism's labor-capital core (and the sex-gender system underpinning its reproduction), leads to a risky underestimation. Our

two representations suggest that if finance and the gimmick are at times isomorphic, it is not because finance simply *is* a gimmick: that is, superfluous, derivative. It is rather because both are marked by a fundamental uncertainty surrounding value's appraisal.

Let us accordingly end with an update on the tontine, the gimmick showcased in Stevenson's "The Wrong Box." Since its profits come from a "last survivor takes all" approach conducive to comedy-horror plots of the sort we have just examined, the tontine was already an object of suspicion in the seventeenth century when it was used to raise money for the wars of European kings.[81] Yet, even after embezzlement scandals leading to its illegalization in the United States in 1906 (and supersession by life insurance and other financial products), the tontine is currently being reconsidered by economists as a way to improve the efficiency of retirement plans, opening a door to resurrecting the pension.[82] "This might be the iPhone of retirement products," exults one professor of finance.[83] Time will reveal more, one feels obliged to say, about what that comparison means. But our present reveals quite a lot already.[84]

Visceral Abstractions

Eating Face

Barbara Johnson opens *Persons and Things* with a memorable anecdote about her childhood inability "to eat anything that had a face."[1] As she elaborates:

> Not anything that *had had* a face: I was not an incipient vegetarian and was perfectly happy to devour a hamburger, but I could not bring myself to consume anything that might be looking at me while I ate it or that continued to smile cheerfully as parts of its body disappeared into my mouth—gingerbread men or jack o' lantern candies.[2]

Highlighting a gut feeling about ingestion, this anecdote calls up multiple definitions of visceral: "felt in or as if in the internal organs of the body"; "instinctive, unreasoning"; "dealing with crude or elemental emotions."[3] But what if we read Johnson's anecdote as a story about a visceral response, not to a visceral act or a visceral object, but to a kind of abstraction?

This is sure to sound odd, given how the visceral encompasses everything the abstract is not. Indeed, its affectivity and corporeality seem to have made "visceral" resistant to theory in a way noticeably contrasting with the fate of "abstract"—which, as Leigh Claire La Berge points out, has been taken up by so many discourses that when deployed casually, "its precise meaning is almost impossible to ascertain."[4] While abstraction in aesthetics refers to "a mode of nonfigurative representation," and in philosophy to "something not fully realizable by a particular," La Berge

notes that in popular as well as specialist writing on finance, "abstract" has come to designate "complex," "unrepresentable," and even "fictitious"— as if to imply that a real grasp of contemporary finance is somehow no longer possible.[5]

The meaning of abstraction in contemporary economic writing is thus often the exact opposite of what it means to Karl Marx. For Marx, as for G. W. F. Hegel, for whom knowledge moves from abstract to increasingly concrete notions, the distinction between abstract and concrete does not map neatly onto the distinction between the ideal and the real.[6] As we will see below, Marx's account of how capitalism works implies a process of "real abstraction" (even if Marx himself does not use this term). Moreover, in Marx's critique of political economy, the abstract is simple while the concrete is complex, in the sense of being the "result" or "concentration" of multiple determinations: "The concrete is concrete because it is the concentration of many determinations, hence unity of the diverse. It appears in the process of thinking, therefore, as a process of concentration, as a result, not as a point of departure, even though it is the point of departure in reality and hence also the point of departure for observation and conception."[7] As La Berge glosses this passage, for Marx "the concrete is a metabolized result and the abstract a social intuition capable of leading to the concrete," which is precisely why the two must be deployed together: "If we begin with too abstract a concept to orient our investigation, then we preclude our own access to the quotidian, material, perceptible world. And if we begin with too concrete a term, then we may be unable to understand its organization within a larger social totality."[8]

Across all the theoretical traditions in which it has played key roles, however, the abstract is defined as the concrete's opposite, and as such associated with the noncorporeal and unparticularized. This brings us back to the oddness of reading Johnson's anecdote as a response to abstraction. What could be more of a corporeal experience than "parts of [another's] body disappear[ing] into [one's] mouth"? And what could be more irreducibly particular than what Emmanuel Levinas calls the "face of the other"?[9] Yet the cheerful visage we find stamped not just on food but on virtually every type of artifact in the capitalist economy, from Band-Aids to diapers to text messages, is obviously not a representation of a specific, unrepeatable individual, nor even the idea of one. The smiley face rather expresses the face of no one in particular, or the averaged-out, dedifferentiated face of a generic anyone. It calls up an idea of being stripped of all determinate qualities and reduced to its simplest form

through an implicit act of "social" equalization, relating every face to the totality of all faces.

The simplest abstractions are the achievements of the most highly developed societies, Marx notes in the *Grundrisse*, if in a way that their use in political economy often obscures. He elaborates this claim with the example of "labour" or "labour as such": a "general" abstraction arising "only in the midst of the richest possible concrete development, where one thing appears as common . . . to all" and thus "ceases to be thinkable in a particular form alone."[10] There are thus determinate conditions for the emergence of the abstract category of "labour in general," which Marx credits Adam Smith for introducing into political economy, despite its "validity—precisely because of [its] abstractness—for all epochs."[11] At the same time, Marx suggests that there are also historical conditions under which "labour in general" not only becomes mentally conceivable but also "true in practice":

> Indifference toward specific labours conforms to a form of society in which individuals can with ease transfer from one labour to another, and where the specific kind is a matter of chance for them, hence of indifference. . . . Such a state of affairs is at its most developed in the most modern form of existence of bourgeois society— in the United States. Here, then, for the first time, the point of departure of modern economics, namely the abstraction of the category "labour," "labour as such," labour pure and simple, becomes true in practice. The simplest abstraction, then, which modern economics places at the head of its discussions, and which expresses an immeasurably ancient relation valid in all forms of society, nevertheless achieves practical truth as an abstraction only as a category of the most modern society.[12]

A similar thing could be said about the smiley face, which first achieves its "practical truth" not in rapidly industrializing, nineteenth-century England but in the postwar United States during the golden age of capitalism. Designed in 1963 by the adman Harvey Ball, who was hired to create a logo to improve customer service and employee cooperation for the State Mutual Life Assurance Company of America (now Allmerica Financial Corporation) after a series of disorienting mergers and takeovers, the smiley face quickly migrated out of workplace culture into sixties consumer culture and counterculture.[13] To this day, numerous subcultures continue to appropriate the corporate version of the smiley and endow it

with ironic or subversive inflections. Whether as the bloodstained smiley of Allan Moore's *Watchmen* or the relentlessly affirmative "rollback" smiley of Walmart, however, the smiley always confronts us with an image of an eerily abstracted being. Is the disturbing effect of this icon's averaged-out appearance something we should chalk up to a long-standing American phobia about the loss of individual distinction to social homogenization? Or could it be registering something else?

Finally, if it is the idea of eating an abstraction that generates visceral sensations for Johnson, what about the similarly unsettling idea of having sex with one? We are asked to imagine this in *Music for Porn* (2012), a book of war poetry in which Rob Halpern depicts "the soldier's body *hieroglyph of value*" as simultaneously "spirit" and "beef."[14] For Halpern, the body of The Soldier is abstracted at multiple levels: as a national representation "severed from the real bodies of military men"; as a corpse removed from public view; as a homosexual icon or "exaggerated type like one you'd see in gay porn from the 70s"; and as a "*hieroglyph*" or allegory of value.[15] At the same time, this abstract-allegorical body is incongruously presented as the visceral object of the poet's lust, sexual fantasy, and a range of conflicting emotions: love, hate, disgust, shame. In evoking "the soldier as neither a thing nor an idea, but rather a relation *like capital like value* visible and measurable only in the effects it achieves and the affects it arouses," *Music for Porn* not only insists on the compatibility but stages the interpenetration of queer and Marxist thought.[16]

This chapter focuses on how Halpern's queer take on visceral abstraction draws from an explicit engagement with Marx's concept of abstract labor and his notoriously tricky description of it as "value-forming substance."[17] We therefore need to take a closer look at Marx's concept.[18]

Abstract Labor

In the capitalist production process, existing value in the form of constant capital, or what Marx at times calls dead labor, is brought together with variable capital, or living labor. Only living labor has the capacity to produce additional value while also carrying over the value of the commodities functioning as means of production, such as machines and raw materials, into the value of the product. Capitalist production is thus a process of "valorization" that takes place only when the two things whose separation forms its basic precondition, labor power and means of production, are rejoined through the privileged and expanded agency of capital. Yet the

values valorized in production also have to be "realized" through their conversion into the independent and necessary form of value, which is money.[19] As Jim Kincaid glosses:

> Value is not realized, made *real*, until the commodity has been sold for money—and that depends on its use-value finding a matching demand on the market. If no one wants to buy the commodity, or if those who want or need it lack the necessary cash to buy it, then some or all the labour that went into making that commodity is negated, wasted, annulled, does not achieve real existence. Value exists only potentially until the sale is made, and the final metamorphosis of commodity into money has been effected.[20]

The realization of value is an unstable process that depends on the uncoordinated actions of a vast number of independently acting, often unknowingly interconnected actors. It is here where the "suprasensible or social" phenomenon of abstract labor first emerges, co-constituted in both production and circulation.[21]

Abstract labor contains a fundamental tension: it is the form that *social* labor assumes in a society based on the *private* organization of production and circulation. As Marx states in the *Grundrisse*, because capitalist production is not immediately organized by society but rather consists of private, independently expended acts of labor, "the social character of production is *posited* only *post festum* with the elevation of products to exchange values and the exchange of these exchange values."[22] Abstract labor therefore reflects what Ernest Mandel calls the basic contradiction of capitalism: "that goods are at one and the same time the product of social labour and private labour; that the social character of the private labour spent in their production cannot be immediately and directly established; and that *commodities must circulate*, their value must be *realized*, before we can know the proportion of private labour expended in their production that is recognized as social labour."[23]

The abstraction of labor is not an abstraction by thought, but rather by the collective practice of actors, unknowingly.[24] As Marx puts it in a passage where he famously describes value as a "social hieroglyph," "Men do not . . . bring the products of their labour into relation with each other as values *because they see* these objects . . . as the material integuments of homogeneous human labour." Rather, he notes, "The reverse is true: *by* equating their different products to each other in exchange as values, they equate their different kinds of labour as human labour. They do this

without being aware of it."[25] Abstract labor, the "value-forming substance" Marx uncovers through his analysis of value's necessary appearance as exchange-value or money, is thus the achievement of the empirical behaviors of persons, even if it is produced, as Marx likes to say, "behind their backs."[26] While multiple commentators have stressed this point, Georg Lukács puts it in an especially compelling way in his late unfinished work, *The Ontology of Social Being*:

> [The emergence of the "average character of labour"] . . . is not a matter of mere knowledge . . . but rather the emergence of a new ontological category of labour itself in the course of its increasing socialization, which only much later is brought into consciousness. Socially necessary (and therefore ipso facto abstract) labour is also a reality, an aspect of the ontology of social being, an achieved real abstraction in real objects, quite independent of whether this is achieved by consciousness or not. In the nineteenth century, millions of independent artisans experienced the effects of this abstraction of socially necessary labour as their own ruin, i.e. they experienced in practice the concrete consequences, without having any suspicion that what they were facing was an achieved abstraction of the social process; this abstraction has the same ontological rigor of facticity as a car that runs you over.[27]

Abstract value-forming labor—a socially *specific* kind of labor—"has the same ontological rigor of facticity as a car that runs you over." Yet it is difficult to grasp because it is what Marx calls "suprasensible or social" and also, as Nicole Pepperell stresses, "emergent," arising "as an indirect, aggregate effect of complex interactions among many different sorts of social practices, none of which is explicitly oriented to achieving this specific overall effect."[28] Understood as "value-forming substance," abstract labor is also conceptually slippery because of the seemingly "backwards" way Marx derives it from his analysis of exchange-value and money. When we think of how "labor" might form, in the sense of becoming or generating, the "substance" of value, we tend to assume its ontological priority. First, labor; then, value. But *abstract* labor—the labor that for Marx specifically constitutes value, as opposed to material wealth—is not labor physically expended by workers in real time in heterogeneous and uncoordinated acts of production. It is rather a "relation of social validation" established retroactively in exchange, which fulfills the actual function of relating independently performed labors to the total labor of society.[29]

It is of course true that abstract or what Marx also calls "socially necessary" labor ends up having a palpable effect on concrete, actually expended labor, insofar as it comes to inform, via the mediations of the wage and other, similarly emergent capitalist abstractions like the average rate of profit, how concrete labor is practically organized, whether or not it is intensified in what lines of production, how much or little of it hired, and under what conditions.[30] And so it is not the case that socially necessary labor, simply in being posited retroactively in circulation rather than expended in the real time of production, is somehow disconnected from empirical labor. To forestall this impression, Diane Elson argues that abstract and concrete labor are not generic "kinds" but rather "aspects" of capitalist labor mediating each other, though with the former aspect dominating the latter.[31] Yet abstract value-forming labor is never identical to concrete or actually expended labor, just as it is not the same thing as the abstract *concept* of "labour in general" or "labour pure and simple." As Michael Heinrich argues, what makes "concrete acts of expended labor *count* as a particular quantum of value-constituting abstract labor, or . . . *valid* as a particular quantum of abstract labor, and therefore as an element of the total labor of society" is the mediation of the individual labor of isolated producers to the total labor of society.[32] In societies where producers do not explicitly coordinate their acts of production, this mediation happens only when their products are exchanged. But although the mediations of exchange have the "formal ability to weave a web of social coherence among the mass of private individuals all acting independently of another," as Alfred Sohn-Rethel notes, the socializing effects of their activities *also come to appear to them as an independent force not of their own making*, which oppositionally confronts them as a "second nature."[33] As Marx puts it, referring to the rise of the world market, what appears is not just the "connection of the individual with all, but at the same time also the independence of this connection from the individual."[34]

The "*connection of the individual with all, but at the same time also the independence of this connection from the individual*": this is what I would argue we "see" when faced with the capitalist smiley. It is perhaps the best explanation for why this utterly banal image nonetheless has the power to unsettle us. "In a society in which individual activities have a *private* character, and in which therefore the interests of individuals are divided and counterposed," writes Lucio Colletti, "the moment of *social unity* can only be realized in the form of an *abstract equalization*."[35] Abstract labor, the result of this equalization, is therefore labor "said to be

equal or *social*, not because it genuinely belongs to *everyone* and hence mediates between the individuals but because it belongs to *nobody* and is obtained by ignoring the real inequalities between the individuals."[36] Or as I. I. Rubin puts it, abstract labor "becomes social labour *only* as impersonal and homogeneous labour."[37] I would therefore suggest that the visceral feelings provoked by the smiley are underpinned by something more profound than dread about the erasure of individual particularity. For the smiley is not just an image of abstract personhood but also an uncanny personification of the collectively achieved abstractions of the capitalist economy: abstract labor, value, capital. Its unflinching gaze as we encounter it daily as a cookie, on a price tag, or in a comic book, confronts us with the conditions of generalized commodity production.

Let us deepen our discussion of Marx's concept of abstract labor a little further before turning to *Music for Porn*. We have seen that for Marx, abstract labor qua "value-forming substance" is a form of labor specific to capitalist production and its peculiarly asocial sociality.[38] Patrick Murray refers to this labor as "practically abstract" labor and meticulously disambiguates it from two other versions of abstract labor in Marx's writing: the phenomenological account of universal human labor as a "metabolic interaction between man and nature," which Marx discusses briefly in chapter 7 of the first volume; and more significantly, since it is more easily confused with socially necessary labor, the analytically abstract category of "labour in general" that Marx credits Smith for introducing into political economy in the *Grundrisse*.[39] Though historically determinate in origin, this abstraction has a legitimate, general applicability to the labor of all societies in a way that implies—and for Murray, permits—its conflation with "simple" physiological labor.[40] As labor from which all concrete qualities have been subtracted and reduced to a hypothetical, minimal expenditure of calories, "simple" labor is also a mental abstraction. Although we can easily imagine it, no labor in such reduced form actually exists (although, as Murray notes, the concept of such labor is logically presupposed by the concept of "labor in general").[41]

Marx's concept of abstract, value-forming labor is thus neither "human labour in general" nor the concept of "simple" physiological labor that the former logically entails. Confusions nonetheless arise because of the infamously contradictory first chapter on the commodity in volume 1 of *Capital*, where Marx repeatedly refers to abstract, value-forming labor in exactly these terms: as "an expenditure of human labour power, in the physiological sense"; as "human labour pure and simple, the expenditure

of human labour in general"; as "simple average labour"; as the "expenditure of simple labour-power, i.e. of the labour-power possessed in his bodily organism by every ordinary man, on the average, without being developed in any special way."[42]

The contradiction comes to a head in "The Value-Form, or Exchange-Value," section 3 of chapter 1, where we are confronted with diametrically opposed accounts of value-creating labor placed in almost overlapping proximity:

> It is only the expression of equivalence between different sorts of commodities which brings to view the specific character of value-creating labour, by actually reducing the different kinds of labour embedded in the different kinds of commodity to their common quality of being human labour in general.
>
> However, it is not enough to express the specific character of the labour which goes to make up the value of the linen. Human labour-power in its fluid state, or human labour, creates value, but is not itself value. It becomes value in its coagulated state, in objective form. The value of the linen as a congealed mass of human labour can be expressed only as an "objectivity" [*Gegenständlichkeit*], a thing which is materially different from the linen and yet common to the linen and all other commodities.[43]

The first of the two paragraphs tells us that the "specific character of value-creating labour," which Marx has already referred to several times as "abstract labour," is brought to view "only" through "the expression of equivalence" that "actually reduces" different labors to a social average. This evokes what we have seen Marx's commentators call the real or practical abstraction of the capitalist realization process, the retroactive positing of social labor through the transformation of independently produced commodities into money in exchange. So far, so clear.

The ambiguity enters with the next paragraph, which, in an unannounced way, subtly shifts its purview from labor rendered abstract in exchange, in which the becoming-value of labor entails the social equalization of multiple, independently performed labors (hence "expression of equivalence") to what seems to be a very different kind of abstraction of labor in production, in which the becoming-value of labor involves something like its transformation from a liquid to a solid state (hence "expressed only as an 'objectivity'"). This is where Marx describes value, previously described as a form of *abstract*, "suprasensible or social" labor,

as a "*congealed mass* of human labor."[44] Startling in its incongruity with Marx's earlier presentation of value-forming labor as socially averaged or equalized labor, the phrase now invites the reader to regard "value-forming substance" as a *physical* substance, which in turn seems explicitly to invite a view of value-constituting labor as departicularized, "simple" physiological labor.[45]

How do we account for this seemingly contradictory juxtaposition of "suprasensible or social" *and* sensuously material accounts of abstract, value-forming labor? Noting the difficulty of clearly distinguishing Marx's own point of view at moments from those of the economists he critiques, commentators who focus on what Kincaid calls the "performative dimension" of *Capital* might invite us to attribute it—as they tend to attribute the tonal ambiguity, stylistic assertiveness, and occasional theoretical inconsistency of the early chapters of the first volume overall—to Marx's often deceptively unmarked use of irony or what Dominick LaCapra calls "double-voicing."[46] It is true that in a manner akin to Hegel's way of inhabiting the perspectives of the various shapes of consciousness in *Phenomenology* (which Katrin Pahl suggestively describes as a kind of "free indirect discourse"), Marx often ventriloquizes the perspectives of the "pundits of economics" to mock them.[47] Critics such as Robert Paul Wolff accordingly follow the early lead of Edmund Wilson in reading the first chapter of *Capital* as a "burlesque" of political economy as well as of the idealist metaphysics that tacitly inform its major concepts.[48] In a similar vein, Murray argues that Marx's counterintuitive alignments of abstract labor in chapter 1 with "substance," "embodiment," "crystals" and "congealed labor" are aggressively "taunting" and perhaps even meant to "shock" the reader.[49] Indeed, Murray suggests that one of Marx's earliest descriptions of abstract labor, as the "'residue' that remains once all the concrete, natural properties of commodities have been abstracted away," is a satire of "Descartes's famous derivation of material substance (*res extensa*) from his analysis of the bit-turned-blob of wax at the end of the second Meditation."[50] Pepperell pushes this logic furthest by reading Marx's early chapters as satirical theater: as a series of "plays" containing smaller "playlets" in which Marx amplifies his parody of the arguments of bourgeois economy by aligning them with consciousness's various claims to certainty in Hegel's *Phenomenology*.[51] The voice in chapter 1 describing "abstract labour" in that strangely universal, un-Marxian way as "human labour, pure and simple" and "value" as a strangely thinglike "congealed mass of human labor" might thus be that of an economic or

metaphysical point of view that Marx is only temporarily ventriloquizing in order to satirize.[52]

Reading Marx's writing in this section as satirically double-voiced (and therefore booby-trapped) would certainly be a way to explain the contradictory characterizations of abstract, value-forming labor in the two paragraphs above. If not a parodic echo of the story of melting/hardening wax in Descartes's derivation of res extensa, as Murray suggests, for instance, one might hear in the second paragraph's reference to value as a "congealed mass of human labor" a parody of Ricardo's embodied-labor theory of value. Yet the meaning of the contradiction as such deserves more attention. Highlighting a metamorphosis in its form, the distinction between "fluid" and "coagulated" labor in the second paragraph is fairly clear: the former refers to living labor deployed as variable capital in the production process, whereas the latter corresponds to dead or past labor—that is, previously produced, realized, or fixed value—in the form of commodities functioning as constant capital or means of production. The second paragraph emphasizes that the former "creates" value, while the latter simply is or "becomes" value (Marx refers to this "previously worked up" labor as "crystallized" or "congealed" labor repeatedly elsewhere in *Capital* and in many other writings). But what is the relation of the abstract labor/value relation in the production process, once we recognize its interacting facets of "fluid" living labor and "congealed" labor, to the abstract labor/value relation described in the first paragraph about exchange? Is Marx presenting accounts of the *same* abstraction or becoming-value of labor from the dual perspectives of circulation and production, as if to reflect the "twofold" nature of labor itself—abstract and concrete—under conditions of generalized commodity production?[53] Are these intended to emphasize distinct yet fundamentally continuous ways in which labor finds itself abstracted by the "law of value," one corresponding to the realization of exchange value, the other to the creation of use values? If there are in fact two distinct concepts of the becoming-abstract or value of labor here, what is the relation between the two, and what does *that* relation tell us about the "specific character of value-creating labour"?

One thing we can be certain about is that the passage's tone, like that of the entire chapter, is hard to pin down. Marx's diction changes midstream, making an unannounced shift from the dry, anti-imagistic, theoretical language of political economy used to describe value-creating labor in the first paragraph ("It is only the expression of equivalence between different sorts of commodities which brings to view the specific character of

value-creating labour") to the sensuously material language of fluidity and viscosity used to describe it in the second. Passages like the second make it easier to understand the otherwise puzzling proliferation of "naturalist" or "substantialist" approaches to Marx's "value theory of labour."[54] Finally, while Marx's language of congealing substance is empirical or even "materialist" in the vulgar sense (where "matter" means visible, tangible, physical substance), Marx's *use* of that language is imagistic or figurative. Regardless of the ambiguity surrounding the characterization of value-constituting labor in the two paragraphs above, by the end we are left with that labor reframed by metaphors that make value-creating labor *seem like* generic, transhistorical labor.[55] Indeed, these metaphors leave the reader with a conspicuously un-Marxian impression: that as a "crystal" of labor lodged unchanging in the commodity, value is a natural, intrinsic, embodied property of the individual commodity as opposed to an emergent, historically contingent relation.

While sharing the interest of LaCapra, Wolff, Kincaid, Murray, and Pepperell in recovering *Capital*'s affective and specifically satirical dimension, Keston Sutherland takes a different tack in reading this passage. Instead of arguing that Marx's description of value as a "congealed mass"—Ben Fowkes's translation of "bloße Gallerte"—is problematically substantialist, or so grossly materialist that we might suspect it of being a parody of Descartes or Ricardo, Sutherland argues that the term is too conceptually *abstract*; that like Samuel Moore and Edward Aveling's translation of the same phrase, "mere congelation of homogeneous labor," it does a disservice to the visceral impact of Marx's "bloße Gallerte unterschiedsloser menschlicher Arbeit" by erasing the specificity of Gallerte: a gelatinous condiment made from the "meat, bone, [and] connective tissue" of various animals.[56] Sutherland writes:

> Gallerte [unlike "congelation"] is not an abstract noun. Gallerte is now, and was when Marx used it, the name not of a process like freezing or coagulating, but of a specific commodity. Marx's German readers will not only have bought Gallerte, they will have eaten it; and in using the name of this particular commodity to describe not "homogeneous" but, on the contrary, "unterschiedslose," that is, "undifferentiated" human labour, Marx's intention is not simply to educate his readers but also to disgust them.

As a word referring to a more richly determined artifact, "Gallerte" as opposed to "congelation" undeniably bestows concreteness to Marx's

unparticularized, perversely substance-like image for the objectivity of value. In both cases, however, the imagery of *substance* remains fundamentally the same—and the use of that imagery remains fundamentally catachrestic.[57]

The question of whether "Gallerte" is more true to the spirit of *Capital* than "congelation" thus seems less important than the question of why Marx is using such a strained or anti-intuitive metaphor—physical matter—for the concept of abstract, value-constituting labor to begin with. What is the reason for using an image that makes a specifically capitalist abstraction (and specifically Marxist theoretical concept), socially necessary labor, sound confusingly *like* simple physiological human labor? Is it because there is no existing terminology other than that of substance to express the "objectivity" of "suprasensible or social" value?[58] To rephrase the question, borrowing language from Wolff, why *must* Marx mobilize catachresis to capture the peculiar ontology of capitalist abstractions?[59]

The Soldier's Body

Music for Porn's treatment of the male soldier's body as an eroticized abstraction—but also, quite specifically, a capitalist abstraction—has its own unique way of bearing on questions raised by Marx's presentation of abstract labor. Although military work is typically nonproductive (which does not rule out its use in enabling value-productive labor to take place), the body of the soldier in Halpern's text is so tightly coupled with "value" that the terms almost always appear together: "Value clings to the soldier like self-preservation *a film of cash*."[60] (Italics in all lines of Halpern's poetry I will be citing are his original italics).

This body enters the world of the poem already "working overtime as allegory." Prior to being reconscripted by Halpern to explore capitalist abstractions and their material effects, his soldier is already The Soldier: a "phony apparition"; "an exaggerated type"; a "comic strip character" with features as "amplified and distorted" as "those of the capitalist, the worker, the terrorist" and who "might appear among the Village People, that band of iconic queer bodies: Indian Chief, Construction Worker, Leatherman, Cowboy, Cop, Soldier."[61] As *Music for Porn* suggests, there is a further complexity to this allegorical abstractness, since the official symbolism The Soldier provides for the coherence of the nation depends on his being a body for use. While the soldier's labor is thus like that of the sex worker, Halpern suggests that his contractual agreement to being

potentially used up entirely makes him that much more of a "meat man," "purest meat," "*bare life, dead meat.*" Indeed, one of the other things for which Halpern's soldier functions as allegory is a "corpse"—moreover, one that the nation hygienically hides from view. Qua "sacrifice," the soldier's *death* can be brought into the public sphere and mourned, but ironically not the soldier's *body*, qua "corpse."[62]

Yet at every moment where we might expect *Music for Porn* to rescue this repeatedly abstracted and occulted body by insisting on its concreteness as visceral object of the poet's lust, the description flips back into a testimony to its abstractness. As if to refuse to let us forget the ideological barring of the combatant's corpse from public view by bringing the act of barring itself to the fore, "the body" in the poem is a perpetually "withdrawn" body, subsumed into economic abstractions almost immediately on mention: "The body required to ensure the nation's vision of freedom and democracy is a dead one *note the nimbus around his withdrawn corpse, function of pure exchange*"; "My soldier's no match for this, he's too real, being capital's proper corpus, extension of its management and concern." First expropriated as sign from the bodies of real combatants who no longer control its dissemination or meaning, only to be "removed from public circulation" as corpse, it comes as no surprise that the soldier's body seems available to stand in for virtually anything ("*function of pure exchange*"). He can even seem like the agent of his "own" alienation and ensuing symbolic availability: "Having cut himself loose from the social relations that make him what he is, his figure stands in for universal profit."[63]

"Universal profit" is the organizing principle of a society whose wars have helped stave off economic crisis and whose official military culture surreptitiously conscripts—even while explicitly proscribing—male homoerotic affect and camaraderie, "pressing it into the service of nation building," as Halpern notes about Whitman's *Drum-Taps*. The instrumental use of "queer affections . . . to bind our national interests" thus results in the denial of the very body for which homoerotic desire is aroused, even as that body becomes further sublimated, by way of The Soldier's more conventional symbolic work, into transcendent concepts like democracy and freedom. It is this particular elision of the soldier's body, in contradictory lockstep with its simultaneous exploitation *and* eroticization for national symbolic ends, that Halpern calls "unbearable,"[64] and which his experiment in making poetry into an accompaniment to pornography tries to undo representationally by countering its abstraction with . . . more abstraction. Rather than insist on the concretely physical as every abstraction's obscured

truth, as seems to be the prevailing move in so much contemporary theory, *Music for Porn* is poetry about war in which the soldier's body is phantas-matically reclaimed precisely through the mediation of allegory and indeed by doubling down on its use.

The political difficulty of this project is formally reflected in *Music for Porn*'s unstable status with respect to genre as it alternates among se-quences of stark, carefully patterned objectivist lyrics (some collaged from site reports and military intelligence interviews), prose poems in a more discursive vein, and essays that, in directly addressing the theoret-ical aims of the lyric and prose poems, enable Halpern to fold an account of the book's making into the book. The theoretical essays are haunted, however, by an italicized subdiscourse that implicitly questions the validity of the statements to which they cling by whispering substitutable expres-sions: "vehicle of exchange and pleasure *receptacle of cash and cum*"; "militarization *financialization*"; "phony apparition *fragile appearance*"; "allegories *zombies of living labor*"; "ghost *money*."[65] The main effect of these phrases is that of correcting or even undoing the concepts immedi-ately preceding them, even when their function also seems to be expli-cating or elaborating them further:

> I want to undo Whitman's militarized vision *democracy fulfilled* by betraying its perversity. And yet my poems become evermore dis-torted, frustrated, and perverted in the process *turned away from their impossible aim* because their own utopian longings are blocked by current conditions under which a demilitarized world is incon-ceivable *depressing conclusion of this research*.[66]

Capitalist abstractions and their visceral effects intermingle constantly with the language of sex, with concepts like circulation, overproduction, and trade imbalance mixed into descriptions of blow jobs: "The feel of his balls in my mouth is pretty hot, and his theory of agrarian development in the South is even hotter." The coupling of the sexually explicit with forms like value and capital is especially prominent: "Value clings to the soldier like self-preservation *a film of cash, relation of no relation* betraying my love for the death drive"; "Just as he disavows the debauchery of capital *whose servant he is* my soldier becomes evermore debauched *sinks below the hemisphere of sense, as I might sink my nose in his ass* down along the precipitous fault of old imperialisms."[67] More importantly, this "interpenetration of corpus and finance" by which "global processes . . . collide with the body's intimate recesses" is reinforced by an image of a

congealing substance exactly identical to the kind used by Marx and high-lighted in Sutherland's reading of Marx. (In what follows, I underline the sections of Halpern's poetry I wish to emphasize; all italics are in the original text).

> The hole a weapon makes, where global processes *accumulation by dispossession*, neoliberal austerity, environmental degradation, prof-itable incarceration collide with the body's intimate recesses all my desires and repulsions externalized, obdurate and opaque to my cog-nition. <u>Residues of living labor congeal in such bodies where love hardens with the muscle</u> *interpenetration of corpus and finance*.[68]

Hardening here refers not just to sexual arousal or to the objectification of abstract labor in/as value (a process for whose expression no concept other than that of congelation seems available) but to their perverse "in-terpenetration," as if this is what truly constitutes the poem's pornographic dimension. The imagery of hardening and congealing in association with the interpenetration of sexual and economic registers recurs repeatedly throughout *Music for Porn*. Consider the following instances:

> I mean the soldier, he's my sick muse and deserves more compas-sion than I appear to offer, but <u>he's already hardened into allegory</u>.

> So I go on thinking about . . . this poem, how it goes on and on and on because the moment to realize has become my job, my filth, a collective residue, <u>a thin film of integument that hardens</u> around a body interred behind the wall, or buried in the yard, where it goes on secreting the mystery of my well-being.

> Ghostly void or <u>dead zone around my body // Collects a hyaline film and my mucous hardens</u> / Yielding new sugars upon decomposition sordid / Shapes assume their own lost object

> Being is a <u>value-slope, a residue of aura hardening</u> inside refurbished Gulf War mat obstruction.

> Thus the spirit's wiped clean, purged, <u>leaving this residue of life, a hardened edge of mucous and bile</u>. Like a film of cash, yr hot sol-dier jizz, never again on earth becoming.

> <u>Nature hardens</u> in the money form *whore's make-up soldier's thighs*

> <u>Nucleus of time crystallizes</u> in a lug way down deep inside // My soldier's groin goes deeper still

My soldier is the narrative of these disjunctions . . . eternal integument _hardened skin_ around a liquidated meaning, as if his hardening alone could arrest these processes of decay

Strewn in fields of waste, organs sensing under siege, <u>mere shadow case of value, a hardened rind</u>, or money form, whatever remains when you stop believing it.

Time itself, having already become <u>a hardened artifact of the system</u>, renders my orgasm co-extensive with the demands of production, but this is neither true nor false.

Hazy eros _residue of money_ hovers around this figure, and <u>settles on my skin</u>. I can't wash myself of its <u>thick condensation</u>.

And now, as the rain keeps falling on this deserted town, my <u>social relations cohere</u> around all these militiamen I want to fuck inside abstracted huts where no one lives anymore.

My soldier thus becomes my swan, my muse, my washed-up whore. <u>Like an allegory, he hardens around all our abstract relations</u> _values_ assuming a shape around history's contusions and contradictions, a scar where my alienable form has been hygienically sutured to the loss he represents.

<u>Aura concentrates</u> in the figure of the fallen soldier _so attractive so repulsive_[69]

Note that for the most part, the entities described as hardening or congealing are conspicuously intangible: "time," "eros," "aura," "social relations," "void," "value" or "value-slope," "allegory."[70] Redoubling the "abuse" of the already paradoxical metaphor of likening _body_ to _value_, these intangibles are furthermore endowed with qualities that underscore their ethereality: the "eros" that condenses is a "_hazy_ eros"; the "value" that becomes a "hardened rind" is a "_mere shadow case_ of value"; the "void" that "collects a hyaline film" is a "_ghostly_ void."[71] As if to replicate Marx's similarly catachrestic descriptions of abstract labor and value, the imagery of congealing in _Music for Porn_ is applied predominantly to abstractions, and especially capitalist abstractions. The abstract noun "abstraction" itself repeatedly appears in the poem as continuous with "value" and "allegory": "With the militarization _financialization_ of daily life, <u>lyric is caught up in these abstractions</u> _value credit debt_ as overproduction

penetrates the soldier's body and weds it strangely to my own *radical discontinuity of flesh and world that the poem longs to bridge*"; "Like an allegory, he hardens around all our abstract relations *values* assuming a shape around history's contusions and contradictions."[72]

"Value," the most "abstract" of Halpern's abstractions, is also the one most frequently described with the stereotypically "concrete" language of solidifying matter. Conversely, *Music for Porn* abounds with names of viscous fluids—"jizz," "glue," "sap," "cum," "mucous," "ejaculate," "plasma"—presented in the *already hardened* forms of "film," "laminate," "veneer," "trace," or "residue."[73] While both "glue" and the social relation "value" appear as these "distillations of capital," only abstractions like the latter are depicted as actively congealing.[74] Why does this admittedly subtle difference matter? Why in other words represent "value," "value-slope," "allegory," and "aura" in the process of "hardening" before us as if they were physical substances *like* glue: a viscous substance whose entire purpose is to harden but that in this poem surprisingly does not?

With *Music for Porn*'s repeated return to the functions performed by the "soldier's body *hieroglyph of value*," as we see it put to the task of shoring up entities such as the nation, the public sphere, imperialism, finance, the prison system, and homophobia, we might start to suspect that one reason both Halpern and Marx make use of the same catachrestic image of congealing substance as a metaphor for value is to underscore the *socially binding action of capitalist abstractions*. And more specifically, to emphasize the synthetic or *plasticizing* action of an abstraction like value—the way it palpably shapes the empirical world of collective activity to which it belongs and in which it acts.[75] This view stands in vivid contrast to both the idea of value as an inert substance residing in the individual commodity after its production and forming one of its natural properties (as in the embodied-labor theories of value of Smith and Ricardo, who as Marx notes, neglect "the form of value which in fact turns value into exchange-value") and also the idea of value as a "void" or ontologically empty form constituted entirely in the exchange process (as in some versions of Marxist value-form theory, which, like the nineteenth-century neomercantilisms Marx describes in *Capital*, run the risk of "see[ing] in value *only* the social form, or rather its insubstantial semblance").[76] If the former "overlook[s] the specificity of the value-*form*" (which is acquired in the exchange of already produced commodities for money), the latter overlooks its social "*substance*" (which is acquired in the production process, through the interaction of living and dead labor).[77]

Value, as depicted with strikingly materialist imagery in both Halpern and Marx, is neither an inert "crystal" created in production nor a pure form of circulation disconnected from everyday activity (although, as Beverly Best stresses, it is inherent to the mechanism of abstraction, "core function of the capitalist mode of production," that value take on the appearance of this autonomy).[78] Hence only catachrestic language seems adequate to both authors for objectively capturing the contradictions of value and the world that it and other capitalist abstractions bring into being.[79] Like socially necessary labor, value is neither a thing-like substance, nor an "insubstantial semblance" or contentless, frictionless form, but a "suprasensible or social" relationship whose representation requires a constant crossing of the realms of "the spirit" and "the beef." Value thus resembles the generic Animal surreally commingling with real animals below, in Marx's allegory of money as the freestanding expression of exchange value:

> It is as if, in addition to lions, tigers, hares, and all other really existing animals which together constitute the various families, species, subspecies, etc., of the animal kingdom, *the animal* would also exist, the individual incarnation of the entire animal kingdom.[80]

Fabular yet scientific (we hear echoes of both Aesop and Darwin), this portrait of a capitalist abstraction never fails to give me the willies, for reasons possibly akin to those which make the idea of eating a smiley unnerving to Johnson.

Highlighting the plasticizing effects of capitalist abstractions, or how they remain continuous with concrete activities while seeming autonomous, Halpern's use of catachresis to describe the abstract-allegorical work of the soldier's body in *Music for Porn* helps clarify Marx's stake in his own use of catachresis to describe "value-forming substance" in "The Value Form." There is a key difference, however, in how the agency of abstraction gets figured. For in contrast to Marx's description of the value expressed in the commodity's exchange value as Gallerte, animal parts boiled and then cooled to harden into a semisolid jelly, the dominant image in *Music for Porn* is not that of a *material substance* congealing *into* something. It is rather that of an *intangible abstraction*, congealing *around* a *nothing*, or void (my underlining in the following):

> The consistency of the situation hangs on the body, being <u>a hole around which everything that appears appears to cohere.</u>

And now, as the rain keeps falling on this <u>deserted</u> town, <u>my social relations cohere</u> around all these militiamen I want to fuck <u>inside abstracted huts where no one lives anymore.</u>

Sensing its own decay, value <u>clings</u> with fierce tenacity to the very things *bodies* <u>that will be sacrificed for it.</u>

Even after swallowing his piss, I still see myself everywhere I look, a series of seemingly endless grammatical subordinations, <u>circling the withdrawn violence</u> that structures the limits of our perceptual field, a <u>blank</u> in my own dislocation.

note the <u>nimbus around his withdrawn corpse</u>, function of pure exchange

A whole metaphorics of love and war *my phalynx of clichés* <u>converge around his vulnerability to penetration.</u>[81]

As if to suggest a portrait of catachresis itself, understood as a figurative operation based on a "lexical lacuna," or the "absence of an original proper term which has been lost or never existed," everything that "cohere[s]" or "converge[s]" in the lines above does so around a "hole."[82] Social relations cohere in a deserted place. Value clings to what will eventually be sacrificed in its name. A nimbus collects around the space left empty by a withdrawn corpse. Substitutions circle around a blank. Metaphorics converge around a wound or orifice (evoked by "vulnerability to penetration"). And note, again, that what coheres *around* these sites of past, present, and future absence is not a tangible substance but an abstraction: "everything," "social relations," "value," "substitutions," "metaphorics."

Is this imagery of abstraction hardening around nothing an allegory of the "ontological emptiness which lies at the heart of capitalism," which is the inherent emptiness of the value-form?[83] Not exactly, since as with the other abstractions above—"social relations," "everything"—its insistence is on "value" as a "suprasensible or social" *substance* in the process of plasticizing. Moreover, the void around which this synthetic action takes place is not an "ontological emptiness," but a space that Halpern is careful to show as having been *rendered* empty through the activity of social actors, from something in it having been actively *withdrawn*. I therefore think that the image of the "hole" or "blank" around which social substance is shown cohering in *Music for Porn* is summoned to metaphorically counteract our impulse to triumphantly uncover a thingly substance—as opposed

to an emergent or unintended social relationship—as the hidden truth of every abstraction. At the same time, the image of matter congealing seems contrapuntally deployed to combat our temptation to regard the abstractions in *Music for Porn* as ideal or immaterial: that, because the "soldier's body *hieroglyph of value*" is an abstraction cohering around nothing, as opposed to a kernel of matter obscured by a shell of abstraction, it is therefore somehow less real than a "car that runs you over."

Applied to "value" in a way intended to produce a visceral response, the almost cartoonishly "concrete" image of hardening substance is thus put to work like a seal or caulk against the idea, revived by many of today's "new materialisms," that abstractions can only be thought-induced mystifications of particularity (and as such, mystifications that can be simply dissolved or corrected *with* thought). Calling attention to the oft-remarked tension between the concrete and abstract dimensions of *Capital* as well as to its own illicit coupling of poetry and theory, *Music for Porn*'s openly catachrestic poetics illuminate the stake of Marx's similarly catachrestic use of Gallerte/congelation, as a metaphorical *image* for the theoretical *concept* of abstract, value-constituting labor. But in addition to providing an exaggerated way of impeding dissemination of the popular conception that "abstract" means "unreal," the metaphor also implies that with the objective distortions of logic created by capitalism, its act of exaggeration is somehow *theoretically* necessary. In this manner, Halpern's use of catachresis dramatizes what Wolff, Kincaid, and others note Marx uses the "performative dimension" of *Capital* to dramatize: that an "abuse" of logic by the analyst—including the logic of equivalence and substitution underpinning metaphor—is required to show how the basic relations and operations of capital work.[84]

It also highlights another peculiarity of capitalist reproduction already visible in the passage from "The Value-Form." Although what makes capitalism distinctive is its historically unprecedented integration of production and circulation—starting from the worker's "free" exchange of labor power as a commodity, production and exchange mediate each other at every point—the two spheres often appear autonomous.[85] A kind of "abuse" begins to seem necessary to restore the fundamental connection between the two halves in representation, as evinced when we begin to suspect that Marx's references to labor "in a coagulated state" in *Capital* are a purposely catachrestic way of reminding us of the material effect that abstract labor, qua "relation of social validation" established in exchange, ends up having on labor used in production. Labor is abstracted

or socially homogenized by the practice of actors in *both* capitalist exchange and production, in *both* the realization of value and the valorization of value, but in different ways that seem to call for different registers of discourse (recall the shift in language of the two paragraphs from "The Value-Form" above). *Music for Porn* suggests that the effort to rejoin these languages, part of its larger effort to think labor as use value and exchange value together, will inevitably involve a poetics of catachresis.[86]

The visceral abstractions in *Capital* and *Music for Porn* finally direct our attention to a philosophical problem. Whatever value is said to be, one thing on which we can agree it is *not* is an inherent property of individual objects. This is strikingly true for "value" in all three of its registers. Moral values like "good" are most obviously projections of subjective evaluations that are ultimately expressions of the will to power, Friedrich Nietzsche argues. Similarly, if in a way that is less obvious, as Kant devotes the entire *Critique of Judgment* to showing, the "beautiful" is not a quality of things but a subjectively felt pleasure reflecting a harmonious relationship between the mental capacities of the judge, which in turn points to a relation between herself and other judges. Finally and least obviously of all—for here subjectivity and its misrecognitions are no longer relevant—a commodity's value is not a property that the individual commodity possesses. Nor is its magnitude determined by the amount of labor time an individual producer has expended on and thereby "stored" in the commodity. Value, as Marx repeatedly shows us, is a process and a complex, dynamic relationship among multiple actors.

Yet in a way also strikingly true across all its instances, value *cannot but be perceived and spoken of* as a quality of things. It is not illusory in the sense of being unreal or insubstantial, as Marx and Halpern draw on their exaggeratedly visceral images to underscore. Like the generic Animal mingling with specific animals, value moves with "material force" in the world alongside the human beings whose uncoordinated activities give rise to it.[87] Yet there is something illusory *about* value, in that it not only objectively but by necessity appears as something that it is not: an autonomous property of individual objects. If this apparitional quality is something commodity value shares in common with other kinds of value, the "visceral abstractions" in this chapter have a particularly vivid way of bringing it home to us.[88] Precisely by triggering crude and elemental feelings, Johnson's smiley face, Halpern's soldier's body, and Marx's Animal allegorize the catachresis of value, with an affective power mirroring the social power of all capitalist abstractions.

CHAPTER SIX

Rødland's Gimmick

1.

Something is obtruding. Something is sticking out of, through, or into something else. Hair extensions out of the mesh of a hanging wire basket. Wet toilet paper around the shoulders of a drenched, fully dressed man. The verb "to stick" is not fastidious about prepositions, but "on" might be the one to which it most frequently adheres. A toupee-like tuft of grasses on a graffiti-covered rock. Tiny coils of Silly String on a tasseled mortarboard cap. The Styrofoam sign "Our Wedding" on a densely looped carpet (Fig. 6.1).

Torbjørn Rødland's photographs present a comedy of stuck-on-ness. What types of objects tend to be described in this way? Garnishes, ornaments, frills: inessential aesthetic devices, often regarded as feminine. Wigs, clips, tiaras, fake nails: fetishes and the prosthetics of everyday gender performance. Afterthoughts, postscripts, appendices, codas, epilogues: discursive forms associated with hindsight. There is also of course the genre of the capitalist "sticker": tape cassette, bumper, promo, price. Not to mention the sticky substances that seem to be everywhere in Rødland's images.

From cake decoration to sale tag, what we stick on is usually intended to stick out—if mostly in ordinary, not necessarily disruptive ways. Indeed, things often seem to get stuck on "gratuitously", "haphazardly", "absent-mindedly," "unthinkingly," and almost always "belatedly." A meditation on the aesthetic logic of obtruding—on the spatial relation of

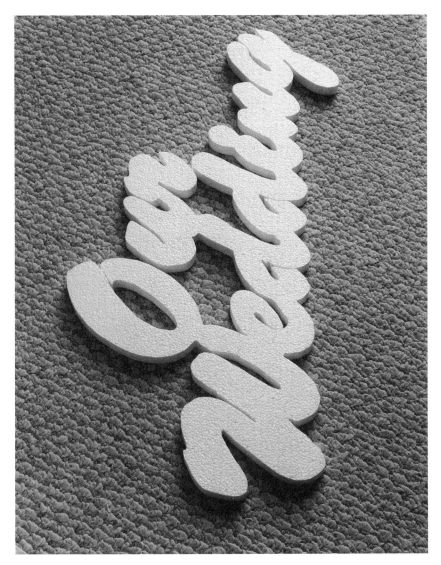

FIGURE 6.1

stuck-on/sticking-out—thus opens a path to thinking about the temporal relation of lateness. We will return to this motif at other moments in this essay.

For now let us linger on "unthinkingly." For those who know it, this term will recall art critic Ina Blom's essay "I'm With Stupid" at the end of

Rødland's first book *White Planet, Black Heart* (2006). Here, swimming against the tide of an "art critical discourse generally in love with other criteria," Blom introduces "stupidity" as a concept for grasping Rødland's practices as a totality. She shows how it draws us into a broader theoretical reflection on the connections between postconceptual art and rock music, whose "strategic stupidity," which "basically consists in hiding your aesthetic competence and sophistication behind a carefully cultivated veneer of dehumanized automatism and uncontrollable power surges," can be associated with the "fascination for events and for contingency" that defines photography and other modern recording technologies.[1] This same fascination also subtends, interestingly, the poetics of nature-oriented romanticism—three things that repeatedly come together in Rødland's videos and early serial works, such as the *Black* suite and *Close Encounters*.

The affinity between rock's "event aesthetics" and the contingency or "'whatever' principle" of photography *and* romanticism is for Blom most brought out in Rødland's images of cassette tapes: "dead" images of a distinctively uncharismatic postmodern technology that are also, in a sort of pun, refusals to provide a more lively and accessible image of Nordic black metal (Fig. 6.2).

> The dead, blunt, mute, and flat cassette tape refusing to represent any ideas of musical "life" is Rødland's visual take on the "whatever" principle of mechanical recording. The precise musical reference in the image is simply what ties this particular articulation of "whatever" to the cultural sphere of rock. The photograph is a self-reflexive object of rock culture that does not obey any other law than the desire for a visual production that creates its own reality based on the key terms of this cultural sphere. *It is representative of a body of work that seems to avoid all traces of the snapshot aesthetic without for that matter entering into high-concept staging or image manipulation.* (n.p., my emphasis)

Evinced for Blom primarily in the refusal of "ideas" and avoidance of "high-concept staging," stupidity joins these threads to another key tendency in Rødland's work: his borrowing from commercial photographic genres (landscapes, advertising, food photography, erotica) without the "research" vibe informing this appropriation in first-wave photography-based conceptual art (Ed Ruscha, John Baldessari, Dan Graham) or the ironic commentary of the subsequent Pictures Generation (Cindy Sherman, Richard Prince, Sherrie Levine). "Under any circumstance, Rødland's work

198

FIGURE 6.2

seemed to avoid *all* forms of recognizable intellectual investment, such as critical appropriation, social documentation, expression of radical subjectivity, or conceptual distance and rigor," Blom notes in a more recent essay in *Artforum*.[2] The closing sentence in Rødland's "Sentences on Photography," an explicit rejoinder to Sol LeWitt's "Sentences on Conceptual Art," seems to bear this assessment out: "The photography characterized by these sentences is not conceptual photography."[3]

2.

There is, at the same time, a transparent will to concepts in Rødland's photography. Indeed, there is a repeated staging of a confrontation between the viewer and an "idea," if in a comically damaged form that makes this way of continuing to engage with cognitive material—signs, concepts, and information—surprisingly compatible with Blom's insights above. Think here of the wobbly "&" symbol carved out of processed meat in *Ampersand*; the brittle flimsiness of the sign in *The Coming Together of*

Opposites; or the separated halves of the couple's keychain in *Black Mirror Object*, engraved with "Metal" and "Cute," with the stereotypical "genders" of the two interpenetrating concepts reversed (Figs. 6.3 and 6.4).

Even while showing ambivalence about "intellectual investment" in exactly the way Blom argues, it is clear that Rødland's photographs often feature discursive or semiotic materials in addition to being thoroughly contrived. How do his pictures make this not a contradiction? By ensuring that the "idea" comes in the damaged guise of the gimmick: a compromised form encoding an ambivalent aesthetic judgment in which our contempt is mixed with admiration. The gimmick is thus the overprocessed symbol; the "lite" Styrofoamy concept; the all too obvious joke (Cute and Metal are fucking—get it?). "Good ideas are easily bungled," says Sentence on Photography #5. It is useful to compare this explicit reference to a spoiled concept to what Sol LeWitt's manifesto implies about the inherent resistance or even imperviousness of concepts to failure: "It is difficult to bungle a good idea."[4]

FIGURE 6.3

FIGURE 6.4

The gimmick is what obtrudes. Like the shiny plastic Starbucks cup wedged in the cleft of the backside of the model in *Twintailed Siren*, it is what we feel compelled to call a device that makes presumptuous, unsolicited claims on our attention and illicit claims for aesthetic autonomy (Fig. 6.5). The gimmick is thus the bad twin of Roland Barthes's melancholic, critically hallowed *punctum*, in a way underscored by its contrastingly intimate relation to comedy. Across all the domains in which it confronts us (but in this one, in particular) it is also known as the hook, the angle, the shtick.

The gimmick is also, like *Twintailed Siren*, double-sided: both a technique of capitalist enchantment and our term for registering disappointment in technique. It is what we say when we want to show that we, unlike implicit others, are not buying into what a device is promising. By contrast, if a device does not strike us as aesthetically suspicious, we will not perceive it as a gimmick but as a neutral device, simply doing what it is supposed to do. It is however key to remember that under conditions of capitalist

201

FIGURE 6.5

Welche Thiere gleichen einander am meisten?

Kaninchen und Ente.

FIGURE 6.6

production, unproblematic devices can flip into obtrusive gimmicks at any moment (technological aging will often do the trick) and vice-versa as well. Every concept/gimmick is a potential gimmick/concept—a Wittgensteinian duck/rabbit (Fig. 6.6).

Barthes's punctum gone wrong or turned inside out, and a botched version of the neo-avantgarde's vaunted concept, too, the gimmick is at the same time irritatingly attractive. Like the keychain in *Black Mirror Object*, it is a "stupid" idea with a perversely ineliminable charm: a ploy, a stunt, an ensorcellment, a trick. Underscoring its flawed and yet persisting allure, some dictionaries suggest the word is an anagram for an older spelling of "magic." Yet all ideas are susceptible to gimmickification under the information-driven, knowledge-saturated conditions of capitalism, and especially when produced for circulation in a "marketplace of ideas." Not every commodified idea is necessarily a gimmick, but every gimmick bears traces of a commodified idea. In a world in which thought

is simultaneously reified and fetishized, dumbed down for maximum ease of transmission and consumption while engineered to be increasingly clever, "gimmick" and "concept" are well-nigh synonymous. We find them conflated not only in the realm of advertising (where gimmicks are legion) but in education, food, politics, finance, engineering, fashion, architecture, journalism, manufacturing, pornography, management, law, criticism, and art.

"You gotta get a gimmick," bellow the strippers in the musical *Gypsy*, by which they mean, you'll need to rig up a concept for your act. Dramatizing the gimmick's slippage between cerebral idea and physical thing, here the "concept" takes the specific form of an eroticized prosthesis. As we saw in the Introduction, one stripper shows how she "pump[s] it" with a trumpet; the other, strung with blinking lights like a Christmas tree, demonstrates how she "does it" with a switch. "Concept" here means "contraption"—a trap for one's attention, in Alfred Gell's anthropological theory of artworks—which in turn means "gimmick": an unsubtle strategy for sticking out, differentiating your performance from those of others in a world where survival depends on it.[5]

Gimmicks are what all concepts fall under threat of becoming under conditions of capitalist valorization. At the same time, as an expression of aesthetic dissatisfaction, and indirect refutation of another subject's positive evaluation of the same device, the gimmick retains a baseline criticality. It is our way of communicating the falseness of a thing's promises of reducing labor, saving time, and expanding value, *without disavowing their appeal or social effectivity*. The gimmick is therefore fundamentally ambivalent. While its experience is primarily one of suspicion, that suspicion contains a layer of socially displaced belief. This manifests in the form's irritatingly persistent attractiveness, even as denunciation automatically takes place in the sheer act of its naming.

Thus Blom is right in suggesting that Rødland's art summons "stupidity" as a kind of resistance to "high-concept staging," a practice ubiquitous in both "pictorialist" and "anti-aesthetic" tracks of conceptual photography. It is at the same time crucial to see that Rødland's photography is not *not* conceptual but rather stages the viewer's confrontation with concepts in the gimmick's compromised key.

Recognizing Rødland's move of taking the gimmick seriously casts fresh light on his oft-noted proclivity for "contrived arrangements." It also asks us to pay closer attention to his commitment to comedy, in which the gimmick's insouciance comes to the fore.[6] With this in mind, we might read the obnoxiously obtruding objects in Rødland's sexually provocative

photographs in particular—the shiny wet coins jutting out of *Apple*; the nipple-like doorbell just out of the toddler's reach in *Doorbell*; the thermometer sticking perkily out of the ass in *Fever*—as comedic instantiations of the gimmick itself. Other photographs offer even more explicit diagrammings of the gimmick as "hook," that catchy device that, in spite of our

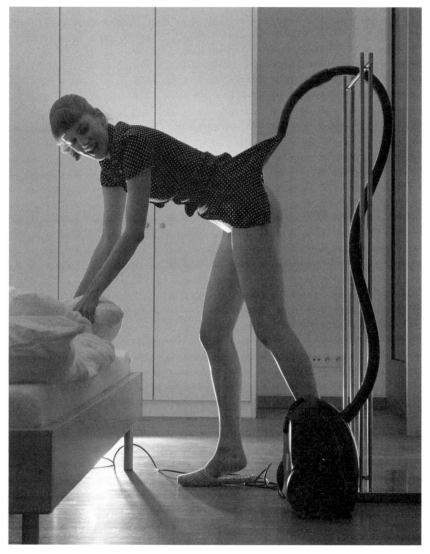

FIGURE 6.7

contempt for its transparent intentions, manages to suck us in: in *Vacuum Cleaner*, the skirt of a "maid" pulled into the tube of a vacuum cleaner, itself archly hooked over a coatrack into the shape of a question mark; in *Red Pump*, the heel of a pump "accidentally" caught on—but also hooking at—the edge of someone's pants (Figs. 6.7 and 6.8).[7] Allegories like these

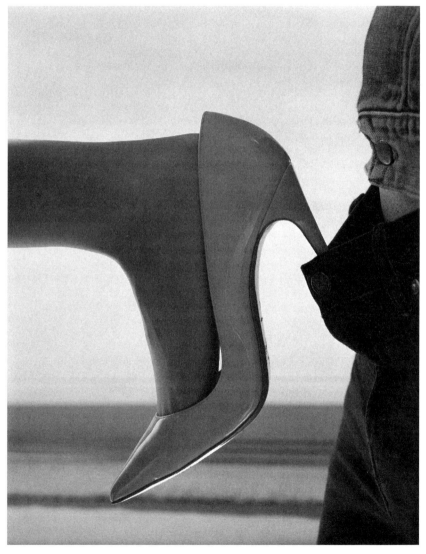

FIGURE 6.8

provide the answer to a question Rødland states he was trying to ask in his film *Non-Progress*, in which an actress performs Mitch Hedberg jokes that have "lost most of their humor."[8] The question is "What does a joke [become] when it's no longer funny?" A gimmick, of course.[9]

Irritating, stupid, yet affectively complex, the gimmick also helps make sense of why so many critics describe Rødland's work as full of "lure[s]," "traps," and of course "insidious hook[s]," while drawing on even more explicitly negative terms to characterize the kind of visual pleasure it offers: "smarminess"; "adolescent glee"; "idiotic"; "annoying"; "perverted"; "fetishizing"; "retarded."[10] The gimmick is not just another term to be added to this series; it names the logic of effrontery that gives rise to the chain. For as with the object of disgust theorized by Kant, what makes the gimmick most repulsive is the way it claims we have *desire* for it.[11] "You *want* me," the gimmick outrageously says. But as Rødland's photographs show us, it is never entirely wrong.

Almost half a century after the initial "field-expanding" works of protoconceptualists like Bernd and Hilla Becher, why would a photographer who has distanced himself from the project of conceptualism nonetheless choose to continue engaging with the intellectual object at its center by repeatedly staging our encounter with its comedic declension? Perhaps to register uncertainty about what an art whose impact resides in being devoted to signs and concepts will continue to mean in an era of "cognitive capitalism."[12] We might say that staging the return of the "idea" in an explicitly botched or downgraded condition allows Rødland's work to call attention to the lateness of our contemporary situation, in which the sheer persistence of certain forms is at times surprising.[13] At the same time, Rødland's use of a specifically damaged version of conceptualism's concept with an equally specific, strangely indefatigable *charisma* suggests that he is not relinquishing art that shuttles between image and discursive meaning for its production of aesthetic pleasure. Polemically substituting the comically bungled gimmick for the informational cool of the concept (rather than rejecting both in favor of some pure immediacy of pictorial presence) invites the viewer to acknowledge a threat that could not be fully acknowledged by the first wave of conceptual artists working in photographic series: the *inherent* potential for every concept to devolve into a gimmick, particularly in knowledge-intensive post-Fordist capitalism.[14] For all the works' self-deprecating playfulness, the *conceptualism* of Ruscha's *Twenty-Five Gas Stations* and Eleanor Antin's *100 Boots* was always serious. The danger of the gimmick overtaking and discrediting the idea was precisely what

such neo-avantgarde works could *not* confront in their initial quest for recognition as serious, anticommercial art.

There is of course risk in taking a compromised aesthetic like the gimmick seriously, particularly since Rødland's photographs do not merely put it to work. Many of his pictures seem to be meditations on, and as such, enactments of its overperforming/underperforming form: from the tortured contortions of the body in *Heart Like a Spine* ("working too hard") to the slick, impenetrable, nothing-to-seeness of *Thirteen Forty-nine* ("working too little"). One thinks here as well of the silken lassos, candy necklaces, and chains of sausages looped around objects in *Vanilla Partner*: images of playful bondage that double as studies of the easy ways in which one's attention gets roped. Overall, Rødland's project of investigating a range of everyday aesthetic categories by inhabiting rather than ironizing them—the gimmick, of course, but also cuteness and raunchiness—inevitably commits his works to taking on some of the dubious features of the styles he examines. This in turn accounts for the doubleness repeatedly attributed to his work. Mirroring the "twintailed" structure of the gimmick as site of the convergence of suspicion and belief, Rødland's photographs are described as having the "ability to both exploit and pry apart"; as images in which a "deep-seated will to believe" coexists with "an imperative to stay alert to cultural coding."[15] In a similar vein, the gimmick is a judgment in which skepticism and enjoyment coincide.[16] It reminds us of how ordinary and even necessary it is for these feelings to coincide in a "society of the spectacle" in which most of our aesthetic experiences are by default equivocal—that is, universally grasped as prestructured or shaped in some way by advertising—if in a way that no longer scandalizes us.

3.

"Ideas" in Rødland's photographs come to us through the confrontational address of the gimmick. One wonders if their polemical staging of the encounter stems from how closely photography and conceptual art's trajectories have been aligned since the early 1970s, when the latter came of age. Indeed, at the dawn of a "late" but ongoing phase of capitalism commentators continue to describe with multiple names ("post-Fordism," "postindustrial capitalism," "globalized financial capitalism," the "long downturn"), there is a sense in which photography gave rise not just to conceptual art but postmodernism writ large. Over the following decades, as George Baker

notes, one well-established artistic practice after the other came to remake itself in photography's image, reorganizing itself around the medium's "logic of the copy, its recalcitrance to normative conceptions of authorship and style, its embeddedness in mass-cultural formations, its stubborn referentiality and consequent puncturing of aesthetic autonomy."[17]

"Referentiality" and "aesthetic autonomy" are opposed in Baker's account of photography in a way that evokes a plethora of roughly similar theoretical characterizations: "indexicality/iconicity" (Rosalind Krauss), "capture/construction" (Joel Anderson), "fossil/representation" (Walter Benn Michaels), "snapshot/time-exposure" (Thierry de Duve), "automatism/agency" (Diarmuid Costello and Margaret Iversen).[18] In each case, the opposition concerns the tension between what appears mechanically recorded by an apparatus and what looks to have been purposefully contrived by a human agent. This tension between the "automatism" of, say, dead labor, and the "agency" of living labor, reflects the interlinking variables of the capitalist valorization process, in which ratios of dead to living labor embodied in an artifact (the organic composition of capital) are pegged to the movement of historical time.

The opposition of instantaneousness and duration in De Duve's "snapshot/time-exposure" schema is in turn inflected by a polarization of value between the ephemeral flash in the pan (the cheap, "trashy" snapshots of Nan Goldin or Mike Kelley) and the historically "monumental" (Jeff Wall's magisterial, expensive-looking tableaux). At the root of these transformations, works too little/works too hard remains suggestively implicit across all the major theoretical oppositions used to characterize the medium of photography. Ambiguities about value and time in capitalism stem from ambiguities about labor.

If at this point we sense that there might be something about the theoretical image of photography that is eerily conducive to conjuring up the form of the gimmick, the ambiguous historical situation of art photography since the 1970s seems to do so as well. Was photography indeed the forerunner of postmodernism, harbinger of a "historical logic" it played a key role in consolidating, or did it in retrospect prove to be postmodernism's stillborn progeny? Baker notes that the second argument has proven more prevalent: "Critical consensus would have it that the problem today is not that just about anything image-based can now be considered photographic, but rather that photography itself has been foreclosed, cashiered, abandoned—outmoded technologically and displaced aesthetically."[19] As he elaborates:

[T]he extraordinary efflorescence of both photographic theory and practice at the moment of the initiation of postmodernism [is said to be] something like the last gasp of the medium, the crepuscular glow before nightfall. *For the photographic object theorized then has fully succumbed in the last ten years to its digital recoding, and the world of contemporary art seems rather to have moved on, quite literally, to a turn that we would now have to call cinematic rather than photographic.* (122, my emphasis)

At once "early" and "late," art photography's historical situation at the dawn of the long downturn shares the gimmick's anachronistic temporality. In this light, Baker adds, it seems telling that the "artist stars of the present photographic firmament are precisely those figures . . . who reconcile photography with an older medium like history painting . . . [or those] who have most fully embraced the new scale and technology of photography's digital recoding" (122).

In history as well as theory, then, we find a kinship between the interlinked uncertainties about labor, time, and value surrounding photography and those at the heart of the capitalist gimmick, making the medium and aesthetic category propitious for illuminating the other's features. This affinity in turn might shed further light on why a post-postmodern photographer like Rødland, indifferent to both the media-hybridizing and digital position-takings mentioned above—and interestingly interested neither in the ephemeral snapshot nor monumental imagery—makes photographs that continue to confront us with conceptual aspirations in the gimmick's contradictory form.[20] That is, for the way in which its paradoxically repellent charm draws out the ambiguity of art photography's entanglement with conceptualism.[21]

Conversely, the centrality of the gimmick to what is art historical about Rødland's photography invites us to regard the theory of photography in a different light as well. The seemingly endless and wearisome debate over whether the essence of photography is indexicality or iconicity becomes finally interesting if reinterpreted as an oblique way of raising a question about the continuously changing interface of dead and living labor in artistic production. One could read this question, in turn, as an indirect way of probing the increasingly ambiguous status of artistic labor in a capitalist era supposedly dominated by the rise of so-called immaterial labor, which can be both highly and poorly skilled and remunerated.[22] Both questions are what I would argue Rødland deploys the gimmick qua

downgraded idea to reactivate—on the ruined yet strangely persisting site of an art once but no longer scandalously based on the manipulation of discourse, information, and signs.

If something about "indexicality" triggers deeper economic anxieties experienced in our dissatisfaction with the problematic shortfall of "work" in a photograph, do similar anxieties undergird how "iconic" photographs—staged in ways that make authorial will or intention transparent—often come across as "trying too hard"? Here we once again see how photography's theoretical image and the gimmick raise analogous questions, if from the other side of the automatism/agency divide. Indeed, if we take the willfully deceptive "trick" photograph as our paradigmatic representative of the medium, following a hint dropped by Abigail Solomon-Godeau, rather than the family snapshot or war photo privileged by Barthes and Sontag, we can see how the suspicion of fraudulence epitomized in the capitalist form suffuses the medium too.[23] Given photography's history of functioning as chicanery as it shades into entertainment (from Barnum's museum exhibits to the photoshopping of models), the marginalization of tricks, illusions, and deceptions in the theorization of photography as medium, in striking contrast to the parallel theorization of cinema (where the concept of "suture" was pivotal) is in some ways surprising. Could Rødland's stake in the stunt-like gimmick, then, be conjoined to an interest in medium specificity? Even more than his interest in concepts (however wobbly, brittle, or overprocessed), this argument seems hard to reconcile with a photographer with a strong proclivity for taking pictures of kittens, models, and sugary food.[24] It is however explicitly linked to Rødland's foregrounding of the gimmick qua dubious contrivance.

Consider *Baby* (Fig. 6.9). The marvel of this image is, of course, its contingency ("works too little"): the sheer accident by which the camera happened to record the subject looking at the photographer in this unnervingly knowing, almost smirking way. Yet what the accident caught by the recording apparatus *is*, is an astonishing look of posing or deliberate playing to an audience ("works too hard"). With a confrontational gaze that makes its seemingly casual covering of its chest seem all the more like a calculated display of modesty (in a way eerily akin to Édouard Manet's *Olympia*), it is as if the baby is making a sardonic comment about the frequently one-sided character of photography theory's indexicality/intentionality debates. It is as if the baby even knows the rule of the photographic portrait—that prior to any question of what the camera might automatically record, the genre is already marked by a split between two intentions: that of the

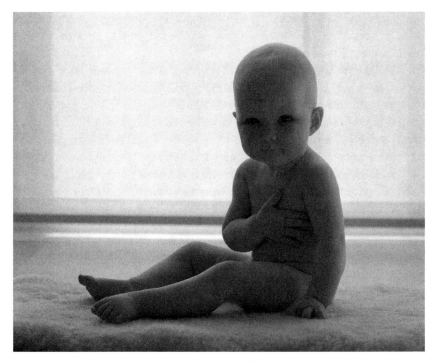

FIGURE 6.9

portraitist, who will want to present his subject in a specific way, and that of the subject, who may want to present herself in a different one.[25] In contrast to Barthes's purely indexical punctum, Rødland's gimmick is where the indexical and intentional intersect. For exactly this reason, it is not clear whose aesthetic will finally prevail in *Baby*. Staring directly at spectator, photographer, and apparatus, the baby seems to be saying, "I know what you want—*me*!" If the gimmick repels most in its insolent claim to fulfilling our unacknowledged desire for it, *Baby* underscores this by experimenting with the thinness of the border separating the icky and the cute—qualities here aligning exactly with the overtly staged and the mechanically captured.

Rødland's meditation on the overworking / underworking *gimmick*, I am suggesting, is doubling as a meditation on the iconic / indexical *photograph*. Or is it the other way around? The appropriately titled *Twintailed Siren* brings this to the fore. Everything about this photograph feels set up for the see-through joke; there seems to be nothing "candid" or spon-

taneous about it. (Underlining the presumptuous tone of the gimmick's address, Rødland's photographs meditating explicitly on hooks tend to be the ones that are most explicitly sexualized.) And yet, as in the image of the dress artfully and/or accidentally caught by the sucking device in *Vacuum Cleaner*, the thing in *Twintailed Siren* that looks most carefully staged is what most evokes the semblance of randomness. This is the placement of the transparent Starbucks cup, with its green mermaid logo facing us, her two tails redoubled by the green plastic straw sticking out of the lid. The cup, containing just a sip left of water, has been deftly tucked in the butt of a model for whom the same cup-and-straw double as "tails," turning the entire image into a recursive "duck/rabbit."[26] What is obviously the hook paradoxically comes off as an afterthought, as if it were added at the last minute, haphazardly. Being stuck on gives the gimmick the *appearance* of an accident, regardless of whether it was the case.

Rødland's attraction to the look of the stuck on finally seems to have something to do with how it captures this intersection of the contrived and the contingent. It is here that we also come to see the ambivalence elicited by the overperforming/underperforming gimmick, and photography theory's obsession with automatism/agency, as twin reflections on the ambiguities of capitalist production. If a dialectic of deskilling and reskilling can also be detected in the bifurcation photography undergoes in the aftermath of its uptake by conceptualism in the 1970s—the postmodern track primarily associated with artists in the United States (splitting threefold across the informational aesthetic of Dan Graham and Douglas Huebler, the appropriationist aesthetic of Sherman and Louise Lawler, and the snapshot aesthetic of Goldin and Kelley) and the modernist track associated primarily with photographers in Europe and Canada (Thomas Struth, Thomas Demand, Rineke Dijkstra, Wall)—we can see how the specificity of Rødland's interest in the "twintailed" gimmick/concept counts as both a continuation and departure.

4.

As we have seen across this book, the history of Western capitalist culture is full of artists working in diverse media who enjoy mobilizing contrivances. So what finally distinguishes Rødland's use of the gimmick from that of others who draw on its equivocal form?

To conclude on this question, I'd like to pay attention to a device used across a significant number of Rødland's photographs: a hand, entering

FIGURE 6.10

from an unseen space outside the boundaries of the picture, in order to manipulate, tinker, or interact with something within its frame.[27] Both somehow belonging and yet alien to the pictures it invades, ambiguously describable as both diegetic and extra-diegetic, the meddling hand (or sometimes hands) is yet another instantiation of the gimmick's obtruding form (Fig. 6.10).

Sometimes the hand encroaches into pictorial space obnoxiously extending a microphone toward an unhappy or unresponding person (*Young Men*; *Untitled [NRK]*). In *Blue Portrait [Nokia N82]*, it thrusts itself straight across our line of vision to confront us with an outdated cell phone displaying an uncannily vivid photograph of a smiling Anne Frank. The hand is sometimes elderly and laid gently on the faces of young persons (*Wordless*) or uses scissors to slice through clothing (*The Cut*). Sometimes it is a childish hand groping breasts (*Groped*). Sometimes it is a hand supporting puppies on a table, as if to prepare them to be professionally photographed (*Backlit Puppy*).

Sometimes the contrivance enters the image for the narcissistic purpose of flaunting something about its own appearance: long fake fingernails

(*Black Nails*) or the fact that is wielding a King Size Sharpie (*Minnesota Sharpie*). "Sharpie" is a brand of permanent marker; it is also North American slang for a "cunning person, especially a cheat" and thus a metonymic figure for the tricky gimmick.[28] Photographs like these, in which the manipulating hand with its agency-extending prostheses insists on being the center of attention, seem most like portraits of the gimmick as such. In such cases it can be unclear if the gimmick is meant to be viewed as an extension of a human body, hence synecdoche for living labor, or a figure of the dead labor crystallized in machines. *Tattoo* deliberately raises this question by featuring a white-gloved, disembodied hand that looks a bit like the cartoonish Hamburger Helper (Fig. 6.11). The iconic gimmick

FIGURE 6.11

evoked by this hand, an advertising mascot originally designed to market a product promising to save women labor in the preparation of family meals, is perched like a winged creature on the neck of a human. That neck in turn happens to be tattooed with a winged hand that almost seems to function as an advertisement for the mascot, rather than the product the mascot was devised to sell. What results from this simulacral re-doubling of Rødland's all-too-handy helper—ambiguously located in a zone between promotional image and labor-saving device—is a sense of the gimmick being both dead and alive, at once an animated body and a disembodied tool (Fig. 6.12).

Sometimes the gimmick intrudes to draw attention to the aesthetic consequences of its own intrusion. In *Golden Lager* the hand enters from the frame's bottom corner to emerge once again out of a circular opening of a sleeve (Fig. 6.13). The ring of this opening is echoed by the stripes encircling the sleeve, as if to underscore that the hand has broken through multiple frames. The hand dips a finger into a circular glass of amber liquid

FIGURE 6.12

FIGURE 6.13

positioned to fit perfectly in the circular corner of a beveled marble table, right at that corner's outer edge. As if to once again mimic the gimmick's brazen act of self-assertion/insertion and its specifically pictorial consequences, the finger dipped into the encircled space constituted by the glass of liquid appears transformed by having entered that smaller frame. It no longer looks like a finger but an amber-colored shape. Tiny bubbles cling

to it, like smaller, similarly encircled miniature worlds. Meanwhile, two fingers on either side of the one plunged into the encircled space of the drink remain in physical contact with the rim of the glass, underscoring both its materiality and penetrability as border. Through these recursions, *Golden Lager* makes us alert to Rødland's gimmick as a transparent form surprisingly capable of producing enigma and even contemplative immersion.

The hands obtruding into Rødland's photographs come from an unseen realm specifically indicated by and contiguous with the world of the picture. Eyal Peretz refers to this "haunting invisible outside" of every framed image—photographs, paintings, stages, screens—as the "off."[29] The "off" is not the space outside the image occupied by a spectator in the gallery but part of the image, "belonging to something we might call [its] fictional realm . . . a realm that is "larger" or "more" than what the [picture] makes visible . . . an outside only made possible by, and in fact to a certain extent co-extensive with, the [picture] itself" (4). For Peretz, images of things entering the picture from this "off"—his strategically chosen examples, all about sons abandoned by fathers and thus ambivalently released from the authoritative guidance of their laws, include Peter Bruegel's *Landscape with the Fall of Icarus*, Rembrandt's *The Sacrifice of Isaac*, and Andrej Tarkovsky's *Solaris*—highlight a fundamental feature of modern artworks: how by "creating a frame that cuts visibility," which in turn makes the "off" possible, they "allow for an invisibility *belonging to the [image]* to appear" (5, my italics). Peretz stresses that this is not, however, a godly or cosmological invisibility, through which various identities (national, racial, and so on) are shored up or fixed through the Law of the Father. It is rather a site of nonbelonging and disorientation opening us up to the existential groundlessness of modern artworks themselves. The "off" is "something . . . not actually present anywhere, but that *nevertheless affects what is* [in the framed image] *by exposing it to a dimension that displaces it*" (20, my italics).

While the "off" in Peretz's examples tends to be invoked passively by beautiful creatures falling or drifting into the frame, Rødland's images activate it deliberately through an obtrusive device. In each case, the manipulative hand exaggerated by its prosthetic extensions, underscoring the gimmick's tendency to spawn further gimmicks in turn—fake fingernails, sharpie, microphone—bears a consistently unclear relation to the bordered space in which it appears (Fig. 6.14). It could be said that activating the "off" through this device enables Rødland's pictures to remain enigmatic

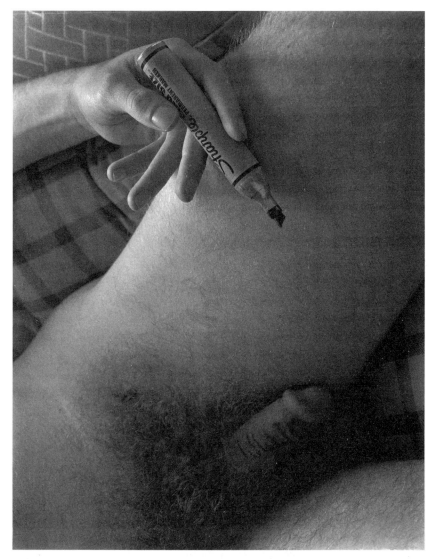

FIGURE 6.14

in spite of their transparent, sometimes stupid, themes. This might imply that the role of the gimmick is to instantiate the "off" as a space of aesthetic surplus, imaginary plenitude, or fictional excess. But what the gimmick's pointing to the "off" does is the opposite, and here we enter what is strangest about Rødland's maneuver. For precisely in inviting us

to imagine a beyond belonging to the picture, which would naturally seem to deepen or expand its "worldhood," the manipulating hands activating this "fictional realm . . . 'larger' or 'more' than what the [picture] makes visible" call our attention to how *thin* the worlds of Rødland's images are.[30] Like the use of flatness in comedy (usually for the purpose of enticizing universals), this thinness is deployed to do a specific kind of aesthetic work.[31]

The deficient environmentality to which Rødland's gimmicks alert us is in fact carefully achieved through decisions resulting in overlapping effects. First, the relatively near distances at which his subjects are photographed, such that regardless of size or category—banana, bodybuilder, dilapidated cottage—they occupy most of the space in the frame. Second, a lack of perspectival depth between foreground and background. This absence rules out any ambiguity about the official subject of representation: it is the banana, the bodybuilder, the cottage. All is signal, as opposed to noise; there are no background details that look registered by accident.[32] Third, absence of dynamic relation between the subject and what little surrounding or environment for it exists. Figures sometimes interact with other figures but against whatever static backdrop they passively happen to be photographed against. Neither figure nor ground, nor the relation of over-againstness binding them together, seems to condition or shape our experience of the other.[33]

It is as if the confrontational address of the gimmick forces everything else about these images to become frontal. Even landscapes seem less like environments than abstract studies of texture. What gets brought out is a kind of groundlessness Peretz provocatively argues is *endemic* to landscape, qua "arena of the disoriented . . . movement of our eyes, abandoned . . . by perception's guidance . . . aimlessly roaming and meandering, without any privileged point to anchor them."[34] One begins to wonder if Rødland's still lives of objects evenly scattered across a nondescript field—cassette tapes, baseballs, guns, pipes—are not in this sense covert landscapes too.[35] Deficiency of environmentality thus introduces a further disorienting opacity around what seems most transparent about Rødland's photographs, which is their affiliation with easily recognizable genres. This comes across most vividly in his representations that look like but are perhaps not finally portraits. Because the people often looking or smiling directly at us do not seem to have any definite relation to the environments in which they are photographed, we are not invited to wonder about them as people—as opposed to, say, emblematic figures.

220

This leads to what I think is primarily at stake in Rødland's use of the gimmick: to bring out a surprising abstractness in each differentiated image.[36] Because Rødland's images are elaborately staged *and* environmentally thin, what they depict feels like neither our world, nor the world of the subject, nor that of the photographer. It is this triple negation that gives Rødland's photographs the quality so many commentators rightly if also vaguely refer to as "uncanny." In spite of the inviting themes, accessible subjects, and intimacy produced by the low heights at which they are hung in exhibition, these pictures are not images of "everyday life."[37] They are rigorous fictions that seem designed to refer primarily if also obliquely to one another, to create meaning through likeness and difference with others of their ilk.[38]

There is thus a surprising continuity between the official subjects and the gimmicks that repeatedly barge in from offside to meddle with them. Neither look like they belong to the locations in which they are photographed. The settings in which we encounter the baby in *Baby*, the puppy in *Backlit Puppy*, and the siren in *Twintailed Siren* do not resemble places for dwelling but generic sites for the "taking place" of photography—bare sites which are in turn a synecdoche for a broader, not immediately self-evident abstraction that all of Rødland's sensorially rich and richly differentiated images share.[39] *The world repeating across each of the photographs is the one and the same nonworld.* Such remarkable uniformity across highly variegated subjects is arguably something of a challenge to achieve. Hence the need for a contrivance like the helper or sharpie, which specifically alerts us to an abstractness within as well as between the photographs.

Our gimmick-assisted realization that each Rødland photograph depicts the same nonworld—and that it, too, like the unseen domain the hands arrive from, is a domain of abstraction—totalizes his photographs. It draws them together as a kind of combinatorial system, akin to the experimental novels of Samuel Beckett or Alain Robbe-Grillet. Note here that the decision to produce pictures that, when developed for exhibition at varying intervals after shooting, speak to other members of their "collective" in ever-shifting subgroups and scenarios, is possible only when these interrelationships have not been predetermined by the concept organizing a series. We see this commitment to combinatorial as opposed to serial form reflected in two other aspects of Rødland's practice.[40] The first is his dedication to the book, which would seem to allow maximal control in changing the sequence in which images appear, hence the ability to repeat, recombine, and alter the meanings of specific images. The second

is his tendency to vary intervals between photographic production and dissemination, which is in turn paratextually reflected in his dating system, with "2011–15 [indicating] the gap between when the negative was exposed and when the first print was made."[41]

Ironically, then, it is the rigorously maintained worldlessness of each image that brings a historically concrete world back into the picture: one in which, as Alberto Toscano puts it, the "articulation of . . . differences gives rise to an impersonal 'principle' that is itself devoid of determinations and cannot be led back to any of its constituents."[42] With assistance from the gimmicks, sharpies, and helpers that activate the "off"—a realm of abstraction we come to realize simply extends a kind of abstraction already at work within the picture, and which we may have in fact missed without the helper's intervention—the repetition of worldlessness discloses what we first perceive as a series of individually disconnected pseudo-worlds as in fact a continuous representation of a single world marked by shared disconnection. This is not only an entirely specific world: it is finally *our* world, the one both viewer and photographer share. One begins to think of Rødland's corpus as a pack of tarot cards, in which each picture represents an allegorical figure capable of being combined with others in a finite but stupefyingly vast number of permutations: the Siren, the Puppy, the Baby, the Bodybuilder, the Nudist, the Hairy Thing, the Lassoed Thing, the Gelatinous Thing.[43] Alerting us to an abstractness disclosing a single shared world across each of these representations, Rødland's gimmick could thus be redescribed as the production of a combinatorial narrative about subjects *who live in the same abstraction-dominated world.* "Shared" in this case does not imply "intersubjective," since the figures who populate this world with one another do not seem aware that they do so.

Note, finally, that the abstraction-dominated world that Rødland's emblematic characters inhabit is also a sensuously and symbolically rich world—that the two features are by no means antithetical. Indeed, I would argue that the oft-noted "mystique" of Rødland's photographs goes hand in hand with the specific *kind* of abstraction his gimmicks activate, which, in contrast to the existential or phenomenological groundlessness implied by Peretz's concept of the "off" as site of radical indeterminacy, is a distinctively capitalist abstraction with a historical character. It evokes what Alfred Sohn-Rethel calls "real" or practical abstraction—an abstraction that is not the result of thought, but of the collective if uncoordinated actions of people.[44] Practical abstraction is the unconscious "social synthesis" of capitalism itself, qua system "that can only integrate . . . via the

atomization of workers, their separation from the means of production and their thoroughgoing domination."[45] Taking place where "the thinking and efforts of men are absorbed by their acts of exchange," it produces the distinctively asocial sociality arising from a system in which people create their deepest ties to one another "behind their own backs," producing "the social" itself as something standing over and against them.[46] If, to repeat, the "crux of capitalism" is that it is "woven of complex material and ideological differences, but the articulation of these differences gives rise to an impersonal 'principle' that is itself devoid of determinations and cannot be led back to any of its constituents," the specifically gimmick-activated, by no means immediately discernible abstraction in Rødland's visually and symbolically rich photographs offers a figure for this "empty reality principle."[47] Thanks to the contrivances switching on this abstraction that we otherwise might miss, distracted by the lushness, sensorial repleteness, and richly differentiated specificity of images like *Baby*, *Puppies*, and *Twintailed Siren*, Rødland's photographs disclose reality as a "specific articulation of differences" while also "revealing the void at the heart of Capital."[48]

What is the final upshot of Rødland's involuted, self-relating combinatorial of photographs? We could see it as part of a project dramatizing the achievement of aesthetic autonomy on the part of a notoriously heteronomous medium, if at the level of a totalized corpus rather than individual works. Yet as a totality in which things are at once uniform and changing, projecting a system of relationships opaque to the figures bound together in it, the hermeticism of Rødland's combinatorial, like that of the isolated sanatorium in Thomas Mann's *The Magic Mountain*, has a specifically historical content. It produces an image of the paradoxical blend of crisis and stasis that defines our age of secular stagnation. It models the hermeticism of the gimmick itself, as that historically specific form that makes something about capitalism at once transparent and opaque.

The Color of Value: Stan Douglas's *Suspiria*

Turning to the gimmick as a "special effect" and machine for generating apparitions of value, this chapter will tell a tale of two *Suspiria*s. The first is Dario Argento's garishly colorful 1977 horror movie. While drawing on iconic films like *Snow White* (1937) and *The Wizard of Oz* (1939) as influences, Argento's film was not, as is sometimes said, the last film in the West shot in Technicolor. Technicolor's cumbersome and noisy three-strip cameras were discontinued by 1955; already outsized due to the extra reels, each machine had to be encased in a sound-reducing "blimp" while shooting. *Suspiria* was however one of the last films printed using Technicolor's dye transfer process and imbibition machines before the company closed its facilities in 1978 and sold its equipment to China's Beijing Film Lab, which after 1980 became the only dye transfer printing facility left in the world.[1] It thus rightly remains a film history touchstone for how markets mediate the social aging of industrial technologies under the systemic pressures that transform them toward increased productivity, routinely turning special effects into everyday techniques, and techniques into outmoded gimmicks.

"Technicolor" itself functions as shorthand for this dynamic. Initially associated with the innovations of one company in the 1930s and 1940s, the name quickly came to signify an overarching look. More paradoxically, it came to stand for a process that became the industrial standard while never losing its connotations with specialness. As Murray Pomerance writes, Technicolor was synonymous with "color in the movies" but was also that "magical thing" that "exaggerated, warped, intensified,

indeed romanticized everything it showed," in ways that could seem tawdry as well as luxurious.[2]

The second *Suspiria*, presided over by the spirit of the first one, will in fact be the primary focus of this chapter: a computerized, permutating DVD installation by Canadian artist Stan Douglas (2003). Originally made for the international exhibition Documenta in Kassel, Germany, Douglas's version references Argento's through its fairytale-based story segments, electronic soundtracks, and Technicolor palette of oversaturated reds, greens, and blues. Both capitalist fairytales will be described in greater detail below, as I focus on Douglas's version as a lens for understanding his corpus as a whole. For now, I want to introduce both as a springboard for this chapter's way of deepening our analysis of the gimmick: by approaching it as a temporally unstable "special effect" and a complex judgment in which our evaluation of an object's form as aesthetically compromised overlaps with ethical and economic evaluations of it as fraudulent and cheap.[3]

The fact that Technicolor looked outdated (and slightly tawdry) to European and American audiences in 1977 was exactly the reason Argento wanted it for *Suspiria*, to evoke a "thirties or forties aesthetic" associated with *Snow White*. Yet the effect could signify contemporaneity to others elsewhere around the globe.[4] Moviegoers in the United States tend to find dubbing aesthetically impoverishing, while Italian audiences do not. But while objects of the judgment obviously vary, every subject who lives in a world shaped by capitalism experiences something as gimmicky for crucially identical reasons related to value, labor, and time. More specifically, our aesthetic dissatisfaction with the gimmick points to a deficiency of economic value that the judgment spontaneously diagnoses, revealing our sense that there is also something "wrong" about the ratios of labor and time it encodes.

The normative force exerted by all aesthetic judgment thus becomes amplified in the gimmick, which registers the discrepancy between an overprized object's false claim to value and what we take to be its true worth. While our feeling of aesthetic dissatisfaction laminates these conflicting evaluations together, the false one arrives first, as if to suggest its indispensability to the true one. The gimmick thus binds essence to appearance in a way analogous to the objective "forms of appearance" produced by everyday activities in capitalism, in which value necessarily appears as something other than itself (money or price), and relations of exploitation appear as ones of equal exchange.[5] The wage for instance matter-of-factly looks like a payment for labor but represents the socially

average cost of the reproduction of labor-power. For this reason, Marx quips, the concept of the " 'price of labour' is just as irrational as a yellow logarithm" (vol. 3, 957).

Marx's image is remarkably apposite, for as C. L. Hardin writes in *Color for Philosophers*, "Color is an illusion, but not an unfounded illusion."[6] We know, from seeing lemons at night in a dark room, that yellow is not an objective property of objects.[7] Yet as David Batchelor notes, the idea of objects "having" color is part of everyday common sense. Like the "price of labour" and all of the economic categories on which capitalists and laborers base their everyday activities, "it is a particularly stable illusion that can be . . . cross-referenced and predicted."[8]

Across *Capital*, Marx shows how the similarly stable, cross-referenceable categories of bourgeois economy can be traced back to the mother of all of capitalist phantasmagoria: wealth in the form of "value" itself. From volume 1's opening deduction of value's necessary form of appearance as money or price, and what this reveals about its substance, to the extensive analyses of why value cannot be increased in circulation in volume 2, we arrive at volume 3's critique of the Trinity Formula. Source of capital's most powerful self-mythologizations, this is the "formula" that makes it appear as if capital earns profit; land earns rent; labor earns wages.[9] Distribution of a total mass of surplus value extracted in production thus ends up looking like the production of value by independent agents, obscuring the interlinked nature of their activities in a way that Marx likens to fairytales: "Capital—profit (or better still capital—interest), land—ground rent, labour—wages, this economic trinity . . . completes the mystification of the capitalist mode of production, the reification of social relations, and the immediate coalescence of the material relations of production with their historical and social specificity: the bewitched, distorted and upside-down world haunted by Monsieur le Capital and Madame la Terre, who are at the same time social characters and mere things."[10]

In addition to registering the divergence of a thing's show of value from its actual shortfall, our judgment of the gimmick involves the social insight that others will be convinced by the appearance whether we are or not. The indispensability of this thought to our aesthetic encounter underscores that any true appraisal evoked in the judgment will be inseparable from the false one. Analogously, a system that accumulates wealth in the form of surplus value makes surplus value inseparable from the appearance of profit, even as this very form of appearance (profit) is what conceals the essence (surplus value) from view. Indispensable to the

essence as its necessary form of expression, there is a sense in which the appearance is the essence *of* the essence, as Patrick Murray notes. The "whole logical figure" consists of "both the appearance [profit] and that which does not necessarily appear [surplus value]."[11]

As a metajudgment adjudicating between evaluations on a variety of planes (our own and that of others; false and implicitly true claims to worth; spontaneous appraisals of labor and time), the gimmick also coordinates economic and ethical judgments of cheapness and fraudulence with its primary one of aesthetic deficiency. Its genealogy can thus be traced back to the flow between value discourses at the second half of the nineteenth century that George Caffentzis argues inspired the design of *Capital*. "It is no accident that Marx begins his major critique of political economy in *Capital I* (1867) with Value," since this was the "originary axiom of the genre Marx was critiquing." Yet "there are other, contextual reasons as well to account for [its] attractiveness . . . for during *Capital*'s composition in the 1850s and 1860s, the concept of value transcended the boundaries of political economy into ethical and mathematical discourse, especially in Germany."[12] In ethics, "value" came to signal a "new terrain of volitions and affective dispositions versus the realm of fact and the norms of pure reason"; and in logic, "a shift from a substance-abstraction to a function-relational formation of concepts and mathematical ontology" (93). In this mathematics, which laid the groundwork for set theory, values are understood as dependent upon "variables, laws, sets and series that can become values of further variables, laws, sets and series, i.e., . . . open to being reflexively transvalued." Similarly, in Marx's critique of political economy, "the notion of value arises not through the stripping of the qualities of the commodity to find an 'inherent' property, but through its manifold actual and potential exchange relations with other commodities (especially that prime self-reflexive universal commodity, money)." For this reason:

> The "value" of mid- to late-19th century mathematics and logic and the "value" of political economy (as Marx analyzes it) are not mere homonyms. Value discourse . . . allowed Marx to both use the language of the object of his critique, political economy, *and to be able to transvalue the values he criticized*. In other words, valuation and transvaluation in their political-economic, ethical and logical dimensions were the entrée to a set of conceptual revolutions in his era that Marx could hardly resist. (93, my italics)

227

The gimmick owes its origin to the same transvaluative matrix inspiring *Capital*'s analysis of how capitalism hides exploitation in ordinary measurements.[13] For here, in our encounter with its intrinsically overrated, extravagantly impoverished form, economic value's deficiency appears as aesthetic dissatisfaction. Conversely, our sense of aesthetic manipulation points to a systemic exploitation at once expressed and concealed by the forms in which economic value appears. Within the delimited radius of the aesthetic, then, the gimmick allows for what Caffentzis notes labor-value discourse affords: a measurable definition of exploitation in capitalist society and an alternative to the Trinity Formula's ideological illusion that capital produces wealth, implying its legitimacy as "force to determine the future of humanity."[14]

Against the grain of widespread academic belief in the obsolescence of labor-value theory, the gimmick reveals it as alive and kicking in the realm of aesthetics: as a judgment through which people process the qualitative, sociological effects of capitalism's "law of value" in everyday conversations about pleasure and displeasure.[15] In especially sharp contrast to claims that value defies measure altogether in late capitalism, whether due to the rise of finance, biopower, or internet platforms, every encounter with the gimmick attests to our perception of the discrepancy between mystified and objective ways of appraising it.[16] At the same time, as we will see below, the gimmick can be a machine for generating as well as diagnosing capitalist phantasmagoria ("yellow logarithm[s]"), including the spectral effects of value tied to "abstract labor."

Synching, De-synching

Over the last thirty years, Stan Douglas has made intensively researched film and video installations returning to the theme of what Ernst Bloch, in his temporal analysis of Germany's turn to the political right in the 1930s, calls the "nonsynchronism" of capitalist modernity, with its "unsurmounted remnants of older economic being and consciousness."[17] Densely interweaving archival with literary materials, a typical Douglas work tends to focus on a complex historical moment and to be saturated with more content than viewers can grasp. On top of this, automated strategies of repetition and differing expand the temporal dimensions of his cinematographic works to gigantic, even inhuman proportions. Since the 2000s, the full running time of a Douglas installation has grown from days to months to years, drawing a sharp line between the time of the

work and the time of the viewer's experience in what Juliane Rebentisch describes as a characteristic way in which installation-based artworks assert aesthetic autonomy.[18] A Douglas work gives us too much material to process; at the same time, the visual and aural complexity of what we *do* take in makes us continually aware of a totality we cannot fully grasp. All of this makes his technically virtuosic, machine-driven artworks sublime— if in a way that Douglas seems to find discomforting at moments. It is in these moments in which we see something like an activation of the gimmick, qua countervailing aesthetic force.

If occasions on which this happens are rare, the fact that it happens at all is surprising. Though known for its Beckettian humor, Douglas's corpus does not systematically court the gimmick's damaged form in the way that the commercial aesthetic of Rødland does. To even speak of the gimmick in conjunction with Douglas's rich, yet formally austere modernism as he works across a range of postmodern media technologies—a combination of position-takings that has made his work, like that of Jeff Wall's, almost impervious to criticism—feels slightly blasphemous.[19] It is this overarching incompatibility, however, that makes the occasional surfacing of the non-beautiful form of the gimmick in his corpus all the more interesting, inviting us to ask why it might surface in the particular works it does.

Douglas's self-described interest in "temporal polyphony" is evinced at all scales in his work: from its combination of old-fashioned with state-of-the-art technologies, to strategies for repeating (the film loop) with strategies for differing (digital systems for randomizing and remixing units of image and sound).[20] His corpus is filled with imperfect doubles of stories often explicitly about imperfect doubles, and particularly in his "remakes." From *Der Sandmann* (1995), an adaptation of E. T. A. Hoffman's story about an automaton on which Freud draws for his theory of the uncanny; to *Journey into Fear* (2001), a riff on cinematic adaptations of the World War II spy novel routed through Herman Melville's *The Confidence-Man* (1855), a meditation on circulation set on a ship containing multiples of the same person; to *The Secret Agent* (2015), a resetting of Joseph Conrad's fin-de-siècle terrorism novel in Portugal during the "Hot Summer" of 1975, we see the juxtaposition of converging and diverging temporalities.

This motif reappears in Douglas's simplest formal maneuver, which is to stage the coming in and out of synch of two elements of data with discrete time signatures. The elements take varying forms: image and sound, image and image, live footage and recorded footage, words and lip movements, and so on. This phasing technique enables him to allegorize, at

"higher" levels, clashing temporalities or shifting relations between more historically complex forms: say, Berlin in the 1970s and after 1989 (*Der Sandmann*) or antiprofit and profit-oriented economies (*Nu•tka•*). Like Bloch, Douglas is preoccupied with capitalist modernity as a concatenation of anachronisms: from what Bloch calls the "subjective nonsynchronous contradiction" (affects ranging from a "simple torpid not wanting of the Now" to "pent-up anger") to the "objective synchronous contradiction" ("leftover being and consciousness"; "existing remnant[s] of earlier times in the present" like piecework and peasantry.)

Though used primarily as a meditation on technique in early works like *Deux Devises: Breath and Mime* (1983), Douglas's experimentation with various methods for making signals enter in and out of phase—dubbing; modular scripts offering variations at specific narrative branching points; separate looping of picture and soundtracks; multiple channel projections; concurrent display of the same work on live broadcast television and in the gallery—quickly became integrated into his representation of dense historical conjunctures. The two become systematically intertwined over the 1990s in his first mature works made explicitly for international exhibitions. Involving a complex layering of Gothic literature and history, *Der Sandmann* (1995), *Nu•tka•* (1996), and *Le Détroit* (2000) all dramatize the imprecise, shifting superimposition of temporalities via phasing. *Le Détroit*, for example, is a projection of identical black and white 35mm-film loops—one positive, the other negative—on two sides of a semitransparent screen. Because the projection of the negative is delayed by two frames, their interaction produces "constant after-images, shadowy forms that seem to obliterate each other," or "images which look like silvery fish scales flaking off."[21] This ghostly look pervades the film's minimal, six-minute narrative. On screen, a black woman parks her Chevy Caprice, still running with its lights on, in front of a dilapidated house in Detroit's Herman Gardens, a former all-white housing project. She moves slowly through the house as if in search of something she cannot find, closing closet doors that reopen behind her back as she leaves and returns to the Chevy, putting it in gear. This image is how the film begins; the loop starts all over again.[22]

Nu•tka•, set in the late eighteenth century at Nootka Sound in British Columbia, and based on conflicting tales told by Spanish and English captains who both claimed rights to the land already occupied by the Mowachaht Confederacy, is a video based on the initial filming of two

230

images of the same landscape, each comprised of 485 interlacing horizontal raster lines over two tracks. Removing the even lines from one sequence and the odd from the other to generate two newly different, constantly panning and tracking landscape shots, Douglas recombines them to create a restless, shivering single video difficult to watch. Overlapping monologues from the English and Spanish captains are simultaneously broadcast in the room, with the voice of one heard at the front and the other at the back; based on excerpts from the captains' diaries interlaced with quotations from the writings of Edgar Allan Poe, Miguel de Cervantes, Jonathan Swift, Captain James Cook, and the Marquis de Sade, the overlapping voiceovers become increasingly paranoid. At key moments in the 6 minute 45 second presentation, however, the two sequences present the same image and sound before being pulled apart again. At these moments of almost shocking clarity, the two interlaced video images fall into exact registration and also become still for a brief moment. At the exact same moment, the monologues of the two officers, suddenly comprised of the same words, are said in exact unison.[23]

This accumulating toolbox of techniques for bringing elements in and out of phase laid the ground for their automation at the turn of the millennium in what has since become Douglas's "thing": an invisible looping + randomizing device the artist calls his "recombinant machine."[24] With only its output made viewable, the "machine" is not so much hardware as a process or algorithm run through an assemblage of devices varying across changing platforms: in the first incarnation of *Suspiria* at Kassel (two simplified versions were later made for gallery viewing), the assemblage included a computer, an audio sampler, an audio mixer, 2 DVD players, 4 live cameras, and vertical interval switchers.[25] Philip Monk presciently calls it a "value machine" (more on the latter shortly), stressing that it is Douglas's "*singular* invention" (original emphasis).

> Before a machine is put on the market to perform, it must be designed, engineered, and fabricated. Enter the artist. As for the machine's input (which is not the work's content), a pre-existent 'text' (which is never [a single or unified] one—say, "Journey into Fear") is broken apart. Its components are analyzed and quantified. Combinatory operational rules are then re-invented (another analysis). As for output (which is not the work's form), the machine does the rest. Its permutating performances are yet other, multiple real-time analyses.[26]

Beginning in 1999, Douglas uses his machine in conjunction with complex, modular, variation-intensive scripts. In the double-projection installation *Win, Place, or Show*, the machine "flips a coin" at specific narrative branches to select slightly differently filmed variations of six scenes to play. Although the story set in Vancouver in the early 1960s is relatively simple—seasonally employed dockworkers Donny and Bob tell a joke, share a conspiracy theory, examine betting columns in a newspaper, have an argument, toss a coin (like the computer), and physically fight—there are enough variations to ensure that the same exact combination of scenes can only be seen every 20,000 hours, or roughly two years.

The machine thus enables Douglas to produce works that do not permit a "complete and clear viewing," underscoring, as Rebentisch notes, their separateness from the spectator's experience.[27] Their duration has expanded in tandem with Douglas's increasingly compressed historicism. With only two exceptions since its debut in *Win, Place, or Show—Suspiria* and *Journey into Fear*—the installations in which the machine appears focus on documented events in very specific time frames: colonially overburdened Portugal in the aftermath of a bloodless coup on April 25, 1974 (*The Secret Agent*, 2015); a clash between the Tsilhqot'in tribe and encroaching settlers in British Columbia's Cariboo Mountains in 1864 (*Klatsassin*, 2007). At the same time, the turn to the machine has also coincided with Douglas's growing reliance on fictional source texts for the generation of scripts. *Klatsassin* routes its colonial narrative through the tropes of Akira Kurosawa's legendary film *Rashomon* (1950), with five levels of narration that interrupt and overlap one another; the permutations that comprise *Inconsolable Memories* are based on Tomás Gutiérrez Alea's iconic 1968 film, *Memorias del Subdesarrollo* (*Memories of Underdevelopment*). Formally, the machine's arrival made the dimensions of Douglas's installations increasingly "variable" as well as resistant to human spectatorship. *Journey into Fear*, for example, is described on the website of Douglas's gallery, David Zwirner, as a "16mm film installation 15:04 min per rotation, total running time 157 hours (approx. 6.5 days)." *Inconsolable Memories* is "2 synchronized asymmetrical film loop projections; 16 mm black-and-white film, sound; 15 permutations with a common period of 5:39 min; dimensions variable." *The Secret Agent*: "Six-channel video installation, eight audio channels, 53:35 min (loop) with six musical variations, color, sound; overall dimensions vary with installation."[28]

The specs of the gallery version of *Suspiria* are listed on David Zwirner in a strikingly less precise manner: "Single-channel video projec-

tion with stereo sound. *Stories recomposed and music remixed in virtually infinite variations.* Dimensions variable."[29] In the survey monograph *Stan Douglas* published by the Flick Collection, we find it redescribed more briefly, in an almost comical juxtaposition of the concrete with metaphysical: "6 DVDs. Infinite."[30]

Was there something different about *Suspiria* which led to the abandonment of precise calculation in measuring its dimensions? And could this have something to do with the other thing about *Suspiria* that sets it apart from Douglas's other recombinant works, which is its generation of a mildly bad review? Surveying Documenta XI in 2002 for *Frieze*, Kobena Mercer implied that in spite of widespread promotion by curator Okwui Enwezor as the first truly "multicultural," "post-colonial Documenta," the mega-exhibition was more or less conceptual art per usual.[31] Mercer singled out *Suspiria* to illustrate his disappointment in the "emphatically ideas-driven event," noting that "despite the erudite research, it felt as though the artist was doing Stan Douglas by numbers."[32]

"Doing a task by numbers" has an equivocal definition, akin to that of "dialing it in." It can mean doing the task "in a perfect or complete way" but also to "give a lackluster, uninspired, or timid performance"; "to fulfill a responsibility with the minimum rather than appropriate level of effort."[33] Performing with precision but at the same time nonoptimally; working too little but also somehow too well: *Suspiria* is the only mature work by Douglas over which anything remotely like the shadow of the gimmick has fallen. And for reasons possibly related to its intensification of, rather than departure from, aesthetic features associated with "Stan Douglas."

The Color of Value

Suspiria (2003) is to this date still the technically, logistically, and narratively most complicated of all Douglas's recombinant narratives. In the Documenta installation that premiered at the Museum Fridericianum, scenes of bargaining and exchange based on narrative segments abstracted from Grimms's fairy tales, shot in a Vancouver studio and recorded on DVD in a garish Technicolor palette, were overlaid on live, black and white (or more precisely, gray) surveillance footage taken from inside the Herkules Oktagon, the city of Kassel's largest and most conspicuous landmark. A digital switching system coordinated the superimposition of the prerecorded color images over the live gray ones. Another was used to

relay the ensuing mix to the Museum Fridericianum during the day and to a Kassel television station for transmission at night.

Dull, grainy, and washed-out looking, the surveillance images are mostly of empty corridors with dusty stone floors and walls (or rather, cement walls fashioned to look like stone). Transparently superimposed on this paradoxically dead-looking live footage, acts of buying, selling, negotiating, and attempted outmaneuvering between a heroine named Else and a rotation of other characters—Peter, the Innkeeper, a Dwarf, a Merchant, a Tailor, a Charcoal Burner, a Servant, a Giant, a Witch, a Thief, the Devil, Soldiers, and so on—are represented in reds, blues, greens, and sometimes yellows. Based on specific rules about order, a computer coordinated the sequencing of scenes, 256 narrative segments abstracted from the *Complete Tales of the Brothers Grimm*, with thirty-five discrete musical tracks composed and performed by John Medeski and Scott Harding, remixing all elements in real time.

Suspiria's seventy-seven-page script outlines specific branching points in the presentation of scenes at which its computer "flips a coin" to determine which of a series of variations will play. There are a total of six rules, quoted in their entirety to show how the piece acquires its staggering complexity from a relatively simple set of raw ingredients:

Rules for the Script

1. A "story" is a sequence of segments lasting no more than twelve minutes and consists of no less than two segments.
2. Each story begins with an introductory passage read by one of the two narrators (Suspiriorum and Tenebrarum). The segments shall be chosen at random, however, each narrator should introduce at least four out of any ten stories and neither narrator should introduce any more than three stories in a row. No intro from a particular narrator shall be repeated until all of her intros have been heard. (Page numbers are references to the Penguin edition of Karl Marx, *Capital: Volume One*.)
3. Intros and story segments are chosen at random according to Else's spatial location:

 A = Else is Accused of a Crime
 G = Encounter with Giants
 I = Tales of the Inn
 U = Events in the Underworld

W = Travels in the Woods
> = continue from / to next segment in the series

... and her relative wealth or poverty:

R = Else is Rich
P = Else is Poor
* = Else is either Rich or Poor

Tags left of a back slash indicate the segment types that may proceed the current one and tags on the right indicate the kinds of segments may follow.

4. Story segments in this script are grouped in series numbered according to the tales collected in the Pantheon edition of the *Complete Tales of the Brothers Grimm*. Equal weight is given to the possibility of a segment branching to the next one in the series or to an appropriate segment elsewhere in the script. No segment shall be repeated until all other segments have been seen—without breaking any rules of spatial and economic continuity.

5. An iteration of a segment with variations should be chosen at random and not repeated until all variants have been seen. Segments in which questions are asked of Else have eight variations. The first variant shall be chosen at random, and the same response shall be used in subsequent Q&A segments unless it is indicated in the script that responses should advance.

6. Indented passages are performed; flush-left passages are narrated voice-overs. After every narrated story, there is a short story with musical accompaniment and no intro: synch sound is heard but there is no voice-over. Musical scenes are presented in random order and permuted according to the rules in the Appendix.[34]

Although the basic material from which it builds amounts to data easily compressed into a few DVDs—only two hours of video and two hours of audio—it is not hard to see how *Suspiria* came to take on "virtually infinite" proportions. Given the factorial formula for permutations (in which order matters), it would take "longer than human history" for the work to attain closure by repeating itself.[35]

While *Suspiria* relied on state-of-the-art digital technology (the algorithm or machine) to achieve its sublime *scale*, it relied on a process related to outdated analog television to achieve its gimmicky, off-brand Technicoloresque *look*. This look noticeably departs from the precision

of Douglas's other film-based installations, and indeed, from the famously crisp margins of Technicolor's dye transfer prints. Outlines of people and objects become uncertain, with colors leaking outside the borders of forms. At the same time, in a way underscored by the dull grayness of the surveillance camera images on which they are superimposed, their interactions boil down to modular, interchangeable acts of money-based exchange. As the "lush saturated colors render its subjects transparent, leaving the black and white walls of the Herkules visible underneath the actors," the "optical effect [is] reminiscent of glorious Technicolor," yes—but in a stripped down, cheap-looking way, resulting in a work which looks at once opulent and impoverished.[36] In making its mythical bearers *transparent*, moreover, disclosing the live surveillance imagery behind them and undermining their timelessness, the way color behaves in *Suspiria* mirrors how commodity exchange in *Capital* desolidifies its agents, revealing them as personifications of capital and labor (Figs. 7.1 and 7.2).

The bleeding reds, blues, and greens unleashed by acts of exchange in Douglas's fake Technicolor *Suspiria* evoke the similarly retro colors of Argento's late Technicolor *Suspiria*. At the same time, the *behavior* of color

FIGURE 7.1

236

FIGURE 7.2

in Douglas's version signals a significant departure. As epitomized in the geometrical design of its first of many highly stylized murders, colors in Argento's film have sharply defined edges. Stabilized hues and the elimination of "fringing" were Technicolor's most significant achievements in the early twentieth century. Colors in Douglas's *Suspiria*, by contrast, messily bleed outside the borders of the objects that would seem to contain them, while shifting in hue (what starts out as orange suddenly becomes yellow). For the first and only time, Douglas's skills at technological manipulation were used to generate screened images that looked unfocused rather than precise, garish rather than austere, and low-tech rather than high-def—almost like badly executed spirit photography, or a 3D movie without glasses (Fig. 7.3). We could say that it was one of his few experiments in tarrying with the gimmick.[37]

The blurry spectral look of a botched special effect in *Suspiria*'s representation of exchange was achieved by Douglas "tweaking" a feature of the analog NTSC system (National Television System Committee). Used in North America from 1954 until the 2000s, when it was replaced by the digital ATSC standard (Advanced Television Systems Committee),

FIGURE 7.3

NTSC was originally black and white.[38] When color was introduced, the standard was not reconfigured but rather adapted, by using the black and white picture information (luminance) as a carrier signal over which the color information (chrominance) could be superimposed or "ride piggyback."[39] This was done to solve the problem of transmitting maximum visual information over a restricted bandwidth.[40] For greatest transmission efficiency, engineers "chose (a) to let the black and white signal handle the fine detail and (b) to convey chromatic information by a difference signal."[41] This meant that only differences between wavelengths, rather than all the data points representing complete information about each individual color, would need to pass through the cable.[42]

Based on one signal superimposed on another, as Douglas notes, "the color television system in North America is . . . a system of ghosts."[43] This "system of ghosts" made the general look of *Suspiria* surprisingly easy to pull off: "If two video signals share a common 'time base' or synch, their luminance and chrominance components can be interchanged *by simply switching a few cables*: this is how prerecorded scenes derived from the

Grimms's Fairy Tales shot in a Vancouver studio were superimposed over live images from the Herkules."

> Four synchronized black and white surveillance cameras on computer-controlled pan-and-tilt heads were installed in the corridors of the Oktagon. Their video signals were to be fed to a switching system that combined their real-time luminance signals with prerecorded chrominance signals played back from DVD. The effect of this superimposition causes over-saturated faces and figures to bleed over and into their setting, changing in hue as the quality of daylight changes within the space.[44]

Douglas's MacGyver-like trick, in other words, was to deprive his color images of their supporting black and white signals (which provide most of the image detail, including information about edges), swapping them out for the black and white signal of the surveillance cameras (Fig. 7.4). If the chrominance images were reunited with their original luminance signals, colors in *Suspiria* would look stable, as opposed to, say green suddenly mottling into red, depending on the changing luminosity of the surveillance camera signals.[45] Against the sophistication of his digital sequencing systems, the simplicity of Douglas's technique for generating the spooky look of color escaping its containers evokes the anachronism at the heart of the gimmick form. Superimposing not just old and new technology but live and prerecorded action, in a work consisting entirely of scenes of exchange, *Suspiria* evokes capitalism's overall way of combining "unsurmounted remnants of older economic being and consciousness" with contemporary forms.[46]

Color asserts itself in Douglas's *Suspiria* by bleeding into grayness, whereas in Argento's it asserts itself in bold outlined shapes. Equally vivid, the colors *behave* and therefore ultimately look differently. In Argento's film, they look like real Technicolor, which, in a way his retro aesthetic

FIGURE 7.4

can distract one from remembering, they *are*: printed on one of last imbibition machines owned by this company. The simulated Technicoloresque look of *Suspiria* is different, and as we know, unrelated to the older technology; what we see is a chrominance signal separated from its original luminance signal and rejoined with a different one. While the Technicolor dye transfer process results in "sharp 'black' blacks . . . excellent contrast, and distortion-free" colors, the reds, greens, and blues in Douglas's faux version look like "Technicolor" gone slightly wrong, and thus like a generically botched version of a special effect.[47]

Another way to describe the difference between the way color looks in the two *Suspirias* is to liken it to the difference between the behavior of surface colors, which are produced by light reflecting off the surface of material, and luminous colors, which are seen through a transparent medium combined with a light source. As David Batchelor explains: "surface colours appear opaque and to be in or on that material; luminous colours, on the other hand, often appear to be a quality of light and space, and consequently are less bound to a surface or a material."[48] Luminous color thus has a primarily temporal rather than spatial character; its transitory status makes us experience colour less as a thing than an event (50):

> Luminous colour seeps, spills, bleeds and stains. . . . [These] are colours that escape their containers and bleed into the street; they deliver what colour always promises but doesn't always achieve: a release from the surfaces and materials that support it, a release that leads to the fleeting magic of the "fiery pool reflecting in the asphalt" [Walter Benjamin's description of seeing the color red detached from its neon advertising]. This escape of colour, this assertion of its autonomy and independence from the objects that lay claim to it, is momentous, in its way, but also momentary. (49)

The world of perpetual exchange Douglas's *Suspiria* represents is one in which, strikingly, the *only* colors we see are luminous ones. Surface colors are missing, as if *because* its world consists only of acts of exchange: the landscape we see during the voiceovers at the beginning of each "story," before the humans appear with their commodities, is grey only. Luminous colors, while more unstable than the surface colors dominant in nature, are also more intense. As Batchelor notes, they do not "grey out" like the colors of trees, flowers, birds, and bodies of water at night, and are the primary way in which color is "delivered to us" in the built 24/7 worlds of capitalist modernity: as "fluorescent light glowing through colored Plexiglas, arcs of

vibrant neon, fairground rides decked out in thousands of dazzling, flashing, multicolored bulbs, and hyperactive LED matrixes" (47).

What brings the gimmick to haunt *Suspiria* is the way it represents color *in conjunction with* commodity exchange. For color's phantom-like behavior in this artwork, constantly escaping the borders of objects, evokes how "value" acquires its own spectral objectivity, or what Marx calls "gespenstige Gegenständlichkeit."[49] "Spectral" and "objectivity" are not opposites here. Rather, the appearance of thinglike substantiality is generated *through* ghostlike behavior, and the quality of seeming ghostlike *through* the assertion of thinglike substantiality. *Suspiria*, to put it another way, uses exchange to reveal the spectrality of value's social substance, which entails giving visibility to a collectively generated abstraction intrinsically resistant to the empiricism of our senses. The appearance of color *solely and exclusively in conjunction with representations of labor-abstracting exchange* conjures the image of capitalist "value" as such.

Like color, as luminous color especially illuminates, value is not an inherent property of things. In the first volume of *Capital*, Marx stresses this point on his way to showing why value must appear in the form of exchange-value, or why, against the proposed substitution of paper "time-chits" for money by utopian socialists, the particular kind of "labor-time" that constitutes value in capitalism cannot be directly expressed *in* or *as* labor time.[50] The fact that value is not inherent to objects does not mean that it lacks objectivity or cannot be measured: only that the objectivity that it does have is endowed with a special "phantom-like" character. According to Michael Heinrich, Marx's most emphatic statement of this can be found in his revised manuscript for the first edition of *Capital*, in which Marx states that when a coat is exchanged for linen, both are "reduced to an objectification of human labor per se."[51] In the act of exchanging coat for linen, commodity A for commodity B, an "objectifying" reduction, distillation, or abstraction of each to something called "human labor per se" takes place.

The abstraction that bestows objectivity to the value of commodities, or makes their immanent value as labor-time measurable, takes place in the equalizing act of exchange. As Marx stresses, "[neither coat or linen] is in and of itself value-objectivity [Wertgegenstandlichkeit], they are this only insofar as that this objectivity is commonly held by them. *Outside of their relationship with each other—the relationship in which they are equalized*—neither coat nor linen possess value-objectivity or objectivity as congelations of human labor per se." As a consequence, Marx writes,

"a product of labor, considered in isolation, is not value, nor is it a commodity. *It only becomes value in its unity with another product of labor.*"[52]

A product of labor only "becomes value" in its unity with another product of labor. And in *Suspiria*, forms populating its bewitched and yet dreary land acquire color only in the equalizing relationship between one thing and another. To put it another way, the act of exchange in *Suspiria* cannot take place without flooding its otherwise colorless world with a substance that behaves in a distinctively ghostly way.

Value attains its ghostly and yet thinglike objectivity—attains what Marx calls its social "substance" as abstract labor—only in the equalization of one product of labor to another. This requires money, because only a general equivalent, set apart from other commodities, can set a commodity in relation to all other commodities as values. As something that is not inherent, but mutually bestowed, the objectivity of value is "social" *and therefore* ghostlike. The main example Heinrich uses to illustrate the spectral, *because social* quality of value-objectivity (Wertgegenstandlichkeit) is color:

> The substance of value is not something that two commodities have in common in the way, for example, that both a fire truck and an apple have the color red in common. Both are red even in isolation from each other, and when they are placed alongside each other, we detect that they have something in common. The substance of value, and thus the value-objectivity, is something only obtained by things when they are set into relation with one another in exchange. *It's as if the fire truck and apple were only red when they're actually standing alongside one another, and had no color when separated (the fire truck in the fire station, the apple hanging from an apple tree).*[53]

Other commentators gloss Marx's concept of value-objectivity differently. Riccardo Bellofiore describes the value of a product of labor as virtual or ghostlike *prior* to the exchange-abstraction, and as "embodied," hence presumably nonghostly thereafter.[54]

> Value in the single commodity, considered in its "ideal" existence, is still nothing other than a pure "ghost." Marx says this, explicitly, in *Capital*. That spectre must "take possession" of a body: in this sense, it must "incorporate" or "incarnate" itself. The body of which value takes possession is that of commodity-money. (30)

Though both commentators stress that the importance of money in Marx's writing is for its "function as guarantee of the very existence of a nexus between value and labour" (and not for the sake of theorizing money as such), Heinrich's gloss of "gespenstige Gegenständlichkeit" arguably gets at something deeper about capitalist forms.[55] Here, value's ghostly quality resides precisely *in* its "incarnation" in money: value acquires its spectral character *when* socially validated and objectified in exchange. What makes value objective (and measurable) is what makes it social; what makes it social is in turn what makes it spectral. Heinrich's emphasis on the necessary form of value's appearance thus brings out a counterintuitive link between *spectral* and *social* that is unique to capitalism, which the main special effect in *Suspiria* similarly underscores.

Exchange, as mentioned, is the only activity represented in *Suspiria*—and always in garish, bleeding color. Conversely, the world of *Suspiria* is one that acquires color only at moments of equalizing, value-objectifying, labor-abstracting exchange. Depending on what version of this virtually infinite, endlessly recombining work we end up viewing, a pig may be exchanged for a goose and a goose for a grinding stone; a giant turnip is exchanged for a sack of gold, a taler for a magic rock; a meal is "advanced until payday" on the condition that the recipient "spend three nights on the grave" of the person who advances it; labor is exchanged for "wages." Each bargain, contract, or swap is succeeded by another, with the order of swaps determined primarily by the state of the protagonist's finances, which in turn plays a key role in determining her location. These "weights" are for the sake of narrative continuity, which *Suspiria* sticks to with almost comical fidelity. If Else is in the inn in a preceding segment, she can still be in the inn or in the woods in the next one, but not the underworld, since the only portal to the underworld seems to be in the woods; if Else loses all her gold in the preceding segment, the segment that follows cannot be one in which we see her spending it; she is therefore likely to not show up at the inn (Figs. 7.5 and 7.6).

Variations within these 256 microstories about exchange are swapped in and out for each other as well. Take "The Giant and the Tailor," which has three variations: 1a, 1b, and 1c. In each, the giant, who has hired Else for a job after an odd response to her question about wages (naming an amount of time, as opposed to money), asks Else to fetch a specific object (water, firewood, a boar); Else replies with a correspondingly specific sarcastic remark that the giant mistakes for a true statement of her magical ability to produce wealth.

FIGURE 7.5

FIGURE 7.6

183. The Giant and The Tailor

Suspiriorum

183-1a [P/*] W/G,W

Else came upon a *Giant*, whom she asked for a job. The *Giant* told her of an available position.

Else: "And what will my wages be?"
Giant: "Every year, three hundred and sixty-five days, and in a leap-year, one more in the bargain. Doesn't that suit you?"
Else (staring in disbelief, thinking): That certainly is a large giant.
Giant: "Then you can start by fetching some water."
Else (sarcastic): "Why not the whole well? I can bring it on my back?"

The *Giant* was surprised by *Else*'s response. He thought to himself, "Be careful of this one Hans, she has mandrake in her blood."

183-1b [P/*] W/G,W

Else came upon a *Giant*, whom she asked for a job. The *Giant* told her of an available position.

Else: "And what will my wages be?"
Giant: "Every year, three hundred and sixty-five days, and in a leap-year, one more in the bargain. Doesn't that suit you?"
Else (staring in disbelief, thinking): That certainly is a large giant.
Giant: "Then you can start by fetching fire wood."
Else (sarcastic): "Why not the whole forest? I can chop it in one stroke."

The *Giant* was surprised by *Else*'s response. He thought to himself, "Be careful of this one Hans, she has mandrake in her blood."

183-1c [P/*] W/G,W

Else came upon a *Giant*, whom she asked for a job. The *Giant* told her of an available position.

Else: "And what will my wages be?"
Giant: "Every year, three hundred and sixty-five days, and in a leap-year, one more in the bargain. Doesn't that suit you?"
Else (staring in disbelief, thinking): That certainly is a large giant.

Giant: "Then you can start by fetching a boar for supper."
Else (sarcastic): "Why not a thousand? I can kill them all with one
shot."

The *Giant* was surprised by *Else*'s response. He thought to himself,
"Beware of this one Hans, she has mandrake in her blood."[56]

All 256 of the continuously interchanged segments about exchange are
prefaced by a voiceover "introduction" by either Suspiriorum or Tene-
brarum, two of the three Mothers in the Argento trilogy of films launched
with *Suspiria*. One or two are exact quotations, like this one from *Capi-
tal*'s chapter on "Primitive Accumulation" in which Marx ventriloquizes
the Grimms to poke fun at Adam Smith's theory of capitalism's origins:
"Long, long ago there were two sorts of people; one, the diligent, intelli-
gent and above all frugal elite; the other, lazy rascals, spending their sub-
stance and more on riotous living. . . . Thus it came to pass that the former
sort accumulated wealth, and the latter sort finally had nothing to sell but
their skins."[57] Most of the voiceovers, however, are distorted doubles of
sentences from *Capital*, volume 1. We might think of them as instances of
out-of-synch Marxism:

We may twist and turn a cudgel as we wish, but until it is swung it
is impossible to grasp it as a thing possessing value. (138) [/*]/I,W

Else never cared much for superstition, but she believed the old tales
contained a grain of truth: a rational kernel within the mystic shell.
(103) [/*]/I,W

A man is an innkeeper only because others stand in relation to him
as guests. They, on the other hand, imagine that they are guests
because he is an innkeeper. (149) [/*]/I

Else apprenticed as a magician, but it was too much work. As her
master told her, magic must reflect nothing apart from its own ab-
stract quality—and nothing of human labour. (150) [/P]/I,W[58]

The voiceovers accompany the grey, mechanically panning and tilting
camera images of empty Oktagon corridors. It is only when these voices
fall silent, and the representation of value-objectifying, labor-abstracting
exchanging begins, that the screen becomes flooded with border-escaping
reds, greens, and blues. Binding the system's high-tech switching and

sequencing system to a remarkably low-tech special effect, the concatenation of representations (commodity exchange and ersatz Technicolor) brings Douglas's recombinant machine to the foreground as a true "value machine." *Suspiria* is an allegory of capitalist exchange-abstraction rather than a meditation on a historical moment, and this thematic focus draws it into an intimacy with the gimmick which Douglas's artworks rarely have.

Suspiria suggests that the "color" of value-objectifying exchange is luminous. There is, after all, no other kind of color in its bewitched world, and no other situation in which color appears. Exchange, meanwhile, qua abstracting activity, putting products of independent acts of labor in relation and making value measurable, does not take place without unleashing phantomlike colors—and only via the pairing and switching operations of the recombinant machine. The way we come to "see the machine" as we do not in other installations by Douglas thus coincides with the unsettling way in which *Suspiria* makes us "see" the spectral objectivity or social "substance" of value. It has something do, in short, with the way it makes us "see" abstract labor, that strange thing resulting from what Alfred Sohn-Rethel calls the "exchange-abstraction."[59] How does one make a substance that is "suprasensible or social" visible?[60] By representing it as one of culture's most familiar phantom-like objectivities: a ghost. And as Douglas himself hints, as the "ghost" of two or perhaps even three media practices: Technicolor, analog television, spirit photography.

Via color escaping the borders of forms, or the image of a phantom-like substance generated in exchange, *Suspiria* represents capitalist abstraction differently than the artworks in the previous chapters, if in a way similarly relying on the gimmick's extravagantly impoverished form. Douglas essentially says this, noting that while there are only two hours of scripted performance and two hours of recorded tracks, "they combine to produce more than the sum of their parts—an effectively infinite concatenation of stories—much like Marx's famous formula, M-M′, the process by which money produces more money, as if by magic."[61] In appearing to generate, endlessly, "something for nothing," or "infinity" from "6 DVDS," *Suspiria* is "basically like capitalism itself."[62] Like the golden bird producing golden coins that Else briefly acquires in one of its stories, it exemplifies, in a certain sense, the gimmick writ large.

The representation of value in *Suspiria* thus points to the gimmick once again as the aesthetic flip side of capitalist sublimity. For here the comic appearance of a badly executed special effect enables Douglas to undercut

an interpretation of the computer-driven endlessness of exchange as a claim about the historical invulnerability of capitalist "value machines." Apotropaically averting this, *Suspiria* deploys the low-tech gimmick of form-escaping color—the ghostly look of the reduction of products of specific labors to an "objectification of human labor per se"—as an aesthetical counterweight against the engine of precision at its center. An uncanny representation of abstract labor is thus summoned to question the seemingly invulnerable power of capitalist automation. This is the power palpably embodied in Douglas's "singular invention": the machine which, since its first appearance in *Win, Place, or Show*, has increasingly dominated Douglas's work in a way that the artist may have started to find slightly troubling. It is as if a "value machine" capable of generating "infinity" from finite material, or some surplus from nothing other than circulation or recombination, were suggesting the inexhaustibility of capitalism itself, in a way that only the flimsy gimmick can aesthetically combat.

Manipulating outmoded technology to highlight the autonomous behavior of luminous color, which in turn allegorizes value's ghostlike objectivity acquired in exchange, *Suspiria* sets a cheap effect and a fancy machine in dialectical opposition, playing the former's transience and ephemerality against the latter's endlessness. It pits the temporally unstable gimmick against the capitalist sublime, while seeming to know that these two experiences are cut from the same linen. Sometimes the gimmick comes to the fore in our viewing, while at others the sublime prevails. But the "opponency" between the two aesthetic categories facilitates our perception of each.

Sounds Gimmicky

As one of Douglas's two works about value in circulation (the other, as Monk notes, is *Journey into Fear*), *Suspiria* invites us to read the switching and coordinating operations of its logistical center differently. The thing usually said is that the point of the machine is to resist narrative "resolution."[63] This indeterminacy, it is also said, renders his artworks porous, enabling viewers to enter and exit them at any point. But what is overlooked with this emphasis on openness versus closure is the simpler fact that the machine enables Douglas to produce works of gigantic, viewer-resistant, mathematically sublime *size*.

As in all Douglas's recombinant works, the sublimity of *Suspiria* is achieved via the intensive variations enabled by its machine. But the work's

248

attitude towards its algorithmic engine feels uneasy. As if the focus on "exchange-abstraction" made the machine too formally obtrusive, the solution to the problem of its encroaching dominance seems to have been to harness it to the production of a transient, comically bungled-looking effect. The device of form-escaping color, unleashed only in acts of exchange—the world of *Suspiria* is tellingly colorless when no exchanging takes place—offers a striking image of "gespenstige Gegenständlichkeit." Certainly, one cannot see the social substance of value (abstract labor). But through the jerry-rigging of an obsolete technology to generate a discounted, off-brand version of Technicolor, *Suspiria* makes us see something that approximates what seeing it "feels" like, and in a way that directly works against the work's simultaneous display of capitalist might, pitting the transient "special effect" against the infinity of the digital/automated machine in what we might think of as yet another way of staging a "polyphony" of temporalities.

Via the gimmick/effect and its disruption of what seems to be endless, value-increasing circulation, *Suspiria* gives us a comically garish depiction of the suprasensible/social substance of capitalism's privileged form of wealth. If in *Le Détroit*, the superimposition of two projections turns the protagonist into a "ghost chasing after her own image," the labor-abstracting exchange of commodities in *Suspiria* unleashes a flood of colors bleeding outside the lines of forms.[64] And if *Suspiria* finds, in this way, a clever trick for representing the ghostlike objectivity of the substance of value, via acts of equalizing exchange sequenced by an unseen machine, the video also offers a meditation on the question of capitalist automation and its promise of worklessness. While both utopian and dystopian visions of this development abound, Detroit activist James Boggs offers a memorable one from the perspective of the permanently unemployed:

> When you travel around this country and see new automated plants springing up in one area after another, it becomes apparent that the era when man had to earn his right to live through work is rapidly drawing to a close. Within a few years, man as a productive force will be as obsolete as the mule.
>
> It is in this serious light that we have to look at the question of the growing army of unemployed. We have to stop looking for solutions in pump-priming, featherbedding, public works, war

contracts, and all the other gimmicks that are always being proposed by labor leaders and well-meaning liberals. . . . By all kinds of gimmicks—including war work, which may end up killing off those for whom jobs are being created, and a host of government agencies set up to study the problems of "full employment"—the American government is now trying to make work when we are already on the threshold of a workless society.[65]

If Boggs invokes the gimmick to deflate euphoria about automation's elimination of toil (as we saw in our Introduction), Douglas mobilizes it as a transient effect against the eternity of his "value machine."

This again does not happen in every installation. It is the case only in Douglas's two works thematizing money and timing, circulationist themes that make the machine newly visible *as* a "value machine." *Suspiria*, as we have seen, is one of them. It is time to say a few words about the other, which also immediately preceded it: *Journey into Fear* (2001).

Set on a container ship afloat in international waters, *Journey into Fear* interweaves scenes of negotiation and exchange from Melville's experimental novel, *The Confidence-Man*, into the storyline of Eric Ambler's eponymous spy novel and the two films inspired by it. In each of these variations, one character attempts to convince another to postpone the cargo ship's arrival in Genoa from Istanbul by one day. In one case, the late delivery of its freight (weapons) will give Germany a military advantage in the Second World War (Ambler's 1940 novel; Norman Foster's 1942 film); in another, an economic advantage to a corporation hunting for oil deposits during the Oil Crisis (Daniel Mann's 1975 film). In Douglas's remake, which features a tense conversation between Möller, the secret agent disguised as a supercargo, and Graham, a pilot sent by the port to guide the *Fidèle* through local waters, the delay of the arrival of a particular container is to have a dramatic effect on the stock market, from which Möller's hidden client will stand to gain 75 million US dollars.

Note how David Zwirner describes *Journey into Fear* in the gallery's original press release:

A man and a woman are arguing in the cramped cabin of a container ship. The dialogue reveals their tension; something big is at stake. He needs her confidence. . . . She rejects. He offers bribes and threatens murder. But mostly, the two just talk. Their conversation

seems to go nowhere and more than that, it appears to go on for-
ever as the film loops between the exterior scenes shot on the ship
(are they flashbacks or flash-forwards?) and the interior scenes.

Stan Douglas has created a fixed loop of scenes within the pic-
ture track of his work. However, the dialogue accompanying these
scenes, changes (almost) endlessly as a computer picks at random
from different dialogue possibilities that are lip-synched through a
dubbing process. As the scenes and its actions repeat themselves,
the dialogue mutates continuously so that it would take days for
the exact same scene and dialogue to reappear.

Stan Douglas evokes the 1970s as a backdrop for an intense psycho-
logical exchange. In his "Journey into Fear," protagonist and antag-
onist continuously trade places as the claustrophobia of the endless
film and dialogue loop contracts *until the film finally reveals its true
identity, that of a machine.* Its repetitions and mutations create a
haunting metaphor for the perception of time in modernity.[66]

"The film finally reveals its true identity, that of a machine." What kind
of a machine? One whose operations do what they do in every Douglas
installation: build a work of daunting, viewer-resistant scale. But one also
used here to generate the comic effect of *badly executed dubbing*, which
we might think of as the auditory equivalent of *Suspiria*'s leaky, border-
escaping colors.

How does this work? As noted above, *Journey into Fear* is an installa-
tion in which a picture track loops while changing dialogue tracks are laid
over it. The film's timeline is divided into four scenes of interaction (1–4)
that enable branching; at these forks, the computer randomly decides
which of five variations (A–E) on the four conversations will be performed.
As in tone row composition, a different permutation of dialogue is to ac-
company each repetition of the picture track until all have been presented:
segment 1A could be followed by 2A, but just as well by 2C, 2D, or 2E;
2A could in turn be followed by 3A, 3B, 3C, 3D, or 3E, and so on. Like
the character system of *The Confidence-Man*, in which it is never clear if
we are encountering one man in various disguises (the Black Rapids Coal
Company "transfer agent," the Herb Doctor, the Man with the Brass
Plate, and so on), or seven all interacting with their marks in a similarly
transvaluative way (asking for money as objectivation of the mark's "trust"
or "confidence" in both the economic system and society writ large), the
possibility of variation feels endless even if technically finite. A total of

625 combinations are possible, which means the work's full viewing duration amounts to about six days.

With its modular structure and rotating cast of virtually interchangeable characters, Melville's novel itself may have itself been designed to be a kind of "recombinant machine."[67] One contemporary reviewer described it as a text that could be read in any order, much to the same effect: "After reading the work forwards for twelve chapters and backwards for five, we attacked it in the middle . . . as a last resource we read it from beginning to end; and the result was we liked it even less than before."[68] In a similar spirit, *Journey into Fear*'s machine superimposes a rotation of sometimes slightly differing, other times wildly mismatching dialogue tracks over closeups of Graham and Möller. The gimmick is that even when variants have the same rhythm and length, dialogue and lip movements never exactly match. This is because in Douglas's version, there is no "original" conversation from which variants deviate. Strictly speaking, what seem to be variations are *simulations* of variation.

Here we glimpse the small-factory-sized amounts of collective labor that go into every Stan Douglas installation, which makes his willingness to insert the gimmick into some of them all the more interesting. As Monk notes, inventing lines that when spoken will sound as if they are both resembling and differing from *a paradigmatic, mythical conversation that in fact never took place* is an astonishingly difficult literary feat.[69] Compare, for example, these two variations, both written as possible soundtracks for segment 3 on the picture loop.[70]

3B: Protean Chair

Graham: Have you heard of the Protean Wheelchair? Of course not. It was invented by a chemist after his daughter was stricken with meningitis. The Chair works off neurochemical changes in the body and converts them into computer-friendly data. All you have to do is think and it takes you where you want to go.

3A: Black Guinea

Graham: There's something I really need to ask you. I'm not sure how to put this but someone on board this ship doesn't believe your name is Möller or that you're a supercargo, and as much as I'd like to say this is none of my business, it is my business, and I think you owe me a pretty good explanation.

Möller: Just by thinking. So if I thought about going to the bar that's where I'd end up. Where do I get one?

Graham: It's not only going to help the infirm get around, it's got an infinite number of other applications. The technology's up for grabs. Dr. Tranh's figured out a way to read electrochemical changes in the nervous system, from any part of the body. Can you imagine the potential this thing has? The Chair's a gimmick. But you can't blame a butterfly for having been an ugly caterpillar.

Möller: And are you sure he has the patent?

Möller: Who are you talking to? Only Banat and the Mate speak English—and the Mate, he's a hophead.

Graham: Look. Either we straighten this out here and now or I will take it up with the Port. Personally I don't care what happens. But if there's any doubt as to whether you are who you say you are I would consider that, and your presence, a very serious breach of safety. And I am, by law, required to report anything imperiling the lives of the crew.

Möller: What do you want me to say?

We can see how the script was written to result in loose synching of words to lip flaps. *The Chair's a gimmick. But you can't blame a butterfly for having been an ugly caterpillar* and its interchangeable equivalent, *And I am, by law, required to report anything imperiling the lives of the crew* are both twenty-four beats long. Yet the script also contains variants with comically lopsided pairings. In variation 3D, Graham and Möller are discussing the duckbilled platypus, "this goofy animal from Australia with a duck's bill and fur that lays eggs." "Maybe it's just apocryphal," says Graham (103).

Möller: Apocalypse? (105)

In 3E, however, dialogue designed to accompany the same close-up of Möller speaking consists of a word with only one syllable. Responding to a veiled threat by Möller to throw him overboard, Graham says, "I don't think you'd do that."

Möller: Oh? *A beat.* (125)

The stage direction stresses what we can already surmise by eyeballing the script: that when *Oh?* rather than *Apocalypse?* is superimposed over the same close-up of Möller speaking in the picture track, we will continue hearing a voice speaking after the actor's mouth has closed.

The strange goal of all this complexity is to showcase something like a subpar performance of a globally popular audiovisual translation technique. If *Suspiria*'s meditation on capitalist circulation generates the "spectral effect" of poorly done Technicolor, *Journey into Fear* generates that of poorly executed dubbing. In one case, colors bleed out of the forms to which they seem to belong. In the other, sounds fall out of synch from the images that correspond to them. The former, we might say, highlights how the gimmick or capitalist exchange-abstraction looks, while the latter offers a representation of how it sounds. It could also be read as a reflection on the uncanny experience of hearing voices disconnected from bodies, which as Michel Chion notes, points to an ordinary truth about the way sound works in the movies.[71] But Douglas's simulation of a *badly executed* version of this technique seems designed less to reflect on the "acousmatic" nature of cinematic sound than on the meta-aesthetic intimacy between the sublime and the gimmick.

We've noted that Douglas's basic move across his works is to stage the coming in and out of phase of elements with differing time signatures. Dubbing in professional sound engineering, similarly, is the subtle art of combining precise and imprecise timings, of interlacing "tight" co-ordinations with moments in which things are allowed to slightly fall out of phase.[72] Imprecision is possible thanks to the "modest" phenomenon Chion calls "synchresis," the "spontaneous and irresistible weld," often "independently of any rational logic," which the brain generates between a "particular auditory phenomenon and visual phenomenon when they occur at the same time."[73] Synchresis enables us to accept all kinds of imperfect synchronization in dubbing. It is what sustains the illusion that the noises we hear when watching a movie are coming from screens, even when we are listening through headphones plugged into an airplane seat.[74]

Something like synchresis also stems from the capitalist value form and its related appearances, which *Suspiria* highlights through its own subtler invocation of dubbing. In this light, it is worth returning briefly, for a closer look, at narrative segment #183, in which Else attempts to

exchange her labor-power for wages. Just one of the three variants will suffice here:

183-1a [P/*] W/G,W

Else came upon a *Giant*, whom she asked for a job. The *Giant* told her of an available position.

Else: "And what will my wages be?"
Giant: "Every year, three hundred and sixty-five days, and in a leap-year, one more in the bargain. Doesn't that suit you?"
Else (staring in disbelief, thinking): That certainly is a large giant.
Giant: "Then you can start by fetching some water."
Else (sarcastic): "Why not the whole well? I can bring it on my back?"

The *Giant* was surprised by *Else*'s response. He thought to himself, "Be careful of this one Hans, she has mandrake in her blood."[75]

The elements this odd conversation tries to unsuccessfully force into synch, or to at once align and misalign, are measurements of labor, value, and time. Hearing Else's question about her *wages*, the Giant responds with a statement about *days*. In response to the Giant's statement about *time*, Else thinks about her employer's physical *size*. In response to Else's silent, seemingly tacit agreement to the catachrestic terms of her employment—her exchange of labor power not for money but "three hundred and sixty-five days"—the Giant issues a request for a modest task to which Else responds with a sarcastic remark indicating her resistance to it as an out-of-scale impossibility ("Why not the whole well?"). Unable to detect irony, the Giant's response to this is to feel afraid of his worker's magical powers ("Be careful of this one, Hans").

In a system of production in which labor, time, and value are in fact measured by one another, there is a logic to these misprisions. Wages as we have seen look like payment for labor, while in fact representing the time a worker must work to earn the value of the commodities needed to reproduce labor-power, with all remaining time amounting to unpaid surplus labor.[76] From a certain perspective, then, the Giant's reply of "three hundred and sixty-five days" to Else's question makes sense. But if thanks to the ordinary distortions of capitalism, none of these verbal exchanges are entirely nonsensical, it is more obvious that none are right. In this scene

of capitalist contract-making, the exchange between employee and employer thus evokes a poorly dubbed film, underscoring the disconnection of voices from bodies in a way strikingly analogous to the behavior of color in *Suspiria*. It is as if the words spoken by the seller and buyer of labor-power were recorded in separate locations, then artificially grafted to a visual recording of their face-to-face interaction.

Douglas produces a similar effect in narrative segment #100, in which, as Suspiriorum narrates, "Else was so poor she accepted a seven-year contract in Hell, where her sole duty was to stoke the coals that kept the hell-broth burning. The seven years passed like seven weeks."[77] In one of the variants, after receiving a sack of coal as wages, Else realizes the coal has turned to gold; in another, she exchanges gold for a night's stay at the Inn; in another, her sack is stolen by the Innkeeper. In yet another, Else is asked to provide one out of a series of rotating stock responses to the same question, making her sound like a soundtrack randomly imposed on whatever the accompanying visual track happens to depict:

100–1.2 [>/*] >/W

Devil: "In order to receive your wages, go over and fill your bag with coal, then be on your way. If another should ask you from whence you came, you will say:

[Responses Advance with this Phrase]
a "Running from hell!"
b "I'm a Traveller."
c "For Money."
d "I am looking for the tree of life."
e "From the North Sea."
f "One can do better."
g "May God Have Mercy."
h "I don't know"

And if she were asked who she was she should respond,

a "The Devil's dirty sister"
b "I'm a Traveller."
c "Myself Alone."
d "None of your business, shrimp."
e "Gallows's Meat."
f "Grist for the mill."

g "May God Have Mercy."
h "Let the Carrion lie in the pit." (40)

Variation 100–3.2 offers an even more echolaliac version, underscoring the same effect of dialogue mechanically matched—and therefore always slightly mismatched—to a body or situation:

100–3.2 [>/ *] >/I

Else:

> a "Running from hell!"
> b "I'm a Traveller."
> c "For Money."
> d "I am looking for the tree of life."
> e "From the North Sea."
> f "One can do better."
> g "May God Have Mercy."
> h "I don't know"

Innkeeper: "Do you know anyone about here?"
Else:

> a "The Devil's dirty sister"
> b "I'm a Traveller."
> c "Myself Alone."
> d "None of your business, shrimp."
> e "Gallows's Meat."
> f "Grist for the mill."
> g "May God Have Mercy."
> h "Let the Carrion lie in the pit."

Innkeeper: "Right." He reckons she's nuts. (41)

Suspiria seems to want to demonstrate that even when a voice (Else's) is "properly" paired with its own body (Else's), the effect can be of a bad dub.

To be sure, the question of what counts as bad dubbing depends on conventions shaped by economies and history.[78] As Chion notes, "the French, who are accustomed to a tight and narrow synchronization, find fault with the postsynching of Italian films." As he continues, "What they are objecting to in reality is a looser and more "forgiving" synchronization that's often off by a tenth of a second or so."[79] Conversely, Chion

suggests, tight synching could be described as an "ideological" effort to compensate for, or even "mask" the contrivance of all post-synching.[80]

> Marguerite Duras coined the idea that the contemporary cinema stringently requires voices to be *nailed down* to bodies. It's this nailing, which is for her a form of cheating, that she tried to break with in *India Song*. Here she unfastened the voices and allowed them to roam free. "Nailing-down" nicely captures the rigidity and constraint in the conventions that have evolved for making film voices appear to come from bodies.
>
> What we might call an *ideology* of nailing-down is found for example in the French and American film traditions. More than others, these cinemas seem obsessively concerned with synchronization that has no detectable "seams."
>
> So this nailing-down via rigorous post-synching: is it not there to mask the fact that whatever lengths we go to, restoring voices to bodies is always *jerry-rigging* to one extent or another? (130–31, original italics)

The American expression "jerry-rigging," for which the *Oxford English Dictionary* offers no entry (though it has one for "macgyvering") refers to inelegant technical maneuvering in circumstances involving stress.[81] It seems to be a synthesis of two nineteenth-century British words stemming from worlds of manual work: the nautical term "jury-rigging," which refers to a hoisting of a "jury" or temporary sail, presumably in emergency conditions; and the more apocryphal term "jerry-built," which refers to the overhurried, slipshod construction of houses. The gimmick's equivocality about labor thus presides over Chion's concept for dubbing. Quick engineering in stressful conditions, reflecting a capacity for grace and even creativity? Or rushed and therefore badly done labor?[82]

Even in countries where dubbing is popular, it can't seem to shake its associations with the gimmick.[83] It comes across as jerry-rigged, even when engineered with virtuoso actors and state-of-the-art equipment. It is aesthetically regarded as cheap, though it is literally expensive. Subtitling has always cost a fraction of what dubbing costs, which is why it was originally preferred by countries with smaller film industries than Italy. Dubbing by contrast remains a labor-intensive, time-consuming, and *still primarily nonautomated process*. Though a handful of companies offer automated revoicing services, they are applied to a limited range of products for television, most notably nonfictional content featuring solitary narrators

speaking in neutral tones (documentaries, travel shows, cooking shows).[84] Automated dubbing shows no sign of penetrating the market for feature films. At the same time, dubbing's association with cheapness is clearly related to the deskilling that comes with rationalization. If, as commentators from multiple countries have remarked, dubbing sounds neither like "real oral discourse" nor "external production oral discourse (i.e. what dialogue sounds like in original target-culture films)" but like a distinct language, that sound stems from its Taylorized creation.[85] Voice talents record tracks in separate locations in a "series of stops and starts," with the task of reassembling tracks delegated to sound engineers.[86] To facilitate comprehension, role interpretations are exaggerated and the volume of voices turned up higher than normal, which is why dubbed language often sounds melodramatic.[87]

Oscillating as Technicolor does in both *Suspirias* between expensive technology and impoverished contrivance, a standard feature of cinematic production and fancy trick done on its sidelines, dubbing shares the gimmick's morphology in a way that throws *Journey into Fear*'s emulation of it into sharper relief. For it is not only the look/sound of what happens during Graham and Möller's discussions of arbitrage, investment opportunities, and "gimmicks" like the Protean Chair. Dubbing is in a sense the essence of this circulation-themed work. Douglas describes his "remake of a remake of a remake" in exactly this way, as "mimicking the life of a Hollywood film as it moves from country to country" becoming revoiced into different languages.[88] We might also describe *Journey* as mimicking the generic appearance of any special effect as it shades into becoming an ordinary, not-so-special one. It mimics the ontologically and temporally unstable gimmick itself.

A version of dubbing also gets staged in *Suspiria*—a work featuring colorful acts of value-objectifying exchange, if not container ships or acts of international intrigue. This suggests that in both texts, what is at stake in its activation, qua gimmick countervailing a mode of capitalist sublimity, is circulation's promises of magically increasing value. The fantasy is that if an act of exchange simply happens *at the right time*, or in the right order, as seems inevitable when a recombinant machine is ensuring that these exchanges will be "infinite," Else will at some point end up with a self-replenishing sack of gold ("For Money"), even if she has started out with coals, a turnip, or nothing other than labor-power ("Myself Alone").

This fantasy is the capitalist gimmick in nuce, which is perhaps why both installations comically align exchange, or "value," with a poorly

executed special effect produced by tweaking old technology. In *Suspiria*, exchange looks like off-brand "Technicolor." In *Journey into Fear*, it sounds like inept dubbing. In both cases, the spooky-looking delamination of two originally combined elements—colors from the outlines of the objects to which they would seem to belong as properties, voices from the bodies from which they would seem to emanate—suggests that their initial synching may have been a mask for what was jerry-rigged all along: the fantasy of new value produced by simply getting the timing of one's exchanges right.

In both cases, a version of the gimmick's compromised aesthetic is provocatively juxtaposed against the capitalist sublime. And in both cases, this sublime-countervailing gimmick takes the form of an aesthetic technique whose underlying principles have not changed much since its initial development. While technical refinements in postproduction have certainly made tighter sound synchronization possible, the science behind it today remains essentially the same as it was a century ago.[89] More importantly, in both Douglas's circulation-themed installations, the sublime-countervailing gimmick takes the form of a process that while thoroughly rationalized has nonetheless proven difficult or even impossible to automate.

That difficulty has made dubbing permanently expensive in relation to subtitling in a way sure to eventually catch up to it, overriding the difference cultural preferences set in place by history have made so far to its economic sustainability. Decades before the digital revolution, Technicolor was being phased out at the moment Argento was making *Suspiria* for the same reason.[90] Although imbibition printing continued to be used after the discontinuation of the camera and specialized film made for it, its time-consuming process and large overhead costs made it resistant to both flexible production and economies of scale. Even in its final phase, the process required the extra materials, labor, and plant costs of fabricating its color separation matrices, which operate like stamps when loaded with dye and pressure-rolled against blank film stock.

Dubbing still has the inflated, reverb-boosted sound it did fifty years ago. The oversaturated look of a film printed using Technicolor's dye transfer process in 1977 is not that different from that of a film made in 1937. As effects that have also remained static at a formal or aesthetic level, the gimmicks Douglas highlights in his two installations about value make us think of others that have similarly failed to "advance." The star wipe transition, let me hazard, is never going to look nonostentatious, even if now included on the menu of choices in Microsoft's Power Point. And

in spite of many attempts to integrate subjective camera into mainstream film since the 1940s, to this day it remains a marginal, trick-like effect. Indeed, the extremity of the device finds itself underscored by its use to represent the point of view of psychopaths, as Brian De Palma brings out at the beginning of *Blow Out* (1981), a film incidentally also about audiovisual jerry-rigging and the jarring, uncanny-bordering-on-gimmicky effects of dubbing in particular.[91] What is similarly comical about the Superconducting Quantum Interference Device in Kathryn Bigelow's *Strange Days* (1995) is that the cyberpunk technology, which extracts memories from one's cerebral cortex onto a disc for the experience of others, is represented with, and as—subjective camera. "One man's mundane and desperate existence is another man's Technicolor," says the film's villain, referring to the oversaturated colors of what people experience when they wear the Device. We could conversely say that one person's Technicolor is everyone's subjective camera: a technique that for all its standardization still strangely obtrudes, even in experimental and / or pulp films, as a slightly tawdry special effect.

Certain aesthetic techniques never transcend their gimmickiness. Certain labor processes, analogously, remain resistant to increased productivity through distinctively capitalist refinements (e.g., automation, higher organic compositions of capital). It is precisely these jobs that make up an increasing percentage of all jobs in big economies: in the United States in 2017, 80 percent of private employment; 45 percent and ticking upward in China.[92] In a useful departure from object-focused definitions of "service" (for example as a commodity consumed in the same time of its production, or a commodity used for the reproduction of capital), Jason Smith defines the service sector as one in which "real subsumption" is difficult or impossible; it is one in which "labor processes can only be *formally* organized along capitalist lines."[93] As Aaron Benanav and John Clegg put it:

> Services are, almost by definition, those activities for which productivity increases are difficult to achieve otherwise than on the margin. The only known way to drastically improve the efficiency of services is to turn them into goods and then to produce those goods with industrial processes that become more efficient over time. . . . Those activities that remain services tend to be precisely the ones for which it has so far proven impossible to find a replacement in the world of goods.[94]

261

The two fastest growing occupations in the United States and Britain, home health care aide and teaching assistant, cannot be technologically enhanced to meet the increasing productivity standards of capital "without the quality of the product suffering considerably."[95] In similar areas like retail and hospitality, higher output comes only through longer working days or the hiring of more workers, resulting in an increase of absolute rather than relative surplus value. With relatively little capital spent on machinery, plant, or raw materials, Smith notes, "capitalist profits in this sector are inversely correlated with wage levels: any rise in the latter squeeze the former."[96] The continuing expansion of labor-intensive, low OCC jobs, in addition to enabling the continuing profitability of capital-intensive, high OCC sectors, has managed "to keep unemployment rates in the US, at least, within historical averages, to keep the work-week unchanged, and to control the real wage."[97] At the same time, their rise in not just deindustrializing but also industrializing countries explains the secular flatlining of growth, or shrinking total mass of surplus value.[98] Sarah Brouillette notes, "It all depends fundamentally on other people continuing to have money to spend on services. How long can it be sustained?"[99]

The rapid expansion of the service sector—that "mass of occupations and labor processes that, whatever the disparity in wages and skill level among them, have as their common trait that they are technologically stagnant"—might be described, very crudely, as late capitalism's gimmick.[100] On one hand, the growing concentration of employment in these jobs marks "capital's success in finding [a] 'way out' of the falling rate of profit conundrum (by balancing the effects of scientific or cognitive labour with the exploitation of direct living labour)."[101] On the other hand, the same rise suppresses productivity rates across the economy as a whole. And while the service sector also includes occupations that, in contrast to care work, have proved relatively easy to turn into economies of scale—data mining, banking, accounting, and legal services, for example—automation of these services "means that those whose jobs are usurped by the machines will be forced into the provision of low-paid, precarious consumer and personal services."[102] Indeed, Smith suggests, "this migration might already have been triggered."

Looks Gimmicky

Let us end by returning to *Suspiria*, which as I have suggested, pits the gimmick against the sublime, the obtrusive special effect against the invisible

recombinant machine, and the transparency of jerry-rigging against the black box. What does it really mean, however, to "pit" the gimmick against the sublime? How can a definitionally impoverished aesthetic stand in any antagonistic relation to the epitome of aesthetic might?

Yet there is a sense in which the sublime has no other possible opponent. In a world in which computerized logistic systems allow for the "replenishing goods at the exact moment they are sold, with no build-up of stocks along the way," and financial trades take place in microfractions of seconds, *only* an aesthetic of fundamentally bad timing seems capable of countering the image of perfectly synchronized exchange.[103] Only a form arousing contempt for the ease with which we instantly and totally grasp it seems suited to oppose an aesthetic defined by its defeat of our cognitive powers. Only a capitalist aesthetic, arising from the same "law of value" that seems so infallible, could serve as an emblem of the actual fallibility of its value machines.

All of this comes to the fore in Douglas's two machine-based works from the early 2000s on economic themes. If *Suspiria* offers an allegory of capitalist enchantment by abstracting and recombining elements from fairytales about exchange, *Journey into Fear* does so by meditating on circulation's operations writ globally. It does so moreover by drawing from a film hanging on the timing of a delivery and a novel in which verbal exchanges are all attempts at financial transaction pitched as transfers of affect, which in turn serve as vouchers of the participant's moralized "confidence" in the capitalist economy.

We can thus surmise why an artist whose works about capitalist abstraction have expanded to infinite proportions might want to find a way of disrupting their sublimity. We can similarly see why Douglas would turn to the gimmick for this purpose, via poorly executed synchronization and jerry-rigged effects. For when the recombinant machine is said to be the artwork's essence, the latter becomes reduced to its acts of timing and sequencing. The viewer is then led to assume that these operations are the underlying cause of not just the perceptual blockage instigating awe but of what she does in fact perceive: the ersatz "Technicolor" of hues leaking outside the borders of figures engaging in acts of exchange; the "bad dubbing" of voices falling out of synch with the bodies from which they would appear to emanate.

The seductive image of the machine as author of these effects would belie the fact that neither is produced by its specific repertoire of operations. Both are generated by low-tech methods. The ghostly look of colors

escaping from their forms is made possible by manipulating a principle of analog television. The look of badly executed dubbing is primarily a result of the fact that lines exchanged between characters were written to sound mismatched, prior to being subjected to the computer's randomizing coin-flips. Cable switching and scriptwriting are most directly responsible for these results, in contrast to the computer that controls *the timing of their presentation*. But how is the viewer to discern traces of these acts of production, when convinced by *Journey into Fear's* press release that the artwork's logistical system constitutes the artwork? Or that its essence is the automation of circulation? Simply by *coordinating* juxtapositions of images and texts, the machine generates the appearance of having *produced* them. Similarly, as Marx shows us repeatedly in *Capital*, capitalism generates forms that make it seem as if value can be produced in circulation alone (Fig. 7.7).

In *Suspiria*, the effect of a poorly executed effect provides a gaudy way of generating the look of "value," highlighting the peculiar character of its objectivity through equalizing, labor-abstracting acts of commodity exchange. As we have seen, this look is that of color behaving in a ghostlike

FIGURE 7.7

way. The algorithm coordinating the exchanges in which this effect makes its appearance is therefore, in a doubled sense, a "value machine." But the algorithm in or by itself is not the generator of "value" qua leaking, form-escaping color. The color is rather achieved by jerry-rigging—a temporally pressured interaction between living and dead labor—that the technical precision of the machine's sequencing operations conceals. The capitalist's machines, or investments of capital they represent, are similarly not the source of his surplus, as the capitalist will nonetheless come to think when he makes calculations based on wages, interest, and prices of production.

In the end, what seems at stake for Douglas in staging an opponency between special effect and machine is a way to represent capitalist awe and disenchantment at once, countering the cybernetic promise of "zero work" and endless accumulation with images of transience, the persistence of labor, and a specific concept of value tied to labor's abstraction. The gimmick thus works as a sort of aesthetic homeopathy against the circulationist fantasies that the very artwork mobilizing it promotes. It blocks us from equating Douglas's recombinant machine with the artwork tout court. It blocks the artwork from becoming a pure instance of capitalist sublimity. And it blocks us from seeing perfectly timed exchanging, coordinated by technology, as a cause of value's perpetual increase.

The gimmick even counteracts a tendency to see the gimmick as more of a true opposite to the sublimity of capitalist technology than it finally is. For without disrupting any of the machine's exchange-coordinating operations, the proximity of the outdated effect makes its operations signify differently. As colors leak outside of the forms that would seem contain them, and voices and bodies fall out of phase, the machine grinds on, continuing to determine the order in which the exchanges take place. But it also starts to seem merely mechanical, as if indifferent to, or uncertain about, its own aesthetic power. The recombinant machine, in other words, begins to show a resemblance to the gimmick undermining its sublimity. We are thus reminded of how these two categories are interconnected by the same "law of value," such that, like dysphoric and euphoric versions of "zero work," abstract labor and the money form, or even labor and capital themselves, the appearance of one always accompanies the other. The flip side of historically low unemployment rates is the rise of low-paid, precarious service jobs. The flip side of capitalist awe is the rise of the gimmick.

Henry James's "Same Secret Principle"

1.

This chapter suggests that Henry James's narrative style cannot be adequately grasped in isolation from his storytelling and that its development is pegged to one recurring storyline in particular.[1]

In the 1890s, a pattern involving the theme of labor and secrecy, already incipient in earlier fictions, begins to crystallize across James's longer works of prose fiction. More pronounced in some works than others—it is arguably clearest in "The Turn of the Screw" (1898), boiled to a formula in *The Sacred Fount* (1901), and finessed to greatest subtlety in *The Golden Bowl* (1903)—its visibility surges after a key change in James's habits of production: his shift to writing in the presence of an employee. Midway through composing *What Maisie Knew* (1897) and "In the Cage" (1898), a worsening repetitive stress injury compelled James to make a permanent alteration from writing in longhand, silently and alone, to dictating to a hired typist.[2] Critics have argued that James's first signs of movement toward his mature style begin with this new technique, which seemed to have encouraged an already prolix writer to become even more verbose.[3]

And also, we might say, more corny. Take, for instance, this conversation between the Prince and Fanny Assingham in which they euphemistically refer to his and Charlotte's (highly convenient) marriages as boats.

"We're in the same boat"—and the Prince smiled with a candour that added an accent to his emphasis.

Fanny Assingham was full of the special sense of his manner: it caused her to turn for a moment's refuge to a corner of her general consciousness in which she could say to herself that she was glad *she* wasn't in love with such a man. . . . "I don't know what you mean by the 'same' boat. Charlotte is naturally in Mr. Verver's boat."

"And pray am *I* not in Mr. Verver's boat too? Why but for Mr. Verver's boat I should have been by this time"—and his quick Italian gesture, an expressive direction and motion of his forefinger, pointed to deepest depths—"away down, down, down."[4]

Extravagantly handled for all of its thinness, this impoverished vehicle remarkably keeps going. Or rather, more and more weight is added to it:

"The 'boat,' you see"—the Prince explained it no less considerately and lucidly—"is a good deal tied up at the dock, or anchored, if you like, out in the stream. I have to jump out from time to time to stretch my legs, and you'll probably perceive, if you give it your attention, that Charlotte really can't help occasionally doing the same. It isn't even a question, sometimes, of one's getting to the dock—one has to take a header and splash about in the water. Call our having remained here together to-night, call the accident of my having put them, put our illustrious friends there, on my companion's track—for I grant you this as a practical result of our combination—call the whole thing one of the harmless little plunges off the deck, inevitable for each of us. Why not take them, when they occur, *as* inevitable—and above all as not endangering life or limb? We shan't drown, we shan't sink—at least I can answer for myself. Mrs. Verver too, moreover—do her the justice—visibly knows how to swim." (223)

While James's metaphors are always more analytical than poetic, as F. R. Leavis has argued, their quasipedagogical expansion was likely encouraged by the shift to speaking his stories aloud.[5] The addition of a silent listener turned fiction writing into both instruction and theatre, encouraging "exhibitory flourishes" along with a mounting use of colloquialisms and fillers ("he hung fire"; "as it were").[6]

A great deal of scholarship has been done on the importance of the typewriter to James.[7] I however want to read the shift to dictation to which his later style is linked—a style that was not only abstract and elliptical but *also* crude; and for exactly this reason conducive to his underexamined

experimentation with gimmicks—in a more economically generic way: as committing James to writing not so much in the presence of a typist, as an employee. That is, someone receiving wages for performing a service, newly made possible in this case by a manufactured good.

Interestingly, it is the switch to *production* with a waged employee, in distinction from the nonproductive consumption of domestic services, which coincides with an intensified preoccupation with gender in James's fiction.[8] Leon Edel refers to this period as "The Little Girls," the "sequence dealing with female children, juveniles, and adolescents, written between 1895 and 1900."[9] James's focus on girls trying to "systematically study" the web of relations in which they find themselves enmeshed, in *What Maisie Knew*, "The Turn of the Screw" (1898), "In the Cage" (1898), and *The Awkward Age* (1899), was important but ultimately transitional, Edel argues, offering James "unconscious self-therapy" after the humiliating failure of his play *Guy Domville* (1895) and enabling his recommitment to narrative fiction. I will however argue that his preoccupation with this figure stayed with him to the end, up through his versions of the story featuring male protagonists.[10]

The theme of subjects engaged in social analysis is not the only thing that works in James's later style have in common. They increasingly feature employees, like the governess in "The Turn of the Screw" and telegraph operator in "In the Cage." More interestingly and commonly, they feature employee-*like* conscripts, like Strether, who find themselves thrust into intimate, oddly compensated relations to those whom they have been deputized to care for or attend. The economic and affective ambiguity of these relations comes to the fore when those who have recruited the attention providers recede or gradually abandon their charges to them. Widened thusly, the category not only includes the governess from "The Turn of the Screw," who is explicitly asked by her London employer to "never trouble him—but never, never: neither appeal nor complain nor write about anything" concerning his orphaned wards.[11] It also includes Mrs. Wix, the inconsistently paid, increasingly indigent nanny with whom Maisie is left at the end of her story; and in a certain way Mr. Longdon, in his informal "adoption" of Nanda at the end of *The Awkward Age*, relieving Mrs. Brook's indebted family of their financial responsibility for her future. We can add the perpetually stiffed tutor Pemberton in "The Pupil" (1890), a male precursor of Mrs. Wix; the abjectly abandoned butler Brooksmith in "Brooksmith" (1891), thrust into a gig economy after the death of his long-term employer; the museum caretaker Morris Gedge

in "The Birthplace" (1902); and May Bartram, Marcher's endlessly serviceable if finally used-up companion in "The Beast in the Jungle" (1903).

James's "girl," a provider of care in a space opened up by neglect on the part of employers and parents, is thus sometimes a man. Sometimes waged and other times not—and sometimes waged but still unpaid—his workers are put in situations prompting them to contemplate the possibility of ostracization or impoverishment. Or, they become immediate witnesses of another person's impending ostracization or impoverishment. This is in part because the employee or employee-like figure's work on behalf of others—as Julie Rivkin notes, James's protagonists are typically "deputies, delegates, or substitutes"—is perceived as excessive in ways that makes it seem vaguely illicit and socially risky.[12] From unpaid but still strangely working tutor to ambiguously compensated, overtly instrumentalized female companion, these figures reflect what we might call James's perioccupational preoccupation: his interest in acts of donated "kin work" in the uncertain zones around older relationships, and particularly in the wake of withdrawals of care from institutions traditionally relied on to supply it (families, employers, imperial centers).[13] Inhabited across classes and other categories of social difference such as age and gender, the economically ambiguous zones opened by newly destabilized relations point to a general uncertainty surrounding moral codes. James's moment was one of ripe capitalism (and late or divesting empire) in which, as Robert Pippin notes, the question of what a parent owes a child, or an employer a long-term servant, or a state an unexpectedly unprofitable colony, was becoming increasingly unclear.[14]

It is as if for James, the mystifying veil of social forms his characters cognitively struggle to penetrate is *somehow connected to reproductive or affective work* through a logic as opaque (and fascinating) to him as it is to them. His mature fictions repeatedly juxtapose these two themes as if in an effort to find the obscured link between them, mirroring the obsessive investigative effort on the part of his characters. In many of these cases, the analyst trying to sort out puzzling social appearances is specifically deputized to give care to others, including those to whom they have no direct or clearly defined kin relation. *The Ambassadors* is a key example here, with Strether conscripted as stand-in for Chad Newsome's mother. So is "The Pupil," in spite of the tutor's final, seemingly deadly hesitation to accept Morgan from the eagerly outthrust hands of his parents.[15]

James's employees or employee-like deputies are providers of services: commodities consumed at the point of production, difficult to separate

from the processes that generate them, that cannot be resold. Waged service workers abound in the later works: governesses, tutors, docents, butlers, antique dealers, flower arrangers, servants. In what is more telling, James's most memorable discreet laborers are repeatedly likened to waged service providers even when they are not waged and particularly when they occupy the position of social analyst. Maggie Verver, for example, imagines herself as an "overworked little trapezist girl" and her stepmother Charlotte as a docent, as she watches Charlotte guiding visitors through the art galleries in Adam Verver's mansion.[16] The occupation of the person hired to appreciate the aesthetic value of other people's artworks—who is also, in a more pedestrian sense, the "person employed to see that, after the invading wave was spent, the cabinets were all locked and the symmetries all restored" (537)—seemed to especially fascinate James. It is how John Marcher, in "The Beast in the Jungle," sees May Bartram when he first meets her at the Weatherend estate. May strikes him as "more or less part of the establishment, almost a working, a remunerated part":[17]

> Didn't she enjoy at periods a protection that she paid for by helping, among other services, to show the place and explain it, deal with the tiresome people, answer questions about the dates of the buildings, the styles of the furniture, the authorship of the pictures, the favourite haunts of the ghost? It wasn't that she looked as if you could have given her shillings—it was impossible to look less so. (497–98)

In a characteristic act of Jamesian paralepsis around the question of payment, Marcher's observation that May didn't look "as if you could have given her shillings" conjures the very image blocked out. James however presents us with May's waged counterpart in Gedge, protagonist of "The Birthplace," who does accept shillings in his role as caretaker and tour guide of Shakespeare's childhood home.

Taken together, these examples point to a complex interest in labor and secrecy running through all of James's fiction; *The Portrait of a Lady*, in particular, is a key precursor. But from the 1890s onward, there is a noticeable intensification of the link between the desire to penetrate social obscurity and the kind of affective work associated with both unwaged reproductive work and the waged provision of services, whether performed by the protagonist or someone on his or her behalf. In the later works especially, James repeatedly juxtaposes or seems to want to think these two things together—as if the relation between the waged and

unwaged versions of the same kind of work were itself the "social secret" sought by his increasingly obsessive analysts.

James's "same secret principle" is thus a plot device in which his career-long preoccupation with characters trying to sort through social appearances sharpens into an even more distinctive pattern. In a sort of mise-en-abyme, the analyst ends up discovering a "principle"—say, an arrangement through which two children pair up with servants of the same gender, or a mingling of two households fostering an adulterous affair—whose content (usually sexual) disallows it from being publicly exposed. There is thus a redoubling of secrecy and labor: not only is the relation itself obscured, pushing the worker's analytical skills to the max; on top of this, she must work to ensure that her efforts at detection do not attract the interests of others. The secret must in fact be tactfully *reconcealed* as soon as it is discovered in order to avoid destroying a tie that it is perceived to endanger and that the analyst feels it her responsibility to protect. Employed or unemployed, all of James's analysts thus perform their services surreptitiously. And even when the analysts are men, the overarching character of this work involving the bestowal of attention or care to others continues to be broadly thought of as feminine due to its resemblance to "kin work" and the socializing work of building relationships rather than activities associated with manufacturing or craft.

Gendered labor is performed to disclose/maintain a social secret and in doing so must itself be hidden. As the pattern repeats, the very covertness of work starts to give off a feminine signal. "It gave her moments of secret rapture—moments of believing she might help him indeed."[18] The sentence just quoted refers to Maisie's efforts for Sir Claude. We could however easily imagine it as referring to the governess thinking about how she might protect Miles from Quint (or Miles's uncle from Miles), the telegraph girl thinking about she might secretly help Everard, Strether thinking of how he will somehow abet Chad Newsome without enraging his mother, or Maggie thinking about how to manipulate her father into saving his marriage by unknowingly saving hers. The same could be said of this moment from *Maisie*: "The little girl was able to recall the effect with which in earlier days she had practised the pacific art of stupidity."[19] For all of James's analysts dissimulate being "stupid" at one point or another, due to having to mask their performances on behalf of the secret. They do so with the aim of shoring up a relation newly destabilized by the declining "coordination in mutual expectations and commitments" once provided in more secure ways by patriarchy or employment relations.[20]

271

It is a relation which the secret even further endangers, and which the analyst may have been explicitly conscripted to protect.

Here the necessarily discreet effort that goes into guarding closets falls into alignment with the monetarily untallied, economically occulted sphere of reproductive work. This donated labor, epitomized in the diplomatic maneuverings of figures with no direct or explicit relation to the capitalist wage, such as Maggie Verver, is in turn aligned with the waged exertions of governesses, docents, and butlers. Once again, James seems to be circling around the logic of the relation between these kinds of labor—and in a way that brings out a surprising willingness to experiment with the gimmick's compromised form in his style. That is, with a form encoding a problematic relation between labor and value, whose primary feature is that of simultaneously overperforming and underperforming, working too little but also working too hard.

Rotating poor and rich, major and minor figures through the same key positions, as if engaged in an effort, similar to that of his analysts, to grasp the logic underlying their organization, the way in which James seems to be writing the same story over and over echoes David Kurnick's striking observation about the uniform way in which his characters talk.[21] Noting the "verbal similarities that hold across the whole cast of Jamesian characters," who in spite of differences in class, age, gender, and nationality "address each other in almost indistinguishable patterns" (215), Kurnick suggests that the "performative universalism" of James's style should be opposed to the "differentiating moralism of his plots" (214). Thus reading style and story as ideologically divergent—the former is collectivist, the latter is particularizing—Kurnick points out that in contrast to what critics repeatedly say about James's commitment to perspectival differences, his style actually extinguishes them in a "bath of stylistic indistinction" (216). What this intimates is a "shared purposiveness" on the part of James's characters that makes them resemble theatrical actors, "conscious of a shared duty to hold up the general tone." Like performers of roles assembled together on stage, they are "haunted by an extra-diegetic consciousness of themselves as engaged in precisely those roles and thus in a larger fictional project." James's "company style" thus has a utopian dimension for Kurnick: it can be "a means to register a democratizing pressure—to hold open, if only imaginarily, the possibility of a radically flattened distribution of narrative sympathy and attention" (218).

Building on Kurnick's insights, what if the "surplus intention" radiating from the uniformity of James's style were also achieved through a

uniformity of plot? In which an analyst's effort to disclose and reconceal a hidden relation ends up requiring strenuous mental exertion, as well as almost acrobatic acts of affective maneuvering? And in which all of this exertion, mirrored by our own in following James's elliptical, abstraction-dominated sentences, must be hidden by further efforts in turn? Suggesting that style and plot in James might be intertwined rather than at ideological and aesthetic odds, the pattern invites another way of reading the image of "corporate and uniform consciousness in which all the characters somehow participate" (218): as an image not of radical democracy but rather the unconscious cooperation endemic to capitalist sociality.

What did James sense or seem to want to say about this sociality via his return to stories about clandestine work? And why does the aesthetically equivocal gimmick seem to constantly hover around this intersection of interests? To put it another way, why does the hint of something *systemic* about the relationship between labor and secrecy come across most strongly in James's works specifically about compromised forms—cracked bowls, bad metaphors, hyperbole—and skeptical responses to aesthetic overvaluation? With these questions in mind, let us now zoom in on three: *The Sacred Fount* (1901), "The Birthplace" (1903), and *The Golden Bowl* (1903). All are works in which James makes flagrant use of what Kent Puckett calls "cheap tricks"—the narrative coincidence, for instance—and in which his style combining abstraction with crude, puzzle-like metaphors intensifies to a point at which these works have often seemed like self-parodies.[22]

2.

If the gimmick is an aesthetic registration of uncertainty about value linked to labor, and also a form that seems to be simultaneously overperforming and underperforming, "The Birthplace" is an avant la lettre study of this category writ large.

"The Birthplace" is also a story about labor done *in* secret to *maintain* a secret. Intellectually ambitious Morris Gedge, whom we first meet working for the "grey town-library of Blackport-on-Dwindle, all granite, fog and female fiction" after the failure of his attempt to start a private school with his wife Isabel, receives a job offer he regards as "too good to be true."[23] The offer, to take over docenting and caretaking responsibilities for a tourist site advertised as the birthplace of England's "supreme poet"—referred to only by He, His, and Him, Shakespeare is evoked via

his name's extravagant avoidance—comes as belated largesse from a rich father of a former pupil, saved from a deadly illness back in the days of the failed teaching business "by the extreme devotion and perfect judgment of Mrs. Gedge" (443, 442).

Attracted by the prestige of the new position even though "the stipend named exceeded little the slim wage at present," Morris is excited by the thought of escaping Blackport-on-Dwindle for an intensified intimacy with great literature. The Gedges thus enthusiastically jump into these new service jobs, for which they are all the more grateful given that they are not the "pair of educated and competent sisters possibly preferred" (441). The position has in fact become available only through the "death of one of the two ladies, mother and daughter, who had discharged its duties for fifteen years; the daughter was staying on alone, to accommodate, but had found, though extremely mature, an opportunity of marriage that involved retirement" (441). The labor of maintaining the Birthplace, a former domestic space, and more specifically the mystique surrounding it, is thus pointedly coded as traditionally feminine work.

Noticing in his first days that it "bristled overmuch, in the garish light of day, with busts and relics," Gedge quickly becomes aware that the auratic object he and his wife are in charge of tending is a fetishized sham (455). The fact is tortuously driven home by the discourse of appreciation their jobs require them to generate while guiding customers through "the Holy of Holies." Gedge feels increasingly burdened by a "critical sense" that sharpens his urge to share his diagnosis of the site's deficient value with others (455, 478). In Gedge's visceral experience of the gimmick as overprized form, critical and aesthetic judgment coincide. Both run directly counter to his family's economic interest.

Haunted by his intensifying compulsion to depreciate the very object his job requires him to discursively inflate, Gedge finds a way to do it surreptitiously. The solution lies in the quintessentially Jamesian art of indirection: a way of keeping up the Birthplace's front of aesthetic worth, while enabling his awareness of its impoverishment to be communicated elliptically. Courting the risk that his rhetorical maneuver will be detected, while secretly hoping that some discerning person will notice, Gedge deliberately whittles down the praise he produces for the crowd. His spiel dangerously becomes thinner and thinner.

Eventually the spiel becomes so provocatively minimal that word gets out from his dissatisfied and perplexed audience to the multinational corporation administering the site. Their sponsor Mr. Grant-Jackson gets

angry and "the Body" threatens to fire both Gedges. Gedge needs to stop—or, find a different method. He does so with the emotional assistance of two members of the crowd who have indeed picked up on Gedge's tonal nuances and returned to the sham attraction because of their newly aroused interest in his risky performance, which for them has displaced the original attraction.

Gedge's challenge is find a trick to counter a trick: a way to fulfill the terms of his contract (generating appreciation, cultivating the gimmick) which will somehow also satisfy his need to share his aesthetic judgment without entirely exposing the gimmick's fraudulence. The strategy of underperforming failed. Fulfilling the first requirement of signaling his knowledge of the Birthplace's secret to others, but not the second all-important one of *preserving* its secrecy, it threatened to give Gedge entirely away. Still driven to find some way of sharing his evaluative correction of the overvalued object whose very inflation he must occupationally sustain, Gedge hits on a new style of judgment as plan. He demonstrates his new technique in the Birthroom to the amazed eyes of Mr. and Mrs. Hayes, the two sympathetic audience members, who have returned from the United States to see his act after a year or so has passed:

> [It] was ever his practice to stop still at a certain spot in the room and, after having secured attention by look and gesture, suddenly shoot off: "Here!"
>
> They always understood, the good people—he could fairly love them now for it; they always said breathlessly and unanimously "There?" and stared down at the designated point quite as if some trace of the grand event were still to be made out. This movement produced he again looked round. "Consider it well: *the* spot of earth——!" "Oh but it isn't *earth*!" the boldest spirit—there was always a boldest—would generally pipe out. Then the guardian of the Birthplace would be truly superior—as if the unfortunate had figured the Immortal coming up, like a potato, through the soil. "I'm not suggesting that He was born on the bare ground. He was born *here*!"—with an uncompromising dig of his heel. "There ought to be a brass, with an inscription, let in." "Into the floor?"—it always came. "Birth and burial: seedtime, summer, autumn!"—that always, with its special right cadence, thanks to his unfailing spring, came too. "Why not as well as into the pavement of the church?—you've *seen* our grand old church?" The former of which questions

nobody ever answered—abounding, on the other hand, to make up, in relation to the latter. Mr. and Mrs. Hayes even were at first left dumb by it—not indeed, to do them justice, having uttered the word that produced it. They had uttered no word while he kept the game up, and (though that made it a little more difficult) he could yet stand triumphant before them after he had finished with his flourish. (485–86)

Tacking as far from understatement as possible, Gedge has become a genius at hyperbole: turning aesthetic overvaluation into an art of its own. "Whether or no he had, as a fresh menace to his future, found a new perversity, he had found a vocation much older, evidently, than he had at first been prepared to recognise." Like a cheap commodity, he "could measure it off by the yard" (485). Yet his gimmickry remains a form of indirection and thus keeps his job safe, since no one seems capable of recognizing it for what it is. Doubling down on the gimmick *form*—on what James calls "humbug"—has thus enabled Gedge to simultaneously express and hide the traces of it in his discourse as *judgment*.[24] Not only has his false or excessive praise of the aesthetic commodity gone unnoticed; it receives aesthetic praise from his enraptured audiences, culminating in transatlantic fame for the performer (as Mrs. Hayes tells Gedge, he is "rave[d]" about in America) and a raise doubling the couple's pay from the Birthplace's directors.[25]

It is worth noting that "The Birthplace" first appeared in print alongside "The Beast in the Jungle" and "The Papers" (both also for the first time) in the 1903 collection *The Better Sort*, since these concurrently written stories offer further variations on the theme of labor and secrecy.[26] Marcher has a hidden fact about him which he conscripts May Bartram to help him keep hidden from others; the journalists in "The Papers" embody the very power of withholding and conferring publicity. In all three narratives, James's stylistic preoccupation with "intangibles," including "almost empty words" such as *here, there, then, now, that, which, those, these, it, thing, matter*, becomes amplified to the point of seeming self-parodic.[27] With each "abstracted, deictic reference" referring to other deictic references, generating secondary and even tertiary layers of abstraction, James's flood of *its* and *thats* not only "violates the copybook rules about 'clarity' of pronominal reference" but produces the effect of "inadvertent clumsiness."[28]

There is of course a reliance on "almost empty words" in all James's texts. But as "The Birthplace" routes its story of labor and secrecy through the gimmick form, deictic pronouns become pressured to the point of grammatical denaturing and start to function like proper names: him becoming Him, they becoming They. They thus invert James's "religiosity," or "characteristic resort to the language and resonance of the sacred, the sacrificial, and the transcendent," into a poetics of blasphemy.[29]

Each text in *The Better Sort* is also, in a significantly related way, a story about the contiguity of hyperbole and minimalism. The story of Marcher, the man to whom "nothing" happens—but for whom that nothing seems exactly the catastrophic "everything"—is also a technically brilliant story about the mechanics of "story" itself; about how we think we know a narrative event when we see one, and how it is possible to miss one taking place right in front of our eyes (and maybe several times, or even repeatedly). Epitomized in Gedge's twin strategies, it is worth simply noting the frequency with which "The Birthplace" juxtaposes "everything" and "nothing" on the page, as if trying to gauge the closest proximity into which the two terms might be brought without either neutralizing the other's effect:

> "Do you know what I sometimes do?" [said Gedge.] And then as she waited too: "In the Birthroom there, when I look in late, I often put out my light. That makes it better."
> "Makes what—?"
> "Everything."
> "What is it then you see in the dark?"
> "Nothing!" said Morris Gedge.
> "And what's the pleasure of that?"
> "Well, what the American ladies say. It's so fascinating."[30]

In the interior of the gimmick, "everything" and "nothing" become strangely interchangeable, as reflected in the way Gedge, correcting himself, briefly confuses emptiness with plenitude: "The only thing They care about is this empty shell—or rather, for it isn't empty, the extraneous, preposterous stuffing of it" (457).

These two faces of the gimmick are increasingly copresent in James's experimentation with dubious forms. The very torque from "preposterous stuffing" to "empty shell," as if nothing existed between them, is itself a kind of aesthetic etiolation as well as hyperbole. Both are endemic to the

mature style. For while James liked abstract, "empty words" like *it*, we've also noted his predilection for piling things on thick when it comes to metaphors: golden bowls, sacred founts. It might be tempting to read what Dorothea Krook calls these "heavy-handed" metaphors as images of bad metaphor, as Barbara Johnson notes about the word "azure" in symbolist poetry.[31] And yet, as we have seen Leavis remark above, James's figures tend to be "diagrammatic" and "synthetic" rather than intuitive: more about "analysis, demonstration, and comment" than the "play of poetic perception," if just as easily overstrained.[32]

Perhaps this is why they teeter between the overindulgent and impoverished: Yeazell refers to their "extravagance," while Seymour Chatman describes them as "commonplace" and "low-grade." As neatly encapsulated in an image juxtaposing the Prince as a finely creamed chicken to Adam Verver as barnyard fowl, they often seem ostentatious and cheap at once.[33] In a similar crisscrossing, what David Lodge calls James's use of "heightened cliché," in which a stripped-down vocabulary of basic words like "thing" is drawn upon for the discussion of social complexities, coincides with his preference for philosophically prestigious words to describe trivial objects.[34] As Chatman quips, "'Phenomena' seems terribly high up in the intellectual scale to describe the gestures and words, plate and silver of a mere dinner party" (47).

Oversimplistic words for complex things; lavish words for impoverished things; too much for too little and too little for too much. The disproportion between James's tenors and vehicles, between his overworked and underperforming, ostentatious yet impoverished images, elicits a feeling of aesthetic suspicion opening a portal to the gimmick as form.

For Yeazell, this "suggests a world in which connections are not easily made, one in which the imagination must strain to see the resemblances of [or relations between] things."[35] While on a certain level James's metaphors are all too transparent, their very simplicity often throws the complexity of the situations they are mobilized to figure in greater relief. Indeed, *The Sacred Fount*, James's most formulaic work—in which the clichéd metaphor flaunted in the title *is* the formula, or gimmick—proves Yeazell profoundly right, as we see an analyst's imagination strained to collapsing (and with it, the story it is meant to support) in his effort to grasp the economic logic subtending relations of taking and giving. Here forms simultaneously express and conceal the logic of social relations in much the same way Gedge's hyperbole does, making connections at once easy and difficult to grasp. This paradox will return us to the question of

why such extremes—the abstract and the visceral, the impoverished and extravagant—are constantly placed side-by-side in James's later texts, and particularly in relation to the pattern connecting labor and secrecy.[36]

<div align="center">3.</div>

"The Birthplace" has an uncharacteristically happy ending. Most of James's labor and secrecy narratives are darker in tone. This is especially so when the secret has a sexual dimension and when the story of its laborious discovery and reconcealment takes place in a domestic setting.

In this case an even more specialized version of the pattern develops. Homing in on a foursome in which half the members are givers and the others receivers of attention or care, an analyst tries to figure out the secret underpinning this structure. Once discovered, it becomes clear that she must reconceal the secret, in order to shield those harmed by its becoming explicit. As the story of the protagonist's struggle moves from the first phase (detection) to the second (protection), what begins as a primarily intellectual endeavor ends up turning into the social and in fact more difficult work of diplomatic maneuvering. The shift from clandestine labor to disclose a secret to clandestine labor to maintain a secret triggers a shift in the *content* of the labor, as well in its level of strenuousness.

If "The Turn of the Screw" presents James's most absorbing use of this "concentrated" pattern, *The Sacred Fount* could be described as its problematic twin.[37] The first features a servant fixated on an ambiguous relationship between children and servants; the second, a man of uncertain occupation obsessed with a woman named Server. What begins as a purely analytical exertion for this first-person narrator—his pursuit of the solution to a logical puzzle—shifts into social maneuvering in order to safeguard Server's secret from detection by others. Both stories cast shadows of moral and psychological doubt over the analyst's increasingly furtive and isolating activities, which, anticipating a similar pattern in *The Golden Bowl*, focus on the geometry of foursomes: Jessel, Quint, Miles, Flora; Mrs. Briss, Gilbert Long, May Server, Brissenden.

The nameless governess is fixated on shielding Miles from her male counterpart, while the nameless analyst in *The Sacred Fount* is fixated on protecting the female Server. It is not clear where his intense urge to "save" Server comes from, but, as readers have noted, it seems to stem more from identification than desire.[38] Indeed, it seems at times to stem from the fact

that he perceives Server as "drained" from activities similar to the acts of secret screening and maneuvering he finds himself doing on her behalf, as if from a feeling of solidarity with a fellow laborer.

Consider the following passages:

> I scarce know what odd consciousness I had of roaming at close of day in the grounds of some castle of enchantment. I had positively encountered nothing to compare with this since the days of fairy-tales and of the childish imagination of the impossible. *Then* I used to circle round enchanted castles, for then I moved in a world in which the strange "came true." [. . .] Yet I recall how I even then knew on the spot that there was something supreme I should have failed to bring unless I had happened suddenly to become aware of the very presence of the haunting principle, as it were, of my thought. This was the light in which [X] . . . alone . . . showed [themselves] . . . at the end of a vista. It was exactly as if [X] had been there by the operation of my intelligence, or even by that—in a still happier way—of my feeling.

> I saw other things, many things, after this, but I had already so much matter for reflection that I saw them almost in spite of myself. The difficulty with me was in the momentum already acquired by the act—as well as, doubtless, by the general habit—of observation. I remember indeed that on separating from [X] I took a lively resolve to get rid of my ridiculous obsession. It was absurd to have consented to such immersion, intellectually speaking, in the affairs of other people. One had always affairs of one's own, and I was positively neglecting mine.

> He continued to look at me; then he gave a laugh which was not the contradiction, but quite the attestation, of the effect produced on him by my grip. If I had wanted to hold him I held him. It only came to me even that I held him too much.

Strikingly similar to key moments in "The Turn of the Screw," these excerpts are all from *The Sacred Fount*.[39] The first, in which the analyst magically stumbles on the person—Server—about whom he has just been thinking, echoes the moment when the governess, thinking "it would be as charming as a charming story suddenly to meet someone" while strolling around the estate at dusk, suddenly becomes aware of the presence of a man—and as it turns out, a servant—on the top of a tower: "What arrested

me on the spot—and with a shock much greater than any vision had allowed for—was the sense that my imagination had, in a flash, turned real."[40] The second, in which the analyst briefly worries about the neglect of unspecified "affairs of one's own," echoes an almost identical thought on the part of the governess: "Of course I was under the spell, and the wonderful part is that, even at the time, I perfectly knew I was. But I gave myself up to it; it was an antidote to any pain, and I had more pains than one. I was in receipt in these days of disturbing letters from home, where things were not going well. But with my children, what things in the world mattered?" (44). The last excerpt, foregrounding the analyst's "grip" on a man who while struggling to get away, can't seem to escape his "hold," echoes the last interchange between the governess and Miles, right before he dies of what seems to be accidental suffocation.

The Sacred Fount and "The Turn of the Screw" are thus doubles at the level of discourse as well as story: first-person narratives of analysts obsessed with servers, engaged in covert acts of first detecting, then vigilantly protecting secrets, with a zealousness leading other characters to wonder about their ethics and sanity. But while "The Turn of the Screw" is an "engross[ing]" work of "speculation" making a technically brilliant use of the labor/secrecy plot, the same set-up in *The Sacred Fount* comes off as a formulaic contrivance for the following reasons.[41]

The first is that the discovery made by the analyst through his covert labors, which he later goes to even more strenuous efforts to reconceal, redoubles his own situation of hidden laboring. For the secret, which is in this case also James's own formula, "donnée," or "little *concetto*," is that to secure the increased vivacity and cognitive sharpness of her male lover Gilbert Long, Server has been unknowingly donating—and draining—her own energy: that, encrypted in his increased value for the society at New-march, is the value that she (specifically in her sexual relation to him) has added.[42] The social secret disclosed by covert affective labor is covert affective labor—and so secreted that it does not seem like labor. By the analyst's own theory, Server does not know (indeed, cannot know) that she is the "fount" of her male partner's augmented social value. Although her state of physical exhaustion, exactly proportional to his increased energy, suggests that "work" in a scientific sense has been done, the narrator's own prose disguises or produces indirection around this fact. He prefers saying that Server is "paying" rather than that "working" for Long. The economic occultation of Server's sex-affective relation to her male partner as the true but hidden source of his cognitive enhancement: Is this James

unconsciously meditating on the buried labor of women hidden in the social form of the wage?

The secret in this instance of the Jamesian pattern is thus, recursively, *the pattern itself*: a narrative relating labor, secrecy, and for the first time, money. Discerning Server's structurally hidden contribution to the social value of her sexual partner seems to require the language of not just "legerdemain" but also ledgers.[43] As the male analyst notes, describing his theory of occulted sexual labor and exchange in a way that tellingly echoes his description of his mode of discovering it ("The obsession pays, if one will; but to pay it has to borrow"): "'One of the pair . . . has to pay for the other. What ensues is a miracle, and miracles are expensive'" (30, 34).

At this point James's metaphors start to pop up everywhere, as if to compensate for the starkness of the analyst's initial formula.[44] Accounting gets superseded by vampires: one member of a couple "conveniently extract[s]" an "extra allowance of time and bloom" from the other, who, in order to supply this quantity, has "to tap the sacred fount."[45] But it is as if this image is still not concrete enough. An even more humble vehicle for economic distribution needs to be found, and so James turns once again to fowl: "'But the sacred fount is like the greedy man's description of the turkey as an 'awkward' dinner dish. It may be sometimes too much for a single share, but it's not enough to go round'" (34).

James's metaphors are themselves like this "'awkward' dinner dish": too much and also too little. Consider the following discussion between the narrator and Mrs. Briss, in which the exchange between giver and receiver is likened to the erotic contact between "lips" and "cheek." The distance between vehicle and tenor is so narrow in this case that the metaphor is almost likening sex to sex, and in a way that brilliantly mimics and almost seems to instantiate the act of physical intimacy. The vehicle (lips touching cheek) seems to "kiss" the tenor (clandestine sexual relation). Yet for all this, the formulaic and indeed literal dryness of the analogy makes it curiously unsexy:

> "It's only, after all," [Mrs. Briss] sagely went on, feeding me again, as I winced to feel, with profundity of my own sort, "it's only an excessive case . . . of what goes on whenever two persons are so much mixed up. One of them always gets more out of it than the other. One of them—you know the saying—gives the lips, the other gives the cheek."

"It's the deepest of all truths. Yet the cheek profits too," I more prudently argued.

"It profits most. It takes and keeps and uses all the lips give. The cheek, accordingly," she continued to point out, "is Mr. Long's. The lips are what we began by looking for. We've found them. They're drained—they're dry, the lips. Mr. Long finds his improvement natural and beautiful. He revels in it. He takes it for granted. He's sublime."

It kept me for a minute staring at her. "So—do you know?—are *you*!"

She received this wholly as a tribute to her acuteness, and was therefore proportionately gracious. "That's only because it's catching. You've made me sublime. You found me dense. You've affected me quite as Mrs. Server has affected Mr. Long. I don't pretend I show it," she added, "quite as much as he does."

"Because that would entail my showing it as much as, by your contention, she does? Well, I confess," I declared, "I do feel remarkably like that pair of lips. I feel drained—I feel dry!" (66–67)

The metaphor of a dry mouth for the economic relation between Server and the man whose social value her occulted labor increases culminates in our first glimpse of the narrator's positional alignment *with* Server:

My original protest against the flash of inspiration in which she had fixed responsibility on Mrs. Server had been in fact, I now saw, but *the scared presentiment of something in store for myself.* This scare, to express it sharply, had verily not left me from that moment; and if I had been already then anxious it was because I had felt myself foredoomed to be sure the poor lady herself would be. Why I should have minded this, should have been anxious at her anxiety and scared at her scare, was a question troubling me too little on the spot for me to suffer it to trouble me, as a painter of my state, in this place. (75, my emphasis)

The narrator's identification with Server is what prompts him to become protective of her secret, initiating his own shift to secret performer of affective labor. But why, as he asks above—and in Jamesian fashion, by calling attention to the fact of his *not* having asked it—does he identify with Server to begin with? ("Why I should have . . . been anxious at her

anxiety and scared at her scare, was a question troubling me too little on the spot for me to suffer it to trouble me. . . .") And why does this very question, in its simultaneously expressed and retracted form, disturb him to the point of triggering tautologies? We sense that the answer is not psychological. What James rather seems after in this ruthlessly analytical, boiled-down version of his labor and secrecy story is something more systemic.

To be sure, a sense of systematicity pervades James's other labor and secrecy narratives as well, with their focus on what Mark McGurl calls "social geometry," but with a rich supply of the "drama of consciousness" noticeably lacking here.[46] Perhaps there is a fairly simple reason for why, in *The Sacred Fount*, the storyline that brings out James's virtuosity in "The Turn of the Screw" turns out to be a dud. In contrast to James's other characters secretly working to protect and thus reproduce the secrets of others, we are told nothing about the analyst in *The Sacred Fount*. We don't know his history, how he has come to know his fellow guests, and nothing about his occupation. At times he even seems to be an abstract personification rather than author of his theory, dissolved by the very sentences in which he articulates it.

This generic quality makes it tempting to see the narrator as a meta-fictional stand-in for James, as Sergio Perosa suggests, struggling to make a novel out of a dubious donnée.[47] Yet that reading still leaves us with the question of what draws James to *this* donnée. In contrast to the governess and Maggie Verver, who also undertake obsessive, self-jeopardizing actions in their efforts to get behind a mystifying social appearance, *The Sacred Fount*'s investigator doesn't really seem to have anything at stake. This in turn makes the idea ostensibly driving his actions seem all the more overwrought: a "turkey" in the novel's own economic image for imbalanced distribution.

The narrator's blankness thus highlights the very contrivance of the "idea" as it takes on a particularly formulaic form: "Keep my play on idea: the *liaison* that betrays itself by the *transfer* of qualities—qualities to be determined—from one to the other of the parties to it. They *exchange*."[48] The donnée in *The Sacred Fount* stays in this raw state throughout, insufficiently "cooked." It explains why we rapidly become bored by the analyst's clandestine activities, while following those of the governess and Maggie with mounting suspense, as well as why he eventually annoys the other characters he at first sympathetically excites. James himself disliked and disowned his story; the book, as he wrote to Mrs. Humphry Ward,

"isn't worth discussing. . . . I hatingly finished it; trying to make it—the one thing it 'could' be—a 'consistent' joke."[49]

Keeping a joke consistent entails letting gimmicks sprout everywhere. *The Sacred Fount* for instance turns on a chapter-length scene in which the guests of Newmarch interpret the symbolism of what I am going to risk calling a sad clown painting. Indeed, it is Long's astonishingly brilliant disquisition on this artwork of uncertain merit that makes the narrator wonder if his donor, Server, has not, like living labor, given more than she had: "It put before me the question of whether, in these strange relations that I believed I had thus got my glimpse of, the action of the person 'sacrificed' mightn't be quite out of proportion to the resources of that person. It was as if these elements might really multiply in the transfer made of them; as if the borrower practically found himself—or herself—in possession of a greater sum than the known property of the creditor."[50] Notice how the "it" in the first sentence, referring to another "it," referring in turn to yet another abstract, deictic reference (the "phenomenon" of Long's suddenly increased eloquence), encrypts the narrator, transforming him into the recipient of the question "it" puts before him. The narrator's syntactical occlusion by the abstractions generated by his own theory about Server's occulted labor (as "fount" of Long's increased value for the social microcosm of Newmarch) thus mirrors the occultation of that labor in the story. Here one begins to wonder: Is the main point the narrator's subordination? Or is it the agency of the abstractions?[51] Which in the case of "it" and "phenomenon" are specifically labor-related, referring to a man's mysteriously boosted value to a social formation and to a female Server as its occulted source?

In "The Birthplace," a service provider who has discovered but cannot expose a gimmick/secret, and in fact needs to maintain and reproduce it on a daily basis, resolves his plight by doubling down on its formula. In *The Sacred Fount*, the same effort fails. Around four-fifths of the way through, the narrator undergoes the loss of his desire to protect Server, for reasons that simply aren't clear. With this, his theory concerning Server as obscured source of her male counterpart's social value no longer interests him as it once did, and after an interminable showdown with Mrs. Briss stretched out over three chapters—a dramatic conversation that nonetheless proves astoundingly dull—the narrative more or less peters out. Here the Jamesian donnée fails to fulfill its goal of developing into a story "worth discussing." It is thus strangely foregrounded not only as a

gimmick—a form linking a diagnosis of deficient value to uncertainties about labor—but a failed one at that.

A very different outcome ensues in *The Golden Bowl*, James's last and arguably greatest novel. This is also the work in which his labor and secrecy plot, in tandem with the crude metaphors of the later style, brings out the impoverished gimmick in a paradoxically glorious way.

4.

The story about labor and secrecy James tells acquires diagrammatic clarity in *The Golden Bowl*, in part because of the novel's pared-down character system. Maggie Verver needs to figure out a way to dissolve an interfamilial dynamic enabling an affair between her husband and stepmother, without those involved or affected knowing she knows of it. Undoing the structure giving rise to the secret thus requires maintaining the secret, and to do this she must work creatively, strenuously, and surreptitiously.

If the development of James's style is pegged to the theme of occulted labor, *The Golden Bowl* makes it clearest that the latter has something to do with gender, and that of affective "kin work" in particular. All three women—Maggie, Charlotte, and Fanny—"work" to keep Charlotte and Amerigo's affair hidden in order to maintain the "equilibrium" of the patriarchal family.[52] It is this unit's preservation that is primarily at stake in the efforts of all three to maintain the secret, even more so than the privacy of the individuals the secret involves.

To be sure, everyone in *The Golden Bowl* uses "work" to discuss anything related to kinship, including the men. "If we've worked our life, our idea really, as I say—if at any rate I can sit here and say that I've worked my share of it—it has not been what you may call least by our having put Charlotte so at her ease," says Adam to Maggie about his marriage to his daughter's husband's former lover (392). Or as the Prince thinks to himself about his marriage to Adam's daughter, "It was all right for himself, because Mr. Verver worked it so for Maggie's comfort; and it was all right for Maggie, because he worked it so for her husband's" (241). The Prince is especially good at "display[s] of the easy working of the family life" (353). He later thinks more elliptically about how existing domestic arrangements have paved the way for his rendezvous with Charlotte, such that the women who have played some role in "working" toward this could be imagined as endorsing both it and him: "All of [it], in Lady

Castledean as in Maggie, in Fanny Assingham as in Charlotte herself, was working for him without provocation or pressure, by the mere play of some vague sense on their part—definite and conscious at the most only in Charlotte—that he was not, as a nature, as a character, as a gentleman, in fine, below his remarkable fortune" (285). Language like this describing domestic or sexual relations as involving "work" of some sort recurs across the novel, irrespective of focalizer. In one rare utterance "from nowhere" that no specific individual clearly focalizes, it is as if the spirit of the entire novel affirms this: "[It] was all right, the noted working harmony of the clever son-in-law and the charming stepmother, so long as the relation was, for the effect in question, maintained at the proper point between sufficiency and excess" (270).

Every character in *The Golden Bowl* thinks a version of this thought, in which domestic relations become aligned with "work" that seems to involve no exertion. Devoid of "provocation or pressure," this is "work" processed through the image of "working harmony" until the participle dissolves and we are left with just "harmony." It anticipates how, since the 1970s up to our present, the accelerated growth of (some) jobs involving "immaterial labor" has been euphorically viewed as a harbinger for a postindustrial "end of work," in both mainstream economic discourse and strands of postmodern Marxism.[53]

But while versions of this at once ideological and utopian image of workless work run through the minds of all the characters, the "work" that *is* represented in the novel as affectively and physically strenuous, in part by being compared to waged service labor, is done entirely by women. Moreover, it is only women who recognize or speak of it to themselves and other women this way. Here for instance is Maggie at a relatively early point in the novel, comparing the work done by Charlotte in/by becoming her father's wife, to the "extra help" of a servant, and more abjectly, to a tire:

> But what perhaps most came out in the light of these concatenations was that it had been, for all the world, as if Charlotte had been "had in," as the servants always said of extra help, because they had thus suffered it to be pointed out to them that if their family coach lumbered and stuck the fault was in its lacking its complement of wheels. Having but three, as they might say, it had wanted another, and what had Charlotte done from the first but begin to act, on the spot, and ever so smoothly and beautifully, as a fourth? Nothing had been immediately more manifest than the

greater grace of the movement of the vehicle—as to which, for the completeness of her image, Maggie was now supremely to feel how every strain had been lightened for herself. So far as *she* was one of the wheels she had but to keep in her place; since the work was done for her she felt no weight, and it wasn't too much to acknowledge that she had scarce to turn round. (341–42)

The secular trend of hired domestic labor being gradually displaced by devices is here enacted at the level of the sentence, as the servant metaphor dissolves almost instantaneously into that of the wheel. While Maggie here perceives Charlotte's marriage as lightening her own "strain," both women work to produce the appearance of things seeming "all so flourishingly to fit" in a way "sublimely projected" by Adam Verver's intention—as Fanny Assingham notes in one of her plot-clarifying conversations with her husband Bob:

> "It takes a great many things to account for Maggie. What is definite, at all events, is that—strange though this be—her effort for her father has, up to now, sufficiently succeeded. She has made him, she *makes* him, accept the tolerably obvious oddity of their relation, all round, for part of the game. Behind her there, protected and amused and, as it were, exquisitely humbugged—the Principino, in whom he delights, always aiding—he has safely and serenely enough suffered the conditions of his life to pass for those he had sublimely projected. He hadn't worked them out in detail—any more than I had, heaven pity me!—and the queerness has been exactly in the detail. This, for him, is what it *was* to have married Charlotte. And they both," she neatly wound up, "'help.'"
>
> "'Both'—?"
>
> "I mean that if Maggie, always in the breach, makes it seem to him all so flourishingly to fit, Charlotte does her part not less. And her part is very large. Charlotte," Fanny declared, "works like a horse." (317–18)

Fanny herself works for, and is shamelessly worked by Maggie, when the latter conscripts her as her "assistant" for the parties she hosts for social research. If Charlotte works for Maggie and her father like a servant, a tire, and a horse, Maggie imagines Fanny's work as akin to the services of a coach, tutor, and entertainer like Gedge: "Fanny Assingham might really have been there, at all events, like one of the assistants in the ring at the

circus, to keep up the pace of the sleek revolving animal on whose back the lady in short spangled skirts should brilliantly caper and posture" (376). Imagining Fanny as animal trainer enables Maggie to imagine herself as a performer, too. With Fanny at her side "giving her constantly her cue" for how to "intensify the lustre of the little Princess," "she might skip up into the light, even, as seemed to her modest mind, with such a show of pink stocking and such an abbreviation of white petticoat, she could strike herself as perceiving, under arched eyebrows, where her mistake had been" (376).

The question of whether coaching people to do well at dinner parties is "real work" doesn't seem the right one to ask here. What we should rather ask is why the novel represents women so removed from world of waged employment repeatedly imagining their "help" or "effort" for others as the paid work of servants and actors. Maggie is as far from this world as seems possible to get: she is a millionaire and a princess to boot. Yet the novel repeatedly compares her secret labors to physically strenuous, even acrobatic forms of *waged* performance. It is as if the comparison is meant to *offset* the appearance of "harmony" in the novel, paradoxically fostered by the work that the women are performing, which is geared explicitly toward making it seem like no exertion is involved.

The task Maggie conscripts Fanny to help her with most is accordingly that of screening her increasingly strenuous acts of cognitive and affective labor from view. "One of her dissimulated arts" for suppressing "tension" was to "interweave Mrs. Assingham as plausibly as possible with the undulations of their surface, to bring it about that she should join them of an afternoon when they drove together or if they went to look at things" (430). Much in the same way Marcher enlists May as protector of his secret ("You help me to pass for a man like another"), and the narrator of *The Sacred Fount*, in helping obscure Server's donation to Long's social value, helps screen her identity as his sexual partner, Fanny helps Maggie pass for someone ignorant of the situation. Such help enables Maggie to hide her activities from Amerigo, from Charlotte (to whom she pretends to be "stupid" to the end), and most of all from Adam, whose suspicion that something could be wrong with his daughter's marriage, his own marriage, and the "working harmony" of the two families he thinks he has secured by the latter is what Maggie dreads awakening above all.[54]

Involving another woman in her secret-maintaining efforts gives Maggie a thrill: "She had her intense, her smothered excitements, some of which were almost inspirations; she had in particular the extravagant,

positively at moments the amused, sense of *using* her friend to the top-most notch, accompanied with the high luxury of not having to explain" (430, original italics). As the text continues: "She didn't care for what . . . dinners of their own the Assinghams might have been 'booked'; that was a detail, and she could think without wincing of the ruptures and rear-rangements to which her service condemned them" (431). Not all her ways of conceptualizing Fanny's "service" are this harsh. Some are ruthless in a softer guise, as when Maggie relies on an image evoking the support Gedge unexpectedly receives from Mr. and Mrs. Hayes: "[Fanny] was like the kind lady who, happening to linger at the circus while the rest of the spectators pour grossly through the exits, falls in with the overworked little trapezist girl—the acrobatic support presumably of embarrassed and exacting parents—and gives her, as an obscure and meritorious artist, as-surance of benevolent interest" (546).

A version of the "overworked little trapezist girl" recurs earlier in the novel, when, having tactically resisted the impulse to interrogate Amerigo about the details of his sexual history with Charlotte (for her long game is to make them separate of their own volition), Maggie imagines the "small strained wife of the moments in question as some panting dancer of a difficult step who had capered, before the footlights of an empty the-atre, to a spectator lounging in a box" (487). Once again, Maggie identi-fies her clandestine labors with hired performance involving physical strain. *The Golden Bowl* suggests that this work must be hidden in part *because* of its strenuousness, which would of course give away both the work and the relation it is designed to conceal. Feminine work must not be recognized as work, and more covert working must be done to ensure that it remains undetectable. The "beautiful harmony" must be "shifted to a new basis" without anyone knowing that Maggie is doing the shifting, or that she might have a reason for doing so.

Women in this novel, in a significant difference from men, repeatedly imagine labor as secret *because* it is strenuous, and as strenuous *because* it is secret; they are also constantly figuring this labor as *hired* service pro-vision. Charlotte's role as hostess at Fawns is similarly imagined by Maggie as waged docent work. She also specifically imagines it to be Char-lotte's anxious way of keeping up appearances, during the "crisis" of her mounting distress at the emotional defection of Amerigo.[55]

The great part Mrs. Verver had socially played came luckily, Maggie could make out, to her assistance; she had "personal friends" . . .

who actually tempered, at this crisis, her aspect of isolation; and it wouldn't have been hard to guess that her best moments were those in which she suffered no fear of becoming a bore to restrain her appeal to their curiosity. Their curiosity might be vague, but their clever hostess was distinct, and she marched them about, sparing them nothing, as if she counted, each day, on a harvest of half crowns.[56]

Adding to our sense of the strain involved for Charlotte in her job as "cicerone" is the fact that she is not good at it. "Maggie met her again, in the gallery, at the oddest hours, with the party she was entertaining; heard her draw out the lesson, insist upon the interest, snub, even, the particular presumption and smile for the general bewilderment—inevitable features, these latter, of almost any occasion—in a manner that made our young woman, herself incurably dazzled, marvel afresh at the mystery by which a creature who could be in some connexions so earnestly right could be in others so perversely wrong" (536–37).

In *The Golden Bowl*, men talk openly about domestic relations in terms of working, while women secretly working to shore up those relations pretend no work is being done. The covert activity of first unconcealing and then protecting a familial secret is strenuous but must look like it isn't; more discreet work is therefore required to maintain the appearance of worklessness. This accounts for a curious ambiguity in both the novel, as well as the discourse of critics, surrounding whether its oft-discussed "equilibrium" finally does or doesn't require effort to maintain. Mark Seltzer for instance writes, "The power of the equilibrium operates so that in the 'whirligig of time' *things come round of themselves*; it is the 'form of the equilibrium' that guarantees the organic form of the action itself and ultimately 'round[s] it thoroughly off.'"[57] If it sounds here as if the economy of the novel really is effortless, it is because there is a reality to its appearance as a self-adjusting system. But this is in turn precisely because of the success of the female efforts to suppress the manifestation of effort we have been tracking above.

In *The Golden Bowl*, the image of a frictionless, smoothly functioning totality coincides with imagery equating half of the gendered persons comprising it to tires, hired help, contortionists, animal trainers, personal coaches, and winded entertainers pausing to gasp for breath under hot spotlights. If *The Sacred Fount*'s inability to live up to its donnée about Server's occulted labor sets off an explosion of clichéd metaphors and

other gimmicks, *The Golden Bowl*'s insistence on the end of exertion through the beauty of social geometry seems similarly connected to its proliferation of garish images of feminine service work.

In other words, if what Seltzer calls James's "organic form" or resilient style "underwrites" the novel's "equilibrium," something like the obtrusive gimmick seems to underwrite the occulted labor which makes it possible.[58] This comes to a climax, as the novel itself does, in a scene revolving around a game of cards. One hundred pages after Maggie imagines her secret machinations as a "some hard game, over a table, for money" between herself and her father, we are confronted with what seems to be this arguably somewhat hackneyed metaphor "come to life."[59] Yet "come to life" (itself a cliché) in a paradoxically reified fashion, with social relations between the players stiffened into thinglike "facts," which in turn serve as reifying metaphors for the players around the table:

[M]eanwhile *the facts of the situation were upright for her* round the green cloth and the silver flambeaux; the fact of her father's wife's lover facing his mistress; the fact of her father sitting, all unsounded and unblinking, between them; the fact of Charlotte keeping it up, keeping up everything, across the table, with her husband beside her; the fact of Fanny Assingham, wonderful creature, placed opposite to the three and knowing more about each, probably, when one came to think, than either of them knew of either. Erect above all for her was *the sharp-edged fact of the relation of the whole group*, individually and collectively, to herself— herself so speciously eliminated for the hour, but presumably more present to the attention of each than the next card to be played. (495, my italics)

Finally there is the narrative coincidence, perhaps most notable of the dubious devices *The Golden Bowl* deploys with relish, in close conjunction with its extravagantly impoverished, overperforming yet underperforming metaphors. As Julian Murphet notes, it is a device that "in prototypical Jamesian fashion the narrator cannot desist from remarking," amplifying its obtrusiveness.[60] "Too prodigious, a chance in a million . . . as queer as fiction, as farce"; "a wild extravagance of hazard"; "their common ridiculous good fortune"; "the general *invraisemblance* of the occasion": these descriptions of Strether's discovery of Chad and Madame de Vionnet on the river equally apply to the narrative event that finally reveals Charlotte and Amerigo's affair to Maggie.

"I agree with you that the coincidence is extraordinary—the sort of thing that happens mainly in novels and plays."[61] This is appropriately what the Prince says to Maggie after she tells him she has purchased the golden bowl—the novel's symbolically overladen object—from the same antique shop in London where, in a meeting unknown to Maggie on the eve of their marriage, he and Charlotte considered it as a possible wedding gift. The shopkeeper makes a special visit to Maggie's home in order to confess to the invisible crack in her purchase, during which, noticing framed photographs of the Prince and Charlotte and commenting on their past visit to his shop, he makes the fact of their prior liaison known to Maggie. (Adding to this pile of conveniently timed events, it turns out that the dealer knows Italian, which is the language in which the Prince and Charlotte thought they were communicating secretly).

The story-advancing disclosure of the secret in *The Golden Bowl* thus hangs on a service provided by a functional character exemplifying the device James condescendingly if affectionately calls the "ficelle." Based on a French word denoting a "string used to manipulate a puppet, or more broadly, any underhand trick," the ficelle is introduced, as Kent Puckett glosses, "not as a necessary and organic part of the plot but rather as means of providing necessary exposition, of moving the plot mechanically forward."[62] While the ficelle is thus "a cheap but effective and maybe unavoidable trick," Puckett rightly notes that the "love of . . . cheap tricks, noble failures, and beautiful mistakes is at the very heart of James's thinking [about narrative practice]" in his prefaces to the New York Edition (1907–1909).[63] What is worth adding is that in James's corpus, and in his late works about labor and secrecy especially, the ficelles "cheaply" employed for expository or plot-advancing reasons primarily tend to be women: Maria Gostrey (who assists Strether); May Bartram (who assists Marcher); Mrs. Grose (who assists the governess); Mrs. Jordan (who assists the telegraph girl); Mrs. Wix (who assists Maisie); and Fanny Assingham (who assists virtually everyone at some point but finally only Maggie). Each "helps" their protagonist in their strenuous (and clandestine) efforts to make sense of a complex web of relations in which they find themselves entangled, and, simultaneously, helps the reader struggling to make sense of James's stylistic indirection.

Sometimes the narrative helpers are waged domestic employees, as in the case of "The Turn of the Screw" and "In the Cage" (Mrs. Jordan arranges flowers for the houses of the rich). In the case of James's own favorite examples of his "light *ficelle*," Henrietta Stackpole and Maria

Gostrey, what is significant is that while neither are servants, James describes them as such.[64] In a comically prolonged metaphor, this happens through a modulating series of contiguous images. Stackpole and Gostrey are first likened to the wheels of a coach carrying a pair of monarchs, *then* to dutiful attendants running besides the coach, and finally, in an unremarked swerve that seems to *overturn* the abjection of the previous two vehicles, to Parisian revolutionaries escorting the coach filled with royals back from Versailles towards the guillotine.

> Each of [my ficelles] is but wheels to the coach; neither belongs to the body of that vehicle, or is for a moment accommodated with a seat inside. There the subject alone is ensconced, in the form of its "hero and heroine," and of the privileged high officials, say, who ride with the king and queen. [. . .] Maria Gostrey and Miss Stackpole then are cases, each, of the light *ficelle*, not of the true agent; they may run beside the coach "for all they are worth," they may cling to it till they are out of breath (as poor Miss Stackpole all so visibly does), but neither, all the while, so much as gets her foot on the step, neither ceases for a moment to tread the dusty road. Put it even that they are like the fishwives who helped to bring back to Paris from Versailles, on that most ominous day of the first half of the French Revolution, the carriage of the royal family. (52–53)

The irony of this "runaway" figure, with its final surprising twist on the theme of labor, gender, and politics, is that the very image used to underscore the ficelle's triviality and subservience ends up magnifying her presence.[65] Elsewhere in his preface, James laments the fact that Henrietta ends up occupying too much space in *The Portrait of a Lady*—yet she ends up stealing the limelight in his preface, too.

Why, asks James, in spite of his own reservations (and indeed, explicitly dismissive account of the ficelle) has he "suffered Henrietta . . . so officiously, so strangely, so almost inexplicably, to pervade?"[66] In part, he tells us, for reasons identical to those underpinning Gedge's strategy in "The Birthplace": the need to cover over a certain "thinness" by cultivating the "lively," and also a preference for "overtreating" over "undertreat[ing]."[67] The ficelle is the formal correlate of the service providers in the late Jamesian story pattern, "keenly clutched at" for the unglamorous purpose of exposition and entertainment, much in the same way as the governess "pounces" on her own expository helper, Mrs. Grose, for information about the servants.

James's service providers seem to require their own service providers. James notes that this is why he "pre-engaged" Maria Gostrey for Strether, who is in turn, of course, "pre-engaged" to assist Mrs. Newsome. As James writes, "These alternations propose themselves all recogniseably, I think, from an early stage, *as the very form and figure* of *The Ambassadors*; so that, to repeat, such an agent as Miss Gostrey, pre-engaged at a high salary, but waits in the draughty wing with her shawl and her smelling-salts."[68] With "[an] office as definite as that of the hammer on the gong of the clock," James continues, "Her function speaks at once for itself, and by the time she has dined with Strether in London and gone to a play with him her intervention as a ficelle is, I hold, expertly justified. Thanks to it we have treated scenically, and scenically alone, the whole lumpish question of Strether's 'past', which has seen us more happily on the way than anything else could have done" (xx).

If Maria Gostrey's "office" in *The Ambassadors* is to "intensify the lustre" of Strether, serving, like May Server for Long and May Bartram for Marcher, as "extractor of his value and distiller of his essence," her own use by James for this function needs to be, in his own words, "artfully dissimulated" (xxi). This must be done because James has made his own "pounce" on Maria so crudely: "without even the pretext, either, of *her* being, in essence, Strether's friend" (xix). Looking backwards, James confesses to something contrived about their friendship in the story. For this reason, in revision, the "seams or joints of Maria Gostrey's ostensible connectedness [needed to be] taken particular care of, duly smoothed over, that is, and anxiously kept from showing as 'pieced on'" (xxi). The "false connexion"—the gimmick—must be covered over with a "due high polish" in order to pass for a "real one." At the same time, James's language clearly indicates a desire not just to conceal, but to *flaunt* his aesthetically dubious use of the ficelles as "direct . . . aid[s] to lucidity" (xix). The art of using a gimmick is the art of camouflaging one's "dependence" on it, involving "deep dissimulation" at the level of style. Yet James also wants "to tear off her mask" (xix). Thus alluding to the "never-to-be-slighted 'fun'" of a technical challenge, he confesses to enjoying the equivocal work involved in "artfully dissimulating" the "pieced-on" nature of his device, much in the same way as the governess, the telegraph girl, and so many of his other protagonists take vaguely illicit pleasures in their own clandestine activities (xxi).

Once again, we find James aligning himself with his secret laborers. It is however crucial to recognize the ambivalence of this identification,

which comes to a head in our last example below. Through a complex extended metaphor comparing all of *Portrait*'s minor characters to hired entertainers, James's initial act of contemptuous self-distanciation from the ficelle and by extension the figure of the service provider slowly modulates into one of alignment. Here is how the comparison begins:

> They were like the group of attendants and entertainers who come down by train when people in the country give a party; they represented the contract for carrying the party on. That was an excellent relation with them—a possible one even with so broken a reed (from her slightness of cohesion) as Henrietta Stackpole.[69]

Directly after introducing this characteristically simple, almost cartoony metaphor, James's syntax suddenly gets very elliptical and flooded with abstractions:

> It is a familiar truth to the novelist, at the strenuous hour, that, as certain elements in any work are of the essence, so others are only of the form; that as this or that character, this or that disposition of the material, belongs to the subject directly, so to speak, so this or that other belongs to it but indirectly—belongs intimately to the treatment. This is a truth, however, of which he rarely gets the benefit—since it could be assured to him, really, but by criticism based upon perception, criticism which is too little of this world. He must not think of benefits, moreover, I freely recognise, for that way dishonour lies: he has, that is, but one to think of—the benefit, whatever it may be, involved in his having cast a spell upon the simpler, the very simplest, forms of attention. This is all he is entitled to; he is entitled to nothing, he is bound to admit, that can come to him, from the reader, as a result on the latter's part of any act of reflexion or discrimination. (52)

It is as if a squid has suddenly gotten nervous about something in its vicinity and squirted ink. We are now in a mist of those "philosophical" words— *truth*; *elements*; *essence*; *form*; *material*; *subject*; *reflexion*; *discrimination*— that always seem "too 'strong,' too hyperbolic" when used in [James's] novels for the "lightweight world of manners and social situations."[70]

Coming where it does, the cloud of abstractions seems designed to obfuscate a discomfiting similarity between those contracted to supply aesthetic entertainment for others and a novelist wanting to be commer-

cially successful. But it is also as if its fog provides temporary cover for James to linger on the parallel and work through it. Yes, something about the image of Henrietta and company as waged suppliers of fun seems to trigger James into becoming spectacularly indirect about his own commitment to "simpler . . . forms of attention." Yet there is a shift from condescending distance to identification with these "attendants and entertainers" as James slowly pivots back to the concrete imagery with which he started. By the end of the passage, we see him embrace the parallel, likening any act of "reflexion or discrimination" on the part of his reader, over and above "simpler . . . forms of attention," as the "tip" that a performer of services might receive on top of her "living wage":

> He may *enjoy* this finer tribute—that is another affair, but on condition only of taking it as a gratuity "thrown in," a mere miraculous windfall, the fruit of a tree he may not pretend to have shaken. Against reflexion, against discrimination, in his interest, all earth and air conspire; wherefore it is that, as I say, he must in many a case have schooled himself, from the first, to work but for a "living wage." The living wage is the reader's grant of the least possible quantity of attention required for consciousness of a "spell." The occasional charming "tip" is an act of his intelligence over and beyond this, a golden apple, for the writer's lap, straight from the wind-stirred tree. The artist may of course, in wanton moods, dream of some Paradise (for art) where the direct appeal to the intelligence might be legalised; for to such extravagances as these his yearning mind can scarce hope ever completely to close itself. The most he can do is to remember they *are* extravagances.[71]

With this image of a monetary gratuity on top of a "living wage," James's identification with the female server—and in a sense, with his "same secret principle" or narrative gimmick—attains a certain completion.

5.

From inflated praise and overtreated ficelles to oversimplistic metaphors and underperforming données, the gimmick's extravagantly impoverished form seems to hover everywhere labor and secrecy intersect in James's works. What might its recurring presence at this crossroads tell us?

More simply: If James wanted to tell a single story over and over again, why was it this one? In which, again, a person struggling to get to a truth obscured by everyday forms finds herself secretly and even more laboriously reconcealing it? Why, as hinted in James's most formulaic version of this story, does the content of the secret itself involve occulted labor? In contrast to his literary contemporaries regarding industrial, financial, or agricultural work as key to understanding their present, why does his pattern foreground unwaged reproductive *and* low-waged service work, and why does it repeatedly figure each in terms of the other? Why is the work done by Fanny, Charlotte, and Maggie compared to that of hired entertainers, coaches and docents, while the work of tutors, telegraph operators, and governesses is represented as flowing over professional boundaries to the point of resembling donated "kin work"? Why are these figures, not others, at the center of James's stories about struggles to penetrate social opacity, which are essentially stories about the desire Jameson calls cognitive mapping?[72]

When it comes to novelists interested in the representation of capitalist totality, we tend to think of Dickens and Pynchon. Even though the task requires modes of abstraction and indirection at which James was skilled (since it ultimately entails representing the system's resistance to representation), a writer who could become engrossed by *What Maisie Knew* rarely comes first to mind. It is as if an interest in femininity renders one's aspiration to totalizing thought illegible. More than the oft-noted fact, typically garnished with an allusion to the "unmentionable commodity" in *The Ambassadors*, that there are no representations of *production* in James's novels, it is perhaps responsible for having distracted readers from sufficiently noticing that James's corpus is nonetheless teeming with *workers*—employed and nonemployed—*whose activities are constantly being cross-compared.*

Indeed, it is exactly by focusing on figures like the governess and the narrator of *The Sacred Fount*—who is obsessed, let us remember, with the idea of a woman as occulted source of her male partner's increased social value—that James shows himself as much of a literary totalizer as anyone else. For in a way mirroring the cognitive efforts of his protagonists, and our own in attempting to follow James's layers of abstract reference, it is precisely through this story of occulted exertion that he is trying to grasp the logic of forms that have shaped the historical trajectory of labor. James was in short writing about two aspects of capitalism that continue to take on charged meaning in debates today: the structural

occultation of female reproductive labor, hidden in and through everyday capitalist forms such as the male family wage, and the rise of an incipient service economy that would eventually come to supersede manufacturing and industry in Great Britain and other wealthy nations. What is more: James's repeated return to his story of labor and secrecy from both of these economic directions—unwaged and waged, Maggie and governess—suggests that he was fascinated by *the connection between them.*

What kind of labor is more structurally hidden, from the perspective of the capitalist whole, than the "ensemble of physical, intellectual, and emotional expenditures required to reproduce the proletariat as workers from day to day, year to year, within the expanded cycle of capital's own self-reproduction"?[73] Due to its apparent disconnection from the wage, "kin work" in the home is essentially clandestine and a donation to capital, much in the same way the "draining" of Server is a concealed donation to the increased vitality and social value of her male sexual partner. Indeed, as Mariarosa Dalla Costa and Selma James argue, the exploitation of women becomes "even more effective" in capitalism than in older modes of production because "the lack of a wage [hides] it," enabling the wage to command a "larger amount of labor than [appears] in factory bargaining." As they continue: "Where women are concerned, *their labor appears to be a personal service outside of capital.*"[74]

An entire mode of production based on surplus labor extracted from waged workers is thus made possible through, or underwritten by, an even more secret layer of unpaid labor that invisibly contributes to *its* value (the social cost of its reproduction)—labor which in the very act of making this contribution, disappears from social view. As Leopoldina Fortunati writes, "the real difference between production and reproduction is not that of value/non-value, but that while production both is and appears as the creation of value, reproduction is the creation of value but appears otherwise. . . . *It is the positing of reproduction as non-value that enables both production and reproduction to function as the production of value.*"[75] Productive and reproductive labor are a single unit, but the wage form conceals this. Indeed, the contribution of women's "personal services" to surplus value must be concealed to sustain the mode of production it makes possible.[76] If the productiveness of reproductive labor were forced in the open, resulting in a demand for wages, profit margins based on surplus labor would shrink and the system premised on it would collapse.[77] Perhaps this is why, in the Jamesian pattern, the social secret involving donated or affective labor must be immediately rehidden.

The wage form obscures, then, in two ways. It purports to represent payment for and thus the value of labor expended, whereas it represents the value of the reproduction of labor power. But within this value lies, even further encrypted, the donation of women. The wage thus includes the nonwage, much in the same way "everything" always seems laminated to "nothing" in James's later texts.[78]

What then is the connection between this occulted labor, highlighted in stories of the secret kin work done by figures like Server and Maggie, and the services *performed in no less covert or affective fashion by employees* like the governess, telegraph girl, and Gedge? More specifically, what might be at stake in trying to think these waged and unwaged activities together? Even though we've just contrasted the waged worker to the unwaged woman whose labor becomes encrypted in the value of labor-power, let us also remember that the reason why James's waged employees are *also* depicted as working secretly is because there is something excessive and therefore risky in their ways of performing their official jobs. Figures like the governess, the telegraph girl, and Gedge do not simply "work": they "help." Once again, James is figuring one kind of work in the other's image. Wives and daughters work (secretly) like docents, attendants, and entertainers. Paid service providers meanwhile work (secretly) like wives and daughters. What is the logic of this crisscrossed relationship?

One reason for James's preoccupation surely lay close to home. In the winter of 1900, James made the decision to let William MacAlpine go: not because he was unhappy with his employee's work but because "he's too *expensive*. . . . I can get a highly competent little woman for half."[79] Using Miss Petherbridge's Secretarial Bureau, he hired Mary Weld in the spring of 1901, who would work with him on *The Ambassadors*, *The Wings of the Dove*, and *The Golden Bowl*. When Weld left the position to get married, James returned to Miss Petherbridge's in 1907 to engage his last amanuensis, Theodora Bosanquet, to whom he dictated his prefaces and revisions for the New York Edition.

James's switch to using female labor in production would be closely followed by the departure of two domestic workers in his employment since 1886. In a letter to his sister-in-law dated September 26, 1901, James referred to this as "the tragedy of the Doom of the Smiths."[80] The Smiths, a butler and wife couple first employed by James in London, had developed alcohol addictions worsening over the years, which became undisguisable during the course of a disastrous luncheon party. James sent for

a doctor, paid the couple's alcohol bills and each two months' wages.[81] He also fired them, replacing both with a single female "cook-housekeeper," Mrs. Paddington, referred to in letters as his "Pearl of Price."[82] Notice how a job disappears in this consolidation of domestic economy. Uncannily presaged by "Brooksmith," it is that of the butler.[83]

At the dawn of the twentieth century, James's household, an intersection of reproductive and productive economy, was thus the site for the phasing-out of a domestic service, as well as cheaper female labor's displacement of male labor. James was therefore aware of the impact on both sexes of the "feminization" of service work, and of the mass movement of middle-class women into clerical positions. As Jennifer Fleissner notes, this specific transition was facilitated by aligning clerical work with unwaged domestic labor. "How . . . was office work for women made not only economically appealing but socially acceptable?" By comparing the typewriter to a "literary piano," and describing the secretary who "plays" this instrument as someone who performs "work looking like the absence of work."[84] If the entry of Mary Weld or Theodora Bosanquet into the world of "male business" could be lubricated by a discourse likening their activities to those of ladies in parlors, could we not imagine James imagining nonwaged middle-class or even ruling-class wives like Maggie imagining the opposite? That is, imagining their own strenuous efforts to keep a patriarchal household together as akin to the work of waged service providers?

There is also, I think, a more politically unconscious reason for why James's pattern concerning labor and secrecy takes the chiasmic form it does, with waged service work figured as unpaid domestic work, and unwaged domestic work figured as waged service work. But to see this we need to reflect on an aspect of the pattern of which we've had glimpses but have not yet discussed. This is the way in which so many of the *employees* laboring in secret in James's later works, *as if* they were structurally occulted reproductive workers, are represented as on the edge of impoverishment and redundancy.

While the world of James is full of formally employed household service providers, it is also filled with reluctant employers who do not seem willing or able to pay them. The Beales in *What Maisie Knew* and the Moreens in "The Pupil" all stiff or owe years of back wages to their domestic workers, as reflected in the declining condition of Mrs. Wix's dress and Pemberton's meals alongside those of their charges. These workers are thus joined to the dependents they are unpaid to care for in more

than one way. The word "abandoned" seems an odd choice for describing an adult. Yet this is how Wix and Pemberton appear when stranded alongside with Maisie and Morgan. It is as if James wants to represent what Marx calls "surplus populations" created by the divestment of capital from unprofitable lines (non-production), but can do so only by refracting that image through a familial metaphor, the parentless child (nonreproduction).[85] In "Brooksmith," which tracks the fate of an overqualified butler unable to secure another post after the death of his elderly employer, certain personal services and a paternalistic culture that may have already artificially extended their historical lifespan seem on the cusp of obsolescence.[86] (James at one point contemplated giving this story a more generic title, "The Servant").[87] It is clear that figures like Miles's governess, Mrs. Wix, and Pemberton are already serving as cost-saving substitutes for trained teachers in schools, as comically underscored by Maisie and Morgan's parents' enthusiasm for free public lectures. But James's employers not only offload children onto the employees they have unenthusiastically hired; they want to offload the employees, too.

New uncertainty about the obligations of kinship is a key part of the ethical challenges instated by "modernity" that fascinated James.[88] What is striking is to find this expressed not just through the motif of fobbed-off children—Maisie, Morgan, Flora, and Miles—but also that of fobbed-off *workers*. Children and workers are thus conjoined in what the families/employers like to portray as a self-sufficient unit, whose emancipation they hope for.[89] Is this a figure of familial neglect in terms of structural unemployment, or is it a figure of structural unemployment figured in terms of familial neglect? In any case, James's way of linking the occulted labor of kin work to the equally secret exertions of waged service providers seems to be doing something even more than reflecting on caring labor's incorporation into capitalism. It suggests his anticipation of the eventual replacement of nineteenth-century personal service occupations with manufactured goods over the course of the twentieth century. James's labor and secrecy plot, in short, contains the seeds of a theory of gender and deindustrialization: a phenomenon often thought of as specific to moments like the 1970s but which, as Leigh Claire La Berge reminds us, has been a "recurrent feature of urban life since the eighteenth century."[90]

At the same time, the supersession of certain services by manufactured goods seems to give rise to a wave of new services.[91] The displacement of the secretary by the typewriter gives rise to the typist; a century later, the replacement of the typist by dictation software gives rise to jobs extracting

the data required to maintain its ability to learn.[92] As Jason Smith puts it, "Much of what we know as the service economy is a direct, complementary, effect of an earlier automation of services: one might even speak of a dialectical pattern, in which a primary term (personal services) passes over into its opposed pole (manufactured good), giving rise to a new, transformed variant of the first term (new or expanded field of services). Only now, these new service occupations are organized, as they were typically not in the 19th century, along properly capitalist lines."[93] This historical dynamic finds its theoretical counterpart in Marx's concepts of formal and real subsumption. While the former involves the subordination of work to capitalist production without the work process changing—even when done for a wage, the labor of caring for children looks much like it always has—real subsumption, epitomized in automation, involves a changed relation between capital and labor that in turn changes the technical features of the working process by increasing its productivity.

Composing his elaborate narratives about occulted labor in the presence of an employee operating a machine in his home, James's pattern invites us to relate, by constantly comparing, unwaged labor secretly incorporated into the wage to affective work performed in covert fashion by waged service providers. The latter category includes employees who are *also* unpaid or deserted by their employers in a way that allegorically hints at the incipient redundancy of their jobs. James is thus giving us a picture of the contradictions that make capitalism prone to crisis *in which gender plays a structural and yet systematically occulted role*. For in the figure of the waged yet impoverished, symbolically "forsaken" employee recurring in his late narratives, as it converges with that of the unwaged and similarly depleted woman, one gets a glimpse of how increased productivity gains achieved through real subsumption end up producing economically left-behind workers. As Joshua Clover writes:

> It is real subsumption's fate to undermine the gains in absolute surplus value gotten through formal subsumption. This in turn proposes further rounds of formal subsumption to defer crisis. As the concomitant productivity increasingly expels labor from the production process, capital must seek absolute surplus value elsewhere: by extending the working day, enlarging the sector, or by opening new lines. At the level of the global economy, intensifying real subsumption in the developed core has compelled new episodes of formal subsumption elsewhere, adding new labor inputs to global

capital against waning rates of surplus value. We might also see this as a dialectic of formalization and informalization: formal subsumption draws people into the formal economy, while real subsumption has as one of its effects the casting of formal workers into the informal economy.[94]

"Formal subsumption draws people into the formal economy": women like the governess and Mrs. Wix receive wages for reproductive labor. Real subsumption meanwhile "cast[s] formal workers into the informal economy": this is what happens to Brooksmith and, it seems likely, to Pemberton.[95] It may not be coincidental that these waged yet impoverished service providers, whose coupling to offloaded children positions the adult employees as victims of familial desertion, start appearing in James's texts in the last decades of the nineteenth century, oft-noted as the start of Great Britain's macroeconomic contraction.[96] If the reproductive family is a metaphor for the productive economy (and vice versa), James's vehicle and tenor are once again unusually close.

And if the occulted labor plot is pegged to the rise of the later style, both are pegged to James's interest in the gimmick as technique, in the "cheap trick" or "never-to-be-slighted 'fun'" of a technical challenge. In showing how extravagance and impoverishment, hyperbole and austerity, and even "everything" and "nothing" are contiguous phenomena, James's "same secret principle" points to the "moving contradiction" of "capital itself," which as Marx writes, "posits the superfluous in growing measure as a condition—question of life or death—for the necessary."[97]

The superfluous becomes a requirement for the necessary. A docent's overtreatment saves his job; an entire novel hangs on a cheap trick; a "light ficelle" overtakes the account of her subordination; philosophical words describe frivolous atmospheres; clichéd metaphors turn into physical objects. The moment quoted above from the *Grundrisse*'s "Fragment on Machines," encoding the dialectical patterns involving services and automation to which James's story of occulted labor points, is one over which the capitalist gimmick's dubious and yet compelling form can already be felt to preside.

NOTES

ACKNOWLEDGMENTS

INDEX

Notes

Introduction

1. In the immediacy of aesthetic experience, judgment and the perception of form cannot be de-laminated. They can of course be separated in analysis. This must happen for the gimmick in particular, since in its case the judgment involves distancing from if not explicit rejection of the form perceived.

2. On this dynamic, see Moishe Postone, *Time, Labor, and Social Domination: A Reinterpretation of Marx's Critical Theory* (Cambridge: Cambridge University Press, 1993), especially "The Dialectic of Labor and Time," 289–91.

3. The quality of being "merely formal" is attributed specifically to "purposiveness without an end" and associated with mental activity that does not conclude in a particular cognition. See Immanuel Kant, *Critique of the Power of Judgment*, ed. Paul Guyer, trans. Paul Guyer and Eric Matthews (Cambridge: Cambridge University Press, 2000), 107, 111, 152. On the significance of "mere" (bloß) to Kant's aesthetics, see Rodolphe Gasché, *The Idea of Form: Rethinking Kant's Aesthetics* (Stanford, CA: Stanford University Press, 2003).

4. Gasché, *Idea of Form*. This figure is central to Gasché's reading of Kant overall, but see especially his chapter on "The Arts, in the Nude," 179–201:

> What permits one to judge the beautiful arts as products of a design without inevitably having to resort to cognitive judgment? There is only one possible solution to this dilemma: the concept in question, without which the beautiful arts could not be arts, cannot be a definite concept but must instead be undetermined. Only if the requisite presiding concept is rendered indefinite, and its determinateness blurred, does art become beautiful art. This is the sole condition under which the determining judgment required by art qua art can be stripped of its determining power and be "reduced" to "the mere act of judging" which asserts the beauty of the product. Pure aesthetic judgments upon the beautiful are possible only in the absence of all determinate concepts, and this condition is met when the concept in man-made art is rendered indeterminate. But whereas an absence of concepts for

307

certain objects of nature is passively experienced by the mind that judges the objects beautiful, such an absence for objects of the beautiful arts must be "actively" engendered in order for them to be judged beautiful, and for the judgments to be aesthetically reflective judgments. A double denuding, then ... of the arts has to occur for an object of the beautiful arts to come into existence and for the judgment relating to it to be indeterminate. With the divesting of the definite concept behind the design to produce a beautiful object, the mere form of the object becomes exposed, judgment is stripped of its determining character, and "the mere act of judging" is laid bare, that is, the sort of judging suited to beautiful objects. Where the concepts guiding their production have undergone such an operation of denudement, or of indetermination, the products of art have the look of objects of nature, that is, of objects of a general acting or working. (185)

5. Neil Harris, *Humbug: The Art of P. T. Barnum* (Chicago: University of Chicago, 1973), 57; see also 61–89.

6. John Roberts, *The Intangibilities of Form: Skill and Deskilling in Art After the Readymade* (London: Verso, 2007), esp. 24–43 and 49–75. D. A. Miller, "Anal Rope," *Representations* 32 (Autumn 1990): 114–33, 115, 122. In "Suspicious Minds," Rita Felski acknowledges the "pleasure" that a hermeneutics of suspicion can provide. Postcritical thought's overarching emphasis however rests on suspicion's unhappy affects: how its "pervasiveness" "testifies to the increasing pressures of professionalization and the scramble to shore up academic authority." Rita Felski, "Suspicious Minds," *Poetics Today* 32, no. 2 (2011): 215–34, 218.

7. On the "Golden Age," see Andrew Glyn, Alan Hughes, Alan Lipietz, and Ajit Singh, *The Rise and Fall of the Golden Age*, Working Paper 43, April 1988 (Helsinki: World Institute for Development Economics Research, 1988). On the "long downturn," see Robert Brenner, *The Economics of Global Turbulence: The Advanced Capitalist Economies from Long Boom to Long Downturn, 1945–2005* (New York: Verso, 1998).

8. On the "spatial fix," see David Harvey, *The Condition of Postmodernity: An Enquiry into the Origins of Cultural Change* (Oxford: Basil Blackwell, 1989), 196. On the "product fix," "technological fix," and "financial fix," see Beverly Silver, *Forces of Labor: Workers' Movements and Globalization Since 1870* (New York: Cambridge University Press, 2003), 39–40. Thank you to Jonathan Flatley for reminding me of this connection.

9. See Silver, *Forces of Labor*, 41.

10. By "seeing" in this sentence, I also mean hearing, smelling, or touching. Forms can be perceived by all of our senses.

11. Robert Pfaller, *On the Pleasure Principle in Culture: Illusions without Owners*, trans. Lisa Rosenblatt, with Charlotte Eckler and Camilla Nielsen (London: Verso, 2014), 2.

12. Gérard Genette, *The Aesthetic Relation*, trans. G. M. Goshgarian (Ithaca, NY: Cornell University Press, 1999), 91.

13. Steven Levy, "Google Glass 2.0 Is a Startling Second Act," *Wired*, July 18, 2017.

14. In a similar vein, Leigh Claire La Berge characterizes "decommodified labor" as a "pause in accumulative temporality." See *Wages Against Artwork: Decommod-*

ified Labor and the Claims of Socially Engaged Art (Durham, NC: Duke University Press, 2019), 27. "It is not commodified presently—*now*, a category with its own philosophical uncertainty—but it may be sooner or later" (202).

15. As Grant Wythoff notes, the conjunction of the "soberly technical and wildly speculative" was common in early popular science. See *The Perversity of Things: Hugo Gernsback on Media, Tinkering, and Scientifiction* (Minneapolis, MN: University of Minnesota Press, 2016), 6.

16. Wythoff, *Perversity of Things*, 43.

17. Karl Marx, *Grundrisse: Foundations of the Critique of Political Economy (Rough Draft)*, trans. Martin Nicolaus (New York and London: Penguin Books and New Left Review, 1973), 706, my emphasis. Located in Notebook VII, the passage continues as follows:

> On the one side, then, it calls to life all the powers of science and of nature, as of social combination and of social intercourse, in order to make the creation of wealth independent (relatively) of the labour time employed on it. On the other side, it wants to use labour time as the measuring rod for the giant social forces thereby created, and to confine them within the limits required to maintain the already created value as value. Forces of production and social relations—two different sides of the development of the social individual—appear to capital as mere means, and are merely means for it to produce on its limited foundation. In fact, however, they are the material conditions to blow this foundation sky-high.

18. George Caffentzis, "Immeasurable Value? An Essay on Marx's Legacy," *The Commoner* 10 (Spring/Summer 2005): 87–114, 89.

19. See Caffentzis, "Immeasurable Value?" Also see Joshua Clover, "Subsumption and Crisis," in *The SAGE Handbook of Frankfurt School Critical Theory*, ed. Beverley Best and Werner Bonefeld (London: SAGE Publications, 2018), 1567–83.

20. Clover, "Subsumption and Crisis," 1570. See also Postone, *Time, Labor, and Social Domination*, 289–91.

21. That is, the wage: the value of the commodities needed to reproduce the worker's ability to work and produce a succeeding generation of workers. See Karl Marx, *Capital: A Critique of Political Economy*, vol. 1, trans. Ben Fowkes (New York: Penguin, 1976), 283–639.

22. Moishe Postone, "The Current Crisis and the Anachronism of Value: A Marxian Reading," *Continental Thought & Theory: A Journal of Intellectual Freedom* 1, no. 4 (2017): 38–54, 48.

23. Marx, *Capital*, vol. 1, 782. This discussion of relative surplus populations falls in the crucial 25th chapter, "The General Law of Capitalist Accumulation." See Marx, *Capital*, vol. 1, 781–93, esp. 786. On the "treadmill effect," in which capitalist production generates increases in productivity and the magnitude of use-values produced per unit time but not proportional long-term increases in the magnitude of value produced per unit time, leading to further pressures to increase productivity, see Postone, *Time, Labor, and Social Domination*, 289–91. In this process, "historical time" is pushed forward as each time unit becomes "denser" (292–98). What results from the ensuing dialectic of abstract and historical time is a peculiar mixture of stasis and dynamism unique to capitalist modernity: one "characterized

by ongoing, even accelerating, transformations of more and more spheres of life" but that also "structurally reconstitutes its own basis: value remains the essential form of wealth and . . . therefore, value-creating labor remains at the heart of the system regardless of the level of productivity" (Postone, "Current Crisis," 48). In other words: "the historical dynamic of capitalism ceaselessly generates what is 'new' while regenerating what is the 'same'"; it therefore "generates the possibility of another organization of labor and of social life and, yet, at the same time, hinders that possibility from being realized" (48).

24. James Boggs, "The American Revolution: Pages from the Negro Worker's Notebook," in *Pages from a Black Radical's Notebook: A James Boggs Reader*, ed. Stephen Wald (Detroit, MI: Wayne State University Press, 2011), 109.

25. This is also a classic feminist argument. See for example Leopoldina Fortunati, *The Arcane of Reproduction: Housework, Prostitution, Labor and Capital*, trans. Hilary Creek (New York: Autonomedia, 1995).

26. Miller, "Anal Rope," 120.

27. Miller, "Anal Rope," 120, 116, 114.

28. James Baldwin, "Letter from a Region in My Mind," *New Yorker*, November 17, 1962.

29. On "racial capitalism," see Cedric Robinson, *Black Marxism: The Making of the Black Radical Tradition* (Chapel Hill, NC and London: University of North Carolina Press, 1983). If "crime" is sometimes a displaced signifier for "revolution," it is tempting to read its formal alignment with "church" as Baldwin's way of symbolically preparing his reader for the interview with Elijah Muhammad and reflections on the Nation of Islam toward which his *New Yorker* essay builds.

30. Charles Wright, *The Wig*, intro. Ishmael Reed (San Francisco: Mercury House, 2003). Originally published in 1966 by Farrar, Strauss and Giroux. "SET IN AN AMERICA OF TOMORROW" appears as an epigraph in the Mercury House edition, but not in the 1966 version as reprinted in the omnibus *Absolutely Nothing to Get Alarmed About: The Complete Novels of Charles Wright* (New York: Harper Collins, 1993).

31. In one of several paratextual discrepancies between the 2003 Mercury House edition and the version included in the 1993 Harper Collins omnibus collection of Wright's prose, the 1993 edition gives *The Wig* a subtitle that the most recent version does not: *A Mirror Image*.

32. *Finally Got the News*, directed by Stewart Bird, Rene Lichhnan, and Peter Gessner (Detroit, MI: Black Star Productions, 1970). Cited in Jonathan Flatley, "Refreshments of Revolutionary Mood," in *Literary / Liberal Entanglements: Toward a Literary History for the Twenty-First Century*, ed. Corinne Harol and Mark Simpson (Toronto: University of Toronto Press, 2017), 103–147, 131.

33. Miller, "Anal Rope," 115, 116, 114.

34. See Stephen Sondheim, *Finishing the Hat: Collected Lyrics (1954–1981) with Attendant Comments, Principles, Heresies, Grudges, Whines and Anecdotes* (New York: Knopf, 2010), 71, 74.

35. Lighting, set, and costume designers are recognized as artists, while property masters are not.

36. Sondheim notes that Electra's parting shot, "Twinkle while you shake it," was originally intended to be "Shake it till you break it," but was changed when choreographer Jerome Robbins wanted to draw more attention to her rigging and the actor's physical interaction with it. See Sondheim, *Finishing the Hat*, 71.

37. Andrew Sofer, "Introduction: Rematerializing the Prop," in *The Stage Life of Props* (Ann Arbor: University of Michigan Press, 2003), 14.

38. As a basic device for maximizing the efficiency of an artistic performance *and* a symbolically overladen object endowed with "affective physicality," the prop's duality mirrors that of the gimmick. Especially when fetishized, props assert "pseudoautonomy," appearing to signify independently of the actor who manipulates them. But for the most part they are "actorial aids" or tools for "extending and physicalizing the body's operation on a material environment." Sofer, "Introduction," 15, 18, 17.

39. Boggs, "American Revolution," 110, 109.

40. Dalglish Chew, "Feeling Critical" (PhD diss., Stanford University, 2017), see especially "Feeling Normative: Problematization and the Desire for Intimate Attunement," 168–278.

41. Anna Kornbluh, *The Order of Forms: Realism, Formalism, and Social Space* (Chicago: University of Chicago Press, 2019), 15.

42. Kant, *Critique of Judgment*, 77. For in aesthetic experience, Cavell parses, "seeing feels like knowing," while "knowing functions like an organ of sense." As he elaborates: "Knowing by feeling" is not like "knowing by touching"; that is:

> it is not a case of providing the basis for a claim to know. But one could say that feeling functions as a touchstone: the mark left on the stone is out of the sight of others, but the result is one of knowledge, or has the form of knowledge—it is directed to an object, the object has been tested, the result is one of conviction. This seems to me to suggest why one is anxious to communicate the experience of such objects. It is not merely that I want to tell you how it is with me, how I feel, in order to find sympathy or to be left alone, or for any other of the reasons for which one reveals one's feelings. It's rather that I want to tell you something I've seen, or heard, or realized, or come to understand, for the reasons for which such things are communicated (because it is news, about a world we share, or could). Only I find that I can't tell you; and that makes it all the more urgent to tell you. I want to tell you because the knowledge, unshared, is a burden—not, perhaps, the way having a secret can be a burden, or being misunderstood; a little more like the way, perhaps, not being believed is a burden, or not being trusted. It *matters* that others know what I see, in a way it does not matter whether they know my tastes. It matters, there is a burden, because unless I can tell what I know, there is a suggestion (and to myself as well) that I do not know. But I do—what I see is that (pointing to the object). But for that to communicate, you have to see it too. Describing one's experience of art is itself a form of art; the burden of describing it is like the burden of producing it. Art is often praised because it brings men together. But it also separates them.

See Cavell, "Music Discomposed," in *Must We Mean What We Say? A Book of Essays* (Cambridge: Cambridge University Press, 1976), 180–212, 192–93.

43. "Communicable": Hannah Arendt, *Lectures on Kant's Political Philosophy*, ed. Ronald Beiner (Chicago: University of Chicago Press, 1992), 63; on judgment

as the "testing that arises from contact with other people's thinking," see 40–42. "Expects others to join in": Rodolphe Gasché, *Persuasion, Reflection, Judgment: Ancillae Vitae* (Bloomington and Indianapolis: Indiana University Press, 2017), 202.

44. Arendt, *Lectures*, 70–72.

45. Michel Chaouli, *Thinking with Kant's Critique of Judgment* (Cambridge, MA: Harvard University Press, 2017).

46. For a more detailed discussion of the German words, see Michel Chaouli, *Thinking with Kant's Critique*, 50.

47. Analyzing ordinary ways of communicating aesthetic feeling as if they were art-like artifacts (and artworks as forms in which specific aesthetic judgments are embedded) is one of the overarching aims of this book and also my previous study, *Our Aesthetic Categories: Zany, Cute, Interesting* (Cambridge, MA: Harvard University Press, 2012).

48. Chaouli, *Thinking with Kant's Critique*, 83.

49. See Ngai, *Our Aesthetic Categories*, 38–48, and the chapter, "Merely Interesting," 110–73.

50. Chaouli, *Thinking with Kant's Critique*, 51. Kant introduces the concept of "subreption" in his discussion of the sublime: "Thus the feeling of the sublime in nature is respect for our own vocation, which we show to an object in nature through a certain subreption (substitution of a respect for the object instead of for the idea of humanity in our subject), which as it were makes intuitable the superiority of the rational vocation of our cognitive faculty over the greatest faculty of sensibility" (*Critique of the Aesthetic Power of Judgment*, § 27, 141). In *Critique of Pure Reason*, transcendental "subreption" refers to a similarly misplaced objectification, the "ascription of objective reality to an idea that merely serves as a rule" and is an illusion specific to the faculty of reason that Kant repeatedly describes as "natural" and "unavoidable." Immanuel Kant, *Critique of Pure Reason*, trans. and ed. Paul Guyer and Allen W. Wood (Cambridge: Cambridge University Press, 1998), 521. Given our focus on the gimmick as a revealing experience of fraudulence, it seems worth adding that the concept of "subreption" derives from canon law and Scots law, where it refers to the "obtainment of a dispensation or gift by concealment of the truth." The closely related concept of "obreption" refers to "obtainment of a dispensation or gift by fraud"; both terms moreover derive from Latin words for theft: *subreptio* means "the act of stealing," and *obreptio*, "the act of stealing upon." Subreption can also be traced to the Latin verb *surripere*, meaning "to take away secretly," which is the base of the Anglicized term "surreptitious," a synonym of "stealthy." See *Merriam-Webster*, s.v. "subreption," accessed October 3, 2019, https://www.merriam-webster.com/dictionary/subreption.

51. Stanley Cavell, *Philosophy the Day after Tomorrow* (Cambridge, MA: Belknap Press of Harvard University Press, 2005), 151–91.

52. By "judgment of conviction," I mean a judgment whose meaning implies conviction, or where conviction inheres in the content as well as form or style of address. For even an aesthetic judgment as semantically equivocal as "interesting" implies conviction at the level of form, in its demand for agreement or claim to normativity.

53. Lauren Berlant comes first to mind; see *Cruel Optimism* (Durham, NC: Duke University Press, 2011). See also Pfaller, *On the Pleasure Principle in Culture*, 99–119.

54. John Francis Rider, *Perpetual Trouble Shooter's Manual* (New York: Radio Treatise Company, 1947).

55. Chew, "Feeling Critical," 258.

56. Although ongoing throughout *Philosophy the Day after Tomorrow*, Cavell's discussion of passionate utterances is most distilled in "Performative and Passionate Utterance," 155–91. See also "Something Out of the Ordinary," 7–27, esp. 16–19.

57. Cavell, *Philosophy*, 172, 180, 181, 185.

58. Cavell, *Philosophy*, 19.

59. "In Austin's case, refusing to recognize a challenge or an offer of marriage or a game of charades is the end of the matter; just as, in happy illocutionary acts, accepting the bet or bequest is the end of the matter. . . . But in the realm of the perlocutionary, refusal may become part of the performance." Cavell, *Philosophy*, 183.

60. Cavell, *Philosophy*, 19.

61. Clarence Major, *Emergency Exit* (New York: Fiction Collective 2, 1979).

62. Mark McGurl, *The Program Era: Postwar Fiction and the Rise of Creative Writing* (Cambridge, MA: Harvard University Press, 2009).

63. James Gindin, "'Gimmick' and Metaphor in the Novels of William Golding," in *Postwar British Fiction: New Accents and Attitudes* (Cambridge: Cambridge University Press, 1962), 196–206.

64. Kevin Davies, *The Golden Age of Paraphernalia* (Washington DC, Edge Books: 2006). "Google-ized": see Jordan Davis's reading of the same passage in "Happy Thoughts! The Poetry of Kevin Davies," *The Nation*, February 4, 2009.

65. Thomas Pynchon, *The Crying of Lot 49* (New York: Harper Collins, 1999), 13, 14.

66. On "crisis ordinariness," see Berlant, *Cruel Optimism*, 10.

67. Kant, *Critique of Judgment*, 131.

68. Kant, *Critique of Judgment*, 134.

69. Aesthetic experience *itself* ends up sitting in a strange place between aesthetic experience and cognition by the end of *Critique of the Power of Judgment*.

70. Kant, *Critique of Judgment*, 134.

71. Alberto Toscano and Jeff Kinkle, *Cartographies of the Absolute* (Alresford, Hants: Zero Books, 2015), 40, my emphasis.

72. While also, as Fred Moten points out, unconsciously or inadvertently invoking the black slave: a literally talking commodity contemporary with Marx's present. See Fred Moten, "Resistance of the Object: Aunt Hester's Scream," in *In the Break: The Aesthetics of the Black Radical Tradition* (Minnesota: University of Minnesota Press, 2003), 1–24, esp. 12–14.

73. Toscano and Kinkle, *Cartographies of the Absolute*, 25, my italics.

74. La Berge, *Wages Against Artwork*, 20.

75. La Berge, *Wages Against Artwork*, 20. If Foucault, in his own words, rejects "a traditional Marxist analysis [assuming that] the capitalist system is what

transforms labor into . . . surplus value," on grounds that "capitalism penetrates much more deeply into our existence" in a way that only the "microphysical" concept of "biopower" grasps, Gary Becker argues that subjects cease to be "laborers" for the same reason, becoming in contrast "investor[s]" or "entrepreneur[s]" of their own capabilities." See Michel Foucault, "Truth and Juridical Forms," in *Power: Essential Works of Michel Foucault*, vol. 3, *1954–1984*, ed. James D. Faubion, trans. Robert Hurley et al. (New York: New Press, 2000), 1–89, 86; on power as a "microphysics," see xxi. For Foucault's discussion of Becker's theories of "human capital," see *The Birth of Biopolitics: Lectures at the Collège de France, 1978–79*, ed. Michel Senellart, trans. Graham Burchell (New York: Palgrave Macmillan, 2008), 220–33, 233, 226. For more on Foucault's ambiguous relation to neoliberalism, including possible attraction to it as a "vantage point" from which to critique the statism of French socialism, see Michael C. Behrent, "Liberalism without Humanism: Michel Foucault and the Free-Market Creed, 1976–1979," in *Foucault and Neoliberalism*, ed. Daniel Zamora and Michael C. Behrent (Cambridge: Polity Press, 2016), 24–62, 44.

76. La Berge, *Wages Against Artwork*, 21.

77. "Formal subsumption," by contrast, designates the transformation of existing labor processes toward increasing absolute surplus-value production. This discussion takes place in "Results of the Immediate Process of Production," originally planned as Part Seven of the first volume of *Capital*, and included as an Appendix to the Penguin edition. See Marx, *Capital*, vol. 1, 1019–38.

78. Michael Hardt and Antonio Negri, *Empire* (Cambridge, MA: Harvard University Press, 2000). "Old competitive capitalism" and "social capitalism of the present age": Antonio Negri, *Marx Beyond Marx: Lessons on the Grundrisse* (South Hadley, MA: Bergen and Garvey Publishers, 1984), xv; cited in Caffentzis, "Immeasurable Value?," 99. For a lucid parsing of the difference between real and formal subsumption and its different uses by different theorists, see Clover, "Subsumption and Crisis."

79. "Negri and Hardt apparently believe that any claim to be able to measure a phenomenon legitimates it and the social form it is a constituent of: 'Even Marx's theory of value pays its dues to this metaphysical tradition: his theory of value is really a theory of the measure of value.' The curse attached to measurability deepens when Negri and Hardt link it with 'the transcendent' and then point out: 'When political transcendence is still claimed today [GC: perhaps a good example is when George W. Bush evokes God as the inspirer of the invasion of Iraq], it descends immediately into tyranny and barbarism' (Negri and Hardt 2000: 355). The implication being: if you insist on measuring value, then you are on the way to supporting genocidal 'shock and awe' displays!" (Caffentzis, "Immeasurable Value?," 103; insertion in square brackets is by Caffentzis).

80. La Berge, *Wages Against Artwork*, 24. It is also, to be sure, a legitimate response to awareness of the fact that most of the work done in the world today (by women, by workers in the Global South) is not "value-productive." That fact that "value" is increasingly an "anachronism," as Moishe Postone writes, does not however mean that it has ceased to be measured by abstract labor or socially necessary

labor time—or that it has ceased to be an abstract form of domination. See "Current Crisis," 46. Note also that post-Marxism's rejection of Marx's value theory is crucially different from its salutary opposition to "value" or to a world in which social mediation is facilitated primarily by labor. But value theory remains necessary for such opposition to be effective.

81. The periodizing version of "real subsumption" travels far in part because Hardt and Negri read it as grounded in two of Marx's own writings, specifically in the unpublished Part Seven of the first volume of *Capital*, "Results of the Immediate Process of Production" and the "Fragment on Machines" passage from the *Grundrisse* on the "moving contradiction" discussed above. See Caffentzis, "Immeasurable Value?," 89; Clover, "Subsumption and Crisis," 1569.

82. Not all biopolitical theory joins what some readers controversially regard as Foucault's later efforts to "elevate neoliberal self-description to an overall 'theory' and declare it . . . an alternative to ideology critique and ideology theory," as Jan Rehmann puts it. But much of it shares his explicit rejection of labor value theory and opposition of forms of measurement to "life." See Jan Rehmann, "The Unfulfilled Promises of the Late Foucault and Foucauldian 'Governmentality Studies,'" in *Foucault and Neoliberalism*, 134–58, 150. See also Anna Kornbluh, *The Order of Forms: Realism, Formalism, and Social Space* (Chicago: University of Chicago Press, 2019), 19.

83. Kornbluh thus points up the antiformalism of this huge swath of contemporary theory while La Berge highlights its jettisoning of labor—a parallel inviting us to linger on how these twin antagonisms to labor and form might be intimately connected.

84. See Gasché, *Idea of Form*.

85. For a more philosophically rigorous and systematic analysis of the relation between the two thinkers, see Michael Wayne, *Red Kant: Aesthetics, Marxism and the Third Critique* (London: Bloomsbury, 2014) and Kojin Karatini, *Transcritique: On Kant and Marx*, trans. Sabu Kohso (Cambridge, MA: MIT Press, 2005).

86. La Berge, *Wages Against Artwork*, 24.

87. Diane Elson, "The Value Theory of Labour," in *Value: The Representation of Labour in Capitalism*, ed. Diane Elson (London and Atlantic Highlands, NJ: CSE Books and Humanities Press, 1979), 115–80.

88. Karl Marx, *Capital*, vol. 3, 956.

89. My thoughts on the gimmick here (and the language I am using to formulate them) are heavily indebted to Patrick Murray's analysis of the importance of Hegel's dialectic of appearance and essence to Marx. See Patrick Murray, "The Necessity of Money: How Hegel Helped Marx Surpass Ricardo's Theory of Value," in *The Mismeasure of Wealth: Essays on Marx and Social Form* (Chicago: Haymarket Books, 2016), 249–76. See also Jairus Banaji, "From the Commodity to Capital: Hegel's Dialectic in Marx's Capital," in *Value: The Representation of Labour in Capitalism*, ed. Diane Elson (London and Atlantic Highlands, NJ: CME Books and Humanities Press, 1979), 14–45, esp. 17–23.

90. See Robert Paul Wolff, "David Ricardo and Natural Price," in *Understanding Marx: A Reconstruction and Critique of* Capital (Oxford: Basil Blackwell, 1985),

39–88. In noting the difference between labor indirectly and directly "bestowed" on commodities in production, Ricardo came close to understanding why capitalist commodities do not exchange in proportion to their values, or why values deviate from prices of production (Wolff, 43–46, 64, 72–73). However, as Wolff and others underscore, a full explanation would not come until Marx's account of it in the third volume of *Capital*. This account, which explains the deviation as a consequence of variations in the organic composition of capital across sectors and thus in the "*temporal pattern* of the bestowal of labor upon production" (analyzed in the discussions leading up to the expanded reproduction schemas of volume 2) is one of Marx's hard-won discoveries, supplying the groundwork for volume 3's analysis of the equalization of rates of profit and redistribution of surplus value through inter-capitalist competition (147). That analysis in turn supplies groundwork for Marx's deduction of the tendency of the rate of profit to fall, in tandem with his careful list of "countervailing tendencies."

91. Patrick Murray, "Money as Displaced Social Form," in *The Mismeasure of Wealth*, 277–93, 278. I am also drawing heavily here on Murray's reading of Marx's reliance on Hegelian essence logic, in "The Necessity of Money: How Hegel Helped Marx Surpass Ricardo's Theory of Value," 249–76, 258.

92. Elson, "Value Theory of Labour," 136.

93. Murray, "Necessity of Money," 258.

94. By the same logic, feminist Marxists argue, the reproduction of labor-power *must* appear as "the production of individuals and thus, as the creation of non-value" or a "'natural process' . . . that costs capital nothing"; indeed, its "non-capitalist appearance" as the opposite of commodity production is a "necessary condition for it to function for capitalism" (Fortunati, *Arcane of Reproduction*, 10). The capitalist relation between appearance and essence is thus intensified in the reproductive sphere, which "can *only* function as a center for the creation of surplus-value *insofar as* it appears as a center for the creation of non-value, the complementary opposite of the factory" (my emphasis, 126). For Fortunati, reproductive labor-power is value-productive simply by dint of being exchanged against a portion of variable capital (the wage) that it is deployed to valorize. The "substance" of this labor is therefore also social or abstract labor: "just as productive work within the process of commodity production requires productive work within the process of reproduction, so too labor is either abstract, social, and simple in *both* or in *neither*. There can be no reproduction work in which the product—labor-power—is realized in terms of abstract, social, simple labor that is not in its turn abstract, social, simple work itself" (105).

95. Caffentzis, "Immeasurable Value?," 103.

96. Kant, *Critique of Judgment*, 107, 216.

97. Caffentzis, "Immeasurable Value?," 94.

98. Profit appears produced by the capital advanced, yet is a "transformed form of surplus-value . . . in which its origin and the secret of its existence are veiled and obliterated." Interest, a subset of profit representing "mere ownership of capital" appears to "have no relationship to labour at all, merely a relationship between one capitalist and another." Rent appears to have its source in land, but like profit is a cut of total surplus value. These revenues seem generated by "factors of production"—

merchant capital, interest-bearing capital, ownership of land—which, in truth, simply enable different ruling-class groups to take home a specific share of that total. Marx, *Capital*, vol. 3, 506.

99. "This semblance is also natural and unavoidable for human reason, and . . . exists and remains, although after the resolution of the apparent conflict it no longer deceives." The speaker here is Kant on the antinomy of taste (§57, 216), yet the statement equally pertains to what Marx says about the naturalized categories of capital, which have the power to generate further appearances in turn. As Marx writes,

> In surplus-value, the relationship between capital and labour is laid bare. In the relationship between capital and profit, i.e. between capital and surplus-value as it appears on the one hand as an excess over the cost price of the commodity realized in the circulation process and on the other hand as an excess determined more precisely by its relationship to the total capital, *capital appears as a relation to itself*, a relationship in which it is distinguished, as an original sum of value, from another new value that it posits. It appears to consciousness as if capital creates this new value in the course of its movement through the production and circulation processes. But how this happens is now mystified, and appears to derive from hidden qualities that are inherent in capital itself. (*Capital*, vol. 3, 139, original italics)

100. I am drawing here on Murray, "Necessity of Money," 258.

101. Thomas Rymer, *A Short View of Tragedy: It's [sic] Original, Excellency, and Corruption, with Some Reflections on Shakespear [sic], and other Practitioners for the Stage* (Menston, England: Scolar Press, 1970).

102. Michel de Montaigne, "On Vain Cunning Devices," *The Complete Essays*, trans. M. A. Screech (New York, Penguin: 1993), 348–51, 348. The techniques "by which reputation is sought" point backwards and forwards: from "the ancient Greeks [who] would form poems of various shapes such as eggs, balls, wings, and axe-heads" to modernists like Apollinaire and Augusto de Campos. They also point to the arts of Montaigne's own time, as in the case of his contemporary "who spent his time counting the number of ways in which he could arrange the letters of the alphabet and found that they came to that incredible number we can find in Plutarch."

103. Montaigne, "On Vain Cunning Devices," 348. One wonders if the opening of this essay (which veers off quickly into another topic) was written to ward off criticisms of a similar character about Montaigne's own stylized experiments with the novel form of the essay.

104. "Ballyhoo": Cavell, *Philosophy*, 77. On "art religion," a term coined by Hegel, Adorno saliently writes:

> [Modern] art that laid claim to dignity would be pitilessly ideological. To act dignified it would have to put on airs, strike a pose, claim to be other than what it can be. It is precisely its seriousness that compels modern art to lay aside pretensions long since hopelessly compromised by the Wagnerian art religion. A solemn tone would condemn artworks to ridiculousness, just as would the gestures of grandeur and might. Certainly, without the subjective form-giving power art is not thinkable, yet this capacity has nothing to do with an artwork's achieving expressive strength

through its form. Even subjectively this strength is heavily compromised, for art partakes of weakness no less than of strength. In the artwork the unconditional surrender of dignity can become an organon of its strength.

Theodor Adorno, *Aesthetic Theory*, trans. Robert Hullot-Kentor (Minneapolis: University of Minnesota Press, 1997), 39.

105. On the problem of praising Shakespeare, and the enactment of its difficulty in *King Lear*, see Cavell, *Philosophy*, "The Interminable Shakespeare Text," 28–60. On the difficulty of praising African American dance in *Bandwagon*, see "Fred Astaire Asserts the Right to Praise," 61–82. For Cavell's reading of problematic praise in "The Birthplace," see "Henry James Returns to America and to Shakespeare," 83–110.

106. Henry James, "The Birthplace," in *Complete Stories: 1898–1910* (New York: Library of America, 1996), 441–95; 461.

107. Henry James, "The Turn of the Screw," in *Complete Stories: 1892–1898* (New York: Library of America, 1996), 635–740, 636. If James's paradigmatic gusher is female, her prototype in British literature is arguably *Sense and Sensibility*'s Marianne. Jane Austen was as fascinated by slightly cringeworthy performances of aesthetic evaluation as James.

108. Kant, *Critique of Judgment*, §42, 178–79. Chaouli's gloss of this moment is salient for us here:

> The . . . man of taste "turn[ing] to the beautiful of nature" in solitude, undaunted by the harm that may befall him from nature's perils—this scene of aesthetic bliss turns out not to be so solitary after all, but itself serves as an occasion for a second-order observation that issues in a second-order judgment. And who performs this observing and judging? None other than "we." "*We*," Kant writes, "would consider this choice of his with high respect [*Hochachtung*]." High respect leads us, naturally, to think of this feeling in moral terms, but we just saw how moral feeling can also appear in the guise of, indeed become indistinguishable from, the sublime. If we follow this opening, the strange possibility suggests itself that *beauty itself* can become the occasion for a sublime experience. While in the sections devoted to the sublime (§§23–29), the feeling of sublimity is summoned in the direct confrontation with excessive size or power (volcanoes, storms, war, the law), here it is beauty that seizes us. Stranger still, it is not beauty I feel, not my own pleasure in the wildflower or insect, but a beauty I witness another enjoying, beauty once removed. (92–93, Chaouli's italics)

Even more interestingly for us, this scene is followed by one in which Kant describes how we might take aesthetic displeasure in the act of observing this same "lover of the beautiful" falling for a gimmick: "artificial flowers" and "artfully carved birds" secretly placed at the scene (§42, 179).

109. Henry James, "The Beast in the Jungle," in *Complete Stories 1898–1910*, 496–541, 496.

110. Scott Thompson, "Philip Morris Promotional Gimmick Kills Two in Poland," *British Medical Journal* 7 (1998): 86–87.

111. Dael Orlandersmith, *The Gimmick and Other Plays* (New York: Dramatists Play Service, Inc., 2003), 16.

112. Boggs, "American Revolution," 109.

113. Miller, "Anal Rope," 114–15, my italics.

114. *Oxford English Dictionary*, 2nd ed. (1989), s.v. "gimmick," accessed October 6, 2019, https://www-oed-com.proxy.uchicago.edu/oed2/00094675.

115. Simon During, *Modern Enchantments: The Cultural Power of Secular Magic* (Cambridge, MA: Harvard University Press, 2002).

116. Daniel Tiffany, *My Silver Planet: A Secret History of Poetry and Kitsch* (Baltimore, MD: Johns Hopkins University Press, 2014), 31. Such disambiguation seems necessary given kitsch's conceptual importance or rapid uptake into intellectual writing since Clement Greenberg's 1939 *Partisan Review* article on "Avant-Garde and Kitsch." It also seems necessary given how easily "kitsch" becomes a giant drawer into which all nonbeautiful aesthetic categories can be stuffed, blocking them from more careful scrutiny. The assimilation of, say, the cute to a subspecies of kitsch is not exactly wrong but inadvertently reduces the former's complex meaning to the latter's overpowering problematic of "bad taste" and the populist/elitist debates that invariably attend it (whether one is "for" autonomous art or mass culture, whether the term can transcend its snobbery, and so on). On this reduction, which I would argue Tiffany transcends through his strikingly original approach to kitsch via poetry, see Sam Binkley, "Kitsch as a Repetitive System: A Problem for the Theory of Taste Hierarchy," *Journal of Material Culture* 5 (2000): 131–52.

117. For an interesting argument about kitsch in relation to ornament and time, see Adam Jasper Smith, *Marginal Aesthetics* (PhD diss., University of Sydney, 2009), 165–90. See also Celeste Olalquiaga, *The Artificial Kingdom: On the Kitsch Experience* (Minneapolis: University of Minnesota Press, 2002).

118. Tiffany, *My Silver Planet*, 224.

119. Vladimir Nabokov, *Nikolai Gogol* (New York: New Directions, 1961), 64; my italics. Nabokov spells the word differently on purpose.

120. As it turns out: we will encounter an early version of the Tingler in Chapter 1, in the form of Villiers de l'Isle-Adam's "The Glory Machine." And Hamburger Helper's disembodied white-gloved hand will make a cameo entrance in Chapter 6. On the recent redesign and remarketing of this labor and time-saving product (now aimed less at housewives than at single men), see "In Redesign, Hamburger Helper Drops the Hamburger," *Bloomberg News*, July 9, 2013.

121. Virginia Woolf, *The Diary of Virginia Woolf*, vol. 3, *1925–1930*, ed. Anne Olivier Bell and Andrew McNeillie (New York: Harcourt Brace Jovanovich, 1980). Cited in Shari Benstock, "Authorizing the Autobiographical," in *Feminisms: An Anthology of Literary Theory and Criticism*, ed. Robyn R. Warhol and Diane Price Herndl (New Brunswick, NJ: Rutgers University Press, 1991), 1138–54, 1444.

122. Adorno, *Aesthetic Theory*, 185–86.

123. Adorno, *Aesthetic Theory*, 210.

124. Adorno, *Aesthetic Theory*, 211. For instance: The "subcutaneous structure of Bach's most important structural works can only be brought out in performance by means of an orchestral palette that he did not yet have at his disposal; yet it would be ridiculous to wish for perspective in medieval paintings, which would rob them of their specific expression" (211).

125. As Cavell elaborates:

I said earlier that the periodicals about music which we were discussing were trying to do what only the art of music itself could do. But maybe it just is a fact about modern art that coming to care about it demands coming to care about the problems in producing it. . . . The problems of composition are no longer irrelevant to the audience of art when the solution to a compositional problem has become identical with the aesthetic result itself. In this situation, criticism stands, or could, or should stand, in an altered relation to the art it serves. At any time it is subordinate to that art, and expendable once the experience of an art or period or departure is established. But in the modern situation it seems inevitable, even, one might say, internal, to the experience of art.

Cavell, "Music Discomposed," 207.

126. "[The] possibility of fraudulence, and the experience of fraudulence, *is endemic* in the experience of contemporary music . . . its full impact, even its immediate relevance, depends upon a willingness to trust the object, knowing that the time spent with its difficulties may be betrayed." Cavell, "Music Discomposed," 188, my italics.

127. This is true even as Cavell explicitly defends the question of artistic intention over and against the object-oriented formalism of New Criticism (Cavell, "Music Discomposed," 181–82). But notice how the way in which he does so immediately pivots away from it toward the "philosophical" question of technique:

Nothing could be commoner among critics of art than to ask *why* the thing is as it is, and characteristically to put this question, for example, in the form "Why does Shakespeare follow the murder of Duncan with a scene which begins with the sound of knocking?", or "Why does Beethoven put in a bar of rest in the last line of the fourth Bagatelle (Op. 126)?" The best critic is the one who knows best where to ask this question, and how to get an answer; but surely he doesn't feel it necessary, or desirable even were it possible, to get in touch with the artist to find out the answer. The philosopher may, because of his theory, explain that such questions are misleadingly phrased, and that they really refer to the object itself, not to Shakespeare or Beethoven. But who is misled, and about what? An alternative procedure, and I think sounder, would be to accept the critic's question as perfectly appropriate—as, so to speak, a philosophical datum—and then to look for a philosophical explanation which can accommodate that fact. (182)

Roger Grant points out to me that the two questions Cavell asks at this juncture, as exemplary of the sorts of questions good criticism should ask, could be read as questions about the use of gimmicks specifically. What is the knocking in *Macbeth*, after all, but a device intended to produce a jump scare? And what is the sudden sharp moment of silence during the bagatelle's progressive fadeout but a "special effect," or rhetorical surprise for the sake of surprise? Both are obtrusive, almost comically timed devices. Cavell once again seems to be circling around the problem of the gimmick and its centrality to modern art and criticism without naming it as such.

128. Leigh Claire La Berge, *Scandals and Abstraction: Financial Fiction of the Long 1980s* (Oxford: Oxford University Press, 2014), 27.

129. Aaron Benanav and John Clegg (Endnotes), "Misery and Debt," in *Contemporary Marxist Theory*, ed. Andrew Pendakis, Jeff Diamanti, Nicholas Brown, Josh Robinson, and Imre Szeman (London: Bloomsbury, 2014), 585–608, 586.

130. This elegant way of describing things comes from Patrick Murray; it echoes the title of his book, *The Mismeasure of Wealth*.

1. Theory of the Gimmick

1. Ivor Brown, *Words in Our Time* (London: Jonathan Cape, 1958), 58–59.

2. David Flusfeder, introduction to Helen DeWitt, *Lightning Rods* (High Wycombe, Bucks, UK: And Other Stories, 2013), ix.

3. "The objects inside [Barnum's American Museum], and Barnum's activities outside, focused attention on their own structures and operations . . . and enabled—or at least invited—audiences and participants to learn how they worked. Adding an adjective to the label, one might term this an 'operational aesthetic,' an approach to experience that equated beauty with information and technique." See Neil Harris, *Humbug: The Art of P. T. Barnum* (Chicago: University of Chicago Press, 1973), 57; see also 61–89.

4. Tom Gunning, "Crazy Machines in the Garden of Forking Paths: Mischief Gags and the Origins of American Film Comedy," in *Classical Hollywood Comedy*, ed. Kristine Brunovska Karnick and Henry Jenkins (London: Routledge, 1994), 87–105, 100. For a discussion of these texts relating the operational aesthetic to the dialectic comedy of Buster Keaton, see Lisa Trahair, *The Comedy of Philosophy: Sense and Nonsense in Early Cinematic Slapstick* (Albany, NY: SUNY Press, 2007), 68–72.

5. Harris, *Humbug*, 57.

6. Gunning, "Crazy Machines," 98, 92. We should however keep in mind that capitalist processes involve complicated kinds of causality less easy to visualize than the unidirectional, mechanical relations of cause and effect showcased in these films.

7. See, for example, this moment from *Capital*: "[The] division of labour is an organization of production which has grown up naturally, a web which has been, and continues to be, woven behind the backs of the producers of commodities." Karl Marx, *Capital: A Critique of Political Economy*, vol. 1, trans. Ben Fowkes (New York: Penguin, 1976), 201.

8. This according to the *Oxford English Dictionary*'s surprisingly listless etymology (given such a charismatic word), which while citing another reference suggesting that *gimmick* might be an anagram of *magic*, finally lists its origin as "unknown." *Oxford English Dictionary*, 2nd ed. (1989), s.v. "gimmick," accessed October 6, 2019, https://www-oed-com.proxy.uchicago.edu/oed2/00094675.

9. Giorgio Agamben, *The Man without Content*, trans. Georgia Albert (Stanford, CA: Stanford University Press, 1999), 14.

10. Citing Frances Dunn, however, Rob Breton suggests that the "critique of the deus ex machina is as old as the device itself." As Breton writes, "Dunn translates the comic poet Antiphanes, who complains that the device 'covers up the incompetence of tragic poets': 'when they don't know what to say / and have completely

given up on a play/just like a finger they lift the machine/and the spectators are satisfied/There is none of this for us'" (Rob Breton, "Ghosts in the Machina: Plotting in Chartist and Working-Class Fiction," *Victorian Studies* 47 [Summer 2005]: 557–75, 557).

11. Thanks to Lauren Berlant for this particularly succinct formulation of my argument.

12. L. C. Knights, "Notes on Comedy," *Scrutiny* 1 (March 1933): 356–67, 356.

13. Marx, *Capital*, vol. 1, chap. 25, sec. 1, 762.

14. Second-wave feminists were quick to notice this about domestic appliances, in particular, countering the optimistic claims of treatises in home economics such as Christine Frederick's *Efficient Housekeeping or Household Engineering: Scientific Management in the Home* (Chicago: Home Economics Association, 1925). Betty Freidan, among others, noted that domestic appliances could indirectly lead to an increase of work for women in the household. See Betty Friedan, *The Feminine Mystique* (New York: W. W. Norton, 2013), 285–88. For a reading of the "device" comedies of American filmmaker Charley Bowers as a satire of Frederick and the Taylorization of housework, see William Solomon, "Slapstick Modernism: Charley Bowers and Industrial Modernity," *Modernist Cultures* 2 (Winter 2006): 170–88, 176.

15. George Oppen, "Of Being Numerous (1–22)," Poetry Foundation, accessed October 3, 2019, www.poetryfoundation.org/poems-and-poets/poems/detail/53223.

16. Maynard Frank Wolfe, *Rube Goldberg: Inventions* (New York: Simon and Schuster, 2000), 53.

17. I take the Rube Goldberg (like the novel *Lightning Rods*, discussed below) as a representation of the gimmick, meditating on how it operates through a mimetic enactment of its form and logic; whereas I take *A Connecticut Yankee in King Arthur's Court* (also discussed below) as a symptomatic instance of it, too. Thinking of the Rube Goldberg as a reflection on the *capitalist* gimmick, it is worth remembering something often forgotten by its contemporary revivalists, which is the frequency with which his contraptions combine their array of inanimate objects (dead labor) with living animals or small human beings (living labor). As Michael North notes, for all their "irrational complexity," the Rube Goldberg devices ultimately rely on simple "organically generated" sources of energy, usually involving animal pain: "A jack-in-box scares a porcupine, a dish of hot chili scalds a porcupine, or a French poodle jumps for joy at seeing a German dachshund collapse, and the works begin to turn." See Michael North, *Machine-Age Comedy* (New York: Oxford University Press, 2009), 90.

18. As we learn from Michael North, Goldberg's cartoons, like the mischief gag films analyzed by Gunning, were part of early twentieth-century "New Humor," a medium-crossing mode of popular comedy influenced by vaudeville, in which comedians began to "favor striking, intense effects over the slow development of comic plots" (North, *Machine-Age Comedy*, 136). To both comedians and audiences, the stage routines, drawings, poems, and stories associated with New Humor seemed "alarmingly more 'mechanical' than the humor of the past" (8). Moreover, as gimmicks came to predominate over traditional storytelling, "the mechanics of comedy [came] to be treated almost as a science"; as "a vocabulary of basic mechanical devices, insertable into any performance regardless of context, and calculated to pro-

duce an immediate and outward response" (8). New Humor was thus comedy redefined by techniques akin to those of industrial production, at roughly the same time as the use of *gimmick* expands beyond the world of entertainment, describing devices (and effects) used in contexts ranging from mechanical engineering to politics.

19. Whether perceived as a device working too little or too hard, our experience of the gimmick involves a judgment about the intensity of labor made in relation to an implicit norm (since any judgment of deficiency or excess presupposes a standard from which deviations occur). This norm is what Marx calls the historical standard of productivity, informed by (and informing) socially necessary labor time. The historical productivity of labor is thus the gimmick's nonaesthetic shadow. Both use labor as a measure of contemporaneity and vice-versa. The gimmick is for this reason unique among other aesthetic categories, which however reflective of capital's relations in other aspects, do not confront us with its social metrics in such a direct way.

Note, however, how the gimmick points to this standard of productivity while leaving it unspecified, as if implicitly recognized as historically moving. We might think of it as affectively encircling its very resistance to purely quantitative measure.

20. As we will see in more detail below, the gimmick highlights contemporaneity as a problem of time, mediated by capitalist sociality, and also as a problem of sociality, mediated by capitalist forms of time. Because both will prove central to the form of the gimmick, it must be underscored that the contemporary is not the same as the present but rather a temporal concept that "performatively projects a [fictional] unity onto the disjunctive relation between coeval times," as Peter Osborne puts it (Peter Osborne, "The Fiction of the Contemporary," in *Anywhere or Not at All: Philosophy of Contemporary Art* [London: Verso, 2013], 23). It is also an equally speculative thesis about mutual belonging or collectivity: "belonging to the same time, age, or period; living, existing, or occurring together in time" (*Oxford English Dictionary*, 3rd ed. [June 2019], s.v. "contemporary," accessed October 6, 2019, https://www-oed-com.proxy.uchicago.edu/view/Entry/40115). Thanks to Jonathan Flatley for reminding me of Gordon Gekko's iconic Motorola DynaTAC 8000X.

21. James Feibleman, "The Meaning of Comedy," in *Theories of Comedy*, ed. Paul Lauter (New York: Doubleday and Company, 1964), 464, 465.

22. See Alenka Zupančič, *The Odd One In: On Comedy* (Cambridge, MA: MIT Press, 2008), 178. Hereafter abbreviated as O.

23. Agnes Heller, *Immortal Comedy: The Comic Phenomenon in Art, Literature, and Life* (Lanham, MD: Lexington Books, 2005), 13.

24. Zupančič, *Odd One In*, 178; my emphasis. "Comic elements always react (to others) in the present, and although they usually give the impression that they . . . unavoidably react as they do, they also—since this always happens right before our eyes—display a radical contingency involved in this very necessity" (178).

25. Though of course the border between aesthetic culture and practical invention will always be porous in an age of what Hal Foster calls "total design." Hal Foster, *Design and Crime (and Other Diatribes)* (London: Verso, 2003), 18.

26. See, for just a few examples, John Francis Rider, *Perpetual Trouble Shooter's Manual* (New York, 1947), 86, 88, 89; *Successful Servicing* (New York, 1951), 2, 12, 31. Copious references to "GIMMICK" abound in issues of *Beechcraft Engineering*

Service, an aeronautics periodical (Wichita, KS, 1943, 1945). In *The Proceedings of the Annual Convention of the National Association of Building Owners and Managers* (Chicago, 1940), 126–28, "gimmick" and "Gimmick Manufacturing Company" are playfully used as names for a generic commodity and manufacturing company in a hypothetical business scenario (and also as explicit substitutes for "widget").

27. Though note how all these primarily descriptive terms for working parts still retain a certain cuteness, which is to say an aesthetic and therefore evaluative dimension.

28. Theodor Lipps, "The Comical and Related Things," trans. Lee Chadeayne, *Theories of Comedy*, 393–97, 394.

29. Sigmund Freud, *Jokes and Their Relation to the Unconscious*, trans. and ed. James Strachey (New York: W. W. Norton, 1989), 242.

30. Helen DeWitt, *Lightning Rods* (New York: New Directions, 2011), 223; hereafter abbreviated *LR*.

31. *Oxford English Dictionary*, 2nd ed. (1989), s.v. "gimmick," accessed October 6, 2019, https://www-oed-com.proxy.uchicago.edu/oed2/00094675; my emphasis.

32. See Villiers de l'Isle-Adam, "The Glory Machine," in *Cruel Tales*, trans. Robert Baldick (Oxford: Oxford University Press, 1985), 48–63.

33. On the preindustrial imbrication of marketplace and the theater, see Jean-Christophe Agnew, *Worlds Apart: The Market and the Theater in Anglo-American Thought, 1550–1750* (Cambridge: Cambridge University Press, 1988).

34. Anticipating Villiers's return to the same device in *Tomorrow's Eve*, the Machine further comes equipped with "twenty Andreides, straight from the workshops of Edison," which we are told can be dispersed among live members of the audience to "lend tone" to the aesthetic reception being produced and enjoyed in simultaneity with the performance ("The Glory Machine," 65).

35. In an interesting parallel to Zupančič's claim about the centrality of plasticized abstraction to comedy, Pfaller argues that comedy is the emergence of a "cogent truth" from "something transparently fictive"; it is "based on a deception which fools no one while at the same time the performers come under its spell" (Pfaller, "Introduction," in *Schluss mit der Komödie! Stop That Comedy! On the Subtle Hegemony of the Tragic in Our Culture*, ed. Pfaller [Wien: Sonderzahl, 2005], 170–71). In a similar vein, Mladen Dolar singles out "find[ing] the Real in the very trade of appearances" as the one of the genre's defining features (Dolar, "Comedy and Its Double," in Pfaller, *Schluss mit der Komödie!*, 182). This emergence of the real thing from its simulation in "The Glory Machine" recurs in *Tomorrow's Eve* when Lord Ewald truly falls in love with Edison's "stupefying machine for manufacturing the Ideal" (Hadaly the female Android) (Villers, *Tomorrow's Eve*, 194).

36. Viktor Shklovsky, "The Novel as Parody," in *Theory of Prose*, trans. Benjamin Sher (Normal, IL: Dalkey Archive Press, 1991), 147–70, 149. At times it is interestingly hard to separate Shklovsky's "device," the thing, from the action of "exposing the device," in part because the device seems to perform this action to itself. This reflexivity throws in even greater relief the curious relationship between Shklovsky's device and the capitalist gimmick, which performs a similar conflation of what it is/does with its own laying bare of what it is/does. I am grateful to Louis

Cabri for initially drawing my attention to this comparison. On the relation between Shklovsky's *ostranenie* and Brecht's *Verfremdung*, see Stanley Mitchell, "From Shklovsky to Brecht: Some Preliminary Remarks towards a History of the Politicisation of Russian Formalism," *Screen* 15 (1974): 74–81.

37. The key difference being also that Shklovsky's "art-as-device" and "exposing the device" (synonymous roughly in his writing with *ostranenie*) are meant to *slow down* aesthetic perception. The goal is to make aesthetic perception less instantaneous, to narrativize or turn it into a "step-by-step structure" ("Novel as Parody," 22), hence countering "automatization" or the "algebraic method of thinking" by which "objects are grasped spatially, in the blink of an eye." This is why the main example of a "device" across Shklovsky's essays is what he calls "the device of deceleration" (5). The labor-saving gimmick, on the other hand, is almost always a way of speeding things up, even when it participates in the operational aesthetic of calling attention to the process by which it achieves its effect and of course especially when it takes the form of the black box. One might say that while the comedic gimmick is an (equivocal) way of reducing energy expenditure, Shklovsky's "device" is a way of increasing it.

38. E. L. Doctorow, *Ragtime* (New York: Plume, 1996), 109.

39. Thanks to Joshua Clover for this observation.

40. Fredric Jameson, "The Aesthetics of Singularity," *New Left Review* 92 (2015): 101–32, 113.

41. Gunning, "Crazy Machines," 96.

42. In various ways and for differing reasons. See, for a few key examples, Jane Elliott, "The Problem of Static Time: Totalization, the End of History, and the End of the 1960s," in *Popular Feminist Fiction as American Allegory* (New York: Palgrave Macmillan, 2008), 21–46; Gopal Balakrishnan, "The Stationary State," *New Left Review* 59 (September–October 2009): 5–26; Jasper Bernes, "Logistics, Counterlogistics, and the Communist Prospect," *Endnotes* 3 (September 2013): endnotes.org .uk/issues/3; Hans Gumbrecht, *Our Broad Present: Time and Contemporary Culture* (New York: Columbia University Press, 2014); Paul Virilio, *The Futurism of the Instant: Stop-Eject*, trans. Julie Rose (London: Polity, 2010); Harry Harootunian, "Remembering the Historical Present," *Critical Inquiry* 33 (Spring 2007): 471–94; Lauren Berlant, *Cruel Optimism* (Durham, NC: Duke University Press, 2011); Eric Cazdyn, *The Already Dead: The New Time of Politics, Culture, and Illness* (Durham, NC: Duke University Press, 2012); and Moishe Postone, *Time, Labor, and Social Domination: A Reinterpretation of Marx's Critical Theory* (Cambridge: Cambridge University Press, 1996).

43. Jameson, "Aesthetics of Singularity," 105. Jameson is here recalling a point made in "The End of Temporality," *Critical Inquiry* 29 (Summer 2003): 695–718.

44. Mark Twain, *A Connecticut Yankee in King Arthur's Court: A Norton Critical Edition*, ed. Allison R. Ensor (New York: W. W. Norton, 1982), 49; my emphasis.

45. Hence the gimmick provokes impatience both for its overfamiliarity (as Brown complains, "not long ago it became impossible to read a notice of a film or play in which the word gimmick did not appear") but also for its exaggerated claims to novelty (even the word is a trendy "vogue-word," Brown also points out) (*Words in Our Time*, 58).

46. Postone, *Time, Labor, and Social Domination*, 300.

47. A key or especially tricky point to grasp here being that capitalist society generates not only a distinctive kind of abstract time but also a distinctive form of concrete time: "The dialectic of capitalist development is a dialectic of two kinds of time constituted in capitalist society and therefore cannot be understood simply in terms of the supersession by abstract time of all kinds of concrete time." Postone, *Time, Labor, and Social Domination*, 216.

48. Postone, *Time, Labor, and Social Domination*, 300.

49. On the "strange identification" of Twain with the "Paige contraption," see James M. Cox, "The Machinery of Self Preservation," *Yale Review* 50 (1960): 89–102; rpt. in Twain, *Connecticut Yankee*, 398.

50. Cushing Strout, "Crisis in Camelot: Mark Twain and the Idea of Progress," *Sewanee Review* 129 (Spring 2012): 336–40, 336. On *Connecticut Yankee* as a "one joke" novel, Strout refers to Adam Gopnik, "The Man in the White Suit: Why the Mark Twain Industry Keeps Growing," *New Yorker*, November 29, 2010. Gopnik is in turn citing Van Wyck Brooks, who "became famous in the nineteen-twenties with a book, 'The Ordeal of Mark Twain,' arguing that Twain, despite outsized gifts, had produced a stunted body of work: a great novel (or at least two-thirds of one) in 'Huck Finn,' one good book for boys in 'Tom Sawyer,' a couple of chapters of memoir in 'Life on the Mississippi,' and not much else worth keeping. There was 'Innocents Abroad' and 'Roughing It,' baggy and relentlessly facetious, and a couple of one-joke productions that are notable mostly for their titles, 'A Connecticut Yankee in King Arthur's Court' and 'The Prince and the Pauper,' and whose sturdy high concepts—New England inventor time-travels to Camelot; rich and poor look-alikes change identities—can't save their stodgy execution" (Gopnik, "Man in the White Suit," 336–40, 336).

51. Anonymous review, *Boston Literary World*, February 15, 1890, 52–53; rpt. in *Connecticut Yankee*, 334.

52. Anonymous review, *London Daily Telegraph*, January 13, 1890; rpt. in Twain, *Connecticut Yankee*, 328, 398. As Louis Budd sums it up, *Connecticut Yankee* seemed to say "almost nothing new as it leaped back thirteen centuries to look forward"; "the very gimmick of bringing the past and present face to face [had become] common property" (Louis Budd, *Mark Twain, Social Philosopher* [Bloomington: Indiana University Press, 1962], 141).

53. "Effects" is Morgan's own term for his spectacles. Twain, *Connecticut Yankee*, 124, 219.

54. Cox, "Machinery of Self Preservation," 401. "As Morgan assumes power in the Arthurian world the fantasy begins to rout the criticism and progression degenerates into mere sequence" (392). At the same time, Paul Lauter suggests that there might be something fundamentally comedic (and thus, with regard to Twain's novel, successful) about "mere sequence" or serial plots: "Critics following his lead . . . assumed that Aristotelian strictures on the need for tragic plots to have an organic structure necessarily applied, *and in the same way*, to comedy. But if, as Schlegel argues, the comic world is not one of tragic necessity, a looser, more 'episodic' plot might be more proper to comedy. And as a matter of fact the best comic novels have often been picaresque—as many recent works, such as Bellow's *Augie March*,

Heller's *Catch-22*, and Pynchon's *V.*, remind us. But critics have not yet had much to say about the comic character of the plotting in the novel" (Lauter, *Theories of Comedy*, xxii).

55. A "fairly mechanical proliferation of burlesque 'contrasts'" (James D. Williams, "Revision and Intention in Mark Twain's *A Connecticut Yankee*," in Twain, *Connecticut Yankee*, 365); "stock devices" and "clichés of travelogue nostalgia" that become "mere parts of the machinery of this mechanical novel" (Cox, "Machinery of Self Preservation," 393, 394, 398); a protagonist "more mechanical than any of the gadgets in which he specializes, [who] grinds laboriously through his 'acts,' his only means of attracting attention being to run faster and faster, to do bigger and bigger things, until the mechanism of his character flies apart" (Cox, "Machinery of Self Preservation," 392).

56. Twain, *Connecticut Yankee*, 8.

57. Henry Nash Smith, *Mark Twain's Fable of Progress: Political and Economic Ideas in "A Connecticut Yankee"* (New Brunswick, NJ: Rutgers University Press, 1964), 86; excerpted in Twain, *Connecticut Yankee*, 413. All in all, after "emphasizing at the outset the protagonist's ability to build or invent all kinds of machinery, Mark Twain seems strangely reluctant to make use of this power in the story" (Twain, *Connecticut Yankee*, 413). It is as if the novel's operational aesthetic, or will to one, runs out of steam in tandem with Twain's rapidly crashing hopes for the Paige. Indeed, as James D. Williams notes, Twain originally planned for The Boss to do even more than makes its way into the final version of *Connecticut Yankee*, including introduce "steam engines, fire companies, aluminum, vaccination, and lightning rods" ("Revision and Intention," 365). The fact that these plans were abandoned well into the writing of the novel (a good fourteen chapters in), suggests that Twain eventually felt something about the initial promise of the labor-saving capitalist machine—the novel's shtick, its foundation—could no longer be sustained.

58. It is worth noting that the questions that the gimmick's form introduces (overworking or underperforming? outmoded or too advanced? cheap or overvalued?) mirror, on an aesthetic plane, the questions an economist might ask when wanting to ascertain whether a capitalist machine or technique is value-productive.

59. Michael Wayne, *Red Kant: Aesthetics, Marxism and the Third Critique* (London: Bloomsbury, 2014), 23.

60. Daniel Spaulding and Nicole Demby, "Art, Value, and the Freedom Fetish," *Metamute*, May 28 2015, www.metamute.org/editorial/articles/art-value-and -freedom-fetish-0.

61. Other dictionaries suggest a different but equally trick-based etymology in "magic," of which "gimmick" is an anagram. Even the word "gimmick" is thus a verbal trick of sorts.

62. The cheap and the kitschy do not align as perfectly. Sometimes kitsch looks and really is expensive, and the expensive look or cost of an object can often intensify its kitsch value, as in the case of a pink marbled mansion or a bejeweled candelabra.

63. We could say that cheapness entails and expresses a nonquantifiable relation to the realm of the quantitative that becomes affectively and sensuously underscored in the aesthetic perception of the gimmick.

64. Immanuel Kant, *Critique of Judgment*, trans. James Creed Meredith and Nicholas Walker (Oxford: Oxford University Press, 2007), 161.

65. William Hazlitt, "Lecture I—Introductory: On Wit and Humor," in *Lectures on the Comic Writers, &c. of Great Britain* (London: Taylor and Hessey, 1819), 1.

66. Elder Olson, *The Theory of Comedy* (Bloomington: Indiana University Press, 1968), 25.

67. *LR*, 9. The first stage involves a machine designed for the stall in men's bathrooms for users with disabilities, mandatory in the United States only since the 1990 passage of the American Disabilities Act. Joe's ability to extract profits from his "big idea" thus hinges on his ability to take advantage of "free" or commonly owned resources: public infrastructure and an existing culture of bathroom segregation by gender. There is much more to say than I can here about the way DeWitt's personification of capital finds ingenious way after way to capitalize on cultural and noneconomic factors, much of it based on Civil Rights legislation protecting the rights of women and minorities in the workplace. There is also much more to say about the novel's use of disability and alignment of sex with disability in particular.

68. Litigation, as the novel makes clear, is the only real counterpower, significantly noneconomic, that women have against "aggro" in the male-dominated world that its story depicts; comically, the main Lightning Rods in the story, Lucille and Renée, all go on to have spectacular second careers as lawyers and judges after their retirement from Joe's firm (*LR*, 27). Threats to the job performance of women from either sexual desire or harassment, meanwhile, do not factor into Joe's scheme as significant enough to warrant countering (or inventing a profitable way of countering). Gay men are similarly excluded, on Joe's premise that their sexual urges are always completely fulfilled and thus under control in the workplace; see *LR*, 26.

69. The phrase "liability model of work" is from Erin Hatton, *The Temp Economy: From Kelly Girls to Permatemps in Postwar America* (Philadelphia, PA: Temple University Press, 2011), 4–18.

70. This, in turn, enables Joe to avoid the costly legal repercussions of violating the Equal Employment Opportunities Act—the real purpose of the PVC device. Prior to its adaptation, Lightning Rods exclusively hired white women, on the grounds that only their anonymity could be secured. See *LR*, 178–185.

71. As Erin Hatton notes, "in-house outsourcing" presupposes a workforce already permanently composed of temporary labor. If one must hire temps in any case, why not hire one's own? In tandem with practices like "payrolling," firing long-term employees and asking them to join temp agencies in order to be rehired to perform the same job (which frees corporations from paying unemployment taxes, worker's compensation, pensions, and benefits); and the outsourcing of entire departments of large businesses such as mailrooms, accounting, and customer service, "in-house outsourcing" has long become normal (Hatton, *Temp Economy*, 110, 74).

72. Hatton, *Temp Economy*, 59–60.

73. Benjamin Franklin's Benjamin Franklin, Villiers's Thomas Edison, Twain's Hank Morgan, Ralph Ellison's "thinker-tinkerer" Invisible, E. L. Doctorow's Henry Ford, and Samantha Hunt's Nikola Tesla, among others.

74. Another De-Witty touch: the unifunctional personnel all have monosyllabic names (Joe, Steve, Ed, Mike, Pete, Al, Ray) while the bifunctional ones have bisyllabic ones (Elaine, Lucille, Renée, Louise).

75. David Kurnick makes a similar argument about style and character in the novels of Henry James. See David Kurnick, "What Does Jamesian Style Want?," *The Henry James Review* 28 (Fall 2007): 213–22, 215.

76. Since comedy is about timing, it is worth noting how the reader's progressive understanding of the surprisingly ordinary "behind" to Joe's labor-saving gimmick develops in synch with the progressive narration of its normalization. It is synched also to our dawning realization about the sort of time the novel represents. What at first seems to be a story about the future is a history of the present, although not one that can tracked to a specific decade like the 1950s (as implied by references to Joe's first job selling vacuum cleaners door to door) or the early 1990s (as implied by references to accessible bathrooms, "PC feminists," and the first appearance of blue M&Ms). Rather, in a way that explains the novel's historical indefiniteness, it seems more like a story of the "perpetual present" Postone associates with the "apparently eternal necessity" of the production of value. If the capitalist development of productivity changes the concrete presupposition of the social labor hour but in a way that leaves the amount of value produced per unit time constant—if it therefore "reconstitutes, rather than supersedes, the form of necessity associated with that abstract temporal unit" such that "the movement of time is continually converted into present time"—DeWitt's gimmick-driven comedy of capitalist procedure enacts a similar conversion.

2. Transparency and Magic in the Gimmick as Technique

1. Viktor Shklovsky, "Art as Technique," in *Russian Formalist Criticism: Four Essays*, ed. Lee T. Lemon and Marion J. Reis (Lincoln: University of Nebraska Press, 1965), 3–24, 12. I am indebted to Louis Cabri for this insight about the gimmick's reversal of Shklovsky.

2. Shklovsky, "Art as Technique," 11, 12, 12.

3. Michael Holquist and Ilya Kliger, "Minding the Gap: Toward a Historical Poetics of Estrangement," *Poetics Today* 26, no. 4 (Winter 2005): 613–36.

4. Simon During, *Modern Enchantments: The Cultural Power of Secular Magic* (Cambridge, MA: Harvard University Press, 2002), 67–68.

5. Theodor Adorno, *Aesthetic Theory*, trans. Robert Hullot-Kentor (Minneapolis: University of Minnesota Press, 1998), 121.

6. Adorno, *Aesthetic Theory*, 119.

7. Adorno, *Aesthetic Theory*, 54.

8. I. A. Richards, *Principles of Literary Criticism* (London: Routledge, 2004), 157. Cited in Jonathan Kramnick and Anahid Nersessian, "Form and Explanation." *Critical Inquiry* 43 (Spring 2017): 650–69, 665.

9. Nelson Goodman, *Languages of Art: An Approach to a Theory of Symbols* (Indianapolis: Hackett, 1976), 104–105. And is not only true of information or

knowledge concretely possessed; the very possibility of attaining that knowledge in the future affects the "character of my present looking" (104).

10. Adorno, *Aesthetic Theory*, 214.

11. First published in *Graham's American Monthly Magazine of Literature and Art*, April 1846. https://ebooks.adelaide.edu.au/p/poe/edgar_allan/philosophy-of -composition.

12. Daniel Tiffany, *My Silver Planet: A Secret History of Poetry and Kitsch* (Baltimore, MD: John Hopkins University Press, 2014), 31.

13. Neil Harris, *Humbug: The Art of P. T. Barnum* (Chicago: University of Chicago Press, 1973), 77.

14. Immanuel Kant, *Critique of the Power of Judgment*, trans. Paul Guyer and Eric Matthews (Cambridge: University of Cambridge Press, 2000), see especially section VI of the introduction, 73–75, 74:

> To be sure, we no longer detect any noticeable pleasure in the comprehensibility of nature and the unity of its division into genera and species, by means of which alone empirical concepts are possible through which we cognize it in its particular laws; but it must certainly have been there in its time, and only because the most common experience would not be possible without it has it gradually become mixed up with mere cognition and is no longer especially noticed. It thus requires study to make us attentive to the purposiveness of nature for our understanding in our judging of it, where possible bringing heterogeneous laws of nature under higher though always still empirical ones, so that if we succeed in this accord of such laws for our faculty of cognition, which we regard as merely contingent, pleasure will be felt.

Thanks to Mark Seltzer for reminding me of this curious passage.

The idea that the pleasure of aesthetic experience is in fact that of "cognition in general" (*Erkenntnis überhaupt*), or more precisely, indexes the "subjective state that prepares the ground for all this cognizing" (as Chaouli puts it) is first introduced in §9, 102–104. Michel Chaouli, *Thinking with Kant's Critique of Judgment* (Cambridge, MA: Harvard University Press, 2017), 59.

15. Jeffrey Weiss, *The Popular Culture of Modern Art: Picasso, Duchamp, and Avant-Gardism* (New Haven, CT: Yale University Press, 1994), 109.

16. Weiss, *Popular Culture*, 114.

17. Weiss, *Popular Culture*, 116–17, 110; 112. On the idea that the aesthetic disorientation Weiss identifies in his discussion of *blague* is related to anxiety about deskilling, see John Roberts, *The Intangibilities of Form: Skill and Deskilling in Art after the Readymade* (London: Verso, 2007), 71–72, 75.

18. Weiss, *Popular Culture*, 117.

19. Cited in Weiss, *Popular Culture*, 117.

20. Weiss, *Popular Culture*, 125.

21. While "Weiss sees *Fountain* first and foremost as a mockery of Cubist labour (all that huffing and puffing for meaning), in the form of the *mystifacateur* deadpan gesture," Roberts rightly notes that the "general absence of any systematic understanding of the reflection on labour in Duchamp's work leaves the concept of *blague* as a mere joke, as bereft from the wider and deeper changes the 'hoax' mediates."

He continues: "As I have argued the unassisted readymades are congeries of simple labour and complex labour, artistic labour and productive labour, alienated labour and non-alienated labour. As such they are not 'mere functional' things, content with their own deadpan implacability. On the contrary they are sites of conflict, meaning that their irony, humour and *blague* are weakened, and even mystified, when divorced from the broader context of labour which underpins the Duchampian culture of anxiety" (*Intangibilities of Form*, 72).

22. T. J. Clark, "All the Things I Said about Duchamp," in *The Duchamp Effect: Essays, Interviews, Round Table*, ed. Martha Buskirk and Mignon Nixon (Cambridge, MA: MIT Press, 1996), 225–7. For a discussion of Clark's intervention, see David Hopkins, "The Politics of Equivocation: Sherrie Levine, Duchamp's 'Compensation Portrait', and Surrealism in the USA 1942–45," *Oxford Art Journal* 26, no. 1 (2003): 47–68, 50.

23. Stanley Cavell, "Music Discomposed," in *Must We Mean What We Say? A Book of Essays, Updated Edition* (Cambridge: Cambridge University Press, 1976), 180–212.

24. A question latently raised by this essay is that of what "criticism" finally is. Is it explanation? Information? Evaluation? Cavell returns to this question more frontally (and to its surprising status *as* a question) at the beginning of *Philosophy the Day after Tomorrow* (Cambridge, MA: Harvard University Press, 2005). His answer there is satisfyingly direct: criticism is conceptual justification for feeling-based judgments: "a work of determining, as it were after the fact, the grounds of (the concepts shaping) pleasure and value in the working of the object" (67). For more on this way of conceiving the relation between criticism and aesthetics, see Ngai, "Merely Interesting," in *Our Aesthetic Categories* (Cambridge: MA, Harvard University Press, 2012), esp. 110–12.

25. Cavell:

I do not see how anyone who has experienced modern art can have avoided such experiences, and not just in the case of music. Is Pop Art art? Are canvases with a few stripes or chevrons on them art? Are the novels of Raymond Roussel or Alain Robbe-Grillet? Are art movies? A familiar answer is that time will tell. But my question is: *What* will time tell? That certain departures in art-like pursuits have become established (among certain audiences, in textbooks, on walls, in college courses); that someone is treating them with the respect due, we feel, to art; that one no longer has the right to question their status? But in waiting for time to tell that, we miss what the present tells—that the dangers of fraudulence, and of trust, are essential to the experience of art. If anything in this paper should count as a thesis, that is my thesis. And it is meant quite generally.

Cavell, "Music Discomposed," 188–89.

26. "In a Classical Age, criticism is confident enough to prescribe to its art without moralism and its consequent bad conscience. In a Romantic Age, art is exuberant enough to escape criticism without the loss of conscience—appealing, as it were, to its public directly. In a Modern Age, both that confidence and that appeal are gone, and are to be reestablished, if at all, together, and in confusion" (Cavell, "Music Discomposed," 208).

27. Roberts, *Intangibilities of Form*, 74.

28. Robert Pfaller, *On the Pleasure Principle in Culture: Illusions without Owners*, trans. Lisa Rosenblatt, with Charlotte Eckler and Camilla Nielsen (London: Verso, 2014).

29. Jan Mieszkowski, *Labors of Imagination: Aesthetics and Political Economy from Kant to Althusser* (New York: Fordham University Press, 2006), 19.

30. On the aesthetic concept as a subtle mix of description and evaluation, see Gérard Genette, *The Aesthetic Relation*, trans. G. M. Goshgarian (Ithaca, NY: Cornell University Press, 1999), 93.

31. Simon Critchley, *On Humour* (New York: Routledge, 2002), 18–19.

32. On the risk of rebuff, see Stanley Cavell, *Philosophy the Day after Tomorrow*, 26.

33. Critchley thus notes a special link between aesthetic judgments and humor. Both call attention to forms of sociality which are normally recessed but that we rediscover as a priori, logically presupposed by our compulsion to make jokes in the first place. Aesthetic judgments and jokes "recall us to what is shared in our everyday practices," and often by first revealing what is not (*On Humour*, 18). Making the same point, Elise Kramer ratchets the argument up a level: "In order to find something funny, one must be able to imagine someone who would not find it funny. [Disagreement is] a necessary component of humor: those who find a joke funny and those who do not are mutually constitutive groups that cannot exist without each other." Elise Kramer, "The Playful Is Political: The Metapragmatics of Internet Rape-Joke Arguments," *Language in Society* 40, no. 2 (2011): 137–68, 163.

34. Pfaller, *On the Pleasure Principle*, 17.

35. Pfaller, *On the Pleasure Principle*, 33. "Stupid plot serving as pretext for the actors to begin copulation" is from Slavoj Žižek, *Looking Awry: An Introduction to Jacques Lacan through Popular Culture* (Cambridge, MA: MIT Press, 1992), 111. Cited in Pfaller, *On the Pleasure Principle*, 160.

36. Pfaller, *On the Pleasure Principle*, 100–103. For another "strong" account of ambivalence, see Lauren Berlant, *Cruel Optimism* (Durham, NC: Duke University Press, 2011), esp. chapter 4, "Two Girls, Fat and Thin," 121–60.

37. Pfaller, *On the Pleasure Principle*, 113–14.

38. "Consumers who want"; Pfaller, *On the Pleasure Principle*, 20.

39. Pfaller, *On the Pleasure Principle*, 26. In keeping with During's insight, the *Oxford English Dictionary* offers this entry: "1936: *Words* Nov. 12/2 The word gimac means 'a gadget'. It is an anagram of the word magic, and is used by magicians the same way as others use the word 'thing-a-ma-bob'." See *Oxford English Dictionary*, 2nd ed. (1989), s.v. "gimmick," accessed October 8, 2019, https://www-oed-com.proxy.uchicago.edu/oed2/00094675.

40. During, *Modern Enchantments*, 62.

41. Pfaller, *On the Pleasure Principle*, 69. Paul Veyne, *Did the Greeks Believe Their Own Myths? An Essay on the Constitutive Imagination*, trans. Paula Wissing (Chicago: University of Chicago Press, 1988). Cited in Pfaller, 6. On the distinction between cultures of belief and faith, see Pfaller, 35–72.

42. Alfred Gell, "The Technology of Enchantment and the Enchantment of Technology," in *Anthropology, Art and Aesthetics*, ed. Jeremy Coote and Anthony Shelton (Oxford: Clarendon Press, 1992), 40–63.

43. Roland Barthes, *The Pleasure of the Text*, trans. Richard Miller (New York: Farrar, Strauss and Giroux, 1975), 9–10.

44. Gell, "Technology of Enchantment," 46.

45. A case in which it famously does is the technological or paranoid sublime represented so frequently in the postwar American novel.

46. The idea of a link between aesthetic power and technical complexity (i.e., opacity combined with transparency) is more elaborately developed in Gell's posthumously published *Art and Agency: An Anthropological Theory* (Oxford: Clarendon Press, 1998), in which he argues that artworks "captivate" or exert agency over viewers by prompting them to make inferences about "social agency" in turn. See especially chapter 5, "The Origination of the Index," 66–72.

47. Gell, "Technology of Enchantment," 48.

3. Readymade Ideas

1. *Oxford English Dictionary*, 2nd ed. (1989), s.v. "gimmick," accessed October 8, 2019, https://www-oed-com.proxy.uchicago.edu/oed2/00094675.

2. If also, in some cases, reskilled. This dynamic—the deskilling and reskilling of artistic labor, in a contiguous if often asymmetrical relation to productive labor—is the central focus of key works by John Roberts and Jasper Bernes. See John Roberts, *The Intangibilities of Form: Skill and Deskilling in Art after the Readymade* (London: Verso, 2007); Jasper Bernes, *The Work of Art in the Age of Deindustrialization* (Stanford, CA: Stanford University Press, 2017).

3. Roberts, *Intangibilities of Form*, 223. The popularity of postmodern "death of the author" discourse, Roberts suggests, kept critical attention so fixed on the former interpretation that it has been difficult to see the latter.

4. Roberts, *Intangibilities of Form*, 223.

5. "Transportable intellectual unit": Nathan Hensley, "Allegories of the Contemporary," *Novel: A Forum on Fiction* 45, no. 2 (2012): 276–300, 287. "*Déjà-là*": "Faced with a demand for justification, capitalism mobilizes already existing things (*un déjà-là*) whose legitimacy is guaranteed, combining them with the needs of capital accumulation." Luc Boltanski and Eve Chiapello, *The New Spirit of Capitalism*, trans. Gregory Elliott (London: Verso, 2005), 20.

6. See Timothy Bewes, "What Is 'Philosophical Honesty' in Postmodern Literature?," *New Literary History* 31, no. 3 (Summer 2000): 421–34. Bewes argues for a qualitative difference between the modern philosophical novel and postmodern novel of ideas, characterizing the latter as a prime example of a kind of "literary dishonesty" hinging on "manipulation of the audience by an omniscient author figure" (423, 427). Paraphrasing Adorno's criticism of Sartre's novels, where "the philosophical thesis so animates the plot and the characters that the latter become merely illustrations of the thesis," Bewes contrasts this version of "literary dishon-

esty" with another in which "the author, far from leading the reader by the nose in a cycle of manipulation, rather pursues the demands and desires of the reader, attempting to satisfy the reader's latest whim" (423). Both versions share a tacit assumption: a fundamental incompatibility between the "artistic integrity" of the artwork and any transparent act of calculation on the part of its maker, whether in the form of a forcefully imposed thesis or a strategy for pleasing one's audience. One could thus pivot from Bewes's emphasis on the moral difference between the philosophical novel and the novel of ideas to what they have in common formally: an all-too transparent reliance on techniques shading into contrivances.

7. The interventions of Roberts and Bernes are crucial texts here, as is Mark McGurl's study of the modernist novel's development in tandem with the rise of the concept of mental labor and professional managerial class, all the while maintaining a desire for the mass market resulting in a noticeable preoccupation with the figure of the "simpleton." See Mark McGurl, *The Novel Art: Elevations of American Fiction after Henry James* (Princeton, NJ: Princeton University Press, 2001).

8. Theodor Adorno, *Philosophy of New Music*, trans. Robert Hullot-Kentor (Minneapolis: University of Minnesota Press, 2006), 14. Adorno is referring to the "uncompromising rigor" of the "technical procedures" of Schoenberg's dodecaphonic compositions.

9. Cited in Claire de Obaldia, *The Essayistic Spirit: Literature, Modern Criticism, and the Essay* (Oxford: Clarendon Press, 1995), 193–94.

10. Marcel Proust, *In Search of Lost Time*, trans. Andreas Mayor, Terence Kilmartin, and D. J. Enright, vol. 6, *Time Regained* (New York: Modern Library, 1992), 279. Cited in Stefano Ercolino, *The Novel-Essay, 1884–1947* (New York: Palgrave Macmillan, 2014), 100.

11. Frederick J. Hoffman, "Aldous Huxley and the Novel of Ideas," *College English* 8, no. 3 (December 1946): 129–37, 135.

12. Roberts, *Intangibilities of Form*, 10.

13. Roberts, *Intangibilities of Form*, 63, 220.

14. Bernes, *Work of Art*, 20. For a parsing of the differences between anticapitalist accounts of the "knowledge economy" and those that come from academic, business, and OECD-World Bank literature, see George Caffentzis, "A Critique of 'Cognitive Capitalism,'" in *Letters of Blood and Fire: Work, Machines, and the Crisis of Capitalism* (Oakland, CA: PM Press, 2013), 95–126. See also Sarah Brouillette, "Creative Labor," *Mediations* 24 (2009): 140–49.

15. I find it fitting to name the two branches of this "fork" after the titles of two panels at a 2008 conference at the Barcelona MOCA aimed specifically at a historical reappraisal of conceptualism ("Conceptualism and Abjection: Towards other Genealogies of Conceptual Art," Barcelona Museum of Contemporary Art, February 8, 2006). The conference featured the following panelists: Lawrence Weiner, Daniel Buren, Michael Baldwin and Mel Ramsden (Art and Language), Robert Barry, John Baldessari, Thomas Schütte, and Luciano Fabro.

16. Lauren Berlant, *Cruel Optimism* (Durham, NC: Duke University Press, 2011), esp. chapter 3, 95–120.

17. Michael McKeon, *The Origins of the English Novel, 1600–1740* (Baltimore, MD: Johns Hopkins University Press, 2002).

18. On the theory novel as "a strangely conservative and undialectical postmodern utopia," see Nicholas Dames, "The Theory Generation," *n+1*, no. 14 (Summer 2012). See also Anna Kornbluh, "The Murder of Theory," *Public Books*, August 1, 2017.

19. Claire De Obaldia, *The Essayistic Spirit: Literature, Modern Criticism, and the Essay* (Oxford: Clarendon Press, 1995), 204, 202.

20. Although not because they are devoid of a historical character. Stefano Ercolino, *The Novel-Essay, 1884–1947* (New York and London: Palgrave Macmillian, 2014). Hoffman, "Aldous Huxley," 129–37.

21. Aldous Huxley, *Point Counter Point*, intro. Nicholas Mosley (New York: Dalkey Archive Press, 1996), 295, 294.

22. Peter Szondi, *Theory of the Modern Drama*, trans. Michael Hays (Minneapolis: University of Minnesota Press, 1987).

23. Theodor Adorno, *Mahler: A Musical Physiognomy*, trans. Edmund Jephcott (Chicago: University of Chicago Press, 2013), 3.

24. Szondi, *Theory of the Modern Drama*, 55.

25. Adorno, "Messages in a Bottle" (excised fragments from *Minima Moralia*), trans. Edmund Jephcott, *New Left Review* I/200 (July/August 1993): 5–14, 10. Cited in Timothy Bewes, *Reification, or the Anxiety of Late Capitalism* (London: Verso, 2002), xvi.

26. Philip Fisher highlights this point in *Making and Effacing Art: Modern American Art in a Culture of Museums* (Cambridge, MA: Harvard University Press, 1997), 49.

27. Angus Fletcher, *Allegory: The Theory of a Symbolic Mode* (Princeton, NJ: Princeton University Press, 2012), 107. "The texture of allegory is 'curiously inwrought,' worked in ornamental detail. This is not realism; it is surrealism." Fletcher appears to be citing the fourteenth-century poem *Pearl*.

28. We might therefore surmise that the novel of ideas is an autumnal form, rather than a mutation heralding radical transformation—and even if one is struck by its ascending popularity among contemporary novelists (Richard Powers, W. G. Sebald, J. M. Coetzee, Sheila Heti, Ben Lerner, Teju Cole).

29. As De Obaldia puts it, the sheer fact that Proust, Musil, and Broch wrote essayistic novels "implies that three of the great exemplars of the novel's 'genius' have somehow managed to get away with doing exactly what a good novel should never do." De Obaldia, *Essayistic Spirit*, 194.

30. J. M. Bernstein, *The Philosophy of the Novel: Lukács, Marxism and the Dialects of Form* (Minneapolis: University of Minnesota Press, 1984), 113.

31. Bernstein, *Philosophy of the Novel*, 107.

32. Bernstein speculates that perhaps realism "might be just this attempt to satisfy the demands of both orders of event determination simultaneously," i.e., from the perspective of discourse or succession, *and* the perspective of story or totality (110).

33. Bernstein, *Philosophy of the Novel*, 109. For a lively intellectual-historical account of the story-discourse relation, see also Kent Puckett, *Narrative Theory: A Critical Introduction* (Cambridge: Cambridge University Press, 2016).

34. "Time-novel" and "withdrawn": Thomas Mann, *The Magic Mountain*, trans. John E. Woods (New York: Vintage International, 1995), 533; 381. See especially the first chapter of Book 7, "A Stroll by the Shore," 531–37.

35. Northrop Frye, *Anatomy of Criticism* (Princeton, NJ: Princeton University Press, 2015), 308.

36. De Obaldia, *Essayistic Spirit*, 194–95.

37. J. M. Coetzee, *Elizabeth Costello* (New York: Penguin, 2004), 8.

38. György Lukács, "The Intellectual Physiognomy in Characterization," in *Writer and Critic and Other Essays*, ed. and trans. Arthur D. Kahn (London: Merlin Press, 1970), 149–87.

39. Eugene Goodheart, "Thomas Mann's Comic Spirit," in *A Companion to Thomas Mann's Magic Mountain*, ed. Stephen D. Dowden (Columbia, SC: Camden House, 1999), 41–52, esp. 43–44.

40. Nathan Hensley, "Allegories of the Contemporary," *Novel: A Forum on Fiction* 45, no. 2 (2012): 276–300, 287.

41. For a key example of this skepticism around a term often applied to her own writing, see Mary McCarthy, *Ideas and the Novel* (New York: Harcourt Brace and Jovanovich, 1980), 16–19.

> So intrinsic to the novelist medium were ideas and other forms of commentary [in the nineteenth century], all tending to "set" the narration in a general scheme, that it would have been impossible in former days to speak of the "novel of ideas." It would have seemed to be a tautology. Now the expression is used with such assurance and frequency that I am surprised not to find it in my *Reader's Guide to Literary Terms*, which is otherwise reasonably current. . . . If the NOVEL OF IDEAS does not figure as a entry (though NOVEL OF THE SOIL does), it may be because the authors were not sure what the term covered. I must say it is not clear to me either, *though I sense something derogatory in the usage*, as if there were novels and novels of ideas and never the twain shall meet. (18–19; my emphasis)

Picking up on this "derogatory" inflection, elsewhere McCarthy writes: "What is curious . . . is that ideas are still today felt to be unsightly in the novel, whereas the nether areas—the cloaca—are fully admitted to view" (15).

42. Lionel Trilling, *The Liberal Imagination: Essays on Literature and Society* (New York: New York Review of Books Press, 2008), 275. Compare statements like "literature, by its very nature, is involved with ideas" (282) with "I venture the prediction that the novel of the next decades will deal in a very explicit way with ideas (273).

43. This proneness to gimmicks might in turn explain why so many novels of ideas are also comedies, written in what Käte Hamburger calls the "humoristic tone" associated with the "theoretical and reflective interpolations" of narrators in novels by Fielding and Jean Paul. See *The Logic of Literature*, trans. Marilynn J. Rose (Bloomington: Indiana University Press, 1973), 161–62. Hamburger's idiosyncratic (if rigorous) approach to the distinctions between epic, drama, and lyric would of course lead her to disagree with most of the theorists cited in this chapter.

44. On free indirect discourse in Hegel, see Katrin Pahl, *Tropes of Transport (Evanston IL: Northwestern University Press, 2012)*.

45. Seymour Chatman, *Story and Discourse: Narrative Structure in Fiction and Film* (Ithaca NY: Cornell University Press, 1980), 69. "The cinema has trouble with summary, and directors often resort to gadgetry."

46. Significantly, increased reliance on stage directions and the introduction of the "stranger," a character often hauled in for what seems like the sole purpose of providing narrative exposition, figure prominently among the techniques Szondi singles out as evidence for "epic" or narrative tendencies in late nineteenth century and early twentieth century drama. See *Theory of the Modern Drama*, esp. 45–49. For Szondi, these often awkward devices indicate a moment in which drama strives toward the "epic distance" of the novel (*Theory of the Modern Drama*, 48)—much in the same way that increased reliance on dialogue and direct speech by narrators point to a reverse desire on the part of the novel of ideas.

47. As Frances Ferguson writes, free indirect discourse is "the novel's one and only formal contribution to literature." See "Jane Austen, Emma, and the Impact of Form," *Modern Language Quarterly* 61 (2000): 157–80, 159.

48. Hoffman, "Aldous Huxley," 132.

49. Martin Puchner, *The Drama of Ideas: Platonic Provocations in Theater and Philosophy* (Oxford: Oxford University Press, 2010), 125.

50. If channeled via David Kurnick's *Empty Houses: Theatrical Failure and the Novel* (Princeton, NJ: Princeton University Press, 2011), the same insight permits us to see the novel of ideas as less of a peripheral phenomenon in the history of the *novel* than it might initially appear. We might see its dramatic qualities for instance as a logical culmination of an overlooked intimacy between the nineteenth-century novel and theater that Kurnick reinstalls at the center of the novel's history. If Kurnick and Puchner's arguments reverse each another—Kurnick brings a theatrical account of sociality back to bear on the novel, while Puchner "restores the theory of the novel back to drama, whence it came in the first place" (*Drama of Ideas*, 125)—there is a sense in which the novel of ideas reconciles or joins them together.

51. Ercolino, *Novel-Essay*, 93, 93, 40. For Ercolino, the novel-essay is a special subcategory of the much wider category of philosophical literature, including works by Voltaire, Diderot, Balzac, Proust, and Sartre that might on first squint resemble but are finally not novel-essays.

52. Ercolino, *Novel-Essay*, 92. The citation is from Guido Mazzoni's *Teoria del romanzo*, n.p.

53. Kenneth Burke interestingly disagrees with this definition of drama's essence. For Burke, dramatic form is fundamentally about action and the relation of agents to acts; character (and especially the question of "well-rounded" or developing character) is a secondary development if not a back formation: "one should . . . proceed not from character-analysis to the view of the character in action, but from the logic of the *action as a whole*, to the analysis of the character as a recipe fitting him for his proper place in the action." Burke explicitly refers to the first approach as "novelistic" rather than dramatic. See Kenneth Burke, "Othello: An Essay to Illustrate a Method," *The Hudson Review* 4, (Summer 1951): 165–203, 187, 182.

54. Lukács, "Intellectual Physiognomy," 152.

55. Angus Fletcher, *Allegory: The Theory of a Symbolic Mode* (Princeton, NJ: Princeton University Press, 2012).

56. T. J. Reed, "The Uses of Tradition," in *Thomas Mann's The Magic Mountain*, ed. Harold Bloom (New York: Chelsea House, 1986), 53–66, 65–66.

57. See Goodheart, "Thomas Mann's Comic Spirit."

58. Mann, *Magic Mountain*, 457.

59. Goodheart, "Thomas Mann's Comic Spirit," 47. As Anton Zijderveld argues regarding clichés as "the supersedure of meaning by function," the words the two men hurl at each other "bypass reflection" and therefore "relativization," in which the "content of meaning of the statement is no longer taken for granted." See *On Clichés: The Supersedure of Meaning by Function in Modernity* (London: Routledge & Kegan Paul, 1979), 6. Zijderveld compares clichés to "coins of an inflated economy" (24), arguing that in "abstract society," the artificial clarity and stability they offer substitute for functions once supplied by institutions (clichés are, in effect, "mini-institutions" [47].) Weak in content but powerful in function, clichés are also likened to magical incantations (73); they also have a particularly direct impact on our experience of time (75–78).

60. Georg Wilhelm Friedrich Hegel, *Aesthetics* (Oxford: Oxford University Press, 1975), 1214–15. Cited in Franco Moretti, "'Operationalizing'": Or, the Function of Measurement in Modern Literary Theory," *Stanford Literary Lab Pamphlet* 6 (December 2013): 10.

61. Moretti, "'Operationalizing,'" 12.

62. Fletcher:

> The most striking sensuous quality of images in allegories is their "isolation" from one another. Allegorical painting and the emblematic poetry that takes after it display this very sharply. They present bits and pieces of allegorical "machinery," scales of justice, magic mirrors, crystal balls, signet rings, and the like. These devices are placed on the picture plane without any clear location in depth. [At] the same time they preserve their identities by being drawn with extremely sharp-etched outlines. This is not the result of a sheerly compositional criterion on the painter's part. "Isolation" of imagery follows from the need to maintain daemonic efficacy. (*Allegory*, 86)

Due to its apparent lack of relation to other objects (including other emblems in the same hierarchical matrix), the isolated image becomes something the user can "address . . . with total concentration," since it seems "[cut] off from any function other than its daemonic, magical function" (87). The isolated abstractions in the passage from *Magic Mountain* do not however achieve the same effect; they sit in the text like objects, not talismans.

63. Wayne Booth, "Irony and Pity Once Again: 'Thaïs'' Revisited." *Critical Inquiry* 2 (Winter 1975): 327–44, 339.

64. Bernstein, *Philosophy of the Novel*, 110.

65. Mann, *Magic Mountain*, 501.

66. Roland Barthes on *The Magic Mountain*: "Autarky: a structure made up of subjects, a little 'colony' that requires nothing beyond the internal life of its constituents." And further: "Sanatorium: a wholly autarkic milieu; this includes the intradependence of affects; affective plentitude. All the affects you want can be found in the sana; you don't need the outside world. Once the structure (the Living-Together) is established, it's ever-lasting; it runs on and on—like a homeostat" (37). Roland Barthes, "Autarky," in *How to Live Together: Novelistic Simulations of Some Everyday Spaces*, trans. Kate Briggs (New York: Columbia University Press, 2013), 36–37.

67. In other words, "allegory delivers its message by way of concealing it." Fredric Jameson, *Allegory and Ideology* (New York: Verso, 2019), xiv. For his own account of the "strange case of a nonallegorical allegory," see 13.

68. Robert Pfaller, *On the Pleasure Principle in Culture: Illusions without Owners*, trans. Lisa Rosenblatt, with Charlotte Eckler and Camilla Nielsen (London: Verso, 2014), 20.

69. Brought into the novel for this one and only purpose, the "device" of the gramophone plays a role similar to that of the telepathically gifted Elly Brand, a minor character showing up for the first time on page 645 of a 706 page novel, accompanied by self-conscious comments from the narrator about this very fact, for the sole purpose of assisting this heavily gimmick-mediated, yet rationally inexplicable or supernatural event. As with the gramophone, we never hear of Brand again.

70. Adrian's response: "Reason and magic . . . surely meet and become one in what is called wisdom, initiation, in a belief in the stars, in numbers." Thomas Mann, *Doctor Faustus* (New York: Modern Library, 1975), 205, 208.

71. Ali Smith, *Artful* (New York: Penguin Books, 2014), back cover.

72. Mann, *Magic Mountain*, xi.

73. Nicola Barker, *Clear: A Transparent Novel* (New York: Ecco Press, 2004), 54.

74. Rosalind Krauss makes this argument about the photographer Francesca Woodman. See Krauss, "Francesca Woodman: Problem Sets," in *Bachelors* (Cambridge, MA: MIT Press, 2000), 161–78.

75. Ina Blom, *On the Style Site: Art, Sociality, and Media Culture* (Berlin: Sternberg Press, 2007), 131.

76. *Clear* is thus an instance of what Roberts calls "copying without copying," the technique Duchamp used in the readymade to sever the concept of artistic labor from craft and bring the artwork into "full alignment with the modes of attention of modern mass production" (*Intangibilities of Form*, 54, 39).

77. Nicola Barker, "Author interview on *Clear*," HarperCollins Publishers Book Interview, accessed October 8, 2019, https://b0f646cfbd7462424f7a-f9758a 43fb7c33cc8adda0fd36101899.ssl.cf2.rackcdn.com/book-interviews/BI-9780060 797577.pdf.

78. Alex Clark, "'I Won't Make You Feel Better,'" *Guardian*, April 28, 2007.

79. Roberts, *Intangibilities of Form*, 220. The "fast artwork" gives rise, in turn, to internet-based works in which we find art indistinguishable from design or information, promoting the diffusion of art "into the flow of all other commodities" (220). Citing projects by Superflex and Critical Art Ensemble in which artists collaborate with politicians, scientists, and activists to "transform art into artistically invisible social practices" such as a media campaign, a shop, or new line of soda (215), Roberts notes that the convergence of "fast thinking" and the "fast artwork" was already anticipated in "the speed of the readymade," which sought to capture the "immediacy and transparency of the commodity" itself (220, 39).

80. Barker, *Clear*, 53–54.

81. Jay Rayner, "Le Cinq, Paris: Restaurant Review," *Guardian*, April 9 2017.

82. Is comedy bound up in a special way with this particular one of our four metaresponses to aesthetic pleasure/displeasure: taking pleasure in the sharing of one's distaste?

83. Barker, *Clear*, 9.

84. The styles in which aesthetic judgments are performed are not random but reflect each aesthetic category's inner significance. The condescendingly affectionate manner in which I perform my judgment of cuteness is thus what Silvan Tomkins would call an "analog amplification" of cuteness, understood as that which I regard tenderly as unthreatening or harmless.

85. Albert Burneko, "I Just Love This Juicero Story So Much," *Deadspin*, April 19, 2017.

86. Roland Barthes, *Mythologies*, trans. Richard Howard and Annette Lavers (New York: Hill and Wang, 2012), 137.

87. De Obaldia, *Essayistic Spirit*, 193–246.

88. Giorgio Agamben, *The Man without Content*, trans. Georgia Albert (Stanford, CA: Stanford University Press, 1999). On the increasing prominence of aesthetic judgment in contemporary culture, see Ngai, *Our Aesthetic Categories: Zany, Cute, Interesting* (Cambridge, MA: Harvard University Press, 2012), 236–37.

89. Ina Blom, *On the Style Site: Art, Sociality, and Media Culture* (Berlin: Sternberg Press, 2007), 131.

90. Viewable twenty-four hours a day during the forty-four days of its duration, and thus available to those working night shifts as well as days, Blaine's gimmick draws together Londoners whom the novel implies might otherwise have never met due to the way work temporally structures lives. The novel is quick, however, to deflate any reading of this as a sentimental account of the importance of aesthetics to democracy or of how art facilitates encounters "across different walks of life." First and foremost, its auratic object is a gimmick. Second, when the novel opens, we learn Adie has been mainly using "Blaine's box" as a way to find one-night-stands—basically, like a pub. Or perhaps, we might say, like a gallery space, transformed by a neoconceptual artist into a facsimile of a pub. In any case, Adie has been hilariously caught in this instrumentalization of the "boxed-up Illusionist" by a woman who visits it at the same late hours he does. The woman (Aphra) seems to have a "purer" aesthetic relation to the performance, which as it turns out Adie shares. He's simply willing to have it both ways, in a way similar to Barker: both regard the "boxed-up Illusionist" as a genuine object of aesthetic interest but also as a convenient device or platform for experiments (or just exercises) in social interaction.

For this reason Blaine's gimmick as represented by Baker evokes Ina Blom's concept of the "style site," a term she uses to refer to neoconceptual works by artists also widely associated with relational aesthetics. Works by Liam Gillick, Philippe Pareno, Pierre Huyghe, Jorge Pardo, and Rirkrit Tiravanija do not "simply *have* a style, in one sense or another," Blom argues, but "work *on* the contemporary 'question of style' itself," and through style, qua site where affective subjectivity is most transparently an object of capitalist capture, on modes of capitalist sociability (*On the Style Site*, 13). While continuing the constructivist tradition of expanding art's intersection with design, for Blom the contemporary "style site work" is more specifically about the representation and production of time: in particular, new ways of imagining, simulating, or producing the time of nonwork, relaxation, and leisure,

which the commitment to self-fashioning enjoined by late capitalist culture demands but also simultaneously whittles down or destroys. If "lifestyle issues take center stage in recent neo-Conceptual work," writes Blom, "it primarily attests to the fact that the 'power of style' is today more deeply entrenched, more diversified, and more widely distributed," affecting the lives of more people in an "information economy increasingly set on capturing the forces of life itself" (54). In *Clear*, similarly, "art, technologies, media, economic production, and personal lifestyles are treated as a continuum," precisely in order to highlight style as what travels across these zones and renders them continuous (60). Meditations on Blaine's gimmick open the novel up to a flood of proper names of celebrities and brands.

With *Clear*, we have thus reached an interesting turn in the story of the gimmick-prone, idea-driven artwork this chapter tries to tell. In the history of Western visual art, concept-driven artworks incline toward the discursive condition of literature, a trend that reaches a certain apex in the "nonretinal," information-based conceptual art of the late 1960s and 1970s. In *Clear*, conversely, we have a work of literature aspiring to resemble a neoconceptual work of relational aesthetics. It could be said that Blaine's box, hanging over and illuminating Potters Fields at all hours like a never-switched-off lamp, clock, or television, transformed that space—used mostly by workers heading in and out of the office buildings surrounding it—and arguably London itself into a more intimate bar, lounge, or hangout space. Much in the same way that visual artists in the same period transformed galleries and museums into facsimiles of bars and living rooms, "Above the Below" is represented in *Clear* as producing a subtle but meaningful expansion of spaces in which people can hang around and talk. Yet, in contrast to the consistently mellow vibes of the paradigmatic relational aesthetics piece, the boxed illusionist promoted vehement and ugly forms of sociality too.

91. Dave Beech, *Art and Value: Art's Economic Exceptionalism in Classical, Neoclassical and Marxist Economics* (Leiden, the Netherlands: Brill, 2015), 256.

92. Karl Marx, *Grundrisse: Foundations of the Critique of Political Economy (Rough Draft)*, trans. Martin Nicolaus (New York and London: Penguin Books and New Left Review, 1973), 706. The passage on "general intellect" appears directly after the paragraph on the "moving contradiction" in Notebook VII, "The Chapter on Capital," subheaded "Contradiction between the foundation of bourgeois production (value as measure) and its development. Machines etc.":

"The development of fixed capital indicates to what degree general social knowledge has become a direct force of production, and to what degree, hence, the conditions of the process of social life itself have come under the control of the general intellect and been transformed in accordance with it. To what degree the powers of social production have been produced, not only in the form of knowledge, but also as immediate organs of social practice, of the real life process."

93. Beech thus argues that evaluative discourses do in fact shape art's "value" in the broadest sense and not just price; in this case it is however value based on esteem, not socially necessary labor time. See *Art and Value*, 312.

94. Beech: "The 'lot description' of an artwork not only includes details of the work's production and provenance, but a bibliography and a list of exhibitions in

which the work has been included. Auction houses write up 'lot descriptions' and 'lot notes' to indicate the reputation of an artist or work by documenting the work's selection by curators and museums and quoting authorities referring to them" (Beech, *Art and Value*, 307).

95. For a reading of Keats's "Ode on a Grecian Urn" as a "mixed-media event . . . whose elevation into the poetic pantheon simultaneously occurs alongside its expression of . . . poetic cliché," see Orrin Wang, "Two Pipers: Romanticism, Postmodernism, and the Cliché," in *British Romanticism: Criticism and Debates*, ed. Mark Canuel (New York: Routledge, 2014), 518–26.

96. This concept comes from Marta Figlerowicz, for whom a "flat protagonist" is a progressively simplifying figure. See *Flat Protagonists: A Theory of Novel Character* (New York: Oxford University Press: 2016).

97. On this contradiction and its changing expression across different phases of capitalism (liberal competitive, stage-managed, and financialized), see Nancy Fraser, "Crisis of Care? On the Social-Reproductive Contradictions of Contemporary Capitalism," in *Social Reproduction Theory: Remapping Class, Recentering Oppression*, ed. Tithi Bhattacharya (London: Pluto Press, 2017), 21–36. See also George Caffentzis, "On the Notion of a Crisis of Social Reproduction: A Theoretical Overview," in *Letters of Blood and Fire: Work, Machines, and the Crisis of Capitalism* (Oakland, CA: PM Press, 2013), 252–72.

98. Fraser, "Crisis of Care?," 34. If the elimination of the "care gap" is the ultimate political fantasy of Barker's gimmick-driven novel, notice that it is one in which that gap is eliminated through acts of care performed by volunteers like Adie—male citizens of British nationality—as opposed to female immigrants from poorer countries. We could of course read that fantasy as xenophobic. But it could also be interpreted as feminist, projecting a world in which the "care crisis" in high GDP countries like England could be solved *outside the domestic family* but *within the same nation*—that is, without merely displacing it, as it has in reality been outsourced and displaced, to individual households or the Global South—and by distributing that reproductive work so that it does not disproportionately burden women.

99. Susan Ferguson, "Capitalist Childhood, Anti-Capitalist Children: The Social Reproduction of Childhood," unpublished paper, 2015. Cited in Tithi Bhattacharya, "Introduction," *Social Reproduction Theory*, 2.

4. *It Follows*, or Financial Imps

1. For an overview of these positions, see Dimitris P. Sotiropoulos, John Milios, and Spyros Lapatsioras, *A Political Economy of Contemporary Capitalism and its Crisis: Demystifying Finance* (New York: Routledge, 2013), 7–58.

2. Covering a period of 700 years, Arrighi's theory of capitalism is also a theory of accumulation prior to capitalism. Giovanni Arrighi, *The Long Twentieth Century: Money, Power, and the Origins of Our Times* (London and New York: Verso, 2010).

3. Randy Martin, *Financialization of Daily Life* (Philadelphia, PA: Temple University Press, 2002).

4. Sotiropoulos et al., *Political Economy of Contemporary Capitalism*, 56. On the transformation of the reproductive household into a financial asset (which is a related but different argument), see Dick Bryan, Michael Rafferty, and Chris Jeffries, "Risk and Value: Finance, Labor, and Production," *South Atlantic Quarterly* 114, no. 2 (April 2015): 307–29.

5. Sotiropoulos et al., *Political Economy of Contemporary Capitalism*, 56–57. In line with this way of thinking, Robin Blackburn notes that over the last decade, financial profits in the United States and U.K. have primarily come from the annulment of contractual promises made to employees, most spectacularly in the elimination of pension benefits after corporations strategically file bankruptcy. Blackburn suggests that this maneuver could be described as a kind of relative surplus value extraction—the classic form of "capitalist exploitation"—stretched out across time. See Robin Blackburn, "Finance and the Fourth Dimension," *New Left Review* 39 (May–June 2006): 39–70.

6. Leigh Claire La Berge, *Wages Against Artwork* (Durham, NC: Duke University Press, 2019), 64. The relation between labor and capital has, nested within it, a more structurally obscured relation between waged and unwaged labor; it is also *that* relation, and *its* relation to capital, that keeps popping up all over this book.

7. "The banks advance to the firms the nominal money wage-bill that allows the purchase of labour-power on the labour-market. The financing of production plays, here, the role of a *monetary ante-validation of labour performance* in capitalist production-processes." See Riccardo Bellofiore, "The *Grundrisse* after *Capital*, or How to Re-read Marx Backwards," in *In Marx's Laboratory: Critical Interpretations of the* Grundrisse, ed. Riccardo Bellofiore, Guido Starosta, and Peter D. Thomas (Leiden and Boston: Brill, 2013), 17–42, 31; my italics. "[G]uarantee of the very existence of a nexus between value and labour": Riccardo Bellofiore, 30; other quotations are from Marx, cited in Bellofiore, 31.

8. See Sotiropoulos et al., *Political Economy of Contemporary Capitalism*, 223–25.

9. Karl Marx, *Capital: A Critique of Political Economy*, vol. 1, trans. Ben Fowkes (New York: Penguin, 1976), 188.

10. Patrick Murray, "Unavoidable Crises: Reflections on Backhaus and the Development of Marx's Value-Form Theory in the *Grundrisse*," in Bellofiore, Starosta, and Thomas, *In Marx's Laboratory*, 121–48, 125.

11. Karl Marx, *Capital: A Critique of Political Economy*, vol. 3, trans. David Fernbach (New York: Penguin Books, 1991), 516, my emphasis.

12. Sotiropoulos et al., *Political Economy of Contemporary Capitalism*, 134.

13. "The Bottle Imp" was first published in the Sunday *New York Herald* between February 8 and March 1, 1891 and translated into Samoan for the missionary magazine O *Le Sulu Samoa* (The Samoan Torch). It was reprinted in Stevenson's collection *Island Nights' Entertainments* (1893), one year before his death in 1894.

14. Richard W. Stevenson, "Markets Shaken as a British Bank takes a Big Loss," *New York Times*, February 27, 1995.

15. Wolfgang Streeck, *How Will Capitalism End? Essays on a Failing System* (New York and London: Verso, 2016), 15, 47. On the ambiguity of the "interregnum," see Antonio Gramsci, *The Prison Notebooks*: "La crisi consiste nel fatto-

che il vecchio muore e il nuovo non puo nascere . . . in questo interregno si verificano i fenomeni morbosi piu svariati." Cited in Streeck, *How Will Capitalism End?* 36.

16. Sharae Deckard, "Capitalism's Long Spiral: Periodicity, Temporality, and the Global Contemporary," in *Literature and the Global Contemporary*, ed. Sarah Brouillette and Mathias Nilges (Cham, Switzerland: Palgrave Macmillan, 2017), 83–102, 92. Deckard's essay meditates on forms of slowness as well.

17. By the 1880s, the price of machine tools in the United States had fallen to half of what it cost to produce them in Great Britain. Britain also lost its position as the world's leading producer and exporter of steel. Between 1883 and 1913, British steel cost roughly a third higher than iron and steel in the United States and Germany, where prices fell by 14 and 20 percent, respectively. See D. H. Aldcroft, "The Entrepreneur and the British Economy, 1870–1914," *The Economic History Review* 17 (1964): 113–34, 121–22, 116.

18. One of the most spectacular is the railway crash in "The Wrong Box," no doubt an allusion to the century's earlier wave of crises involving burst bubbles in railroad speculation.

19. Robert Louis Stevenson, "The Bottle Imp," in *Island Nights' Entertainments* (New York: Charles Scribner's Sons, 1895), 127–82, 130.

20. Kevin McLaughlin, "The Financial Imp: Ethics and Finance in Nineteenth-Century Fiction," *NOVEL: A Forum on Fiction* 29 (Winter 1996): 165–83, 175.

21. Stevenson, "Bottle Imp," 164.

22. *It Follows*, directed by David Robert Mitchell, written by David Robert Mitchell, featuring Maika Monroe and Keir Gilchrist (Lionsgate, 2015), DVD, 100 minutes.

23. "Northville Psychiatric Hospital," *Detroiturbex.com*, accessed October 9, 2019, http://www.detroiturbex.com/content/healthandsafety/northville/index.html. Thank you to Jonathan Flatley, Danielle Aubert, and Scott Hocking for helping me identify this structure.

24. It is an example of what some critics of this imagery call "ruin porn," as Annie McClanahan notes: "real estate porn's uncanny double." See *Dead Pledges: Debt, Crisis, and Twenty-First-Century Culture* (Stanford, CA: Stanford University Press), 130.

25. *It Follows*, DVD; all subsequent quotations from the film are from the DVD unless identified otherwise. As Annie McClanahan notes, "Attempts to slow or block circulation have thus become the tactical correlative of an economy driven by consumer debt." See *Dead Pledges*, 187. On the significance of slowness in general in contemporary cinema, see Lutz Koepnick, *On Slowness: Toward an Aesthetic of the Contemporary* (New York: Columbia University Press, 2014); for an especially interesting take on it in the western, see Ted Martin, "Weather: Western Climes," in *Contemporary Drift: Genre, Historicism, and the Problem of the Present* (New York: Columbia University Press, 2017).

26. On the technique of moving characters across diverse locations in urban space as a spatial substitute for narrative closure, see Fredric Jameson's discussion of *Videodrome* in *The Geopolitical Aesthetic: Cinema and Space in the World System* (Bloomington: Indiana University Press, 1992), 31–32.

27. McClanahan, *Dead Pledges*, 133.

28. Marx, *Capital*, vol. 3, 616.

29. David Robert Mitchell, *It Follows*, screenplay, version 15 (September 29, 2013), registration #1497688, 74.

30. Looking outside the car window, Yara says, "When I was a little girl my parents told me I wasn't allowed to go south of Eight Mile. I didn't even understand what that meant. It wasn't until I got a little older that I realized that was where the city started and the suburbs ended. I started thinking how weird and shitty that was." "My parents said the same thing to me," says Paul. *It Follows*, DVD.

31. Mitchell, *It Follows*, 105.

32. See, as good overviews of how the diffusion of debt into daily life works, John Lanchester, *I.O.U: Why Everyone Owes Everyone and No One Can Pay* (New York: McClelland & Stewart, 2010); and Ivan Ascher, *Portfolio Society: On the Capitalist Mode of Prediction* (Cambridge, MA: Zone Books, 2016).

33. Martin, *Financialization of Daily Life*. As Melinda Cooper notes, since George W. Bush's policies encouraging home ownership, individual asset-owners are encouraged to leverage home equity, in particular, "as a way of hedging against multiple life risks." Melinda Cooper, "The Strategy of Default—Liquid Foundations in the House of Finance." *Polygraph* 23/24 (2013): 79–96, 82.

34. Lanchester, *I.O.U*, 69.

35. Bryan, Rafferty, and Jeffries, "Risk and Value," 320–21.

36. On performativity and second-order observation in particular, see Donald Mackenzie, *An Engine, Not a Camera: How Financial Models Shape Markets* (Cambridge, MA: MIT Press, 2006). For a useful overview of and meditation on theories of performativity in finance, see also Elena Esposito "The Structures of Uncertainty: Performativity and Unpredictability in Economic Operations," *Economy and Society* 42, no. 1 (3013): 102–29.

37. Melinda Cooper, *Family Values: Between Neoliberalism and the New Social Conservatism* (Cambridge, MA: Zone Books, 2017), 162.

38. On the sources for "The Bottle Imp" (including Balzac's *The Wild Ass's Skin*) and a fascinating riff on its potential influence on anthropologist Bronislaw Malinowski's study of the kula exchange ring, see Carlo Ginzburg, "Tutsitala and His Polish Reader," in *No Island Is an Island: Four Glances at English Literature in a World Perspective*, trans. John Tedeschi (New York: Columbia University Press, 2000), 69–88. Ginzburg ventures that Stevenson's story was inspired by a "specific passage in Balzac's novel, the moment when the mysterious old man gives the wild ass's skin to Raphael: "Then he began again thus: 'Without forcing you to beg, without causing you to blush, without giving you a French centime, a Levantine para, a German heller, a Russian kopek, a Scottish farthing, a single sesterium or obol of the ancient world or a piastre of the new world, without offering you anything whatsoever in gold, silver, bullion, banknotes or letter of credit, I will make you richer, more powerful and more respected than a king can be—in a constitutional monarchy'" (78).

39. On the "Final Girl," see Carol Clover, *Men, Women, and Chainsaws: Gender in the Modern Horror Film* (Princeton, NJ: Princeton University Press, 1993).

40. On this temptation, see Ted Martin, *Contemporary Drift*, especially "Decade: Period Pieces," 24–56. At the same time, it would be wrong to say that the temporality of the film is ambiguous. *It Follows* may not have a decade but it has a season, which is autumn. It also has a time of day, which is twilight. Scenes all look shot in the gray of dusk, even when it is morning or noon in the story. These signifiers are reinforced by more allusive signs of "twilight," in what comes across overall as a felt reluctance to leave adolescence. Under the circumstances produced by the circulating deferral, legal adults like Jay, Hugh, and Greg seem happy to hang out with younger teens still in high school. All of the characters are nostalgic for childhood. Galvanized by the curse, this nostalgia provides the glue of their existence as a collective. Paul was not only Jay's but also Kelly's first kiss. Jay's closest friend is her younger sister. Paul ends up having sex with his childhood crush.

41. See Hans Blumenberg, "Being—A MacGuffin: How to Preserve the Desire to Think," trans. David Adams, *Salmagundi* 90/91 (Spring–Summer 1991): 191–93.

42. The screenplay identifies it as a "pink-shell-compact cell phone," but on screen there are no signs of it ever being used as such. One wonders if its initial description as a cell phone was altered to make other aspects of the plot make sense. For example, why doesn't anyone else in this world have one, and why doesn't Yara ever use it to call for help?

43. A cell phone is used in the opening frame tale or prelude to the story, but it is clear that this moment takes place in another story, at another time.

44. Yara seems to be quoting from the following edition: Fyodor Dostoyevsky, *The Idiot*, trans. Henry Carlisle and Olga Carlisle (New York: Signet Classics, 1969), 42.

45. Annie McClanahan makes a similar argument in her critique of a prevailing reading of foreclosure photography in *Dead Pledges*. "Detroit's economic ruination preceded the collapse of the markets in 2008 by many decades, spurred on by deindustrialization, the globalization of manufacturing labor, and persistent structural racism. Well before 2008, after all, Detroit was facing high unemployment and an overabundance of empty housing stock and was unable to provide basic services to its citizenry" (131). Photography that turns Detroit into a symbol of crisis in *just* the FIRE sector is thus "bad historicism" (131). In a similar vein, the historical equivocality in *It Follows* seems less ahistorical than an effort to circumvent inaccurate history.

46. On the impact on contemporary subjectivity of this "time warp" induced by financialized capitalism, see Eric Cazdyn, *The Already Dead: The New Time of Politics, Culture, and Illness* (Durham, NC: Duke University Press, 2012).

47. Nathan Hensley, "Allegories of the Contemporary," *Novel: A Forum on Fiction* 45 (2012): 276–98. Also reading Stevenson and Franzen alongside Giorgio Agamben's *Homo Sacer* (1995), Hensley discloses an aesthetic pattern in which "brute physicality emerges with an almost mechanical inevitability in conditions of material downturn." In each case, he notes, we find a "curiously inverse political dynamic between violence and geopolitical power . . . whereby the fading of imperial power produces an apparently paradoxical increase in open violence" (284). The dialectic between order and force in late imperial works also manifests at the level of "an irresolvable theoretical ambiguity between metaphysics and history," as for instance when Stevenson and Franzen both "tell an apparently timeless story

of evil emerging out of good" while showing an obsessive preoccupation with par-ticularizing dates (287).

48. Henry James, "The Beast in the Jungle," in *Complete Stories: 1898–1910* (New York: Library of America, 1996), 496–541, 529.

49. Melinda Cooper, "The Strategy of Default—Liquid Foundations in the House of Finance," *Polygraph* 23/24 (2013): 79–96, 88. Violent reconnection of M-C and C-M (Marx's abbreviations for production, the transformation of money into commodities; and circulation, the transformation of commodities into money): Joshua Clover, personal communication.

50. Alex Woloch, personal communication.

51. On this temporal paradox as endemic of the "chronic" status of capitalist crisis in our moment, in which crisis is no longer "defined by its short-termness," Cazdyn is especially eloquent: "There is a time warp at work, one in which the future has already come and is still to come, a double future. We can think about ecological predictions that forecast the end of natural resources and how it is al-ready too late to reverse this categorical trend, or we can return to the military realm and consider how posttraumatic stress disorder attacks the soldier in the future for acts committed or witnessed in the present. In both cases there is a looping of time in which the future is spelled out in advance, granting to the meantime an impos-sible location that is heading somewhere and nowhere at once. But this is not a simple fortune telling, a determination already decided and thus eliminating con-tingency. This is, rather, a radically different experience and operation of time, one in which categories such as determination and contingency are refunctionalized. Or, even more to the point, this is an experience of time that enables the very shifting of how time works." *Already Dead*, 4.

52. With the exception of the father in the "frame narrative," which as many commentators have noted seems to be take place in a different era from that in which the film is set (as if to get viewers to anticipate possible sequels or prequels).

53. Cooper, "Strategy of Default," 82.

54. Cooper, "Strategy of Default," 82.

55. Cooper, "Strategy of Default," 83.

56. Melinda Cooper, *Family Values: Between Neoliberalism and the New So-cial Conservatism* (Cambridge, MA: Zone Books, 2017), 199. On a theoretical level, this entailed the reassertion of a kind of fundamentalism over and against the anti-foundationalist tenor of arguments for a general income or social wage (whose pro-ponents once included both Milton Friedman and Nixon), in parallel with what Cooper and Martin Konings describe as "the continuously reinvented role of foun-dation in the operation of the most deterritorialized and evanescent of financial mar-kets." See "Contingency and Foundation," 246.

57. Cooper, *Family Values*, 23.

58. Cooper, *Family Values*, 25–117.

59. Both figures highlight the "production of nonproduction" Joshua Clover as-sociates with the "Long Crisis." See Joshua Clover, "The Long Crisis," in *Riot. Strike. Riot: The New Era of Uprisings* (New York: Verso, 2016), 129–52, 134.

60. Cooper, *Family Values*, 199.

61. The fact that *It Follows* is about finance thus does not mean it is for this reason *not* about AIDS, an entirely correct reading of this historically ambiguous film about relatively-slow-to-arrive death circulated through the medium of sex. For the AIDS crisis was a pinnacle for converging neoliberal and neoconservative interests around the goal of reducing public healthcare. It was the moment at which these same interests unified to produce a distinction between "deserving" and "undeserving" recipients of public healthcare—HIV-infected drug users, sex workers, and nonheterosexuals (Cooper, *Family Values*, 202).

62. It may be worth noting at this point that every single text in this book about gimmicks is either comedic (if not comedy), horrific, or a mixture of both.

63. Cooper, *Family Values*, 162.

64. See Cooper, *Family Values*, 10–11. On Polanyi see also Cooper and Konings, "Contingency and Foundation," esp. 239–42.

65. Anna Kornbluh, *Realizing Capital: Financial and Psychic Economies in Victorian Form* (New York: Fordham University Press, 2014), 24.

66. The promises the labor-saving gimmick makes about labor, time, and value are relatively easy to understand. The financial gimmick however makes its promises in jargon—hence the popularity of books like *How to Speak Money*—and as Leigh Claire La Berge has noted, is spoken of even by experts in the industry as "cryptic" and "abstract." See Leigh Claire La Berge, "The Rules of Abstraction: Methods and Discourses of Finance," *Radical History Review* 118 (2014): 93–112, 93.

67. As Melina Cooper and Martijn Konings note, the performative approach initially "burst onto the scene as a means to understand economic phenomena in nonreductionist ways—as effects of cognitive devices and discursive techniques," but "over time has accrued exactly the kind of . . . idealist connotations for which it was meant to serve as an antidote." Melinda Cooper and Martijn Konings, "Contingency and Foundation: Rethinking Money, Debt, and Finance after the Crisis," *The South Atlantic Quarterly* 114 (April 2015): 239–50, 242. The performative perspective on finance in sociology ultimately hews to a systems-theoretical or observer theory informed idea about the reflexive agency of models, as in Michel Callon's essays on the agency of economics in the economy or sociology in society. See for example, "Introduction: The Embeddedness of Economic Markets in Economics," in *The Laws of the Markets*, ed. Michel Callon (Oxford: Basil Blackwell, 1998), 1–57. For an excellent overview of these positions, see Esposito, "Structures of Uncertainty."

68. Marx, *Capital*, vol. 3, 139.

69. Marx: "We have seen that the average profit of the individual capitalist, or of any particular capital, is determined not by the surplus labour that this capital appropriates first-hand, but rather by the total surplus labour that the total capital appropriates, from which each particular capital simply draws its dividends as a proportional part of the total capital. *This social character of capital is mediated and completely realized only by the full development of the credit and banking system*" (vol. 3, 742). Sotiropoulos et al. draw on moments like this to argue that "Marx placed finance at the heart of capitalism, regardless of the historical phase of the latter" (*Political Economy of Contemporary Capitalism*, 55).

70. Sotiropoulos et al., *Political Economy of Contemporary Capitalism*, 55.

71. Marx, *Capital*, vol. 3, 612.

72. Alex Preda, *Framing Finance: The Boundaries of Markets and Modern Capitalism* (Chicago: University of Chicago Press, 2009), 15. This is particularly the case as part of credit capital becomes autonomous, no longer used for production and related commercial activity but for the purpose of turning noncapital into capital. As Preda notes, "It is exactly this part [of credit capital] which is significant [for] the multiplication of the modes of reproduction: the autonomous part of credit capital engulfs and transforms savings (something which industrial, productive capital could only differently achieve)."

73. Marx, *Capital*, vol. 3, 614, 613.

74. For a particularly lucid account of this, see McClanahan, *Dead Pledges*.

75. Preda, *Framing Finance*, 1. Meanwhile, as Blackburn notes, pension fund managers are encouraged to invest in hedge funds which are often extended credit for their shorting operations by same big financial houses that sponsor the pension funds ("Finance and the Fourth Dimension," 47).

76. Arrighi, *Long Twentieth Century*, 6.

77. Similarly, autonomous tendencies in finance are not usually the cause of financialization, as Greta Krippner points out. In United States, for example, the increasing reliance of nonfinancial companies on financial rather than productive activities in the 1980s was an inadvertent effect of ad hoc responses by government policymakers to the economic crises of the 1970s. "The turn to finance would answer the dilemmas posed by inflation, similarly allowing policymakers to avoid the constraints associated with declining affluence." See Greta R. Krippner, *Capitalizing on Crisis: The Political Origins of the Rise of Finance* (Cambridge, MA: Harvard University Press, 2012), 140.

78. "The Slumps that Shaped Modern Finance," *The Economist*, September 1, 2017, http://www.economist.com/news/essays/21600451-finance-not-merely-prone -crises-it-shaped-them-five-historical-crises-show-how-aspects-today-s-fina. Such "metalepsis" is by no means specific to this moment; as Anna Kornbluh notes, the "substitution of effect for cause forms the central trope of Victorian financial discourse" (*Realizing Capital*, 23). It is a substitution reflected upon throughout the *Grundrisse*, as Marx returns repeatedly to the tendency of the bourgeois political economist to mistake "presuppositions" for "results." Nonetheless, if something about capitalism overall seems to promote metaleptic reasoning, finance seems to be its starkest exemplar. One cannot properly grasp a form as simple as interest-bearing capital without a concept of surplus value, of which it is a socially channeled and channeling distribution. Yet surplus value and its origin are exactly what is obscured when "capital as capital become[s] a commodity" (Marx, *Capital*, vol. 3, 463).

79. Leigh Claire La Berge, *Scandals and Abstraction: Financial Fiction of the Long 1980s* (New York: Oxford University Press, 2015), 4.

80. La Berge, *Scandals and Abstraction*, 25. Whether one agrees with this stronger claim (similar to others about financial performativity), it is easy to concur that "the moment in which those of us not supported—and in many cases directly burdened—by financial activities nonetheless come to view the data that represent

those activities as signs of our economic well-being and as parameters of the economy per se" has proven "crucial to finance's efficacy." As La Berge notes, "It helps that those representations are omnipresent: How many times a day can one catch a glimpse of a stock market chart and hear that its value is 'up' or 'down'?" The representation of finance has also had concrete effects on the print culture produced in the era of its greatest expansion, which in turn have shored up the power of finance: "it was through the representation of finance that realism was rendered more postmodern; that postmodernism became more canonical; and that finance appeared more clearly as a distinct economic and literary object" (*Scandals and Abstraction*, 4).

81. Jonathan Barry Forman and Michael J. Sabin, "Tontine Pensions," *University of Pennsylvania Law Review* 163 (2015): 755–831, 757. For an in-depth history of the tontine, which was in fact the most popular retirement savings instrument in the United States until it was banned by most states in the second decade of the twentieth century, see Moshe Milevsky, *King William's Tontine: Why the Retirement Annuity of the Future Should Resemble its Past* (Cambridge: Cambridge University Press, 2017), 15.

82. Forman and Sabin, "Tontine Pensions," 758–59; Milevsky, *King William's Tontine*, 15. See also Kent McKeever, "A Short History of Tontines," *Fordham Journal of Corporate & Financial Law* 15 (2009): 491–521.

83. Moshe Milevsky, NYU. Cited in Jeff Guo, "It's Sleazy, It's Totally Illegal, and Yet It Could Become the Future of Retirement," *Washington Post*, September 28, 2015.

84. I have copied this rhetorical move from Stanley Cavell. See "Music Discomposed," *Must We Mean What We Say? A Book of Essays, Updated Edition* (Cambridge: Cambridge University Press, 1976), 180–212, 188–89.

5. Visceral Abstractions

1. Barbara Johnson, *Persons and Things* (Cambridge, MA: Harvard University Press, 2010), 4.

2. Johnson, *Persons and Things*, 4.

3. *Merriam-Webster*, s.v. "visceral," accessed October 6, 2019, https://www.merriam-webster.com/dictionary/visceral.

4. Leigh Claire La Berge, "The Rules of Abstraction: Methods and Discourses of Finance," *Radical History Review* 118 (2014): 93–112, 93.

5. La Berge, "Rules of Abstraction," 93, 96. As La Berge puts it, the characterization of financial operations as abstract would "seem less to elucidate financial operations than to obfuscate them," calling forth, on the one hand, "an immediately knowable and representable world of institutional financial transactions," but then "suspend[ing] knowledge and description of that world by claiming its mechanisms are beyond our collective cognitive, linguistic, and epistemological reach."

6. *Encyclopedia of Marxism*, Marxist Internet Archive, s.v. "abstract and concrete," accessed September 18, 2019, https://www.marxists.org/glossary/terms/a/b

.htm#abstract. The argument that the method of presentation (as opposed to the method of inquiry) in Marx's *Capital* tends to move from the abstract to the increasingly concrete is the generally accepted account, based on Marx's remarks in his draft work. See Karl Marx, *Grundrisse: Foundations of the Critique of Political Economy (Rough Draft)*, trans. Martin Nicolaus (London: Penguin Books, 1973), 100–108, esp. 101, 108. For a more nuanced account of the dialectical relationship between the abstract and concrete in Marx's presentation as it relates to the tension between logic and history in his method overall, see Ernest Mandel, introduction to Karl Marx, *Capital: A Critique of Political Economy*, vol. 1, trans. Ben Fowkes, (London: Penguin Books, 1990), 11–86, esp. 20–21 (cited in Beverly Best, *Marx and the Dynamic of Capital Formation: An Aesthetics of Political Economy* [New York: Palgrave Macmillan, 2010], 91–93). Kevin Floyd follows Mandel's lead in noting that, contrary to his remarks in the *Grundrisse*, Marx's method in *Capital* involves a "double movement" from concrete to abstract and then abstract to concrete. In the first movement, a "chaotic conception of the whole" like capitalism is broken down into increasingly simple abstractions (commodity, value, human labor in the abstract, socially necessary labor, etc.), which are disclosed as determinations that internally differentiate that totality, while in the second movement, the simple abstractions "are themselves concretized by establishing the simultaneous differentiation and connection *between* the various determinations to which they refer—by establishing, for example, the social process of capital of which social class, wage labor, and value are all defining moments." See Kevin Floyd, *The Reification of Desire: Toward a Queer Marxism* (Minneapolis: University of Minnesota Press, 2009), 28. For an alternative argument highlighting the predominance of abstraction in Marx's own method of analysis as continuous with the social abstraction that is the motor and defining characteristic of the capitalist mode of production, see Best, *Marx and the Dynamic*, esp. 61–116.

7. Marx, *Grundrisse*, 101.

8. La Berge, "Rules of Abstraction," 97.

9. Emmanuel Levinas, *Totality and Infinity*, trans. Alphonso Lingis (Pittsburgh, PA: Dusquesne University Press, 1969), 24.

10. Marx, *Grundrisse*, 104.

11. Marx, *Grundrisse*, 105.

12. Marx, *Grundrisse*, 104–105.

13. See Jimmy Stamp, "Who Really Invented the Smiley Face," Smithsonian.com, March 13, 2013, https://www.smithsonianmag.com/arts-culture/who-really-invented -the-smiley-face-2058483/.

14. Rob Halpern, *Music for Porn* (New York: Nightboat Books, 2012), 153.

15. Halpern, *Music for Porn*, 153.

16. Halpern, *Music for Porn*, 51.

17. Marx puts this last phrase in quotation marks, seeming to indicate his ironic distance from it, but there is no attributed source. See Marx, *Capital*, vol. 1, 129.

18. The phrase "abstract labor" is used rather sparingly by Marx. Its uses are concentrated in the first chapter of volume 1 of *Capital*, where they always appear in jarring conjunction with the image of "congealed" labor or labor-time. There is only a single subsequent reference in the rest of volume 1, where Marx's irony

becomes less concentrated and less ambiguous (isolated sarcastic remarks pop up, but they are also clearly signposted as such), as his analysis of capital becomes increasingly historical. There are no uses of the phrase "abstract labor" in the unfinished volumes 2 and 3, where Marx's use of irony is also more intermittent and clearly demarcated. (An index entry exists for "abstract labor" in volume 2, but the entry seems to have been created not for this precise phrase but for mentions of "value-forming labor.") The appearance of the phrase "abstract labor" thus seems roughly to correlate with the intensity of Marx's irony and use of figurative language and to correlate inversely with the concreteness of his analysis of capital. For all these reasons, the phrase "abstract labor" (if not its concept or meaning) needs to be seen as one about which Marx himself clearly had some ambivalence, perhaps because of, as I will show, the explicitly metaphorical language that its elucidation appears to require. At the same time, a robust body of work has grown around the concept of value-forming labor as "abstract" labor by commentators who recognize—rightly—that despite the infrequency of the term in Marx's writing and the verbal and tonal ambiguity that surrounds its use, the "value theory of labor" it describes is absolutely central to Marx's theory as a whole. For this reason, I examine the concept of abstract labor from the perspective of these commentators before turning to the more complex difficulties it presents in the writing of Marx himself. On Marx's theory of value as a "value theory of labor" as opposed to a labor theory of value, see Diane Elson, "The Value Theory of Labour," in *Value: The Representation of Labour in Capitalism*, ed. Diane Elson (London: CSE Books, 1979), 115–80.

19. Jim Kincaid, "A Critique of Value-Form Marxism," *Historical Materialism* 13, no. 2 (2005): 99.

20. Kincaid, "Critique of Value-Form Marxism," 99.

21. Marx, *Capital*, vol. 1, 165. Marx uses this phrase to describe commodities, "sensuous things which are at the same time suprasensible or social," but as Nicole Pepperell and others have noted, the concept applies to abstract labor, value, and capital as well. See Pepperell, "Disassembling Capital" (PhD diss., RMIT University, 2010), 1. For a good parsing of the differences between the "co-constitutive" version of value-form theory and the "exchange-only" version first introduced by Samuel Bailey (whom Marx critiques for exactly this reason, while also commending Bailey's criticisms of Ricardo's labor theory of value), see Patrick Murray, "Avoiding Bad Abstractions: A Defence of Co-constitutive Value-Form Theory," in *The Mismeasure of Wealth: Essays on Marx and Social Form* (Chicago: Haymarket, 2017), 425–42.

22. Marx, *Grundrisse*, 172.

23. Ernest Mandel, introduction to Karl Marx, *Capital: A Critique of Political Economy*, vol. 2 (London: Penguin Books, 1992), 15.

24. Marx, *Grundrisse*, 105.

25. Marx, *Capital*, vol. 1, 166–67; my emphasis.

26. Marx, *Grundrisse*, 225.

27. Georg Lukács, *The Ontology of Social Being: 2. Marx*, trans. Ferenc Jánossy (London: Merlin, 1978), 40.

28. Pepperell, "Disassembling Capital," 16–17.

29. Michael Heinrich, *An Introduction to the Three Volumes of Karl Marx's "Capital,"* trans. Alex Locascio (New York: Monthly Review Press, 2012), 50.

30. Marx, *Capital*, vol. 1, 129. I am grateful to Jasper Bernes for stressing this point to me (email message to author, February 20, 2014). The reverse is also true, since socially necessary abstract labor is also adjusted in response to the concrete, historical development of technology and the skill of workers. On this see Best, *Marx and the Dynamic*, 15; see also I. I. Rubin, "Marx's Labor Theory of Value," in *Essays on Marx's Theory of Value*, trans. Milos Samardzija and Fredy Perlman (Delhi: Aakar Books, 2010), 61–275, 119–20 (quoted in Best).

31. Elson, "Value Theory of Labour," 148–50.

32. Heinrich, *Introduction*, 50.

33. Alfred Sohn-Rethel, *Intellectual and Manual Labour: A Critique of Epistemology* (Atlantic Highlands, NJ: Humanities, 1978), 33.

34. Marx, *Grundrisse*, 161. As Marx puts it: "Their own collisions with one another produce an alien social power standing above them, produce their mutual interaction as a process and power independent of them. Circulation, because a totality of the social process, is also the first form in which the social relation appears as something independent of the individuals, but not only as, say, in a coin or in exchange value, but extending to the whole of the social movement itself. The social relation of individuals to one another as a power over the individuals which has become autonomous, whether conceived as a natural force, as chance or in whatever other form, is a necessary result of the fact that the point of departure is not the free social individual. Circulation as the first totality among the economic categories is well suited to bring this to light" (196–97).

35. Lucio Colletti, "Bernstein and the Marxism of the Second International," in *From Rousseau to Lenin: Studies in Ideology and Society*, trans. John Merrington and Judith White (New York: Monthly Review Press, 1972), 87.

36. Colletti, "Bernstein and the Marxism of the Second International," 87.

37. Rubin, "Marx's Labor Theory of Value," 142; my emphasis.

38. I am therefore with Pepperell when she argues that interpreters of Marx's theory of the fetish character of the commodity form are slightly off when they describe it as a theory of how an *intersubjective* relationship among human agents takes on the appearance of a property of things. As Pepperell notes, the commodity as value-bearing form more accurately points to "a distinctive type of *non-*intersubjective social relation" ("Disassembling Capital," 95).

39. Patrick Murray, "Marx's 'Truly Social' Labour Theory of Value: Part I, Abstract Labor in Marxian Value Theory," *Historical Materialism* 6 (2000): 27–65.

40. As Murray further disambiguates, the concept of abstract "physiological" labor used in political economy refers to an aspect of *all* labor and is thus a "general abstraction," whereas the concept of "practically abstract" labor introduced by Marx refers to a specific *kind* of labor and is thus a "determinate abstraction" ("Marx's 'Truly Social' Labour Theory of Value," 32).

41. Note the irony here: it is the superficially concrete-sounding approach to abstract labor as simple physiological labor that is the most abstract or general abstraction, since it applies to the labor of every single society, while the much more abstract-sounding definition of abstract labor as a "relation of social validation" is

the concrete or determinate abstraction, both in the sense of being specific to capitalism and also in being achieved by the empirical activity of human beings.

42. Marx, *Capital*, vol. 1, 137, 135, 134, 135.

43. Marx, *Capital*, vol. 1, 140; my emphasis.

44. Marx, *Capital*, vol. 1, 142; my emphasis.

45. For Murray, there is something "ludicrous" about the very act of describing "abstract" labor as "congealed" or "embodied" ("Marx's 'Truly Social' Labor Theory of Value," 57–58).

46. For a particular example of focus on the "performative dimension," see David Harvey, *A Companion to Marx's "Capital," Volume II* (New York: Verso, 2013), 306. On "double-voicing," see Dominick LaCapra, "Reading Marx: The Case of *The Eighteenth Brumaire*," in *Rethinking Intellectual History: Texts, Contexts, Language* (Ithaca, NY: Cornell University Press, 1983), 270. For a particularly interesting example of the difficulty of distinguishing Marx's perspective from those of the economists he subjects to critique, see Harvey, *A Companion to Marx's "Capital," Volume II*, 306.

47. Katrin Pahl, *Tropes of Transport: Hegel and Emotion* (Evanston, IL: Northwestern University Press, 2012). "Pundits of economics": Edmund Wilson, quoted in Robert Paul Wolff, *Moneybags Must Be So Lucky: On the Literary Structure of Capital* (Amherst: University of Massachusetts Press, 1988), 9.

48. Wolff, *Moneybags Must Be So Lucky*, 54.

49. Murray, "Marx's 'Truly Social' Labour Theory of Value," 60, 57. At the same time, Murray argues that the copresence of the specifically Marxist concept of abstract, value-forming labor and political economy's concept of abstract, in the sense of "simple," physiological labor, is due to the fact that "the concept of abstract labor is presupposed by the concept of value-producing labor . . . we need to know what it means for labor to be abstract before we can tell whether or not a certain social type of labor is abstract in practice. So the 'physiological' concept of labor is a necessary object of analysis, even though it is not the ultimate object of analysis" (60).

50. Murray, "Marx's 'Truly Social' Labour Theory of Value," 60. I hear an echo of Hegel's equally ironic presentation of the claim to certainty of the second of the "two Enlightenments" into which pure Insight splits after its antagonistic conflict with Faith in *Phenomenology of Spirit*. For this second Enlightenment (who may in fact be Descartes?), "*pure matter* is merely what is *left over* when *we abstract* from, feeling, tasting, etc., i.e. it is not matter that is seen, tasted, felt, etc.; what is seen, felt, tasted, is not *matter*, but color, a stone, a salt, etc. Matter is rather a *pure abstraction;* and so what we are presented with here is the *pure essence of thought*, or pure thought itself as the Absolute, which contains no differences, is indeterminate and devoid of predicates" (*The Phenomenology of Spirit*, trans. A. V. Miller [Oxford: Oxford University Press, 1977], 351, para. 577).

51. Highlighting Marx's description of *Capital* as a narrative featuring "characters" placed on an "economic stage" (vol. 1, 179; quoted in Pepperell, "Disassembling Capital," 73), Pepperell more specifically argues that Marx makes his representatives of the ideas of bourgeois economy (never explicitly marked as such) deliver their monologues (also never explicitly marked) from the one-sided perspec-

tives of Hegel's Perception, Understanding and Force. Pepperell cautions that we therefore cannot unilaterally trust Marx to mean what he is saying in the first six chapters of *Capital*—not, however, because he is attempting to obscure or deconstruct his own theory, but precisely in the interests of constructing an immanent critical theory.

52. Hegel himself often satirizes the claims to certainty of his shapes of consciousness in *Phenomenology* (the hilarious phrenologist of Observing Reason, for example, for whom "the being of Spirit is a bone"). See *Phenomenology of Spirit*, 208, para. 343.

53. In the second section of the first chapter of volume 1 of *Capital*, Marx states that like the dual character of the commodity (use value and exchange value), "labour, too, has a dual character: in so far as it finds its expression in value, it no longer possesses the same characteristics as when it is the creator of use-values. I was the first to point out and examine critically this twofold nature of the labor contained in commodities" (vol. 1, 132).

54. Marx, *Capital*, vol. 1, 140. Heinrich, *Introduction*, 50, 54. For an overview of the key differences between the neo-Ricardian, "crystalised-labour" or "embodied labour" approach to Marx's labor theory of value and the "abstract labour" approach," see Alfredo Saad-Filho, "Concrete and Abstract Labor in Marx's Theory of Value," *Review of Political Economy* 9, no. 4 (1997): 457–77. Departing from Heinrich and others who emphasize (I think rightly) that abstract labor is not labor expended in production (though this emphasis risks giving the impression that abstract and concrete are freestanding *types* of labor), Saad-Filho helpfully argues that "in capitalism workers perform concrete and abstract labour simultaneously." More specifically, the "commodity's use value is created by the concrete labour performed, and its value is created by the simultaneous performance of abstract labour" (468).

55. For an explicitly political critique of the misinterpretation of abstract labor as physiological labor (and a useful survey of different approaches to Marx's theory of abstract labor), see Werner Bonefeld, "Abstract Labor: Against Its Nature and on Its Time," *Capital and Class* 34 (2010): 257–76.

56. Keston Sutherland, "Marx in Jargon," *world picture* 1, 2008, http://www .worldpicturejournal.com/WP_1.1/KSutherland.pdf.

57. This observation about Marx's use of catachresis in his account of the relation between abstract labor and value is by no means original. For a helpful overview of differing theories of catachresis and a brief deconstructive account of the trope's role in Marx's writing in particular, see Gerald Possett, "The Tropological Economy of Catachresis," *Metaphors of Economy*, ed. Nicole Bracker and Stefan Herbrechter (New York: Rodopi, 2005), 81–94. For a more extensive account of Marx's concept of "value" as catachresis mediated through a reading of Gayatri Spivak's writings on value, see Best, *Marx and the Dynamic*, 80–82. Both Possett and Best approach catachresis as a "figurative and performative act of resignification which—in applying (abusively) a familiar term with a somewhat different signification—does not signify a pre-discursive object, but rather constitutes the identity of what is named" (Possett, "Tropological Economy," 86), as "a name that has no

literal or adequate referent but is used as if it did, temporarily and provisionally, so that a narrative can be constructed around it" (Best, *Marx and the Dynamic*, 80). Similar to what Pierre Fontanier calls a trope of "forced *and* necessary usage" (quoted in Possett, "Tropological Economy," 86, 84), I use the term to convey the broader, more literal meaning of the Greek word *katachrêsis* as "abuse" or "improper use."

58. Marx, *Capital*, vol. 1, 126. Or is it because there is an inevitable crossing of semantic registers in Marx's implicit characterization of the "material content" of value as "abstract labor" and its "social form" as "exchange value"? Everyday language and practice arguably make it strange for most of us to think of something abstract as being material.

59. This is the simple but powerful question Wolff devotes the entirety of his short book to answering: "What is the logical connection between Marx's literarily brilliant ironic discourse and his 'metaphysical' account of the nature of bourgeois social reality? Why *must* Marx write as he does if he is to accomplish the intellectual tasks he has set for himself?" (*Moneybags Must Be So Lucky*, 10).

60. *Music for Porn*, 152. Halpern's phrase echoes this passage from volume 1 of *Capital*:

> Men do not therefore bring the products of their labour into relation with each other as values because they see these objects merely as the material integuments of homogeneous human labour. The reverse is true: by equating their different products to each other in exchange as values, they equate their different kinds of labour as human labour. They do this without being aware of it. *Value, therefore, does not have its description branded on its forehead; it rather transforms every product of labour into a social hieroglyphic.* Later on, men try to decipher the hieroglyphic, to get behind the secret of their own social product: for the characteristic which objects of utility have of being values is as much men's social product as is their language. The belated scientific discovery that the products of labour, in so far as they are values, are merely the material expressions of the human labour expended to produce them, marks an epoch in the history of mankind's development, but by no means banishes the semblance of objectivity possessed by the social characteristics of labour. Something which is only valid for this particular form of production, the production of commodities, namely the fact that the specific social character of private labors carried on independently of each other consists in their equality as human labour, and, in the product, assumes the form of the existence of value, appears to those caught up in the relations of commodity production (and this is true both before and after the above-mentioned scientific discovery) to be just as ultimately valid as the fact that the scientific dissection of the air into its component parts left the atmosphere itself unaltered in its physical configuration. (166–67; my emphasis)

61. Halpern, *Music for Porn*, 152–53. One finds numerous precedents in literature for these pornographic archetypes. See, e.g., Melville's Handsome Sailor, represented as both an object of male desire and a sociological type in *Billy Budd*, as well as the poems of the modernist Luis Cernuda, who caresses his "Young Sailor" as both a hot body *and* a cool abstraction.

62. Halpern, *Music for Porn*, 50, 83.

63. Halpern, *Music for Porn*, 55, 152, 153.

64. Halpern, *Music for Porn*, 47.

65. Halpern, *Music for Porn*, 158, 153, 152, 155, 154.

66. Halpern, "Notes on Affection and War," in *Music for Porn*, 56.

67. Halpern, *Music for Porn*, 111, 152, 153.

68. Halpern, "Notes on Affection and War," in *Music for Porn*, 57; my underlined emphasis.

69. Halpern, *Music for Porn*, 7, 4, 78, 112, 117, 156, 93, 156, 97, 119, 154, 4, 156, 56; my underlined emphasis.

70. Halpern, *Music for Porn*, 93, 119, 154, 112, 56, 4, 78, 97, 112, 156, 97.

71. Halpern, *Music for Porn*, 154, 97, 78; my emphasis.

72. Halpern, *Music for Porn*, 153, 156.

73. Here, as if to highlight the thinness of the border simultaneously connecting and separating the concrete and the abstract in *Music for Porn*, these words refer to physical matter existing in such an attenuated or reduced form (as in "*distillations of capital laminated on my skin*," 158) that it verges on seeming, well, "abstract."

74. These complex maneuvers are not the only way in which *Music for Porn* explores the dialectical relation between the concrete and abstract. The book also deploys a much more straightforward alignment of "the spirit and the beef" (5), an anomalous pairing echoed by "this confluence of widget and plasma" (35) and "the convergence of lyric and ballistics" (25). At the sentence level, moreover, highly specific local details often get densely piled up only to veer off into abstraction at the last minute, yet by way of that abstraction, leading to the specificities of a vast global economy: "Rocky lowlands, marginal wood ferns densely covered with golden fur and rare lichens brought in from the island, bind the world to theologies of labor, all the cotton gins and pharmaceuticals" (8). A paragraph beginning with historically meaningful descriptive details such as a soldier in "traditional grey, loose fitting Afghan salwar kameez clothing" culminates in the flat announcement of "his particularity being no more than a type" (151).

75. I owe the term "plasticizing" to Jasper Bernes.

76. See Marx, *Capital*, vol. 1, 174n34. According to Christopher Arthur, the value-form "expresses an ontological emptiness which lies at the heart of capitalism" (quoted in Kincaid, "Critique of Value-Form Marxism," 88).

77. Marx, *Capital*, vol. 1, 174n34.

78. Best, *Marx and the Dynamic*, 20.

79. To say this is to fall in line with arguments made by Wolff, Kincaid, and Best.

80. Marx, quoted in Heinrich, *Introduction*, 78.

81. Halpern, *Music for Porn*, 119, 4, 153, 109, 55, 56.

82. Possett, "Tropological Economy," 86.

83. Christopher Arthur, quoted in Kincaid, "Critique of Value-Form Marxism," 88.

84. Kincaid, "Critique of Value-Form Marxism," 86.

85. For an example of how this disconnection between production and circulation plays out in the world of theory, see Joshua Clover, "Value/Theory/Crisis," *PMLA* 127, no. 1 (2012): 107–13.

86. It is useful here to note La Berge's reminder that in "Marx's own Marxism, abstract and concrete are not mutually exclusive positions"; rather, "each is possible only in its realization of the other" ("Rules of Abstraction," 98). Departing from other commentators who argue that only abstract labor is specific to capitalism

(see, for example, Bonefeld, "Abstract Labor"; and Moishe Postone, *Time, Labor, and Social Domination: A Reinterpretation of Marx's Critical Theory* [Cambridge: Cambridge University Press, 1993]), Elson argues that because of the unity (if also relative autonomy) of production and circulation in capitalism, the relation between concrete and abstract labor, like that of socially necessary labor to value, is not one of "discretely distinct variables which have to be brought into correspondence" but "one of both continuity and difference" such as that existing between the differing forms of appearance of a single organic substance. For Elson, Marx's natural or chemical and biological metaphors of "crystallization" and "embodiment" are used to index precisely this metamorphosis or "change of form" ("Value Theory of Labour," 139). For his part, Postone rigorously traces this inseparability of the abstract and concrete back to the dual nature of the commodity form; its fundamental split between exchange value and use value giving rise to the very idea of "labor expressible in [both] abstract and concrete dimensions" and to all the forms that come to embody this particular tension in turn (including value, money, and time itself); see Postone, *Time, Labor, and Social Domination*. Taking a slightly different approach, Floyd suggests that the concrete and abstract dimensions of the commodity (and by extension, of commodity-producing labor) as elucidated by Marx are inseparable *because* of the inseparability of concrete and abstract in Marx's larger methodology (*Reification of Desire*, 28).

87. Marx writes, "The weapon of criticism cannot, of course, replace criticism of the weapon, material force must be overthrown by material force; but theory also becomes a material force as soon as it has gripped the masses" ("A Contribution to the Critique of Hegel's Philosophy of Right: Introduction," accessed October 6, 2019, https://www.marxists.org/archive/marx/works/1843/critique-hpr/intro.htm).

88. What distinguishes value based on abstract labor from all the other kinds of value, Lukács argues, is that while the other kinds presuppose and reflect a given kind of sociality, the former produces and also reproduces this sociality on an extended scale. See Lukács, *Ontology of Social Being*, 154.

6. Rødland's Gimmick

1. Ina Blom, "I'm with Stupid: Notes on Another Form of Rock Photography," in *White Planet, Black Heart*, ed. Torbjørn Rødland and Michael Mack (Göttingen, Germany: SteidlMACK, 2006), n.p.

2. Ina Blom, "Dream Work: Ina Blom on the Art of Torbjørn Rødland," *Artforum*, September 2015, 338–49, 341, my italics.

3. Torbjørn Rødland, "Sentences on Photography," *Triple Canopy*, accessed March 13, 2018, https://www.canopycanopycanopy.com/contents/sentences_on _photography.

4. Sol LeWitt, "Sentences on Conceptual Art (1968)," *Ubuweb*, accessed March 2, 2018, http://www.ubu.com/papers/lewitt_sentences.html.

5. Alfred Gell, "Vogel's Net: Traps as Artworks and Artworks as Traps," *Journal of Material Culture* 1 (1996): 15–38.

6. Not to be confused with the mere utilization of play or humor, this commitment to comedy is arguably challenging to sustain when we consider the relentless alignment of photography in theory with melancholy, pastness, and death. Examples abound: from Christian Metz on photography as "thanatography" to Thierry de Duve's claim that photography might be "the only image-producing technique that has a mourning process built into its semiotic structure" as well as a "built-in trauma effect." See Christian Metz, "Photography as Fetish," *October* 34 (1985): 83; Thierry de Duve, "Time Exposure and Paradox: The Photograph as Snapshot," in *Photography Theory*, ed. James Elkins (New York and London: Routledge, 2007), 109–127, 120. Arguments about photography's "built-in trauma" are in turn reinforced by the saturation of theoretical writing on this medium with melancholic affect. They seem further borne out by the omnipresence of the two formats in which, tellingly, Rødland does not work: the snapshot favored by United States conceptualists, a "deadening artifact" de Duve identifies with "theft of life," and the monumental portraiture of modernists like Wall, Hofer, and Ruff, which aligns with what de Duve calls the "funerary image" (110, 119). In contrast to the melancholic, past-oriented view of photography, Agnes Heller and Alenka Zupančič have argued for the fundamental present-orientedness of comedy. See Agnes Heller, *Immortal Comedy: The Comic Phenomenon in Art, Literature, and Life* (Lanham, MD: Lexington Books, 2005), 13; Alenka Zupančič, *The Odd One In: On Comedy* (Cambridge MA: MIT Press, 2008), 178.

7. Hooks, musicologist Charles Kronengold notes, involve the same dramatization of intentionality as the gimmick; they are the "least accidental" and "most determinate" aspect of a song, its "locus of intentionality and control." Note however that the concept of the hook need not involve the explicitly pejorative judgments that come to surround intentionality in the case of the gimmick, which is a self-reflexive structure involving both the recognition of a display of intention *and* a simultaneous feeling of revulsion at its all too transparent display. See Charles Kronengold, "Accidents, Hooks and Theory," *Popular Music* 24, no. 3 (2005): 381–97, 381.

8. Hanne Mugaas, "Interview with Torbjørn Rødland," *Kaleidoscope* 5, no. 22 (Autumn/Winter 2014), http://kaleidoscope.media/torbjorn-rodland/.

9. The answer however raises a further question testifying to a need for a theory of gimmicks: What then explains the attraction to an unfunny joke? Why would artists in particular feel compelled to repeat them?

10. "Lure[s]": Catherine Taft, "Torbjørn Rødland at Michael Benevento," *Artforum*, October 30, 2010, https://www.artforum.com/picks/torbjoern-roedland -26590; "traps": Martin Herbert, "Torbjørn Rødland; Natasha Egan, Photography Plugged and Unplugged," *Contemporary Magazine* 67 (October 2004): 70–73, 72; "Adolescent glee," "fetishizing," "annoying": Linda Norden, "The Real Content is Elsewhere," in *Torbjørn Rødland: Sasquatch Century*, ed. Milena Hoegsberg (Oslo and Milan: Henie Onstad Kunstsenter and Mousse Publishing), 135–50, 144, 139, 142; "insidious hooks," "perverted": Bob Nickas, "The Perverted Photography of Torbjørn Rødland," VICE, The Photo Issue (June 30, 2009), https://www.vice.com /en_us/article/bndzbm/torbjorn-rodland-perverted-photo-947-v16n7; "retarded": Gil Blank, "Interview with Torbjørn Rødland," *Uovo Magazine* 13 (2007), http://www.gilblank.com/texts/intvws/rodlandintvw.html; "smarminess": Bennett

Simpson, "Torbjørn Rødland's sentimental education," *Nu: the Nordic Art Review* 3–4 (2000): 52–59; "idiotic": Ina Blom, "Dream Work," 341.

11. "In this singular sensation [disgust] . . . the object is represented as it were obtruding itself *for our enjoyment*, while we strive against it with all our might." Immanuel Kant, *The Critique of Judgment*, trans. J. H. Bernard (New York: Hafner Press, 1951), ¶48, 155, my emphasis.

12. On a parallel move in contemporary literature and specifically poetry, see Joshua Clover, "The Technical Composition of Conceptualism," in *Literature and the Global Contemporary*, ed. Sarah Brouillette, Mathias Nilges, and Emilio Sauri (London: Palgrave, 2017), 103–16.

13. As Clover writes: "All of our best periodizing hypotheses, Giovanni Arrighi (2010) foremost among them, tell us that the United States-centered era of late or finance capitalism should have ended, or be in its death throes, 2008 being the terminal to 1973's signal crisis, with a new hegemon or something else entirely in the offing. And yet, to this point, persistence and restoration call the tune against the quavering threnody of intensified and broadened immiseration. This immiseration should be in no context diminished. That said, the persistence and restoration of an era that by all rights should be in the boneyard offers a bizarre and eerie phenomenon, hence all the zombies." See "Technical Composition of Conceptualism," 104. Clover takes conceptual poetry as one case study of this "persistence and restoration" specific to an era of what he calls "long crisis"; one could argue that the reappearance of the concept in the "bungled" form of the gimmick presents another. On the "long crisis," see Joshua Clover, *Riot. Strike. Riot: The New Era of Uprisings* (New York: Verso, 2016), 129–52.

14. "Subservience to discourse": Jacques Rancière, *The Future of the Image*, trans. Gregory Elliott (London: Verso, 2007), 87.

15. Linda Norden, glossing Harald Szeemann. See Norden, "The Real Content is Elsewhere," 139.

16. Even the experience of aesthetic suspicion, in and of itself, can be a source of pleasure, as Neil Harris shows in his remarkable study of P.T. Barnum, early master of the gimmick form. See Neil Harris, *Humbug: The Art of P. T. Barnum* (Chicago, University of Chicago Press, 1973).

17. George Baker, "Photography's Expanded Field," *October* 114 (Fall 2005): 120–40, 120.

18. See Joel Anderson, *Theatre and Photography* (London: Palgrave, 2015); Rosalind Krauss, "Notes on the Index: Seventies Art in America," *October* 3 (Spring 1977): 68–81; Walter Benn Michaels, "Photographs and Fossils," in Elkins, *Photography Theory*, 431–50; Diarmuid Costello and Margaret Iversen, "Photography between Art History and Philosophy," *Critical Inquiry* 38, "Agency and Automatism: Photography as Art Since the Sixties," edited by Diarmuid Costello, Margaret Iversen, and Joel Snyder (Summer 2012): 679–93. For a philosophical approach that attempts to move beyond this binary, see Kaja Silverman, *The Miracle of Analogy* (Stanford, CA: Stanford University Press, 2012).

19. Baker, "Photography's Expanded Field," 122. Baker of course goes on to contest exactly this consensus by performing a structuralist expansion of the pho-

tographic "field" based on the opposition between motion and stasis. Revealing new specifically cinematic-photographic hybrids, his expansion points to the continuing generativity rather than exhaustion of the medium (122). I however want to linger on his initial insight that photography both initiated postmodernism and became immediately displaced by it.

20. I am not a fan of the term "post-postmodern," but Rødland presents a case in which its use seems warranted.

21. Stefan Gronert reminds us that the relationship between photography and anti-aesthetic conceptual art was less binding in postwar Europe than it was in the United States, due in part to the belated institutionalization of art photography in Europe (and thus absence of a tradition for European photographers to "rebel" against). See Stefan Gronert, "Alternative Pictures: Conceptual Art and Artistic Emancipation of Photography in Europe," in *The Last Picture Show*, ed. Douglas Fogle (Minneapolis, MN: Walker Art Center, 2003), 86–96. That said, in interviews and other writing, the photographic traditions that Rødland most frequently references are those of the United States.

22. For an in-depth study of this question, see John Roberts, *The Intangibilities of Form: Skill and Deskilling in Art after The Readymade* (New York: Verso, 2007). See also Jasper Bernes, *The Work of Art in the Age of Deindustrialization* (Stanford, CA: Stanford University Press, 2016).

23. Abigail Solomon-Godeau, "Ontology, Essences, and Photography's Aesthetics: Wringing the Goose's Neck One More Time," in *Photography Theory*, 256–69, 260.

24. The foregrounding of paint-like substances and painterly marks (drips, stains, brushstrokes) in Rødland's photographs is another moment in which we glimpse this interest in medium specificity, played out as a contrast between photography and painting. In *Pump*, for example, that sine qua non of pop art and advertising imagery, a foot in a high-heeled shoe, is made blurry and thus "painterly" by counterintuitively being photographed—photographed, more specifically, to "index" a moment when paint has just been poured to run thickly over it. A photograph of "painting" literally being rendered photographic, *Pump* is thus a punning inversion of Gerhard Richter's overarching project of translating photographs into paintings (his overpainted snapshots in particular) and a riff on Andy Warhol's silkscreened shoe images as well.

25. For an interesting reading of modernist portraiture as a genre defined by the struggle between the subject's act of performance (theater) and the portraitist's exposure of visual codes (autoreferentiality), see Ulla Haselstein, "Gertrude Stein's Portraits of Matisse and Picasso," *New Literary History* 34 (Autumn 2003): 723–43.

26. According to the Starbucks corporate website, the mermaid logo is based on an "ancient Nordic woodcut." "Who is the Starbucks Siren?," accessed October 9, 2019, https://stories.starbucks.com/stories/2016/who-is-starbucks-siren.

27. This gestural device could be included among what Linda Norden has described as Rødland's "rhythmically repeated abstract tropes—gestures of containment, binding, squeezing, flexing" ("The Real Content is Elsewhere," 142). The gestures and the relations among them are not revealed all at once, through a

conceptually predetermined series, but slowly, over time, through the changing combinations of images across Rødland's books and exhibits.

28. The penis, which the Sharpie appears to have inscribed with the initials WWJD—What Would Jesus Do?—lies at an angle suggestively akin to that of Isaac in Rembrandt's *The Sacrifice of Isaac* (1635), similarly exposed below Abraham's "sharpie," right before the angel intrudes from the "off" to intercede. I of course am not suggesting that this parallel to Rembrandt's painting was intended. I am drawing it myself to show how while both pictures "expose us to the dimension of the off-frame," Rødland makes clear that this metaphysical interaction can be comedic rather than heavy (Eyal Peretz, *The Off-Screen: An Investigation of the Cinematic Frame* [Stanford, CA: Stanford University Press, 2017], 27). One for instance can't help but notice that the gimmick is longer than the penis—which after all seems appropriate given it is conspicuously labeled "King Size."

29. Peretz, *Off-Screen*, 5.

30. On Heideggerean "worldhood" as one of the most crucial features of contemporary photography, see Michael Fried, *Why Photography Matters as Art as Never Before* (New Haven, CT: Yale University Press, 2008), esp. 37–62.

31. On this thesis, see Alenka Zupančič, *The Odd One In*.

32. Such relative lack of interest in photography's automatism or capacity for "candid" representation seems borne out by how Rødland borrows from some commercial photography genres but not others. Landscapes, portraits, still lifes, food, and erotica, yes; but no street photography or photojournalism—not even simulated (in the vein of Wall's *Mimic*) or fictional (in the vein of Stan Douglas's *Midcentury Studio* series).

33. It is useful here to think of Wallace Stevens's "Anecdote of the Jar," which opens on a device similar to Rødland's intrusive hands: "I placed a jar in Tennessee." The ensuing tension between the object and its environment becomes everything in Stevens's poem. This tension is exactly what is absent in Rødland's pictures.

34. Peretz, *Off-Screen*, 52, 28.

35. As Peretz puts it, as a genre landscape is the "vision of a world whose orientation has been suspended, a world whose meaning is not given to us but therefore the arena in which meanings can come about. The landscape is the freedom of the world not to be this or that specific world" (*Off-Screen*, 16).

36. It is an abstractness that blocks any impulse we might have to identify with their subjects, even as familiarity, scale, and composition would seem to solicit it. The social homogeneity of the pictures helps in this regard as well: "Whiteness pervades these images, and is especially noticeable in those where we see models. . . . It is reminiscent of the glossy whiteness of the hipster magazines that sometimes commission his work, the sanitized misogyny and artsy urbanity of *Dazed and Confused*, or *Purple*, or the early days of *Vice*—life-style rags that cater to the homogenous tastes and private transgressions of a liberal, affluent and well-educated creative class." See Walead Beshty, "Skin Flicks," in *Torbjørn Rødland: The Touch That Made You*, ed. Hans Ulrich Obrist and Yana Peel (London: Serpentine Galleries and Koenig Books, 2017), 112–28.

37. Brian Sholis makes a similar point. See Brian Sholis, "Torbjørn Rødland," *Aperture* 221 (Winter 2015): 68.

38. *Hands and Eyes, Portrait no. 3*, for example, seems to be a comic reversal of the situation in *Groped*. Now no longer intruding into but triumphantly enclosed within the picture's borders, the gimmick is here presented as vanquished or "dead": limp, flat, two-dimensional sheets of blank paper firmly in the grip of the hands of a model who uses them to cover her breasts.

39. It seems telling here that Rødland's photographs that come closest to looking "candid" or "documentary" are those of children in school plays: events specifically staged to provide adults opportunities for photography.

40. While many of Rødland's early works are serial works, the form favored by conceptual photography does not seem to govern his current practice in a consistent or overarching fashion. Indeed, Brian Sholis reports on the basis of an interview with Rødland in 2015 that the artist is "no longer working in series." Time will of course tell whether Rødland sticks to this or not. What is noteworthy in the meantime is his formulation of this distance from serial form as an explicit aesthetic stance. Sholis, "Torbjørn Rødland," 68.

41. The dating system points to how "at any given moment he has dozens of completed photographs waiting for an appropriate context in which to be published or exhibited." Sholis, "Torbjørn Rødland," 68. Note how it also shifts our overarching understanding of photography from the immobilization of instants to durational process—from what Wall calls photography's "optical intelligence" (in which the "ballistic" shooting stage with its precise capturing of reality is privileged) to its "liquid intelligence" (photography as unstable development). See Jeff Wall, "Photography and Liquid Intelligence," in *Jeff Wall, Selected Essays and Interviews*, ed. Peter Galassi (New York: Museum of Modern Art, 2007), 109–110. Wall's distinction is of crucial importance for Silverman's argument in *The Miracle of Analogy*; see especially chapter 3, pages 67–75.

42. Alberto Toscano, "The Open Secret of Real Abstraction," *Rethinking Marxism* 20, no. 2 (2008): 273–87, 277. This essay gives a rich overview of the stakes around the concept of real abstraction in Marxism and a careful parsing of the differences between commodity-centered and labor-centered takes on it.

43. Bob Nickas makes a closely related observation: "What if there's only one picture that keeps taking different forms, that mutates, is seen from various angles, facets and contours, with a cast of characters that enters and exits its permeable frame over time, that come forward and recede, some returning at later points . . . to appear and disappear?" See Bob Nickas, "Torbjørn Rødland: Fifteen Years Later," in Obrist and Peel, *Torbjørn Rødland*, 28–59.

44. Alfred Sohn-Rethel, *Intellectual and Manual Labour: A Critique of Epistemology* (Atlantic Highlands, NJ: Humanities Press, 1978), 33

45. Toscano, "Open Secret of Real Abstraction," 276.

46. Brenna Bhandar and Alberto Toscano, "Race, Real Estate and Real Abstraction," *Radical Philosophy* 194 (Nov/Dec 2015): 8–17, 9.

47. Toscano, "Open Secret of Real Abstraction," 277. Toscano is glossing an argument by Roberto Finelli, *Astrazione e dialettica dal romanticismo al capitalismo (saggio su Marx)* (Rome: Bulzoni Editore, 1987).

48. Toscano, "Open Secret of Real Abstraction," 276.

7. The Color of Value

1. Richard Haines, *Technicolor Movies: The History of Dye Transfer Printing* (Jefferson, NC: McFarland, 1993), 21, 140. On the Technicolor sound "blimp," see Jack Cardiff, *Magic Hour* (London: Faber and Faber, 1997), 75.

2. Murray Pomerance, "Notes on Some Limits of Technicolor: The Antonioni Case," *The Senses of Cinema* 53, December 2009, http://sensesofcinema.com/2009 /feature-articles/notes-on-some-limits-of-technicolor-the-antonioni-case. The rich golds and reds Argento achieved for *Suspiria* in the late 1970s, when Technicolor products were being phased out and thus relatively tricky to acquire, index this toggle between the discounted and opulent in more ways than one. Argento recalls that to re-create the look of Technicolor movies from the 1930s without the original cameras or film, and to capture the "difficult" colors of gold and red in particular, he and cinematographer Luciano Tovoli planned on using very low ASA film stock, which they thought they could easily acquire in the United States. Kodak, however, had run out. Argento and Tovoli managed to find some 40 ASA stock in a lab in Texas and bought all that was available. This, however, "wasn't very much," which meant that Argento had to economize while filming, shooting only single takes of each scene. See *Fear at 400 Degrees: The Cine-Excess of* Suspiria, directed by Xavier Mendik (Birmingham, England: Cine-Excess, 2009), esp. 16:12 to 17:46.

3. George Caffentzis, "Immeasurable Value? An Essay on Marx's Legacy," *The Commoner* 10 (Spring/Summer 2005): 87–114, 93.

4. Argento, interview, in *Fear at 400 Degrees*.

5. "Forms of appearance": Karl Marx, *Capital: A Critique of Political Economy*, vol. 3, trans. David Fernbach (London: Penguin Books and New Left Review, 1981), 772. My argument here is heavily indebted to Patrick Murray's analysis of the importance of Hegel's "essence logic" for Marx on the value form in *Capital*. See Patrick Murray, *The Mismeasure of Wealth: Essays on Marx and Social Form* (Chicago: Haymarket Books, 2017), esp. chapter 8, "The Necessity of Money: How Hegel Helped Marx Surpass Ricardo's Theory of Value," 249–76.

6. C. L. Hardin, *Color for Philosophers: Unweaving the Rainbow* (Indianapolis, IN: Hackett, 1993), 159. Cited in David Batchelor, *The Luminous and the Grey* (London: Reaktion Books, 2014), 53.

7. Batchelor, *Luminous and the Grey*, 54.

8. Batchelor, *Luminous and the Grey*, 54.

9. See Marx, *Capital*, vol. 3, 953.

10. Marx, *Capital*, vol. 3, 957. Inspired by their invocation in Thomas de Quincey's *Suspiria de Profundis*, Argento also imagines this bewitched world as presided over by a monstrous "trinity": Mother Suspiriorum, Our Lady of Sighs; Mother Lachrymarum, Our Lady of Tears; and Mother Tenebrarum, Our Lady of Darkness. The latter two figures preside over the other films in the series launched by *Suspiria*.

11. Patrick Murray, *Mismeasure of Wealth*, 258.

12. Caffentzis, "Immeasurable Value?," 93.

13. While it is clear to the serf when he or she is working on her own land as opposed to that of the lord, "the moment when the labor-time necessary to create

the value of his/her wage is finished and surplus labor-time begins is systematically obscured by the wage form and the general process of valuation" (Caffentzis, "Immeasurable Value?," 93).

14. Caffentzis, "Immeasurable Value?," 94.

15. "The basic error of the majority of Marx's critics consists of . . . their complete failure to grasp the qualitative sociological side of Marx's theory of value" (I. I. Rubin, *Essays on Marx's Theory of Value*, trans. Milos Samardzija and Fredy Perlman [Delhi: Aakar Books, 2010], 73–74). Cited in Patrick Murray, "Unavoidable Crises: Reflections on Backhaus and the Development of Marx's Value-Form Theory in the *Grundrisse*," in *In Marx's Laboratory: Critical Interpretations of the* Grundrisse, ed. Riccardo Bellofiore, Guido Starosta, and Peter D. Thomas (Leiden and Boston: Brill, 2013), 121–48, 129.

16. Caffentzis, "Immeasurable Value?," 96.

17. Ernst Bloch, "Nonsynchronism and the Obligation to Its Dialectics," trans. Mark Ritter, *New German Critique* 11 (Spring 1977): 22–38, 29.

18. Juliane Rebentisch, *Aesthetics of Installation Art*, trans. Daniel Hendrickson with Gerrit Jackson (Berlin: Sternberg Press, 2012); see especially "Spatial and Time-Based Art," 141–97, 190.

19. Pierre Bourdieu's sociology of art is useful for explaining how an artist, through a series of noncynically calculated, structurally determined position-takings, might end up inhabiting a place relatively sheltered from criticism. If this is arguably the case for Douglas—an installation artist with a modernist aesthetic marked by commitments to medium specificity, aesthetic autonomy, and minimalist beauty, even while working across a wide range of "postmodern" screen genres (including, most recently, theater and smartphone apps)—I suggest it only to highlight the anomalousness of the critical response to *Suspiria*. Douglas's work is also informed by a rigorous historicism which has reflexively enabled him to thematize the "failures" of modernism, or the "collapse" of its "utopias," in a distinctively modernist vein. See Pierre Bourdieu, *The Rules of Art: Genesis and Structure of the Literary Field*, trans. Susan Emanuel (Stanford, CA: Stanford University Press, 1995).

20. Stan Douglas, "Alienation and Parody," interview with Robert Storr, *Art Press* 262 (2000): 26–28. Cited in Anca Cristofovici, *Touching Surfaces: Photographic Aesthetics, Temporality, Aging* (New York: Rodopi, 2009), 188.

21. Okwui Enwezor, "Afterimages: Stan Douglas' *Le Détroit* and Comments on Other Works," *Nka: Journal of Contemporary African Art* 15 (Fall/Winter 2001): 18–25, 24.

22. Enwezor, "Afterimages," 25.

23. For a fascinating conservationist account of why Douglas's liking for incorporating obsolete technologies into the productions of his earlier works has made them difficult to archive, see "Nu•tka•, Stan Douglas," *DOCAM* (Documentation and Conservation of the Media Arts Heritage), accessed September 23, 2019, http://www.docam.ca/en/component/content/article/104-nutka-stan-douglas.

24. Philip Monk, "Discordant Absences," in *Stan Douglas*, ed. Friedrich Christian Flick Collection (Cologne: Friedrich Christian Flick Collection and DuMont Literatur und Kunst Verlag, 2006), 9–58, 46.

25. After the live gallery installation in Kassel, two other versions of *Suspiria* were made: one using 2 DVD players playing recorded scenes, and one playing back from a single Mac Mini.

26. Monk, "Discordant Absences," 46.

27. Rebentisch, *Aesthetics of Installation Art*, 183. Rebentisch is citing Boris Groys, "in der Autonomie des Betrachters. Zur Asthetik der Film installation," *Schnitt* 22 (2001): 12.

28. "Stan Douglas—Survey," David Zwirner, accessed October 6, 2019, https://www.davidzwirner.com/artists/stan-douglas/survey.

29. My italics. See "Stan Douglas—Survey."

30. Friedrich Christian Flick Collection, ed., *Stan Douglas* (Cologne: Friedrich Christian Flick Collection and DuMont Literatur und Kunst Verlag, 2006), 134.

31. Kobena Mercer, "Documenta 11," *Frieze* 69, September 9, 2002, accessed October 9, 2019, https://frieze.com/article/documenta-11-2.

32. Mercer, "Documenta 11."

33. See P.9a-b in *Oxford English Dictionary*, 3rd ed. (2003), s.v. "number," in which American and British uses of the phrase are shown to strikingly diverge in evaluative emphasis in spite of a shared military heritage. Doing something by the numbers is to do it "with military precision" in the former (P.9a) but to do it "in a schematic, unimaginative manner" in the latter (P.9b). Astonishingly, the *OED* offers phrasal sub-entries for "dial down," "dial up," "dial into," and even an entry for "dial for dollars" under "dial," but nothing for "dial it in." Quotations in body text come from *Your Dictionary*, s.v. "dial it in," accessed October 6, 2019, https://www.yourdictionary.com/dial-it-in. The account of the phrase's origin in this crowd-sourced dictionary emphasizes its associations with precision or accuracy over that of unimaginative performance: "Often, complex systems have many dials, which need to be tweaked for optimal performance. Thus, dialing it in involves moving the various dials until the system is performing better."

34. Stan Douglas, "*Suspiria* Draft 7.0" (February 4, 2003), 1–77, 1.

35. Stan Douglas, "Artist's Talk," Architectural Association School of Architecture, London, February 15, 2008, YouTube video, 1:31:57, https://www.youtube.com/watch?v=5Y_L-Ebccb8.

36. David Zwirner, "*Suspiria* Press Release," March 13, 2003–April 12, 2003, https://www.davidzwirner.com/exhibitions/suspiria/press-release.

37. To my knowledge, there has not been another since. After *Suspiria*, Douglas seems to have returned to his "clean" look, in explicitly metamodernist projects like *Midcentury Studio*, *Luanda-Kinshasa*, and *The Secret Agent*.

38. Wikipedia, s.v. "NTSC," Wikipedia: The Free Encyclopedia, last modified December 2014, https://en.wikipedia.org/w/index.php?title=NTSC&oldid=875440371.

39. Hardin, *Color for Philosophers*, 33.

40. Hardin, *Color for Philosophers*, 33.

41. Hardin, *Color for Philosophers*, 33.

42. The engineering behind this dovetails in an interesting way with the modern opponent-process theory of color vision, which discovered, based on the striking overlap or redundancy of absorption spectra on the part of our three retinal cones ("blue," "green," and "red"; or more accurately, shortwave, mediumwave, and

longwave), that if the neural output signals of cone types were simply *added*, they would not be able to differentiate wavelength from intensity information. This in turn led to a theory of color perception as neurologically contrastive and inhibitive: we see colors because of a secondary cognitive process in which the signals from one cone are *subtracted* from those coming from other cones (Hardin, *Color for Philosophers*, 31). There is a parallel, then, between NTSC color television's ingenious technique of having chrominance signals "ride piggyback" on luminance signals, "letting the transmission and detection circuitry do double duty" and separating the two signals at the receiver, and the eye's differencing system for receptor outputs in relaying color information to the brain (33). As Hardin notes: "We recall that the retinal image is sampled by more than 120 million receptors, of which 7 million are foveal cones. Yet all of that information must be transmitted over an optic nerve that contains only 1.2 million fibers" (33). "Transmission economy" is therefore required, and achieved in part "by letting the achromatic system handle fine resolution: psychophysical experiments show that small spatial differences in *luminance* (light energy flow per unit area) are more easily detected than small spatial differences in wavelength with constant luminance." As he continues, "The other part can be achieved by exploiting the redundancy inherent in the considerable overlap of the absorption spectra of the cones. Because of this, the only chromatic information that needs to be transmitted are the *differences* of the outputs, a far more economic alternative than transmitting the output for each cone type separately" (33).

43. "Suspiria," in Flick Collection, *Stan Douglas*, 134–36, 135.

44. "Suspiria," in Flick Collection, *Stan Douglas*, 134–36, 135.

45. Because what Douglas calls the "chrominance gag" accentuates reds and magentas, the vivid greens were in fact achieved by an even more old-fashioned "special effect": face makeup. Personal communication, March 12, 2019.

46. Bloch, "Nonsynchronism," 29.

47. Pomerance, "Notes on Some Limits of Technicolor."

48. Batchelor, *Luminous and the Grey*, 50.

49. Marx, *Capital: A Critique of Political Economy*, vol. 1, trans. Ben Fowkes (London: Penguin, 1976), 128. "Spectral objectivity" is Michael Heinrich's amended translation of Fowkes's "phantom-like objectivity." See Michael Heinrich, *An Introduction to the Three Volumes of Karl Marx's Capital*, trans. Alexander Locascio (New York: Monthly Review Press, 2004), 49.

50. See Marx, *Capital*, vol. 1, 188n1. Socialist proponents of "labor-money" included Proudhon and Owen.

51. Heinrich, *An Introduction*, 53.

52. Marx, *Marx Engels Gesamtausgabe* (MEGA) 2.6: 30–31, trans. Alex Locascio; cited in Heinrich, *An Introduction*, 53.

53. Heinrich, *An Introduction*, 53.

54. Riccardo Bellofiore, "The *Grundrisse* after *Capital*, or How to Re-read Marx Backwards," in Bellofiore, Starosta, and Thomas, *In Marx's Laboratory*, 17–42, 30.

55. Riccardo Bellofiore: "The body of which value takes possession is that of commodity-money. . . . [Money as commodity] is . . . essential not so much for . . . [Marx's] monetary theory . . . *than for its function as guarantee of the very existence of a nexus between value and labour*" (The *Grundrisse* after *Capital*, 30; my emphasis).

56. Douglas, "*Suspiria* Draft," 69–70. Quotation marks in original.

57. Marx, *Capital*, vol. 1, 873; cited in Douglas, "*Suspiria* Draft," 2.

58. Douglas, "*Suspiria* Draft," 2, 2, 2, 4.

59. Alfred Sohn-Rethel, *Intellectual and Manual Labor: A Critique of Epistemology* (Atlantic Highlands, NJ: Humanities Press, 1978), 22. I invoke this concept because of the emphasis on exchange in Douglas's way of visualizing the phantom-like objectivity of value's social substance (abstract labor). For this reason it is important to clarify that Sohn-Rethel's value theory is what Patrick Murray calls an "exchange-only view," in contrast to theories that regard value and its magnitude as "co-constituted" in production and circulation. In the latter view, value is regarded as a "supersensible social property intrinsic to the commodity as a potential, arising in production, whose magnitude is not fully determinate until that potential is actualized with the final act of social validation, the sale of the commodity." See Murray, "Avoiding Bad Abstractions: A Defence of Co-Constitutive Value-Form Theory," in *The Mismeasure of Wealth*, 425–42, 427.

60. Karl Marx, *Capital*, vol. 1, 165. "The products of labour become commodities, sensuous things which are at the same time suprasensible or social."

61. Flick Collection, *Stan Douglas*, 136.

62. Flick Collection, *Stan Douglas*, 136.

63. Examples of this abound: "Twelve Tubs of Popcorn and a Gallon of Coke, Please: Adrian Searle Settles Down for Stan Douglas's Latest, 157-Hour Movie," *Guardian*, March 5, 2002, https://www.theguardian.com/arts/critic/feature /0,,728606,00.html; Tess Thackara, "When Apps Double as Art: Stan Douglas Pushes the Envelope with 'Circa 1948.'" *Artsy*, August 13, 2014, https://www.artsy.net /article/tess-thackara-when-apps-double-as-art-stan-douglas-pushes.

64. Douglas, "Artist's Talk," February 15, 2008.

65. James Boggs, *The American Revolution: Pages from a Negro Worker's Notebook* (New York: Monthly Review Press, 1968), 110.

66. David Zwirner, "*Journey into Fear* Press Release," November 8–December 22, 2001, https://www.davidzwirner.com/exhibitions/journey-fear/press-release.

67. Matt Thorne, "Journey into Fear and Melville's *The Confidence-Man*," in *Stan Douglas, Journey into Fear*, ed. Serpentine Gallery (Cologne: Verlag der Buchhandlung Walther König, 2002), 19–23, 20.

68. Review of *The Confidence-Man*. *London Illustrated Times*, April 25, 1857. Cited in Thorne, "Journey into Fear and Melville's *The Confidence-Man*," 19.

69. Monk, "Discordant Absences," 45. Douglas enlisted novelist Michael Turner as coauthor for this script.

70. Serpentine Gallery, ed., *Stan Douglas, Journey into Fear* (Cologne: Verlag der Buchhandlung Walther König, 2002), 63, 43.

71. As Chion points out, all nonsilent film is subjected to sound post-synchronization, even when no dubbing is involved. Even location sound is always "skimmed of certain substances and enriched with others" (*Audio-Vision: Sound on Screen*, ed. and trans. Claudia Gorbman with a foreword by Walter Murch [New York: Columbia University Press, 1994], 95–96). In a sense, then, nothing could be more ordinary or essential to sound film than the technique of separating

the voice from the body and recombining it with another. Yet as Chion also emphasizes, nothing has been regarded as more obtrusive or unsettling—which is why "acousmatic" sound is often used as a gimmick for generating suspense. Conversely, in films ranging from the *Wizard of Oz* to *Psycho*, the "de-acousmatization" of sound typically coincides with the *alleviation* of suspense, in which the true identity of a killer or self-professed wizard is revealed. See Michel Chion, *Audio-Vision*, 17–30.

72. Frederic Chaume, "Synchronization in Dubbing: A Translational Approach," in *Topics in Audiovisual Translation*, ed. Pilar Orero (Amsterdam: John Benjamins Company, 2004), 35–52.

73. Chion, *Audio-Vision*, 63.

74. Chion, *Audio-Vision*, 70.

75. Douglas, "*Suspiria* Draft," 69.

76. As feminists have noted, the wage form also hides a relation between the waged and the nonwaged, and thus a direct transaction between (variable) capital and women mediated (and cloaked) by the male worker, as we will see in more detail in Chapter 8.

77. Douglas, "*Suspiria* Draft," 40.

78. While dubbed movies are rarely seen in the United States, revoicing has been used in the Italian production of Italian films and television for almost a century. The reasons for the difference go back to Mussolini's bans on foreign language films in 1929 and foreign words in domestic movies in 1934, which quickly made dubbing into a national industry. Dubbing of Italian as well as foreign films continued apace after 1945, due in part to the industry's reliance on war surplus equipment (as one director put it, "most cameras were so noisy it was impossible to record live sound") but primarily tradition. See Roderick Conway Morris, "When in Rome, Don't Trust Actors' Voices," *New York Times*, December 18, 1992. Even in the heyday of Italian filmmaking in the 1960s and 1970s, dubbing came to be artistically preferred by some auteurs, including Fellini and Argento: the entire soundtrack for *Suspiria* was recorded in postproduction. Today, Italy remains the "pre-eminent dubbing country, apparently less inclined to switch to the subtitling practice as other countries." Emilio Audissino, "Italian 'Doppiaggio' Dubbing in Italy: Some Notes and (In)famous Examples," *Italian Americana* 30 (Winter 2012): 22–32, 22.

79. Chion, *Audio-Vision*, 65.

80. Michel Chion, *The Voice in Cinema*, ed. and trans. Claudia Gorbman (New York: Columbia University Press, 1999), 130–31.

81. *Macgyvering*, based on the late 1980s American action-adventure television series MacGyver, brings out this latter aspect of the term but without its more equivocal positioning between meaning ingenuity under pressure *and* clumsy work. The top definition for the *macgyver* in the *Urban Dictionary* is: "Someone who can jump-start a truck with a cactus" (Urban Dictionary, s.v. "macgyver," August, 20, 2003, https://www.urbandictionary.com/define.php?term=Macgyver).

82. With its connotation of improvisation *under pressure*, jerry-rigging is implicitly something only living labor can do. Machines catch and fix errors and grow smarter as a result, but for exactly this reason they do not really jerry-rig anything.

83. Even dubbing's defenders, objecting to the class snobbery that sometimes subtends distaste for revoiced films and the supposedly passive audiences who prefer them, find themselves admitting to unease with the aesthetic technique. As one critic writes, making a plea for better scholarly recognition of dubbing's theoretical importance, "How ironic that a professional field with . . . such widespread exposure to masses of people, with so much power to influence and promote intercultural and artistic understanding, is so vastly underestimated or even deprecated." At the same time she admits: "A regrettable yet undeniable sham quality pervades the image of dubbing." Candace Whitman-Linsen, *Through the Dubbing Glass: The Synchronization of American Motion Pictures into German, French, and Spanish* (Frankfurt am Main and New York: Peter Lang, 1992), 9.

84. Amitai Ziv and Ruth Schuster, "The Startup That Auto-Dubs Movies," *Haaretz*, October 1, 2014, https://www.haaretz.com/israel-news/business/the-startup -that-auto-dubs-movies-1.5309783.

85. Frederic Chaume, *Audiovisual Translation: Dubbing* (Manchester, UK: St. Jerome Publishing, 2012), 36. Cited in Charlotte Bosseaux, *Dubbing, Film and Performance: Uncanny Encounters* (Bern, Switzerland: Peter Lang, 2015), 55–84, 61.

86. Chaume, *Audiovisual Translation*, 37; cited in Bosseuaux, *Dubbing, Film and Performance*, 62.

87. Chaume, *Audiovisual Translation*, 18; cited in Bosseuaux, *Dubbing, Film and Performance*, 63.

88. Douglas, "Artist's Talk," February 15, 2008.

89. See Bosseaux, *Dubbing, Film and Performance*, 57. Similarly, as Scott Higgins notes, while Technicolor's peak usage happened between 1945 and 1955, "the basic methods . . . were set in place [by the 1930s]." Scott Higgins. *Harnessing the Technicolor Rainbow: Colour Design in the 1930s* (Austin: University of Texas Press, 2007), 210.

90. The Technicolor *Corporation*, however, lives on today as a "creator and manager of digital assets" (printing DVDs and making set-top boxes for home televisions). Charlie Fink, "How Technicolor Saved Itself from Creative Destruction," *Forbes*, May 26, 2017, https://www.forbes.com/sites/charliefink/2017/05/26/how -technicolor-saved-itself-from-creative-destruction.

91. On subjective camera as the POV of the psychopath, see Carol Clover, *Men, Women, and Chain Saws: Gender in the Modern Horror Film* (Princeton, NJ: Princeton University Press, 1992), 186–87.

92. Jason E. Smith, "Nowhere to Go: Automation, Then and Now Part Two," *Brooklyn Rail*, "Field Notes." April 1, 2017. Xiang Bo, "Economic Watch: Service Industry Steering China's Firm Growth." *Xinhuanet*, July 30, 2018. In September 2018, the World Bank and International Labour Organization reports a higher number: according to their data, service jobs represented 56 percent of total employment in China in 2017. See https://data.worldbank.org/indicator/SL.SRV .EMPL.ZS.

93. Smith, "Nowhere to Go."

94. Aaron Benanav and John Clegg (Endnotes), "Misery and Debt," in *Contemporary Marxist Theory*, ed. Andrew Pendakis, Jeff Diamanti, Nicholas Brown, Josh Robinson, and Imre Szeman (London: Bloomsbury, 2014), 585–608, 596.

Benanav and Clegg also define "services" as labor processes that have undergone formal but not real subsumption. Why does this matter for thinking about the anxiety about expanded reproduction I am arguing the gimmick reflects? Benanav and Clegg's clarity on an issue that often gets confusing and messy in Marxist debates makes their discussion worth quoting in full:

> Of course the bourgeois concept of "services" is notoriously imprecise, including everything from so-called "financial services" to clerical workers and hotel cleaning staff, and even some outsourced manufacturing jobs. Many Marxists have tried to assimilate the category of services to that of unproductive labor, but if we reflect on the above characterisation it becomes clear that it is closer to Marx's conception of "formal subsumption." Marx had criticised Smith for having a metaphysical understanding of productive and unproductive labor—the former producing goods and the latter not—and he replaced it with a technical distinction between labor performed as part of a valorisation process of capital and the labor performed outside of that process for the immediate consumer. In the Results of the Direct Production Process Marx argues that theoretically all unproductive labor can be made productive, for this means only that it has been formally subsumed by the capitalist valorisation process. However, formally subsumed activities are productive only of absolute surplus value. In order to be productive of relative surplus value it is necessary to transform the material process of production so that it is amenable to rapid increases in productivity (co-operation, manufacture, large-scale industry and machinery)—i.e. real subsumption. When bourgeois economists . . . speak of "technologically stagnant services" they recall without knowing it Marx's concept of a labor process which has been only formally but not really subsumed.
>
> Thus as the economy grows, real output in "services" tends to grow, but it does so only by adding more employees or by intensifying the work of existing employees, that is, by means of absolute rather than relative surplus value production. In most of these sectors wages form almost the entirety of costs, so wages have to be kept down in order for services to remain affordable and profitable, especially when the people purchasing them are themselves poor: thus McDonald's and Walmart in the US—or the vast informal proletariat in India and China. (597)

95. "Teaching tends to involve one or at most two teachers per classroom, with no complex parsing of the labor process. . . . More children can be added to the classroom, but at the expense of the quality of the instruction; the time of teaching cannot be sped up beyond certain rigid limits without a similar, deleterious, effect. Think, alternately, of a nurse specializing in physical therapy: here, too, the quality of the service will be diminished severely once the number of patients reaches a certain threshold, or the time of treatment is reduced beyond a bare minimum." Smith, "Nowhere to Go."

96. Smith, "Nowhere to Go."

97. George Caffentzis, "From the *Grundrisse* to *Capital* and Beyond: Then and Now," in Bellofiore, Starosta, and Thomas, *In Marx's Laboratory*, 265–84, 279. Marx's concept of the "organic composition of capital" (OCC) represents the ratio of constant to variable capital, or ratio of the *value* of means of production to the *value* of employed labor power, as inflected by changes in the ratio of the *physical mass* of both variables (the "technical composition of capital"). See *Capital* vol. 1, 762.

98. As Benanav and Clegg report, the reason for why industrial expansion between 1993 and 2006 in China did not create new manufacturing jobs leading to

a historic increase in the size of the industrial working class is twofold. First, rapid industrialization of the South was matched by equally rapid deindustrialization in the Northeast. Second, "the incorporation of existing labor-saving innovations into the firms of developing countries" means that "even with . . . geographic expansion, each set of industrialising countries has achieved lower heights of industrial employment (relative to total labor force)." China has therefore not only shed manufacturing jobs in older industries; "the new industries have absorbed tendentially less labor relative to the growth of output." See Endnotes, "Misery and Debt," 603.

99. Sarah Brouillette, "Wageless Life," *Los Angeles Review of Books*, October 27, 2018, https://lareviewofbooks.org/article/wageless-life.

100. Smith, "Nowhere to Go."

101. Caffenzis, "From the *Grundrisse* to *Capital*," 272.

102. Brouillette, "Wageless Life"; Smith, "Nowhere to Go."

103. Jasper Bernes, "Logistics, Counterlogistics and the Communist Prospect," *Endnotes* 3 (September 2013): n.p. As Bernes notes, the power of logistics is not just speed or the spatial extension of world market, but the "power to coordinate and choreograph . . . to conjoin and split flows; to speed up and slow down."

8. Henry James's "Same Secret Principle"

1. Singled out by both Ian Watt and Seymour Chatman in their accounts of the late style's "intangibility," the phrase "same secret principle" comes from the first paragraph of *The Ambassadors* (1903). It alludes to a hidden logic motivating the actions of its central character—which, in one of the gimmick's characteristic deflations, turns out to be nothing more than Strether not really wanting to hang out with Waymarsh on arriving in Europe. Seymour Chatman, *The Later Style of Henry James* (Oxford: Basil Blackwell, 1974), 6–10. Ian Watt, "The First Paragraph of *The Ambassadors*," in *Henry James: A Collection of Critical Essays*, ed. Ruth Bernard Yeazell (Englewood Cliffs, NJ: Prentice Hall, 1994), 118–34. Henry James, *The Novels and Tales of Henry James, The New York Edition*, vol. 21, *The Ambassadors* (New York: Charles Scribner's Sons, 1909), 3.

2. James's typists were William MacAlpine, Mary Weld, and Theodora Bosquanet.

3. Leon Edel, *Henry James: A Life* (New York: Harper and Row, 1985), 455 and 456.

4. Henry James, *The Golden Bowl* (New York: Penguin, 2009), 221.

5. F. R. Leavis, "The Later James," in *The Great Tradition: A Study of the English Novel* (Garden City, NJ: Doubleday, 1954), 188–210, 204.

6. Edel, *Henry James*, 456.

7. See, for example, Theodora Bosanquet, *Henry James at Work*, ed. Lyall. H. Powers (Ann Arbor: University of Michigan Press, 2006); Pamela Thurschwell, "Henry James and Theodora Bosanquet: On the typewriter, *In the Cage*, at the Ouija board," *Textual Practice* 13, no. 1 (1999): 5–23; Richard Menke, "Telegraphic Realism: Henry James's *In the Cage*," *PMLA* 115, no. 5 (2000): 975–90; Hazel

Hutchison, "'An Embroidered Veil of Sound': The Word in the Machine in Henry James's *In the Cage*," *The Henry James Review* 34, no. 2 (2013): 147–162. On the living labor component of dictation and the role played by typewriter in domesticating office work, see Jennifer L. Fleissner, "Dictation Anxiety: The Stenographer's Stake in Dracula," in *Literary Secretaries*, ed. Leah Price and Pam Thurschwell (London: Routledge, 2018), 63–90.

8. By the 1890s, at De Vere Mansions, James employed a butler and cook, Mr. and Mrs. Smith (more on them below). They would be joined after James's move to Rye in 1898 by fourteen year-old Burgess Noakes, originally hired as a "houseboy" and eventually as James's valet. The Smiths were fired in 1901. Writing in 1904 to the tenant who would be renting Lamb House during his year in the United States, James mentions four live-in servants: Noakes, cook-housekeeper Mrs. Paddington, parlor-maid Alice Skinner, and an unnamed housemaid. James's gardener, George Gammon, lived in a cottage on the estate. See *Henry James Letters*, ed. Leon Edel, 4 vols., *Volume 4: 1895–1916* (Cambridge, MA: Harvard University Press, 1984), 311–12. See also H. Montgomery Hyde, "The Lamb Household," *Henry James at Home* (London: Methuen, 1969), 130–178.

9. Edel, *Henry James*, 480–83.

10. Edel notes that James's "precocious little females grow a little older in each book, as if they were a single child whose life experience is being traced . . . to coming-of age. See *Henry James*, 481.

11. Henry James, *The Turn of the Screw* (New York: Bedford/St. Martin's, 2003), 28.

12. Julie Rivkin, *False Positions: The Representational Logics of Henry James's Fiction* (Stanford, CA: Stanford University Press, 1996), 2.

13. I am reusing a metaphor from Eve Sedgwick's "Around the Performative: Periperformative Vicinities in Nineteenth-Century Narrative," in *Touching Feeling: Affect, Pedagogy, Performativity* (Durham, NC: Duke University Press, 2003), 67–92. On "kin work," see Micaela di Leonardo, "The Female World of Cards and Holidays: Women, Families, and the Work of Kinship," *Signs* 12 (Spring 1987): 440–53, 442.

14. Robert Pippin, *Henry James and Modern Moral Life* (Cambridge: Cambridge University Press, 2000, 6–7. On the structure of feeling he calls "imperial neglect," or the divestment of England's investment in the West Indies and its impact on those living there, see Chris Taylor, *Empire of Neglect* (Durham, NC: Duke University Press, 2018).

15. We might also grandfather in the earlier *The Portrait of a Lady*, reading Isabel Archer's decision to turn down a relationship defined by sexual and financial freedom for a coercive marriage as stemming from an implicit decision to assume responsibility for and "rescue" her adult step-daughter Pansy, punitively sequestered by her father in a nunnery.

16. Henry James, *The Golden Bowl* (New York: Penguin, 2009), 546.

17. Henry James, "The Beast in the Jungle," in *Complete Stories: 1898–1910* (New York: Library of America, 1996), 496–541, 497.

18. Henry James, *What Maisie Knew* (New York: Penguin, 1985), 84.

19. James, *What Maisie Knew*, 77.

20. Pippin, *Henry James and Modern Moral Life*, 6.

21. David Kurnick, "What Does Jamesian Style Want?," *The Henry James Review* 28, no. 3 (Fall 2007): 213–22.

22. Kent Puckett, *Narrative Theory: An Introduction* (Cambridge: Cambridge University Press, 2016), 127.

23. Henry James, "The Birthplace," in *Complete Stories*, 441–95; 442, 441.

24. "Humbug": James, *The Golden Bowl*, 182.

25. James, "The Birthplace," 490.

26. Each of the three tales in the collection has, moreover, a meta-literary dimension, pointing "inward" to formal questions concerning narrative structure, timing, and plot ("The Beast in the Jungle"), or "outward" to modern cultures of literary production and reception ("The Birthplace"; "The Papers").

27. Chatman, *Later Style of Henry James*, 44, 54.

28. Chatman, *Later Style of Henry James*, 61, 62, 62.

29. "David Howard, Henry James and 'The Papers'" in *Henry James: Fiction as History*, ed. Ian F. A. Bell (London: Vision Press, 1984), 55.

30. James, "The Birthplace," 458.

31. Dorothea Krook, *The Ordeal of Consciousness* (Cambridge: Cambridge University Press, 1962), 391. In her appendix on "The Late Style," Krook refers to the golden bowl in particular as a "clumsy, artificial graft—a scissors-and-paste image" (391–92). "[There] is even a certain physical incongruity, so to speak, in the presence of this large, hard, shiny, insistently material object in a world otherwise composed entirely of the non-material substance of consciousness" (392). On "azure" as a metaphor for "cliché," see Barbara Johnson, "Les Fleurs du Mal Armé: Some Reflections on Intertextuality," in *A World of Difference* (Baltimore, MD: Johns Hopkins University Press, 1987), 116–36, 120.

32. Leavis, "The Later James," 204.

33. Ruth Bernard Yeazell, *Language and Knowledge in the Late Novels of Henry James* (Chicago: University of Chicago Press, 1976), 40; Chatman, *Later Style of Henry James*, 110.

34. David Lodge, "Strether by the River," in *Language of Fiction* (London: Routledge, 2001), 200–226, 208, 211; Chatman, *Later Style of Henry James*, 47.

35. Yeazell, *Language and Knowledge*, 46.

36. It has been argued that this movement between extremes is a feature of "late style" in general. Indeed, in a way useful for thinking about James's interest in the gimmick form, the critical discourse surrounding late style has toggled between seeing it as intensified and simply bad style. As Adorno writes on Beethoven: "His late work still remains process, but not as development; rather *as a catching fire between extremes*, which no longer allow for any secure middle ground or harmony of spontaneity." See Theodor Adorno, "Late Style in Beethoven," *Raritan* 13, no. 1 (Summer 1993): 102–108, 108 (my italics). See also Edward W. Said, *On Late Style: Music and Literature Against the Grain* (New York: Pantheon Books, 2006). While focusing on individual artists rather than larger patterns of collective production, Said and Adorno's accounts recall art historian's George Kubler's arguments about "late solutions" in *The Shape of Time*. Kubler argues that while "early

solutions (protomorphic)" to a given problem [Kubler's definition of "form"] are "technically simple [and] expressively clear," "late solutions (neomorphic) are costly, difficult, intricate, recondite, and animated." See George Kubler, *The Shape of Time* (New Haven, CT: Yale University Press, 2008), 56.

Leo Bersani makes the opposite point, if in a way that reinforces Adorno's argument about late style's extremities: "Writers, painters, filmmakers frequently move in their late work not toward a greater density of meaning and texture, but rather toward a kind of concentrated monotony that designates a certain negativizing effect inherent in the aesthetic." Bersani's main example is the "at times staggering thinness of meaning in James's late novels." He also mentions "Turner's nearly monochromatic late seascapes, the almost imperceptible variations within the dark coloring of the walls in the Rothko Chapel, the willed thinness of Beckett's last fictions . . . the nearly subjectless banality of Flaubert's *Bouvard and Péchuchet*, the relentless reduction of variegated actual behavior to abstract laws of behavior in Proust's *La Fugitive*, the erasure of abstraction itself in Mallarmé's obsessively present *page blanche*." See Leo Bersani, "The It in the I: Patrice Leconte, Henry James, and Analytic Love," *The Henry James Review* 27, no. 3 (2006): 202–214.

"Staggering thinness," "relentless reduction," and the "erasure of abstraction itself": valorized by Bersani for the ways they reflect the virtuality or "phenomenological blankness" of art symbolized in John Marcher's indeterminate character, the characteristics mentioned here are instances of both excess and lack. They represent *too much* of the too little. If there thus is a strange minimalism at the heart of James's more frequently discussed maximalism (his verbosity, indirection, and complex sentences driven into the conditional by preterition), for Bersani it has everything to do with the negativity of late style, which brings out a "certain negativizing effect" in art overall. Here "nothing" is the theoretical key to everything.

But what if the negativity of late style is due to bad craft? Lytton Strachey suggests this in "Shakespeare's Final Period" (1904), written as a rejoinder to Edward Dowden's sentimental account of the late work as the culmination of a spiritual journey. For Strachey, late Shakespeare shows signs of boredom and laziness. It relies excessively on "rhetoric" and its arts of persuasion, foreclosing the effort to align literature with loftier discourses like history. It indulges in showboating that ends up underscoring the triviality of poetry: an abandonment of character and plot for "rhythmical effect," "hopeless anachronisms," and ornamental details akin to Beethoven's unmotivated trills. We could thus say that late style for Strachey is gimmick-prone style. Epitomized in the "medley of poetry, bombast, and myth" of Cymbeline's speeches, its verbal excesses are a symptom of a vacuity at its center. Lytton Strachey, "Shakespeare's Final Period," in *Books and Characters*, accessed October 9, 2019, https://ebooks.adelaide.edu.au/s/strachey/lytton/books _and_characters/chapter3.html. See also Russ McDonald, *Shakespeare's Late Style* (Cambridge: Cambridge University Press, 2006), which in taking the same features Strachey identifies as signs of professional ambivalence, invites us to "[consider] the possibility that, up to a point and in a way he did not intend, Strachey was right" (12).

37. David Halverson refers to it as "that rather zany production." See "Late Manner, Major Phase," *The Sewanee Review* 79, no. 2 (Spring 1971): 214–31, 225.

38. See for instance Stacey Margolis, "Homo-Formalism: Analogy in *The Sacred Fount*," *Novel: A Forum on Fiction* 34, no. 3 (Summer 2001): 391–410.

39. Henry James, *The Sacred Fount* (New York: New Directions, 1983), 97, 72, 151.

40. Henry James, *The Turn of the Screw*, ed. Peter Beidler (New York: Bedford, 2003), 39.

41. "Vampires: A Story about Them by Henry James," *New York Tribune*, February 9, 1901, 8. In *Henry James, The Contemporary Reviews*, ed. Kevin J. Hayes (Cambridge: Cambridge University Press, 1996), 337–39, 337.

42. "Little concetto": *The Complete Notebooks of Henry James*, ed. Leon Edel and Lyall Powers (Oxford: Oxford University Press, 1987), 176.

43. James, *The Sacred Fount*, 34.

44. See Chatman, *Later Style of Henry James*, 5, 109–112.

45. James, *The Sacred Fount*, 34.

46. Mark McGurl, "Social Geometries: Taking Place in Henry James," in *The Novel Art: Elevations of American Fiction after Henry James* (Princeton, NJ: Princeton University Press, 2001), 57–77.

47. Sergio Perosa, "Rival Creation and the Antinovel," in *Henry James and the Experimental Novel* (New York: New York University Press, 1983), 77–106.

48. Edel and Powers, *Complete Notebooks of Henry James*, 176.

49. James, *Letters*, 185, 186.

50. James, *The Sacred Fount*, 49.

51. As Chatman reminds us, abstraction is "strictly speaking . . . an act, not an entity," involving the "selection of a given feature common to a number of different entities" (*Later Style of Henry James*, 3). James's liking for deictics; for the creation of phenomenological substantives out of adjectival qualities (*strangeness* from *strange*); and for "'logical' terms, terms for 'aspects, conditions and relations' . . . which hardly sound like words in a novel" (46; citing Krook) point to a desire to generalize which in turn registers an awareness on the part of his characters that "behind every petty individual circumstances there ramifies an endless network of general moral, social and historical relations" (Watt, "The First Paragraph," 126–27). On top of this, the abstractions that suffuse James's stories might be regarded as stand-ins for other sorts of rationality. The "grammatical submergence" of human actors to these elements in James's prose implies that his social analysts know that they live in a world permeated and governed by capitalist abstractions: collectively generated appearances belonging to, and indispensable for sustaining, an underlying set of gendered relations binding labor to "value" (Chatman, *Later Style of Henry James*, 35). Originating in social activity rather than thought, these reifying appearances have an objective existence, which is perhaps why abstraction ("relation") in James always comes laminated to the crudely concrete ("turkey"); for why his "intangibles" are *entitized* intangibles, or for why his style *converts* mental acts *into* objects; for why vehicles often seem so semantically close to their tenors that his metaphors barely seem like metaphors; for why these metaphors therefore sometimes seem to become magically literal, popping up as "things" in the novel's object-worlds.

52. James, *The Golden Bowl*, 337.

53. On the historical and conceptual convergence of these two discourses, see George Caffentzis, "A Critique of 'Cognitive Capitalism,'" in *Letters of Blood and Fire: Work, Machines, and the Crisis of Capitalism* (Oakland, CA: PM Press, 2013), 95–126.

54. "You help me to pass for a man like another": James, "The Beast in the Jungle," 517.

55. The vehicle ("cicerone") is here already not far from the tenor (Charlotte's function or "job" in relation to her husband and his property), and we will soon see why this is important.

56. James, *The Golden Bowl*, 536.

57. Mark Seltzer, "The Vigilance of Care," in *Henry James and the Art of Power* (Ithaca, NY: Cornell University Press, 1984), 92.

58. Seltzer, "Vigilance of Care," 61.

59. James, *The Golden Bowl*, 386.

60. Julian Murphet, "Aesthetic Perception and 'the Flaw': Towards a Jamesonian Account of Late James," *The Henry James Review* 36, no. 3 (2015): 226–33, 232.

61. James, *The Golden Bowl*, 467.

62. Chris Baldick, *The Oxford Dictionary of Literary Terms*, 3rd ed. (Oxford: Oxford University Press, 2008), 127; cited in Puckett, *Narrative Theory*, 124. The language in which Puckett glosses James's concept is especially noteworthy for us: "[Merely] functional characters like the ficelle are cogs in a narrative machine; they are agents or objects of narrative exchange and thus represent the labor (as, perhaps, opposed to craft) of fiction at its least organic. As a result, these characters tend, once they have fulfilled their function, to be lost, abandoned, or forgotten. . . . [The] ficelle is a point where the narrative machine as machine reveals itself; the *ficelle works* and because it works, it alerts us to the strings pulled behind any apparently seamless act of narrative representation" (124).

63. Puckett, *Narrative Theory*, 127.

64. James, "Preface," in *The Portrait of a Lady* (New York: Penguin, 1984), 53.

65. Alex Woloch highlights this dynamic—an ironic symptom of the very flattening or formalist reduction of the minor character—in his study of character systems. See *The One vs. the Many: Minor Characters and the Space of the Protagonist in the Novel* (Princeton, NJ: Princeton University Press, 2009), especially the second chapter, "Making More of Minor Characters," 125–67. On the representation of the servant in Wilde, Huysmans, and James as adding a further twist to Woloch's analogy between social domination and narrative functionalization, see Andrew Goldstone, "Servants, Aestheticism, and 'The Dominance of Form,'" *English Literary History* 77 (Fall 2010): 615–43. On the importance of servants in James's writings in the 1890s and for his experiments in the representation of consciousness, see Stuart Burrows, "The Place of a Servant in the Scale," *Nineteenth-Century Literature* 63 (June 2008): 73–103.

66. James, "Preface," *The Portrait of a Lady*, 53.

67. James, "Preface," *The Portrait of a Lady*, 55.

68. James, "Preface," *The Ambassadors* (New York: Charles Scribner's Son's, 1909), xx; my emphasis.

69. James, "Preface," *The Portrait of a Lady*, 51–52.

70. Chatman, *Later Style of Henry James*, 10.

71. James, "Preface," *The Portrait of a Lady*, 52.

72. Certainly others before me have regarded James as a cognitive mapper: "[aware] that behind every petty individual circumstance there ramifies an endless network of general, moral, social, and historical relations." See Ian Watt, "The First Paragraph," 126–27. See also the special issue of *The Henry James Review* on James and Fredric Jameson (vol. 36, no. 3, Fall 2015), especially Anna Kornbluh, "The Realist Blueprint," 199–211.

73. Joshua Clover, "Subsumption and Crisis," in *The SAGE Handbook of Frankfurt School Critical Theory*, ed. Beverley Best, Werner Bonefeld, and Chris O'Kane (London: Sage Publications, 2018), 1567–83.

74. Mariarosa Dalla Costa and Selma James, "Women and the Subversion of Community," in *The Power of Women and the Subversion of Community* (New York: Petroleuse Press, 2010), 10.

75. Leopoldina Fortunati, *The Arcane of Reproduction*, trans. Hilary Creek (New York: Semiotext(e), 1995), 8–9.

76. As Fortunati puts it: "[In] order to be mobilized at the real level, [housework] *must at the formal level appear to be a process of individual consumption on the part of the male worker which is activated by just one wage.* If a factory for reproduction were ever constructed and if it showed itself for what it was, the functioning of the entire system of reproduction would be thrown into crisis" (114).

77. This is why, as Federici notes, the demand for wages for housework is a demand that directly "attacks capital." See Silvia Federici, *Wages for Housework* (Bristol, UK: Falling Wall Press, 1975), 5.

78. Nicole Cox and Silvia Federici, *Counter-Planning from the Kitchen* (New York: Falling Wall Press, 1975), 9. Cited in Clover, "Subsumption and Crisis," 1576.

79. Edel, *Henry James*, 540. Writing to Edward Warren on May 12, 1901, James thanks him for helping MacAlpine find a better paid job: "A propos of the Scot, your mention of his prosperity renews my sense of gratitude, for him, to you, and also for myself. . . . His 'lady-successor' here . . . is an improvement on him! And an economy!" Cited in Hyde, *Henry James at Home*, 147.

80. Letter to Mrs. William James, September 26, 1901. See Edel, *Henry James Letters*, 205.

81. Edel, *Henry James Letters*, 206. James describes the events leading up to this to his sister-in-law in the same letter; see 205–207. See also a reference to the already impending "domestic crisis" in his letter to Antonio de Navarro, June 15, 1898, *Letters*, 76.

82. Edel, *Henry James Letters*, 254, 312 (Letter to Jessie Allen, December 12, 1902; Letter to Louise Horstman, August 12, 1904).

83. Burgess Noakes, to be sure, would remain to the end in his position as valet and eventually nurse. This doesn't contravene the fact that after the departure of Smith, who was never replaced, the gender-specific position of butler disappears from James's household economy.

84. Fleissner, "Dictation Anxiety," 83.

85. Karl Marx, *Capital: A Critique of Political Economy*, vol. 1, trans. Ben Fowkes (New York: Penguin, 1976), 786.

86. A notebook entry from July 19, 1884 suggests that the germ of "Brooksmith" came first to James in the form of a story told to him about a "lady's maid." See Edel and Powers, *The Complete Notebooks*, 28.

87. See entry for February 22, 1891, in Edel and Powers, *The Complete Notebooks*, 56.

88. Pippin, *Henry James and Modern Moral Life*, 6.

89. Here we might even count Pansy from *The Portrait of a Lady* and Nanda from *The Awkward Age*, even though, in an interesting, happier, or luckier variation on the pattern, the unrelated caretakers or distant relatives they are fobbed off on by their parents (Isabel Archer and Mr. Longdon) are *not* waged employees and wealthy.

90. Leigh Claire La Berge, *Wages Against Artwork: Decommodified Labor and the Claims of Socially Engaged Art* (Durham, NC: Duke University Press, 2019), 5. For the argument that nineteenth-century Britain prior to 1870 (when deindustrialization is said to begin) was "*never* fundamentally an industrial or manufacturing economy; rather, it was *always*, even at the height of the industrial revolution, essentially a commercial, financial, and service-based economy" (original italics), see W. D. Rubinstein, *Capitalism, Culture, and Decline in Britain, 1750–1990* (London: Routledge, 1993), 24.

91. See Jason Smith, "Nowhere to Go: Automation, Then and Now: Part Two," *Brooklyn Rail*, April 1, 2017. Also see Jonathan Gershuny, *After Industrial Society? The Emerging Self-Service Economy* (London: Palgrave, 1978).

92. As Aaron Benanav and John Clegg put it, this dynamic often involves the transformation of "*labor-saving* process innovations" (often originating as services within specific firms or industries) into "*capital-and-labor-absorbing* product innovations." Moreover, labor-absorbing product innovations tend to *serve as* labor-expelling process innovations, as in the case of the automobile industry after its initial transformation of a service (mechanized transport) into a manufactured good:

> When the car and consumer durables industries began to throw off capital and labor in the 1960s and 70s, new lines like microelectronics were not able to absorb the excess, even decades later. These innovations . . . emerged from specific process innovations within industry and the military, and have only recently been transformed into a diversity of consumer products. The difficulty in this shift, from the perspective of generating new employment, is . . . that new goods generated by microelectronics industries have absorbed tendentially diminished quantities of capital and labor. Indeed computers not only have rapidly decreasing labor requirements themselves (the microchips industry, restricted to only a few factories world-wide, is incredibly mechanised), they also tend to reduce labor requirements across all lines by rapidly increasing the level of automation. Thus rather than reviving a stagnant industrial sector and restoring expanded reproduction—in line with Schumpeter's predictions—the rise of the computer industry has contributed to deindustrialisation and a diminished scale of accumulation—in line with Marx's.

Aaron Benanav and John Clegg (Endnotes), "Misery and Debt," in *Contemporary Marxist Theory*, ed. Andrew Pendakis, Jeff Diamanti, Nicholas Brown,

Josh Robinson, and Imre Szeman (London: Bloomsbury, 2014), 585–608, 596 (my italics)

93. Smith, "Nowhere to Go," n.p.

94. Clover, "Subsumption and Crisis," 1580.

95. On how "employment in the informal sector" won out as a concept over "disguised unemployment" in efforts by the International Labor Organization (ILO) to measure employment insufficiency in less developed countries from the 1950s to 2003, see Aaron Benanav, "The Origins of Informality: The ILO at the Limit of the Concept of Unemployment," *Journal of Global History* 14 (2019): 107–125. "Disguised unemployment" was first used by British economist Joan Robinson in 1936 to describe unwaged or low-productivity jobs (110).

96. This moment also marked, as Nathan Hensley argues, the "climax of empire," as "geopolitical downturn brought with it increasingly open, 'muscular' attempts to maintain England's position in the world. (No fewer than thirty-five imperial wars took place between 1875 and 1885, police actions in a destabilizing global order)." See "Allegories of the Contemporary," *Novel: A Forum on Fiction* 45, no. 2 (2012): 276–300, 282.

97. Karl Marx, *Grundrisse: Foundations of the Critique of Political Economy*, trans. Martin Nicolaus (London: Penguin, 1993), 706.

Acknowledgments

The making of this book was greatly enriched by others. Hans Thomalla listened to my arguments and helped throw many in sharper relief. Lauren Berlant, Alex Woloch, and Jonathan Flatley's comments on the manuscript at varying stages were invaluable. Thanks also to Anna Kornbluh, Jasper Bernes, Kyla Tompkins, Marcia Ochoa, Timothy Bewes, Ben Lee, Franco Moretti, David Kurnick, Gavin Jones, and Anne Cheng for insightful comments on individual chapters. I am also grateful to my anonymous readers at Harvard University Press.

Things I did for fun in 2013 shaped thinking in the book in ways I did not know at the time: a reading group with Joshua Clover and Juliana Spahr; and the Bay Area Public School's free seminar, Crisis Theory for Anti-Capitalists. During this period, Mark McGurl and the dog Dewey made each day ridiculously joyful.

Enormous thanks to Jacob Harris, my research assistant at the University of Chicago. I am also grateful to Abigail Droge for bibliographic assistance at Stanford, and to the wonderful librarians at Wissenschaftskolleg zu Berlin and the University of Chicago. The book grew richer thanks to remarks from audiences at places where I shared parts of it in progress: University of Michigan; Cornell University; 3CT at the University of Chicago; Fordham University; "Living Labor: Marxism and Performance Studies" at NYU Performance Studies; The School of Criticism and Theory; Wissenschaftskolleg zu Berlin; Institute for Cultural Inquiry Berlin; Kennedy Institute at Freie Universität; University of Maryland at College Park; University of Copenhagen; New York University; Johns Hopkins University; University of Toronto; Kaplan Institute for the Humanities at Northwestern University; Ohio State University; University of Wisconsin at Milwaukee; FORART in Oslo, Norway; Southern California Institute for Architecture; "The Politics of Form: What Does Art Know About Society?" at Zentrum für Literatur- und Kulturforschung in Berlin; Center for the Study of the Novel at Stanford University; Yale University; Oberlin College; University of Las Vegas at Reno; University of Pittsburgh Humanities Center; Bucknell University; Brown University; The Aesthetics Seminar at Aarhus University; "Adorno

Symposium" at the Center for Theoretical Inquiry in the Humanities; Indiana University; Centre for the History of the Emotions at Queen Mary; University of London; Kongress der Deutschen Gesellschaft für Ästhetik in Offenbach; Princeton University; University of California Los Angeles; the Society of Novel Studies Biennial Conference at Cornell University; University of Louisville; The New School for Social Research; Wesleyan Humanities Center; and the Miami University of Ohio. Sincere thanks to the organizers who made all of these visits possible.

I also wish to thank Lindsay Waters and Joy Deng at Harvard University Press and the chairs of the departments who have supported my research at the University of Chicago and Stanford. A special thanks to Stan Douglas, Torbjørn Rødland, and Jeff Busby for generosity about permissions.

No one has clearer eyes or a fuller heart than Hans Thomalla. This book is dedicated to him.

Text Credits

Introduction: "You Gotta Get a Gimmick" from *Finishing the Hat: Collected Lyrics (1954–1981) with Attendant Comments, Principles, Heresies, Grudges, Whines and Anecdotes* by Stephen Sondheim, copyright © 2010 by Stephen Sondheim. Used by permission of Alfred A. Knopf, an imprint of the Knopf Doubleday Publishing Group, a division of Penguin Random House LLC and the Helen Brann Agency, c/o ICM Partners. All rights reserved.

Chapter 1 was first published as "Theory of the Gimmick," *Critical Inquiry* 43 (Winter 2017): 466–505, © 2017 by the University of Chicago. Chapter 5 first appeared as "Visceral Abstractions," *GLQ* 21, no. 1 (January 2015): 33–63, © by Duke University Press. The text of Chapter 6 was published as "Rødland's Gimmick" in *Torbjørn Rødland: Fifth Honeymoon* (Berlin: Sternberg Press, 2018). Chapter 8 was first published as "Henry James's 'Same Secret Principle,'" *The Henry James Review* 41, no. 1 (Winter 2020), Johns Hopkins University Press. All texts are reprinted here, with minor edits, with permission of the publishers.

Illustration Credits

Introduction

1. Chloe Dallimore, Nicki Wendt and Anne Wood in *Gypsy*, Arts Centre Melbourne, 2013. The Production Company, Australia. Photograph © Jeff Busby.
2. *Gypsy*. Dir. Mervyn LeRoy, Warner Brothers, 1962.
3. *Left:* Cover of *Yps* 6 (1976). *Right:* Cover of *Yps* 1254 (August 2005) [detail]. Egmont Ehapa Verlag.

ACKNOWLEDGMENTS

Chapter 1: Theory of the Gimmick

1. Rube Goldberg. Artwork Copyright © and TM Rube Goldberg Inc. All Rights Reserved. RUBE GOLDBERG ® is a registered trademark of Rube Goldberg Inc. All materials used with permission by rubegoldberg.com.
2. "Pencil Sharpener." Artwork Copyright © and TM Rube Goldberg Inc. All Rights Reserved. RUBE GOLDBERG ® is a registered trademark of Rube Goldberg Inc. All materials used with permission by rubegoldberg.com.
3. Paige compositor. *Scientific American* (1901).
4. "The Never-Never Girl." Advertisement by Kelly Services.

Chapter 2: Transparency and Magic in the Gimmick as Technique

1. Stan Douglas, *Juggler, 1946*, 2010. Black and white photograph. 107×142 cm. Courtesy of the artist, David Zwirner, New York and Victoria Miro, London.
2. Stan Douglas, *Watch, 1950*, 2010. Black and white photograph. 46×69 cm. Courtesy of the artist, David Zwirner, New York and Victoria Miro, London.

Chapter 4: It Follows, or Financial Imps

1. *It Follows*. Dir. David Mitchell, Northern Lights Films, Animal Kingdom, Two Flints. 2014.
2. *It Follows*. Dir. David Mitchell, Northern Lights Films, Animal Kingdom, Two Flints. 2014.
3. *It Follows*. Dir. David Mitchell, Northern Lights Films, Animal Kingdom, Two Flints. 2014.
4. *It Follows*. Dir. David Mitchell, Northern Lights Films, Animal Kingdom, Two Flints. 2014.
5. *It Follows*. Dir. David Mitchell, Northern Lights Films, Animal Kingdom, Two Flints. 2014.
6. *It Follows*. Dir. David Mitchell, Northern Lights Films, Animal Kingdom, Two Flints. 2014.
7. *It Follows*. Dir. David Mitchell, Northern Lights Films, Animal Kingdom, Two Flints. 2014.
8. *It Follows*. Dir. David Mitchell, Northern Lights Films, Animal Kingdom, Two Flints. 2014.
9. *It Follows*. Dir. David Mitchell, Northern Lights Films, Animal Kingdom, Two Flints. 2014.

Chapter 6: Rødland's Gimmick

1. Torbjørn Rødland, *The Coming Together of Opposites*, 2006. Chromogenic print. 140×110 cm. Edition of 3, with 1 AP. Courtesy of the artist and STANDARD (OSLO), Oslo.
2. Torbjørn Rødland, *White Tapes*, 2003. Black & white RC print. 76×96 cm. Edition of 3, with 1 AP. Courtesy of the artist and Air de Paris, Paris.

3. Torbjørn Rødland, *Ampersand*, 2010. Chromogenic print. 45 × 57 cm. Edition of 3, with 1 AP. Courtesy of the artist and Nils Stærk, Copenhagen.

4. Torbjørn Rødland, *Black Mirror Object*, 2005. Black and white photograph. From the book *White Planet Black Heart* (Mack, 2006).

5. Torbjørn Rødland, *Twintailed Siren*, 2011–2013. Chromogenic print. 57 × 45 cm. Edition of 3, with 1 AP. Courtesy of the artist and David Kordansky Gallery, Los Angeles, CA.

6. Anonymous, duck / rabbit illusion, *Fliegende Blätter*, October 23, 1892.

7. Torbjørn Rødland, *Vacuum Cleaner*, 2002. Chromogenic print. 76 × 60 cm. Edition of 5, with 2 APs. Courtesy of the artist and STANDARD (OSLO), Oslo.

8. Torbjørn Rødland, *Red Pump*, 2014. Chromogenic print. 76 × 60 cm. Edition of 3, with 1 AP. Courtesy of the artist and David Kordansky Gallery, Los Angeles, CA.

9. Torbjørn Rødland, *Baby*, 2007. Chromogenic print. 60 × 76 cm. Edition of 3, with 1 AP. Courtesy of the artist and Galerie Eva Presenhuber, Zurich and New York.

10. Torbjørn Rødland, *Wordless no. 4*, 2010–2017. 110 × 140 cm. Edition of 3, with 1 AP. Courtesy of the artist and Nils Stærk, Copenhagen.

11. Boxes of Hamburger Helper © Sianne Ngai.

12. Torbjørn Rødland, *Tattoo*, 2006. Chromogenic print. 40 × 50 cm. Edition of 3, with 1 AP. Courtesy of the artist and Nils Stærk, Copenhagen.

13. Torbjørn Rødland, *Golden Lager*, 2006. Chromogenic print. 57 × 45 cm. Edition of 3, with 1 AP. Courtesy of the artist and Galerie Eva Presenhuber, Zurich and New York.

14. Torbjørn Rødland, *Minnesota Sharpie*, 2005. 76 × 60 cm. Edition of 3, with 1 AP. Courtesy of the artist and Air de Paris, Paris.

Chapter 7: The Color of Value

1. Stan Douglas, *Suspiria*, 2003. Single-channel video with stereo sound, dimensions variable, infinite. Original in color. Courtesy of the artist, David Zwirner, New York and Victoria Miro, London.

2. Stan Douglas, *Suspiria*, 2003. Single-channel video with stereo sound, dimensions variable, infinite. Original in color. Courtesy of the artist, David Zwirner, New York and Victoria Miro, London.

3. Stan Douglas, *Suspiria*, 2003. Single-channel video with stereo sound, dimensions variable, infinite. Original in color. Courtesy of the artist, David Zwirner, New York and Victoria Miro, London.

4. Single-channel video with stereo sound, dimensions variable, infinite. Courtesy of the artist, David Zwirner, New York and Victoria Miro, London. *Left:* Luminance (Y) signal. Original in black and white. *Center:* Chrominance (C) signal. Original in color. *Right:* Composite (Y/C) signal. Original in color.

5. Stan Douglas, *Suspiria*, 2003. Single-channel video with stereo sound, dimensions variable, infinite. Original in color. Courtesy of the artist, David Zwirner, New York and Victoria Miro, London.

6. Stan Douglas, *Suspiria*, 2003. Single-channel video with stereo sound, dimensions variable, infinite. Original in color. Courtesy of the artist, David Zwirner, New York and Victoria Miro, London.
7. Stan Douglas, *Suspiria*, 2003. Single-channel video with stereo sound, dimensions variable, infinite. Original in color. Courtesy of the artist, David Zwirner, New York and Victoria Miro, London.

Index

Page numbers in italics refer to figures.

abstraction, 174–195; abstract labor, 9, 32, 36–38, 49, 175–186, 228, 247–249, 314n80, 351n18, 354n49; and comedy, 60; and finance, 175, 350n5; and the gimmick (in Rødland's work), 221; and magic, 246; of the narrator in James's *The Sacred Fount*, 284; "real abstraction," 50, 175, 179, 222; as way of countering abstraction, 187

absurdity: and "enigmaticalness," 86

accumulation: diminishing scale of, 146, 379; fantasy of endless, 64, 127, 160, 166, 247, 248, 249, 265; fundamentals of, 7, 9, 32, 39, 145, 309n23; limits of, 4, 51; overaccumulation, 60, 105; phases of, 166; "primitive" (in Marx), 246; temporality of, 69, 308n14; unease about, 8

Adorno, Theodor W.: on art and capitalism, 48–49; on art's "enigmaticalness," 86; on "art religion," 317n104; on art and technique, 86, 99; on Mahler's "poetic ideas," 112–113; and Mann, 48, 106; on suspicion surrounding theory in modern music, 107

aesthetic category: as judgment tied to form, 1, 5, 21, 27, 147

aesthetic judgment. *See* judgment

affect: and ambiguity, 268; and the gimmick, 1–3, 96–97, 106, 135; and judgment, 23, 96–97, 135; and (erroneous/false) praise, 44, 135–136; and speech, 24, 135

Agamben, Giorgio, 35; on the inauguration of modern aesthetics, 138; on proto-gimmicks, 53–54

Ahwesh, Peggy: *She Puppet*, 106

Alea, Tomás Gutiérrez: *Memorias del Subdesarrollo* (*Memories of Underdevelopment*), 232

Allais, Alphonse: *Funeral March for the Obsequies of a Great Deaf Man*, 89. *See also* pranks

allegory, 113, 121–122, 126, 338n62; the body as, 186, 188–190; in Douglas's work, 229, 263; in Golding's work, 28–29; of value, 177; in Rødland's work, 206–207, 222; speculative, 62

ambiguity: affective, 268; of capitalist production, 213; of the concept of "labor-saving," 55; of the gimmick, 55–56; temporal, 63, 68, 81, 147, 162, 164; about value, 209

analysis: the gimmick's resistance to, 9